The Sociology of Art

A Reader

Edited by

Jeremy Tanner

 Routledge
Taylor & Francis Group

LONDON AND NEW YORK

First published 2003
by Routledge
11 New Fetter Lane, London EC4P 4EE

Simultaneously published in the USA and Canada
by Routledge
29 West 35th Street, New York, NY 10001

Routledge is an imprint of the Taylor & Francis Group

Typeset in Perpetua and Bell Gothic by
RefineCatch Limited, Bungay, Suffolk
Printed and bound in Great Britain by
Butler and Tanner Ltd, Frome and London

British Library Cataloguing in Publication Data
A catalogue record for this book is available from the British Library

Library of Congress Cataloging in Publication Data
The sociology of art: a reader/edited by Jeremy Tanner.
 p. cm.
Includes bibliographical references and index.
 1. Art and society. 2. Art—Social aspects. I. Tanner, Jeremy, 1963–

N72.S6S62 2003
306.4′7—dc21 2003001918

ISBN 0–415–30884–4 (hbk)
ISBN 0–415–30883–6 (pbk)

University of Hertfordshire

The

College Lane, Hatfield, Herts. A⊤

Learning and Inf.

A Reader

The Sociology of Art: A Reader provides students with an introduction to the fundamental theories and debates in the sociology of art, using extracts from the core foundational and most influential contemporary writers in the field.

The book is divided into five parts exploring key themes in the sociology and social history of art:

- classical sociological theory and the sociology of art
- the social production of art
- the sociology of the artist
- museums and the social construction of high culture
- sociology, aesthetic form and the specificity of art.

With the addition of an introductory essay that not only contextualises the readings within the traditions of sociology and art history, but which also draws fascinating parallels between the origins and development of these two disciplines, this book opens up a productive interdisciplinary dialogue between sociology and art history as well as providing a comprehensive overview of the subject.

This book is essential reading both for students of the sociology of art and for students of art history.

Jeremy Tanner is Lecturer in Greek and Roman Art and Archaeology and co-ordinator of the graduate programme in Comparative Art and Archaeology at University College London.

Contents

Preface

THIS READER IS DESIGNED to provide students with an introduction to the fundamental theoretical orientations which have characterised the sociology of art from its nineteenth-century origins, in Marxism, to contemporary contributions. Readings have been selected which are both representative of the major debates in the sociology of art and lend themselves most strongly to informing contemporary theoretical debates between art history and the sociology of art.

The introduction explores the development of both art history and sociology as new discourses which developed during the course of the nineteenth century in response to the development of modern social structures and cultural institutions. Consequently, many of the classics of sociological and art-historical thought – for example Weber and Wölfflin – have commonalities both in their intellectual background and in the kinds of intellectual problems in which they are interested: the relationship between collective structures and individual freedom, cultural evolution and the systematic character of processes of cultural change. In other cases, essays which are now recognised as classics in their own fields – Panofsky's essay on the methodology of iconographic and iconological interpretation and Karl Mannheim's introduction to the interpretation of *Weltanschauungen* (worldviews) – were originally written in response to each other, and are much better understood in relationship to each other than in the disciplinary isolation in which they are normally read today. My introduction goes on to explore some of the reasons why art history and sociology developed in separate directions during the course of the twentieth century, and some of the more recent attempts to cross the disciplinary divide, most notably in the sociology of art of Pierre Bourdieu and Michael Baxandall's critical art history.

The core of the Reader consists in five parts each exploring a key area in the sociology of art: the classic theoretical perspectives of Marx, Weber, Simmel and Durkheim; the social production of art; the sociology of the artist; sociological

perspectives on high culture and museums; sociological approaches to style and aesthetic form. Each of the parts begins with a short introductory commentary. These commentaries discuss the main issues and approaches characteristic of the sociology of art in each of these areas, and in particular seek to characterise the distinctiveness of sociological from mainstream art-historical approaches, as well as pointing out areas where each discipline could benefit from deeper insight into and collaboration with the other. The intellectual background and key concepts of each of the selected readings are also introduced and explained in these introductory commentaries.

Any selection of readings in a particular academic discipline, whatever claims it may make to being representative of its field – and I hope this Reader is representative – is also programmatic. This volume is no different. It has two primary goals. First, intellectual excitement: it includes work by some of the finest sociological thinkers from the nineteenth century until today – Marx, Weber, Durkheim, Simmel, Mannheim, Parsons, Elias, Habermas, Bourdieu – all addressing problems which are crucial to our understanding of art: the social functions of high culture, the nature of artistic creativity, the relationship between social structure and aesthetic form. Second, interdisciplinarity: the best art history is, implicitly at least, sociologically informed, and the best sociology of art places questions of artistic agency and aesthetic form at the core of its research. Consequently, a primary aim of this Reader is to make it easier for art history students to see the potential reward of exploring sociological perspectives on art in a more systematic way, and for sociologists to regain access to a critical tradition in art-historical and art-sociological thought which can allow them to address contemporary problems in the sometimes more nuanced, aesthetically informed manner characteristic of certain earlier strands of sociological thought.

Full bibliographical details have been given with each reading, for students wishing to return to the original source. Many of the original texts have been cut, and original notes and references omitted, where it was thought inessential to the main argument of the reading. Conventions of spelling and capitalisation, as also the use of language which might now seem unacceptably gender-biased, have been left unchanged.

Acknowledgements

Many friends and colleagues have contributed to this book in one way or another. In particular, I owe a great debt of gratitude to my teachers in both art history and sociology, especially Mary Beard, Harold Bershady, Robin Cormack, Victor Lidz, Robin Osborne and Anthony Snodgrass. Equally, this book would not have been written without the stimulus of my students in the Comparative Art MA programme at the Institute of Archaeology, University College London. Jas Elsner provided the proximate cause for this particular project, and I am profoundly indebted to him not only for his considerable help in bringing this work to fruition but for his intellectual companionship and many personal kindnesses over a number of years.

The publishers would like to thank all the authors represented in this work, as well as the following publishers for their permission to reprint their material:

The American Sociological Association for permission to reprint Howard S. Becker, 'Art as collective action', from the *American Sociological Review*, 1974.

Blackwell Publishing for permission to reprint Robert Witkin, 'Van Eyck through the looking glass' from *Journal for the Theory of Social Behaviour* 22, 1992; from David Brain, 'Material agency and the art of artifacts' in *The Sociology of Culture*, 1994; and material from Norbert Elias, *Mozart: Portrait of a Genius*, 1993.

Columbia University Press for permission to reprint material from Georg Simmel, *The Conflict in Modern Culture and Other Essays*, 1968.

Kluwer Academic Publishers for permission to reprint Vera L. Zolberg, 'Conflicting visions in American art museums', from *Theory and Society* 10, 1981.

The MIT Press for permission to reprint material from Jürgen Habermas, *The Structural Transformation of the Public Sphere*, 1989.

Oxford University Press for permission to reprint material from Raymond Williams, *Marxism and Literature*, 1977; and from *From Max Weber: Essays in Sociology*, edited by H. H. Gerth and C. Wright Mills, 1946.

Princeton University Press for permission to reprint material from Natalie Heinich, *The Glory of Van Gogh: An Anthropology of Admiration*, 1996.

Progress Publishing Group Corporation for permission to reprint selections from Karl Marx and Frederick Engels, *Marx and Engels on Literature and Art*, 1976.

Routledge for permission to reprint material from Arnold Hauser, *The Social History of Art*, vol. II, 1951; and from Karl Mannheim, *Structures of Thinking*, edited by D. Kettler, V. Meja and N. Stehr, 1982.

Sage Publications for permission to reprint Paul DiMaggio, 'Cultural Entrepreneurship in nineteenth-century Boston' from *Media, Culture and Society* 4, 1982.

University of California Press for permission to reprint material from Max Weber, *Economy and Society*, edited by G. Roth, 1968.

The publishers have made every effort to contact the copyright holders of works reprinted in *The Sociology of Art: A Reader*. It has not been possible in every case, however, and we would welcome correspondence from individuals or companies we have been unable to trace. We will undertake to rectify errors or omissions in future editions of the book.

Introduction:
Sociology and art history

'SOCIOLOGY AND ART DO not make good bedfellows' (Bourdieu 1993b, 139 – see Chapter 7). This difficult relationship is something of a paradox. Art writers such as Friedrich Schiller and Johann Joachim Winckelmann who profoundly shaped the modern discipline of art history had similar preoccupations to those of early sociologists such as Karl Marx and Max Weber. Both art history and sociology were cultural discourses or genres of writing constructed and 'institutionalised' – or given a social basis in sets of routinised social relationships and patterns of action – from the late eighteenth to the early twentieth century, largely in France and Germany. These new cultural practices were a response to the profound social changes which marked the development of modernity in the west. Aesthetics, art history and institutions such as museums were created as part of the process whereby art became increasingly autonomous from the religious and political institutions, such as church and state, which had previously controlled art production and consumption. Sociological writing took place within the same newly emergent sphere of civil society as aesthetics and art history writing. Both discourses addressed how this sphere was increasingly dominated and corrupted by the advances of unregulated market economies; how patterns of economic organisation disrupted moral order, eroded social integration and reduced humanity to the one-dimensional adjunct of a rationalised and mechanistic capitalist 'cage' (Hawthorn 1987; Hunter 1992).

How, then, have art and sociology come to make such an unlikely couple? In this introduction I shall sketch the genesis of both sociology and art history writing in the context of these processes whereby social domains – the political, the economic, the familial – and cultural realms – art, religion, science – became increasingly 'differentiated', separated from and autonomous of each other. I shall emphasise the shared roots of art history and sociology and in particular the degree to which early art-historical writing had a marked sociological orientation. I shall then explore how

sociology and art history became 'institutionalised' as academic disciplines in modern universities, acquiring an organisational and social basis for their intellectual projects. As they acquired this independent social basis for their work, art historians redefined their discipline in such a way as to marginalise sociological concerns, and sociologists developed specific attitudes towards art and methods of analysis which were increasingly peripheral to art historians' core interests. I shall conclude with a critical examination of recent attempts to bridge the gap between art history and the sociology of art, and some suggestions as to how shared disciplinary interests might be further developed.

Art history, sociology and the genesis of modernity

The social and cultural origins of sociology

Sociological and cultural categories are themselves the products of the social and cultural processes they seek to explain.[1] Karl Marx's discovery of the abstract category of 'labour' as the source of economic value, for example, depended on the development of wage-labour and labour markets in early capitalist society. These made the phenomenon of labour visible in ways which it had not been before, in a world of tied peasantry or independent craft-workshops. Similarly, the concept of society and our modern idea of the social are the result of a long process of historical development beginning with the dissolution of feudalism. In the Middle Ages most writing about issues we might regard as social – the family, morality, political authority – remained integrated with theological discourse as part of the religious sphere. Only in the Renaissance and Reformation, as the state administrative apparatus became separated or 'differentiated' from the personal households of individual rulers, did the secularisation of thought make any progress. This period saw the first development of specifically political theory and the articulation of ideas of political interests as phenomena in their own right, irreducible to religion or morality, a process most closely associated with Machiavelli.

The development of absolute monarchy, notably in France, further encouraged the emancipation of literary and intellectual culture from the church. In the seventeenth century, the foundation of academies provided institutionalised patronage for literary-intellectual (and of course artistic) production. The privileges reserved to these bodies in matters of language and literature (the Academie Française), art and aesthetics (Academie de la Peinture), science and technology (Academie des Sciences) enhanced state control over cultural production to the point of a virtual monopoly, largely at the expense of the former dominance of the church over art production. Issues of political and moral theory, for example, were debated within a framework of regulations laid down by the Academie Française, which stipulated that such questions could be dealt with only 'in accordance with the authority of the king, the government and the laws of the monarchy' (Heilbron 1995, 68).

The academies represented a formalised extension of the much broader courtly culture of the salons, the intellectual and social milieu of an increasingly depoliticised aristocracy. Intellectual exchange in these settings took the form of refined and

sparkling conversation, and was open to *bourgeoises* as well as aristocrats, so long as they could meet standards of courtly etiquette. In this context, purely social virtues, such as the ability to construct and maintain relationships, were at a premium. French thinkers such as Voltaire became increasingly aware of *société* and *sociabilité* as phenomena with their own order of reality, independent of ethical or cultural considerations. The concept of *société* was extended from elite social circles to patterns of social relations in general. Bourgeois intellectuals, often somewhat uncomfortably placed on the edge of the intellectual life of the academies and salons, were particularly sensitive to the idea of the social. Alongside salons, clubs and other networks expanded the range of activities not subject to direct regulation by the state. The growth of a bourgeois readership permitted the publication of such major intellectual projects as the *Encyclopédie* outside the patronage and the controls of the academy. This institutional differentiation of civil society from the state, and the model of a society of equals offered by the salons and intellectual clubs, encouraged the development of a purely secular understanding of society, exemplified by Jean-Jacques Rousseau's idea of the social contract as prior to political relations and standing in opposition to the state.

An early example of this sense of a phenomenon irreducible to conventional political categories or a universalistic, ultimately religious, morality is Montesquieu's *Spirit of the Laws*. Montesquieu relates differences in the political structure of regimes to the physical environment and the moral constitution or *esprit général* of nations. This general spirit stands over and sets limits on the legitimate exercise of power of the monarch, performing a similar function to that of the 'collective conscience' in the later sociology of Emile Durkheim. Similarly, Voltaire in his account of *Le Siècle de Louis XIV* put the 'culture of the spirit' of the French nation, not the individual monarch or political events, at the centre of his account.

Although the works of Voltaire, Rousseau and Montesquieu contain in fact or anticipation many of the key concepts of what was to become sociology, their work retains the largely literary and essayistic character of salon culture. The scientisation of social thought was the achievement of the latter part of the eighteenth and the nineteenth centuries. Condorcet had already, in the 1780s, argued that the moral sciences should follow the lead of the natural sciences in developing an 'exact and precise' conceptual language, and exploiting mathematics to formalise analysis. Although such ideas were initially ill received, the revolutionary governments promoted scientific endeavours at the expense of the literary activities associated with courtly culture. This led to a separation between cognitive and aesthetic activities: institutionally marginalised poets and writers became unwilling to acknowledge the literary authority of philosophers and scholars. Scientific activities increasingly also escaped the control of the old academies, as disciplinary differentiation gave rise to more specific scientific societies and journals to publish their members' findings and discussions. It was in this context that Auguste Comte, often regarded as the founder of sociology, sought to define the specificity of sociology as the last of a series of autonomous sciences, each emergent from the science that had historically preceded it, each characterised by the greater level of complexity of its proper object, and each endowed with a unique set of methods: astronomy, physics, chemistry, biology,

sociology. Whilst Comte himself was never more than a marginal figure within the French academic establishment, it was his scheme which provided the basis for the research programme realised and given institutional form by Durkheim and his collaborators at the end of the nineteenth century: sociology as the science of social phenomena – social relationships and actions shaped by them, groups, institutions, communities, societies and their laws of functioning – understood as objects of their own specific type, to be explained in terms of other social phenomena and not reducible to other sciences such as biology or psychology.

The autonomy of art and the origins of art history

It is a commonplace of the history of ideas that the modern concept of the Fine Arts emerged only during the course of the eighteenth century (Kristeller 1990). Here I wish just to sketch the development of the concept of art as an autonomous cultural domain and the associated origins of art history writing, emphasising the institutional dimensions of this process and its parallels with the emergence of sociology. Here also the social development of the object and the cultural development of the possibility of its cognition are closely linked (Bürger 1984; Mannheim 1982).

Medieval aesthetic thought, like medieval social thought, was fused with theology. Only in the Renaissance was a tradition of workshop manuals developed into a body of secular and theoretical thinking on the arts by humanistically educated artists such as Alberti and Leonardo da Vinci. Renaissance artists' writings were primarily concerned with the production of art. They sought to codify and rationalise such dimensions of artistic design as perspective drawing, and to enhance the status of the artist as producer by emphasising the theoretical and scientific over the manual aspects of artistic practice. The claims of Renaissance artists were codified in Vasari's *The Lives of the Artists*, a series of biographies of painters telling the story of the development of Italian art from its rudimentary beginnings in Giotto to perfection in Michelangelo.

Whilst components of the *Lives* provided important models for later art historians, Vasari's accomplishments did relatively little to disembed art from its institutional contexts. The Academy of Design, founded by Vasari in Florence (1563), provided a perfect organisational model for the developing absolutist states to establish centralised control over cultural production at the expense of the eroding cultural monopoly of the church. In France, the director of the Academy of Painting, Le Brun (1619–90), also supervised designs for and managed production in state workshops manufacturing porcelain and tapestries, thus providing the state with a distinctive and uniform high culture (Pevsner 1940; Perry and Cunningham 1999). Within the Academy itself, a central role in the training of painters was played by a series of conferences and lectures, at which works of canonical masters in the classical tradition would be discussed, analysed and evaluated in order to establish models for contemporary painting. As with the *doctrine classique* in literature (Bürger 1983), so in painting the academic orthodoxy sought to rationalise artistic production, subjecting facial and gestural expression and the use of line and colour to calculable control. Such carefully calculated pictorial effects were designed to evoke specific responses on the part of viewers, to induce them to emulate the conduct of the heroes repre-

sented in history paintings, and thus to socialise them into the normative values which underwrote the new absolutist state. In the context of this academic system, and of the resurgence of religious patronage as the Counter-Reformation gathered pace in the seventeenth century, the experience of art remained embedded in the religious practices of believers and the courtly lifestyle of the social elite. Looking at and knowing about paintings was not a special activity dependent on expert knowledge, but part of the everyday culture of the cultivated courtier.

But although on one level the production and reception of art remained 'socially embedded' – controlled by non-specifically artistic groups and interests such as church and state – the open discussion of the norms of art which took place at conferences, involving votes to establish orthodox academic positions on particular issues, represented a real gain in autonomy. Such practices emancipated art production from traditionalistic norms. They also provided art with some protection from the attempts to reimpose such controls characteristic of Counter-Reformation artistic patronage. Moreover, even if the rationalisation of painting was ultimately guided by a desire to inculcate more effectively established social norms, the very practice of discussing and analysing paintings in a formal institutional context standing outside the courtly and sacral spheres for which that art was predestined encouraged an increasing sense of the autonomy of the specifically aesthetic values of art, and in particular of personal and regional styles (Barasch 1985, 354).

It was in countries where academic ideas were only very partially if at all institutionalised – England and the numerous small states of Germany – that a further step was taken in the disembedding of art writing and the experience of art from traditional institutional contexts, and the creation of a new autonomous framework in which art viewing and appreciation were constituted as a specialised activity undertaken in their own right.[2] After the triumph of Parliament in the Glorious Revolution of 1688, any aspirations of the English monarchy to absolutism were effectively eliminated, and the court ceased to play a major role as an art patron. Puritanism, moreover, had greatly reduced the demand for the religious art which played such an important role in Catholic Europe. Art production was increasingly oriented to a market, and sold to collectors composed of aristocrats and wealthy members of the commercial elite. Whether in country houses or London homes, such collections were formed according to primarily stylistic and historical criteria of value shaped by academic art writing. This displaced the representative function of galleries of ancestral portraits characteristic of the old nobility. Both in collections and in auctions, people encountered works of art outside the religious and political contexts in which they had conventionally been experienced. In France, the annual display of academic art in the salons offered opportunities for similar kinds of experience, and was the setting for which Diderot developed his art criticism. Such art critical works were made possible by an expanding middle-class public that needed guidance in encountering and responding to art in these new settings.

Eighteenth-century aesthetic philosophy – Moritz, Baumgarten, Kant – is largely an attempt to articulate this new experience of 'art as such' (Abrams 1989a, 1989b). Made possible by the development of the art market, this tradition, culminating in Schiller's *On the Aesthetic Education of Man*, also represents a critical response to

the increasing marketisation of goods and human labour. It reconstitutes the kind of practical criticism involved in academic art teaching as a 'technique of the self', a set of practices designed to cultivate an individualised aesthetic ethos: critical analysis of the work of art is played off against emotional identification in a spiralling process designed to intensify imaginative experience (Hunter 1992). The interior or spiritual depth engendered by such a process of *Bildung* – or educational self-formation – endows its bearer with an inner composure or freedom against the alienating and fragmenting pressures of modern society. This emphasis on technical 'constructive' freedom, and on the ethical inner freedom of 'composure' on the part of the artist in relation to the object he or she represents constitutes the technical core of the critical German idealist tradition in art history (Podro 1982), and indeed the dominant strand of art history writing even today.

J. J. Winckelmann's *History of Ancient Art* (1764) synthesised a number of dimensions in aesthetic and social thought which we have already encountered. Stylistic categories are used not simply to classify works of art by region or artist but to provide a chronological framework within which the rise, climax and decline of Greek art are explained in terms of the developing political structure of the Greek state, and more broadly in terms of geographical and climatic environment. The analysis corresponds exactly to the model of Montesquieu's *Spirit of the Laws*, but with a much more explicit historical dimension. Anticipating Schiller, whose more developed aesthetic philosophy is heavily dependent on Winckelmann, he represents the Greek male nude as the embodiment of perfectly integrated manhood, self-sufficient and unalienated, an object of identification for the modern viewer fragmented by the divisions and inequalities of civil society described by Rousseau in his *Discourse on the Origins of Inequality* (Potts 1994, 150). Winckelmann enacts through his engagement with Greek art what Schiller was to generalise as a critical aesthetic stance to all art in his letters *On the Aesthetic Education of Man*.

Art and society in eighteenth- and nineteenth-century art history writing

In the light of these parallels between the development of social thought and of writing on the arts, it is perhaps not surprising that much early art-historical writing has a strongly sociological character. Indeed the key issue was the relationship between art and society and the fundamental concept that of art as a *reflection* of society or the nation. Moreover, the authors of early social scientific writing and art or cultural history writing are often the same individuals, working within flexible and open intellectual genres not as yet differentiated in the way they were to be in the modern university (Heilbron 1995, 3). Montesquieu in his notes on a visit to the Uffizi in Florence is largely preoccupied with the changing aesthetic customs (hair fashions, art styles) in the context of the development and decline of the Roman state, rather than the particular personalities of people portrayed which had been the primary interest of earlier writers (Haskell 1993, 164). As early as 1752, the Comte de Caylus had suggested that the arts 'present a picture of the morals and spirit of a century and a nation', but was unable to develop the general insight into a more systematic

theory (*ibid.*, 181). Voltaire used art as an indicator of the spiritual quality or value of different periods, and had originally intended to incorporate an analysis of art in its societal context in his *Essai sur les moeurs* (*ibid.*, 201).

The increasing emphasis placed on the idea of a national societal community, prior to and constraining the state, evident in thinkers such as Montesquieu and Rousseau, was translated into art-historical thought through the writing of Herder and Hegel. Herder criticised Winckelmann for judging all art according to a single stylistic standard, suggesting that periods and traditions despised by Winckelmann – Egyptian, Gothic – should be understood in terms of their own aesthetic standards, themselves conformable to the pattern of life of their own times. Hegel incorporated Herder's historicist vision within a 'determinist' philosophy of history in which each distinctive period and cultural tradition was defined both in its own intrinsic terms and as a necessary step in the evolution of the world spirit:

> Every step, being different from every other one, has its own determined and peculiar principle. In history such a principle becomes the determination of the spirit – a peculiar national spirit. It is here that it expresses concretely all aspects of its consciousness and will, its total reality; it is this that imparts a common stamp to its religion, its political constitution, its social ethics, its legal system, its customs but also its science, its art and its technical skills. These particular individual qualities must be understood as driving from that general peculiarity, the particular principle of a nation.
>
> (Hegel, quoted by Gombrich 1984a, 54)

Art was the privileged vehicle of the Hegelian vision, an 'expression of the Divinity' which 'takes and extracts without adulteration the indwelling spirit of the nation', 'revealing the truth which is manifest in the history of the world'. As we shall see, it is this Hegelian conceptual core – aesthetic transcendentalism, collectivism and historical determinism – that forms the taking-off point for theoretical explorations of both art history and the sociology of art, each appropriating, transforming and – in certain respects – rejecting the Hegelian vision which it sees preserved in the other (Gombrich 1984a, 52). Hegel's word was already becoming flesh as he spoke, in the new art museums of the late eighteenth and nineteenth centuries. As Enlightenment philosophers' ideas about the nation's priority over the state gained currency, states sought to legitimate their power by clothing themselves in the aura of their national art traditions which they claimed to protect and promote. The great national museums such as the Louvre were created as part of the modern state cultural apparatus, and have been aptly described as 'ritual monuments' designed to inculcate in visitors an identification with the state as the guardian of sacred national values. They accomplish this through architectural design – as temples of the Muses – and their interior arrangement – a ritualised walk through the history of art culminating in the development of a national school. This arrangement projects the nation as the heir to the classical tradition and the state as the guardian on behalf of its citizens of the living patrimony of its art (Duncan and Wallach 1980).

This tradition of writing culminated in the second half of the nineteenth century in

the cultural histories of Burckhardt and Taine, which are largely Hegelian in their intellectual presuppositions. Both describe period and national cultures as integral totalities, bearing a 'common stamp' in their politics, religion and art. In Burckhardt's accounts of Italian Renaissance art and culture, the artist is described as a vehicle of a period style and spirit (Haskell 1993, 343; Burckhardt 1958). Taine developed a still influential framework for art interpretation which sought to explain individual works of art or artistic styles in terms of their 'milieu' (Hadjinikolaou 1978, 30–5; Haskell 1993, 366–2; Martin 1963a, 1966). Taine goes beyond Winckelmann by supplementing political and natural environmental explanations with a wider range of possible socio-cultural 'influences'. The features of works of art and styles should be understood in terms of a radiating series of circles of possible influences which pre-dispose the artist to select certain features of content or style: the 'school or family of artists' of a particular period and country, 'another group yet more vast' namely the society within which this family of artists is embedded, along with the corresponding 'tastes', 'sympathies' and 'intellectual conditions' of that society. 'This social and intellectual condition of a community is the standard of that of artists; they do not live as isolated men' (Taine 1867, 4–8). What is interesting about Taine is that his writing includes most of the analytical components which are to be of importance in both history and sociology of art: a concern with style and form and iconography, the individual artist, the networks of artists with whom an artist in question communi-cates and co-operates, the broader social structure within which artistic production and consumption takes place. There is a strong sense of the externality and compelling nature of the social milieu, anticipating Durkheim's sociology: 'a group of circum-stances controlling man, to which he is compelled to resign himself. This situation develops in man corresponding desires, distinct aptitudes and special sentiments' (159). The categories, however, remain somewhat diffuse – 'all surrounding social and intellectual influences' – and the connections between them are very loosely articu-lated, on the assumption that the social ensemble comprises a unity in which all components are equally determinants of all others. Correspondingly, art analysis and contextualisation remain a largely descriptive exercise, rather than an explanatory one in which it is possible to generalise about relationships between art and society. In the following generations, the sharpening of these analytic categories was to separate sociological and art-historical writing much more sharply.

Disciplinary formations: from *Kulturgeschichte* to art history and the sociology of art

Art history for art history's sake: Wölfflin, Panofsky, Mannheim and the problem of art interpretation

So when and why did art history and sociology part company? The second half of the nineteenth century saw the formation of modern higher education in Europe, respond-ing to the demands created by rapid industrialisation, a changing social order and the administrative demands of colonialism. The expansion of universities encouraged the differentiation of disciplines, seeking to study distinctive subjects through the use of

distinctive methods, which provided the basis of their programmes of education and training in autonomous departments. Generic mixing of writings on art, moral philosophy and social studies was increasingly replaced by strictly defined university disciplines (Heilbron 1995, 3). In France, Emile Durkheim's studies of *The Division of Labour* (1893) and *Suicide* (1897) and his programmatic account of *The Rules of Sociological Method* (1895) defined a positivistic framework for sociology as a science of social phenomena, exploring the interrelationships between specifically social orders of facts – social structure and moral codes, social change and social integration. In Germany, Max Weber's methodological writings defined sociology as an *interpretative* science of social action (1905; 1922). That is to say sociology is concerned with the interpretation *and causal explanation* of behaviour to which subjective meaning is attached, and which is shaped in its course by consideration of the actual or expected behaviour of other persons. It was the role of groups, and participation in group life, in creating specific constellations of ideal and material interests and thereby permitting causal explanation which differentiated sociology from more purely hermeneutic or interpretative disciplines such as jurisprudence or history of philosophy.

Art history, like sociology, sought to define itself in relationship to established disciplines such as history, within which it had effectively been absorbed in the cultural history of Burckhardt and Taine. Like Weber, many early art-historical theorists were deeply influenced by the methodological writings of Wilhelm Dilthey, and in particular his recognition of 'objective' forms of culture such as law, art, science and religion each with its own internal logic and each requiring interpretation according to specific hermeneutic methods.[3] Correspondingly, theorists such as Riegl, Wölfflin and Panofsky sought to elaborate concepts which identified the irreducibly artistic dimensions of works of art, and sought in them the basis of art-historical explanation. All these concepts focus on the constructive role of aesthetic form, whether in informing contents (different formal treatments of a single theme, for example a Madonna and child), in aligning a viewer's response to those contents, or purely formal accounts of aesthetic evolution as in Alois Riegl's accounts of the evolution of plant motifs in classical ornament according to supposedly universal principles of design (Iversen 1979). An inherited conceptual vocabulary which had strong connections with more sociological, anthropological and psychological understandings of expressivity was gradually replaced by a more purely aesthetic framework.

In Heinrich Wölfflin's early studies artistic expression is conditioned by human nature and social order (Antoni 1940, 212ff.). In *Renaissance and Baroque* (1888), for example, Wölfflin grounds the expressive potential of architecture and painting in shared human capacities for empathy: our sense of our own body is projected onto other artistically formed bodies, responding to appearances of massiveness, movement or imbalance. In *Classic Art* (1898), this very broad anthropological approach is nuanced or qualified sociologically. The classic style is interpreted in terms of an elite corporeal code elaborated within courtly circles such as those described at Urbino by Castiglione. Although crucial to the explanatory logic of Wölfflin's arguments, these anthropological and sociological underpinnings are somewhat marginal to his more central concern with the particularities of form analysis, and stand alongside quite

marked polemics against cultural historical explanations of 'the history of style as a reflection of changes in the pattern of human life' (1888, 73). Correspondingly, in his methodological treatise *Principles of Art History* (1915) Wölfflin sought to give the discipline of art history a purely formal-aesthetic conceptual foundation. He argues that all styles can be characterised in terms of varying combinations of ten paired categories of pictorial order: linear and painterly, plane and recession, closed and open form, multiplicity and unity, clearness and unclearness. These were *a priori* concepts which defined fundamental alternatives faced by artists in ordering visual form, alternatives grounded in the structure of the human eye. The development of art could be interpreted as a purely visual phenomenon unfolding in a periodic cycle of the elaboration and deconstruction of formal complexity organised through these fundamental representational choices.

Where Wölfflin sought to define art history's disciplinary boundaries against general history, sociology and anthropology, Erwin Panofsky (1920) sought to rid art history of the residual psychological components implicit in Riegl's concept of *Kunstwollen* – 'artistic volition' or 'will to form'. *Kunstwollen*, Panofsky argued, should not be understood in terms of artistic intention, or as some kind of broad cultural disposition characteristic of a period. Such characterisations served only to reduce art to its external sources and elide the 'informing of materials' which distinguished 'artistic activity' from 'general historical activity' (18–25). On the contrary the concept should refer to precisely those phenomena internal to art which Wölfflin had recognised in his fundamental categories of pictorial order. Such concepts could be defined only *a priori*, in aesthetics. This entailed that art history was fundamentally opposed to genetic explanations or causal interpretative frameworks characteristic of disciplines such as sociology and psychology or other disciplines concerned with 'the history of actions' (28–31). Art history sought not to explain actions or objects as products of actions but to decipher aesthetically given meanings.

Panofsky's *Kunstwollen* essay represents a key step in a series of essays which defined the orthodox theoretical orientation and methodological stances of mainstream art history up to the 1980s. Panofsky's later essays were significantly shaped by his reading of the sociologist Karl Mannheim's essay 'On the interpretation of Weltanschauung' (*Weltanschauung*-worldview) (1922). Mannheim was interested in art history as a special case of a cultural science of interpretation, and in particular in its relationship to cultural sciences with more explanatory goals such as sociology. He recognised that all disciplines quite legitimately formed their objects through the kinds of operation of analytic abstraction performed by Wölfflin and Panofsky. He also sought, however, to create intellectual frameworks which could synthesise the varying understandings that different disciplines had of the same objects, or at least co-ordinate the particular insights of different disciplines. He distinguishes three levels of meaning common to interpretations of both everyday social interaction and works of art. The 'objective meaning' of a work of art or an action depends on social and representational conventions, for example the conventions of language which give a sentence a determinate meaning. The expressive meaning of an action or a painting points towards the intention of the person who produced it. The phrase 'I am sorry', for example, has a determinate objective meaning given by the rules of language. However,

its expressive meaning when used to apologise, depends on how the phrase is deployed, features such as tone of voice pointing towards the authenticity or insincerity of the apology. Interpreting an action or an object in terms of its 'documentary meaning' involves seeing it as the product or symptom of some deeper external force which lies behind it – an ethos, a *Weltanschauung* or a *Kunstwollen*, for example. The development of a new way of using the phrase 'I am sorry' could be interpreted as a symptom of changing patterns of courtesy and of the structure of social relations within which such courtesy rules functioned. As things stood, the connections between actions and cultural objects in different domains – such as art, religion, law and science – remained rather unclear, dependent on vague intuitions of precisely the kind that Wölfflin (1888, 76) had criticised. According to Mannheim, a genuine science of cultural phenomena would be realised only when such intuitive links could be articulated more rigorously through conceptions such as correspondence, parallelism, function, causality and reciprocity.

Mannheim's essay provided a model for Panofsky's (1939) classic formulation of art-historical interpretation, 'Iconography and iconology'. Following Mannheim's tri-partite schema, Panofsky distinguished primary or natural subject matter (the world of artistic motifs), conventional or iconographic meanings (the world of images, stories and allegories), and intrinsic meaning or content (the world of symbolical values). Each of these levels of meaning relied on specific kinds of interpretative knowledge, respectively: practical worldly experience; knowledge of literary sources; and synthetic intuition. Interpretation at each level could be validated according to a 'corrective principle': history of style, affording knowledge of how different real-world objects were represented in different periods; history of iconographic types, affording knowledge of what motifs were used to represent particular stories or allegories in different periods; and the history of cultural symbols. From the point of view of orthodox or mainstream art history, Panofsky's essay represents a 'far more systematic codification' of Mannheim's account of interpretation. Panofsky, it is held, 'was able to shed the overly philosophical and obscure verbiage of his earlier theory, to make it a useful construct'. One could validate interpretations using Panofsky's method of correctives 'without referring to causal explanations' (Hart 1993, 553).

Mannheim developed his ideas in quite the opposite direction, in a series of essays written in the 1920s but only recently published. Rather than dispensing with the concept of *Kunstwollen*, he sought to broaden the scope of the concept to other fields of social and cultural action, and contextualise it in group structures and collective ways of life (Mannheim 1982, 233ff.). Mannheim suggests that alongside the concept of 'artistic volition' one might also talk of an 'economic volition', a 'social volition' and ultimately 'a *Weltwollen* or will to the world . . . the deepest unity of style belonging to the consciousness of a community in all of its objectifications, conscious or unconscious' (1982, 233). As the concepts suggest, each of these volitions is carried by members of a social community within specific institutional contexts, and cannot be explained 'by reference to the structure' or patterning of cultural objectifications alone. On the contrary they are grounded in collectively or institutionally organised life processes of a community. They can stand in quite varied relations of complete or partial congruence or contradiction to each other, depending on the particular life

situation of the community or sub-group or institution within a community which is the bearer of such a social, economic or artistic volition or disposition. In other words, for Mannheim the concept of *Kunstwollen* offers a way of lending a dynamic dimension to the analysis of cultural forms, to see them as *principles of action* bound up in quite complex and ongoing social and cultural processes rather than as static objects or unmoved movers as in the case of Panofsky's conceptions of iconology and *Kunstwollen*. The task of the sociology of art is to trace systematically the interconnections between particular forms of artistic volition and collective patterns of experience rooted in social structures and processes of group life (93ff., 233ff.). What for orthodox art history intent on 'elucidating interpretation' of particular objects is an intuitively given background to the work of art becomes the explicit focus of a systematising sociology of art seeking to supplement interpretation with genetic, historical or causal explanation (125ff.; 1922, 183). As we shall see later, the most impressive recent attempts to integrate art analysis and sociology have followed Mannheim's lead in turning back through Panofsky's iconological level of analysis, seeking to specify analytically what is left open as a problem of intuition in Panofsky's schema.

Sociology and art history: conflicts and confrontations

Mannheim (1982) has described how the differing institutional locations of sociology and art history in relation to the art world, and their specific disciplinary interests, encouraged these disciplines to see and characterise ostensibly the same objects, works of art and styles in fundamentally different ways. That is to say, like other systems of thought, both art history and sociology are what Mannheim calls 'perspectival'. Correspondingly, their truth claims, though real, are partial, and must be relativised to the particular institutional and disciplinary contexts within which art historians and sociologists work, and to the ideal and material interests to which these differing contexts give rise. Only in this light can the apparently discrepant claims of sociologists and art historians be seen simultaneously to have validity in their own rather different terms. Such a relativisation of the two perspectives also opens up the possibility of a more synthetic approach which goes beyond merely lumping together perspectives which are, at the levels formulated, incommensurable. It should also mitigate the tendentious polarisation that has characterised the relationship between history and sociology of art in the postwar period. Sociology cannot simply subsume or replace art history, but it is much more than a handmaiden of art history, as some have suggested (Gombrich 1973/1979). Moreover much art-historical criticism of sociological work simply misses the point of what sociology seeks to accomplish, and evaluates it according to inappropriate criteria (the same is true for many sociological critics of art history).

Art history is centrally concerned with questions of aesthetic value (Haskell 1993, 6; Perry and Cunningham 1999; Gombrich 1973/79, 155). The existence of modern art institutions – museums, galleries, art books – presupposes a differential valuation of parts of our cultural tradition over others, linked to ideas of individual and national genius and creativity. The categories of art-historical analysis are the precipitate of past conflicts in aesthetic valuation (Gombrich 1963/66). Debates about

past art, like that between Berenson (1954) and Wickhoff (1900) over the dissolution of naturalism in late antique art, are often informed by contemporary aesthetic disputes, in this case over impressionism and successive styles in modernist art. Choices about what art to study or to exhibit implicitly confirm or contest the artistic canon. Such choices and values are also related to material interests implicit in the social structure of the art world understood in its broadest sense. Museums exhibit artists who will attract numerous visitors who either directly pay for entry or legitimate government subsidies. Scholars who study major artists from 'important' periods find it easier to publish their work, to secure jobs in museums or universities, and to acquire prestige and influence within the art-historical community. Education in art history – whether through books, museum exhibitions or undergraduate degree courses – has as one of its major aims the enrichment of human experience through the realisation of aesthetic value (Gombrich 1967/79, 59). Correspondingly, an emphasis is laid on the cultural competencies – above all connoisseurship, a highly cultivated capacity for looking at and discriminating between aesthetic forms communicable only within a 'culturally close-knit' community – which permit a close 'immanent' or strictly internal engagement with the object (Mannheim 1982, 63, 216). The ultimate goal of the accumulation and transmission of art-historical knowledge is authentic involvement with the individual work of art, synthesising the three levels of iconographical analysis identified by Panofsky into an *Erlebnis* or lived experience of 'intuitive aesthetic recreation' (Panofsky 1955, 14–15; Hart 1993, 554).

Sociologists' choices of research problems are also guided by values (Weber 1917, esp. 29ff. for a discussion of value judgements in art history and sociology of art), but a commitment to art or particular aesthetic values is rather seldom one of them (and in any case not one that can be grounded or justified within the conceptual framework of sociology itself, but only from outside it). Although sociologists have career interests like those of art historians, they are not tied up with the hierarchies of value constitutive of the art world. Art which would be perceived as trivial, scarcely worthy of study within the discipline of art history, can be the object of sociologically extremely significant work (Halle 1994).

Both sociology and art history are rooted in the origins of western modernity and share certain values and interests which compose the core of western culture, most notably the concern with individual autonomy. Moreover, sociologists such as Weber are interested in the distinctiveness of western aesthetic culture, and in the erosion of aesthetic value through rationalisation processes. However, this implies an interest in aesthetics only in so far as aesthetics impinges upon and can be related to the social structures and processes which are the primary object of sociological explanation. The distinctively sociological viewpoint on art thus seems to invert the particular value relationships implicit in art history. Art history is characterised by 'authentic', painstaking and direct engagement with the art object, and by an interest in artistic individuality both of particular artworks and of artists as manifested in the constructive role of form. Sociology is concerned not so much with particular individual empirical facts as with typical types of relationship (Francastel 1940/1948, 50). The ways of representing monarchic power, for example, are very diverse across cultures, but there

is not an infinite range of ways of doing so, and some ways are more similar to each other than others. They can be grouped into types and related to types of social structure. Sociology's characterisation of such types is designed not to explore their intrinsic aesthetic values but to enable connections to be made with social structures and processes. In elaborating the 'context' of an object, sociology by definition seeks to understand the object above all in terms of its functional contribution to social processes, and to define the period being studied in terms of its characteristic social structure, the groups which compose that structure, and which produce and use the works of art in question (Mannheim 1982, 89ff., 129ff.). By virtue of this strongly typologising disposition, and the perception of works of art and change in artistic style in relation to group processes and types of social structure, sociology characteristically constructs as discontinuous styles or periods which to the historian seem like smooth continuous transitions (Mannheim 1982, 116ff., 127). Needless to say, this may appear to the art historian as a wilful neglect of proper respect for the object as such and the particularities of form characteristic of individual objects. But it is an inevitable result of the different interpretative and explanatory goals of sociology. Criticism in such terms simply misses the point, choosing to ignore the distinctive vision of art which a sociological perspective offers: 'this non-immanent consideration of the more distanced view has the value of revealing the entire phenomenon at once, as it is interwoven with the whole of life and experience and as it is indebted to them' (Mannheim 1982, 64). Sociology makes no claim to give a total explanation of art, only to give a distinctive one, valid in terms of its own presuppositions and offering a point of view not afforded by conventional art history.

These differences in ideal and material interests shaping sociologists' and art historians' relationships to art lend themselves to mutual caricature and misunderstanding, as each sees the incommensurable truth claims of the other as a threat to their own claims to truth. In the postwar period these conflicts and misunderstandings have been exacerbated by a number of contingent historical factors which shaped the development of both fields. The rather sophisticated awareness of these epistemological issues developed in German art history and sociology was effectively lost to the scholarly community as a result of Nazism and the Second World War. Exiles in Britain and America encountered an environment hostile to the kind of theoretical work carried out by Panofsky and Mannheim in prewar Germany. Panofsky and his method were hugely influential in postwar American art history, but Panofsky himself no longer wrote theoretical essays, and the method was adopted with little or no critical awareness or discussion of its theoretical underpinnings (Eisler 1969). In England, Mannheim – and his Hungarian colleagues, the social historians of art F. Antal and A. Hauser, – were marginalised by traditions of Courtauld connoisseurship and the Warburg school dominated by Gombrich, the art-historical flag-bearer of Karl Popper's positivism.[4] Within Anglo-American sociology, moreover, it was the structural aspects of German sociology which found most ready reception, rather than those elements derived from the hermeneutic tradition of Dilthey. Max Weber's studies of bureaucracy and economic organisation have in practice been much more influential than his equally celebrated studies in the sociology of religion. Georg Simmel's formal sociology was more or less systematically

stripped of its aesthetic elements as it became absorbed in American symbolic interactionist social theory.

Failure to see the perspectival character of these two relationships to art has led each discipline to overstate its own truth claims whilst dismissing those of the other. A great deal of sociological work is concerned with 'desacralising' art or deflating art world claims to value. Some work in the production of culture perspective (Part Two below) suggests that debates over aesthetic values in art criticism and history are pure ideology, veiling what are really quarrels over more substantial social and economic interests. An important strand of sociological analysis of museums and high culture (Part Four) suggests that the 'true' function of the whole ensemble of practices surrounding museum visiting and looking at works of art is simply to mark social status and reproduce the class hierarchy of modern capitalist society. These claims are part of a broader struggle for a monopolistic claim to true representation of the social and cultural world. This is particularly apparent in the work of the major French sociologist Pierre Bourdieu, perhaps the most influential figure in contemporary sociology of art. Bourdieu contrasts his sociology of the French Academy and the impressionist revolution with that of art historians who, caught up in an evaluative relationship to particular styles, 'allow all the characteristics which would permit an understanding of the works *in the truth of their social genesis* to escape unnoticed' (Bourdieu 1993a, 241). In a striking echo of Plato's dismissal of the visual arts in the *Republic*, Bourdieu dismisses the forms of knowledge embedded in works of art and literature, the experience of which is constructed and mediated by art historians, whether through books or through museum displays, as 'literary alchemy', a phoney substitute for the genuinely scientific and emancipatory knowledge offered by sociology (Bourdieu 1996, 32). 'The form in which literary objectification is enunciated is no doubt what permits the emergence of the deepest reality, because that [the form] is the veil which allows the author and reader to dissimulate it and close their eyes to it.'[5]

A corresponding refusal to countenance the truth claims of sociological approaches to art is found in the work of perhaps the most influential art-historical theorist of the postwar period, Ernst Gombrich. Gombrich has been one of the foremost critics of Hegelian art history, whether in its grander version of art as a vehicle of continuous evolution of the spirit from Egypt to western modernity or in its more localised historicist versions in which art is interpreted as a reflection of the spirit of the age or national spirit. Gombrich's particular objections to Hegelian forms of art history (including for him Marxism and sociology of art) is that they are holist or collectivist and deterministic, consequently allowing no role for human freedom in history and short-circuiting the process of empirical enquiry where hypotheses are tested and modified against data. What is perhaps most striking about his discussions of social historians of art is how Gombrich's normally careful and impersonal logical argumentation breaks down into pure value-assertion or rather tendentious attempts to discredit the work of scholars who do not share Gombrich's radical individualist presuppositions.

The only social history of art that Gombrich is prepared to countenance is one in which sociology is the handmaiden of art history, studying the social 'background' of workshop organisation, contracts and so forth, leaving the art itself to the more

intuitive and personal approaches of true art historians. Any social history which goes beyond this, seeking to explain the stuff of art itself, namely styles, in terms of sociological factors is dismissed as 'collectivist' and 'holist' (apparently synonyms) and therefore 'determinist' (1984a, 63ff.). Gombrich's critique is not simply academic but political, creating a sense of guilt by association. Sociology is described as 'sociologism', to make it sound more like a political ideology than a serious intellectual discipline. Any approach that takes seriously the role of groups or collectivities is 'collectivist', presumably like Soviet agriculture. The vocabulary is that of the Cold War, and Gombrich could hardly have been unaware of the connotations of the words he chose. Mannheim's discussions of the relationship between style and social structure are dismissed without discussion as contaminated by 'political utopianism' and 'historical holism' and therefore in hock with the 'totalitarian philosophies' combated by Gombrich's own idols von Hayek and Popper (Gombrich 1974/79). It is not hard to see how and by whom Mannheim, Hauser and Antal got frozen out of the intellectual debates in postwar art history in London.

When read in the light of his own writings elsewhere, Gombrich's criticisms of Hauser's *The Social History of Art* (1951) reveal rather shabby double standards. Hauser is rebuked because 'for his purpose facts are only of interest in so far as they have a bearing on his interpretation' (Gombrich 1953/63, 86), as if it were a reasonable requirement that all facts irrespective of their relevance to the interpretation at hand should be considered. Elsewhere Gombrich acknowledges that without such a theoretical frame as a basis on which to select and order relevant facts from the infinite chaos of data the 'atoms of past cultures would fall back into dust heaps' (1967/79, 42). When Hauser insists on the ' "indissoluble interdependence" of all history . . . where all human activities are bound up with each other and with economic facts' this for Gombrich 'makes the selection of material arbitrary . . . left to the historian's momentary preference' (1953/63, 86). Yet elsewhere Gombrich insists that 'the history of art is one strand in the seamless garment of life which cannot be isolated from the strands of economic, social, religious or institutional history' (1973/79, 134). Hauser's leading hypothesis connects naturalistic styles with the development of bourgeois classes and more rigid hierarchic styles with the dominance of landed aristocracy. Far from being rigidly determinist, however, Hauser seeks to explore how these general tendencies are realised or checked under varying circumstances: different configurations of class power within varying social structures at different stages of social development. He seeks to render the initial hypothesis more complex by suggesting – for example – that urban patronage within a fundamentally agrarian society contributes to the development of naturalism in Akhenaten's Egypt, or conversely that the dominance of a priestly class prevents the development of naturalism that one might otherwise have expected in the urban civilisation of Babylon. For Gombrich this represents a resort to 'ever new and ingenious expedients to bring the hypothesis into harmony with the facts' (1953/63, 87). Why not see this as simply testing and refining the hypothesis in light of the data: schema, correction; making, matching, making again – Gombrich's own preferred model of both scientific and artistic progress (Gombrich 1960)? Anything which goes beyond a two-variable hypothesis set up to be falsified by testing against data is deemed inadequate accord-

ing to scientific criteria of explanatory adequacy Gombrich derives from Popper's positivist philosophy. One gets the feeling that whatever Hauser said, it had to be wrong, because he was a Marxist and therefore the enemy. If the alternative to determinism is, as Gombrich suggests, a proper acknowledgement of 'the reality of chance' and 'blind coincidence' (1984a, 63–4), determinism must be the only possible basis for rational enquiry. The real question concerns the nature, the complexity and the differential configuration of determinants across different contexts, not determination versus blind chance. But without some kind of generalising analytic framework, whether Marxist or sociological, there is no possibility of making judgements about valid causal or functional relationships between even individual events. The development of such an explanatory framework is ruled out of court by Gombrich's theoretical and methodological strictures. Interpretation becomes the sole legitimate option.

The only time Gombrich deigns to praise Hauser's work is in terms of the individualistic and intuitionist presuppositions of mainstream art history.[6] Poor Hauser must have groaned when the whole point of his careful typologising of types of styles and groups, and the comparisons of different configurations of groups in relationship to each other and to styles during the development of art from Palaeolithic to present, was so egregiously missed. Hard-won analytic generalisations systematising typically recurrent relationships between art and social structure are dismissed as misplaced scientism, while a few relatively trivial paragraphs describing impressionist technique are eulogised for depending on the vague intuitions which Hauser despised and sought to replace with systematic analysis. Gombrich, like many art historians, is sociologically deaf (just as sociologists of art may seem to art historians aesthetically blind). For him the only realities are individuals[7] and such material facts as objects, groups and group identities are not real but hypostases of irrationalism.[8] Systematic thought consists only in the testing of hypotheses which are picked out of the air, what Gombrich calls 'wild questions' (1957/63, 118), not derived from a cumulative body of general theory. The mystery of individual genius is the foundation of art history as of art itself. So long as these are the terms of discussion between sociology and art history, there is of course really nothing to be said.

Sociology and art history: the new syntheses

Art and its contexts in art history and sociology

There have been some more conciliatory efforts to cross the disciplinary boundaries between art history and the sociology of art, particularly in the wake of the structuralist, feminist and Marxist critiques of mainstream art history which took place in the formation of the so-called 'new art history' in the early 1980s (Rees and Borzello 1986). However, even more open-minded art historians tend to revert to the basic assumptions most forthrightly advocated by Gombrich. Sociologists' attempts to cross the divide from the other side have foundered as a result of their starting point, namely Panofsky's idealist theoretical framework, which in practice sociologists merely invert. That said, there are increasing signs of real possibilities of interdisciplinary dialogue, which I shall seek to draw out in the closing pages of this introduction.

Michael Baxandall's *Patterns of Intention* (1985) is one of the more important attempts to achieve a rapprochement between art-historical and sociological modes of explanation (Griswold 1987; Dauber 1992; Hawthorn 1991). He seeks to describe artistic production in terms of a general theory of human action. Since both a painting and an artefact such as Benjamin Baker's Forth Bridge are products of intentional human action, they should be explicable in similar terms. He develops the concepts of 'charge' – the instruction to build a bridge, the goal of Baker's projected actions – and 'brief' – the more specific constraints of technical means, environmental conditions, and institutional context consisting (for Baker) primarily in the economic purposes defining the nature of his project – to point up the similarities between making paintings and making bridges. Baxandall then asks what makes a bridge different from a painting. However, most of the differences he lists between the Forth Bridge and a painting are true only of the modern painting, Picasso's *Portrait of Kahnweiler*, which he uses as an example. Picasso's brief, for example, is not as clear as Baker's because he sets it himself, and it is not made verbally explicit (1985, 39). But this is a function of the unusual institutional arrangements of the modern art world, in which the creative autonomy of the artist is institutionally guaranteed, not in the nature of art or painting as such. One need only compare the contracts of Renaissance painters, or the building specifications agreed between Greek architects and the states who commissioned their projects.

Baxandall's description of the function of painting as 'intentional visual interest directed toward an end' is also potentially a very sociological formulation, in so far as it is possible to recognise that the end of visual interest may vary in different social settings. But Baxandall consistently assumes the particular institutional arrangements which characterise the modern art world, and which shaped the paradigm of art history constructed in the eighteenth and nineteenth centuries. 'The specific terms of the painter's problem', we are told, 'are liable to be primarily a specific view of past painting. . . . There is a historical-cum-critical dimension to the painter's brief' (1985, 46). Correspondingly, the painter formulates his or her own brief, and 'registers his individuality very much by his particular perception of the circumstances he must address' (47). It is here 'that one can most securely locate an individuality' (47). Paintings which do not manifest a clear intentional visual interest, 'a high degree of organisation', explicable in terms of the organising presence of an artistic individuality, are by definition 'inferior' and 'impenetrable' and will not 'sustain explanation of the kind we are attempting' (120).

Baxandall recognises that in practice 'actual market situations' bear little resemblance to his ideal market. 'The forms of institutions are part of the painter's brief because they embody latent assumptions about what painting is' (1985, 48). To admit this is to subvert the whole basis of Baxandall's argument, however, since it recognises that the definition of the purpose or end of painting is historically variable and socially constructed, not, as Baxandall postulated, the production of an object of intentional visual interest comprising a registration of the artist's individuality by means of a transformation of the inherited artistic tradition. In his analysis of Picasso's *Portrait of Kahnweiler*, Baxandall evades these confusing problems of the variable social definition of an artist's role and the purpose of painting by setting up

two (at least from a sociological perspective) false dichotomies: first, between 'whether it is social history or pictures one is addressing' (when pictures are a component of social history, broadly conceived); second, between an inferential criticism or historical explanation of pictures based on 'economic determinist convictions' or one based on no intellectual convictions at all but on a pragmatic intuitionism, invoking likely 'critical yield in the particular case' and what Baxandall 'feel[s]' about the relevance of social factors to the interpretation of individual artists (57). For all the willingness to explain art in the same terms as other forms of social action, and his openness to considering sociological issues, Baxandall's critical aspirations draw him back towards a set of theoretical assumptions which in the end are not so much different from Gombrich's.

Recent work in sociology has in its turn sought to be more attentive to the aesthetic-constructive aspects of art than the dominant approaches of the 1970s and early 1980s which eschewed the perceived subjectivism of formal analysis in favour of more 'objective' approaches to the arts through analysis of production organisations (Coser 1978; Crane 1987). Interestingly, the two most systematic attempts to construct a sociology of art which takes proper account of aesthetic form both use Panofsky's programme in 'Iconography and iconology' (1939) as their starting point. Both Bourdieu and Robert Witkin seek to integrate art history and sociology, and to transcend the stale opposition between internalist and externalist approaches to art, by building on the 'symptomatic' relation of art to its broader social and cultural context identified in Panofsky's iconological level of analysis. In each case they seek to make sociologically determinate the connections which Panofsky thought could be identified only by 'intuition'. In order to do this, they argue that artistic structures and social structures are 'homologous'. That is to say, one finds similar kinds of patterns in the artistic structures or styles of a society as one finds in its social structures, and it is this similarity which allows art and society to fit together as a functional whole.

Witkin (1995; see Chapter 17) argues that the systems of social relations and systems of visual forms characteristic of a society correspond to each other by virtue of both a logical cultural or 'semiotic' neccessity and a 'functional' sociological neccessity. Art styles, Witkin argues, order sense values: colours, tonal contrasts, shapes. Rules of social interaction order social relations. In relatively simple societies, such as those of hunter-gatherers, economic production is heavily determined by natural constraints: seasonal availability of gathered foods and movements of hunted animals. The rules controlling social roles are correspondingly concrete, regulating the 'co-action' of individuals in relation to the natural environment. As societies become increasingly complex so social structure becomes increasingly 'abstracted' from nature: a complex variety of interactions between people, in cities with a high division of labour, become more important than interactions between people and nature, and the rules regulating social action become correspondngly more abstract. Witkin argues that there is a similar evolution in art styles, from ones in which the internal relations between components of a visual image are ordered according to relatively simple concrete principles — for example the simple juxtaposition of flat areas of colour in Egyptian painting — to styles in which the rules regulating such internal relations are more complex and abstract, for example in paintings with perspective and chiaroscuro,

or ultimately in cubist painting. Fundamental principles of social ordering are made co-ordinate with the fundamental principles of ordering the internal formal structure of works of art, Panofsky's *Kunstwollen*. The difficulty with this, as with any such ambitious model, arises in intermediate cases, such as the art of classical antiquity, which Witkin sees as having both naturalistic-abstract elements proper to a more complex society and hieratic-concrete elements characteristic of a less-urbanised society such as theocratic ancient Egypt. In such circumstances of lack of correspondence, can art promote social change or is it merely an epiphenomenon of such a change, more a reflection of social structure than the 'functionally neccessary' component of society Witkin suggests? How do these structuring principles in art and society interact when they are not congruent but contradictory?

The problem reveals itself fully when Witkin moves beyond his schematic evolutionary typology of his earlier study (1995) to an interpretation of artistic innovation in a concrete historical context. In his essay on Manet's *Olympia*, Witkin (1997) gives what amounts to an iconological reading of the painting, which intuitively connects Manet's modernism with the sociological theories of Marx, Weber and Durkheim as parallel forms of spiritual resistance to 'the corruption of value by motive inherent in modernity'. The techniques of modernism in Manet – flatness, the absence of finish thus making evident the work of the brush, strong outline and minimal chiaroscuro, the densely self-referential relationship to artistic tradition – facilitate the combination in the figure of Olympia of different and irreconcilable social types – 'haute-bourgeois/proletarian, courtesan/whore, health/sickness' – in order to deconstruct the hypocritical relationship of bourgeois society to women, sacralised in the home (and the tradition of the nude) whilst sexually exploited as members of the dominated classes in the leisure industries. Such a painting corresponds to 'the sensuous being of the modern subject, moving in the disjunct networks of the modern metropolis, . . . fragmented among a variety of relational contexts that are no longer continuous, that no longer add up' (112). The painting met, however, almost universal critical condemnation and rejection. In explaining this gap between the apparent adequacy of the painting to modern social structure and its clear inadequacy to the sensibility of contemporary viewers, Witkin is forced to resort to a normative art critical rhetoric, quite foreign to his general sociological theory of art. Traditional gender ideology was 'still secure, and the challenge of the work [had] not been met by those receiving it'; viewers could not 'meet the semiotic provocation and engage with the picture in the way it demanded' (123).

Bourdieu draws upon Panofsky's schema to give an account both of the production and of the consumption of art. In his later book *Gothic Architecture and Scholasticism*, Panofsky (1951) developed an unusually determinate iconological reading. This connected the structural elaboration of arches and vaulting in Gothic architecture with scholastic thought through the agency of the 'intellectual habit' and inculcated in scholastic education, of maximising the clarity of logical articulation between the component members of an argument. It is from this source that Bourdieu developed his own concept of *habitus*, intended to transcend both the intentionalism of action and phenomenological theories and the objectivism of structuralism (1996, 179; 1971, 184). *Habitus* performs for sociological theory the same function as the

concept of *Kunstwollen* for Panofksy's art history, in so far as it provides a purely sociological principle for the explanation of the production, reproduction and transformation of social structure, without any need to invoke extra-sociological concepts of culture or psychology. Correspondingly, art is a residual category within Bourdieu's conceptual framework, and is continually reduced back into social structure. He oscillates between a trading upon contemporary definitions of the role of the artist or writer in order to identify the fields, practices and agents he wishes to analyse, and a historicism which denies that there can be a 'universal definition' of artist or writer (1996, 224). On one page we encounter a deeply essentialist account of the differentiation or autonomisation of the modes of artistic expression as 'the gradual isolating of the essential principle that properly defines each art and each genre', in which the 'historical process plays the role of abstractor of quintessence'.[9] Elsewhere, the value of art is interpreted in a radically relativist way, as the product of a system of pure and arbitrary differences which serve to 'distinguish' artists from each other in the perpetual 'struggle for survival' which characterises the modern art world. Such stylistic distinctions have no substance except in so far as they rest on the social positions of the artists who produce them, and the sets of oppositions within the networks of dealers, museums and other mediators who perform the 'symbolic alchemy' of consecration and condemnation, which determines the distribution of the symbolic and economic profits of the field.[10]

The motivation of artists is insistently instrumentalised, and artistic innovation is folded back into social structure as an unconscious effect of the *habitus*. Having analysed the literary structure of Flaubert's novels, and in particular the literary device of free indirect style on which their construction is based, Bourdieu seeks to understand Flaubert's poetics by analysing the 'space of artistic position-taking' on the part of writers within the literary field, which defines the 'differential signification that characterises [poetic choices] within the universe of compossible choices' and was the condition of the formulation of Flaubert's own creative project (1996, 87–8).[11] In practice, these choices are illusory. Flaubert is the 'medium' of social structure not an autonomous creator (4). The 'ruptures' of radical literary and artistic innovation 'are not willed as such [but] operate at the deepest level of the "unknowing poetics", that is to say, in the work of writing and the work of the social unconscious fostered by the work on form'.[12] It is only in so far as the space of the position-takings – to which strategies of the *habitus* unconsciously respond – is itself not consciously known that we are 'not obliged to interpret [Flaubert's] choices as conscious strategies of distinction' (93). There is an obvious alternative. Flaubert's poetics might have a positively defined aesthetic substance (not just a negatively defined difference distinguishing his from his competitors' position-taking), the result of a consciously espoused project. Such a project, and the poetics which it entailed, might have been realised in part as a result of effort arising out of a motivated commitment to a consciously held vocation as a writer (in other words, the assumptions embedded in organisation of modern art worlds and taken as generally valid by art historians such as Baxandall) – situated of course within the objective structures of the field so lucidly explicated by Bourdieu. But this is simply not even a theoretical possibility within Bourdieu's frame of reference, despite the fact that

his own text is laced with quotations from Flaubert's own letters that manifest such a conscious intention (94–7).

Back to the future? A critical research programme for the sociology of art

Recent attempts to reconcile the two disciplinary perspectives are not entirely satisfactory. Art history – at least as currently constituted – cannot systematically take into account sociological questions, nor is it likely to in the future given the links we have seen between the theoretical basis of art history and its functions within the modern art world. Sociology of art remains unable to give a fully satisfactory account of the constructive role of aesthetic form from within its own theoretical horizons. My own feeling is that sociology should be something more than the handmaiden or odd-jobber of art history (as Gombrich and Baxandall suggest), but it cannot simply displace art history in order to reveal the 'social truth' of things as Bourdieu argues. In defining the proper tasks of sociology of art we might do well to return to the work of scholars in the first half of the twentieth century, especially Mannheim and Wölfflin, writing before the divide between sociology and art history had hardened. Their writings suggest potentially fruitful theoretical methods and research programmes which have still to be fully explored.

A number of scholars have noted the similarities between Max Weber's and Heinrich Wölfflin's methods of concept formation (Antoni 1940; Brown 1982). Both Weber's ideal types and Wölfflin's characterisations of styles are examples of 'morphological' rather than 'taxonomic' classifications. That is to say, the universe of classifications they define 'consists not of numerous separate classes but of a continuum of individuals related through principles of formation or transformation' based on fundamental forming powers (Brown 1982, 381). Wölfflin discriminated five sets of polar choices facing visual artists in organising their expressive fields: linear versus painterly, plane and recession, closed and open form, multiplicity and unity, clearness and unclearness. The most fundamental of Weber's ideal types concern different principles of the orientation of action: purposively rational, value rational, traditional and affective; and many of his more complex types can be seen as representing particular configurations of these orientations in more specific contexts such as types of authority system or structures of community. Talcott Parsons sought to systematise Weber's schema by distinguishing five paired pattern variables, defining the fundamental choices which had to be made by an actor in orienting his actions, somewhat comparable to Wölfflin's schema, not least because they are partly concerned with the degree of expressivity (as opposed to instrumentality) of an action: specificity/diffuseness, universalism/particularism, self-interest/disinterest, affectivity/neutrality, achievement/ascription.

The attraction of these kinds of concepts is twofold. First, they allow one to classify an (in principle) infinite variety of forms and systematically relate them to each other as variant recombinations of a small number of discriminations. Art styles, like societies, although each unique, can be systematically related to each other, and grouped into more or less similar structural types. Second, such concepts are

propositional at the same time as being classificatory, pointing towards structural affinities or contradictions between types of action orientation, social structure or style pattern, and to certain 'generalised uniformities of empirical process' (Hawthorn 1987, 160) which result from such affinities and contradictions. Understood in this way, Wölfflin's (1915) account of the evolution of form should not be read as a grand narrative of western art, nor as a strictly determinist evolutionism, but as an ideal typical account of very general processes of the internal development of complex artistic orders, that is to say of processes of aesthetic rationalisation analogous to Weber's accounts of religious rationalisation. This ideal-typical model can then be compared with other processes of the same order – for example style change in classical Greek or ancient Chinese art – to understand their similarities and differences with the type of process sketched by Wölfflin, and the specific social and cultural factors that cause those differences.

Such comparative and analytic narratives might offer an interesting escape from the dilemma in contemporary art history identified by Bal and Bryson (1991). Bal and Bryson argue that the 'synecdochic' tropes of traditional art-historical narrative, based on the assumed unity of style and culture, have been displaced in the new art history by the tropes of 'metonymy', with an 'endless ramification' of contiguous elements, none of which represents a stable foundation for explaining other elements. This is particularly apparent in the concept of 'context', which on the one hand suggests the possibility of a complete causal accounting for the work of art, but on the other hand proves impossible to close: contexts always have their own further context (Bryson 1992). Comparative narratives focused on a particular analytic problem – stylistic process, the socio-genesis of genres such as portraits or landscapes – contrastively contextualise each other, and provide closure which is not absolute or totalising, but sufficient for the given theoretical purposes, when the different factors that shape the varying patterns or outcomes of these processes are identified.

Putting together this kind of research programme would require contributions at a number of different levels of thought. Mannheim distinguishes three levels of discourse in sociological theory, and the sociology of culture: pure, general and dynamic sociologies. In addition to offering a number of approaches to important substantive problems in the sociology of art – cultural production, the role and status of the artist, high culture – the selection of readings in this volume could also be read as a set of examples of different theoretical strategies on each of the levels of argumentation identified by Mannheim.

Pure cultural sociology asks how it is that spiritual or cultural formations come into being which can be shared by a community rather than 'shut up within the monadic closedness of the individual consciousness', and what are the diverse kinds of such formations (Mannheim 1982, 121ff.). Abstracting from any particular concrete context, it asks such fundamental questions as how are society, culture and the forms of culture (art, science, religion) possible? What is their place within the human condition? It is only on the basis of some kind of answer to these questions that we can use such generalising concepts as culture or society at all. And it is on the basis of at least a tacit answer to such questions that our basic sense of the functionality of art depends, and our capacity to compare art institutions of different periods, or at least

to recognise some objects as being proper objects of art-historical analysis and others not. Examples of argumentation at this level are Durkheim's account of symbolism, communication and social order (Chapter 4), Simmel's formal analysis of sociation and social structure (Chapter 3), Mannheim's sketch of 'the dynamics of spiritual realities' (Chapter 16) and Parsons' analysis of art as expressive symbolism (Chapter 18).

General cultural sociology asks 'how the fundamental structures of groups (socialisation and communalisation) relate to the cultural formations corresponding to them'. It 'attempts inductively to order . . . the most general relationships between historically existent social and cultural structures and to comprehend them'. The focus of interest here is not the uniqueness of historical individuals but types of cultural structure, 'past principles which repeat themselves and remain depictable schematically' (Mannheim 1982, 122ff.). The best examples of this kind of analysis are the rich typologies in Weber's *Economy and Society* (1922). These include his brief analysis of typically recurrent patterns of affinity and contradiction between art and religious systems at various levels of cultural evolution (Chapter 2). Other examples in this volume include Elias's generalising account of the transformation of the artistic role in the transition from patronal to market systems (Chapter 10), Becker's and Williams's typologies of production systems (Chapters 6 and 5) and Bourdieu's analysis of the creative field (Chapter 7). Even though many case studies in the sociology of art draw upon generalised theoretical frameworks and seek to generalise their findings, this is perhaps the least well developed level of analysis in the sociology of art. There are some useful models of this kind of analysis. Kavolis's *Artistic Expression* (1968) explores relationships between types of style and for example, stratification systems (open/closed, hierarchical/egalitarian) or political orders. This study is full of interesting and acute comparisons. For example, it shows that the art styles of belief-oriented religions are characteristically more austere than those of feeling-oriented religions which are generally more sensuous, comparing the religious art of India (Buddhist – feeling-oriented) and China (Confucian – belief-oriented) in order to control other potential factors such as level of urbanisation or degree of commercialisation of economic life. Kavolis, however, never goes much beyond the exploration of relationships between two variables, ignoring typical constellations or conjunctures under which any one variable that he identifies might dominate or interact with others. Consequently, both sociologically and aesthetically the result is rather thin gruel, however suggestive. That said, the problems explored by Kavolis certainly deserve further exploration, as do Duvignaud's (1972, 65ff., 98ff.) frustratingly brief sketches first of a typology of aesthetic attitudes and typical grounds for them, and second of the characteristic institutional functions of art in a five-element typology of societies (tribal, theocratic, urban, feudal, monarchical).

Dynamic cultural sociology 'takes concepts appropriate to types which are relatively stable for a period and it elaborates them for the explanation and interpretation of cultural formations' (Mannheim 1982, 126). Particular attention is paid to elaborating concepts and characterisations of cultural phenomena that are adequate to the 'valuations and innermost inclinations of the age under study', rather than straightaway organising them under the extrinsic and more synthetic concepts characteristic

of general cultural sociology. Here the boundary between sociology of art and social history of art is evanescent. What makes a study distinctively sociological is that the period in question tends to be defined in terms of a characteristic social structure and the groups which compose it, and correspondingly cultural formations are explained and interpreted in terms of their development out of and role within processes of group life. The preponderance of contemporary sociology of art takes the form of exactly this kind of period-specific case study. In this volume examples are Hauser's account of the role of the artist in the Renaissance (Chapter 8), Brain's analysis of architectural agency in the New Deal era (Chapter 11), Habermas's, DiMaggio's and Zolberg's studies of the development of high cultural institutions (Chapters 12, 14, 15) and Witkin's reading of Van Eyck's *The Marriage of Arnolfini* (Chapter 17). My own feeling is that such studies should really be the means to the end of a general sociology of art. In practice, however, such a general sociology of art has proved difficult to construct. Such few comparative and generalising studies as slip past art-historical gatekeepers largely hostile to such approaches tend to be either derided or ignored. On what level readers choose to exploit the rich and diverse intellectual capital of the sociology of art represented by the selections in this volume is, of course, up to them.

NOTES

1 My account of the development of sociology depends on Mannheim 1982, Hawthorn 1987, Heilbron 1995.
2 My account here draws on the work of Pears (1988), Abrams (1989a, 1989b).
3 On the importance of Dilthey's hermeneutics to art-historical theory in the first half of the twentieth century see Antoni (1940, 210), Martin (1963a, 1963b).
4 The Courtauld Institute and the Warburg Institute were established in London in the 1930s as the major centres for research and the training of graduate students in art history. The Warburg Institute had originally been established in Hamburg, but was moved to London to protect its staff and resources from anti-Semitic persecution by the Nazis. They remain dominant influences to this day, each characterised by a distinctive perspective: formalism and connoisseurship at the Courtauld, iconography and iconology in the tradition of Aby Warburg and Erwin Panofsky at the Warburg.
5 This is, of course, not a very compelling account of the social effectivity of art. One need only think of the various forms of critical realism in literature – for example the writing of Dickens in *Hard Times* where both the characterisation of figures such as Bitser and Gradgrind and the whole structure of the narrative function as an explicit and potentially mobilising critique of the dehumanising results of industrial capitalism. Similarly, it is precisely the strongly literary and rhetorical form of much of Marx's writing, most notably *The Communist Manifesto*, not just its scientific qualities, which is designed to awaken readers' minds to the injustices of capitalism and act as a spur to action, not a narcotic. For a sociological analysis of a work of art along these lines see Witkin (1997) on Manet's *Olympia*.
6 Commenting on Hauser's treatment of the modern period in his *The Social History of Art*: 'Here he permits himself to trust his own responses and sympathies, the pace

quickens . . . we are made to feel that we are concerned with "people" rather than fac-
tors . . . a page on impressionist technique is alive with the thrill of intuitive understand-
ing', all standing in contrast to Hauser's more general 'misconceived ideal of scientific
sophistication' (Gombrich 1953/1963, 94).

7 Cf. Gombrich 1967/1979, 56–7: 'Cultural history will make progress if it fixes its atten-
tion firmly on the individual human being . . . Cultural historians' concern should be with
the individual and particular rather than with the study of structures and patterns which
is rarely free of Hegelian holism.'

8 Cf. his comments in an essay on Huizinga (Gombrich 1984b, 160): 'What is irrational is
the implicit assumption that victory in one type of contest betokens superiority in other
fields. The fact that the boat of the Cambridge crew arrives at the winning post before
that of Oxford is taken to mean that Cambridge is the better university. I confess I suffer
from a rare disability in this respect. *I find it hard to understand the feeling that "we have
won" merely because someone has won.*'

9 Bourdieu 1996, 138. Cf.: 'a progressive discovery of each art or each genre, beyond
the exterior signs, socially known or recognised, of its identity'. Such claims should take
us into an anthropology of art which is quite beyond Bourdieu's rather narrow sociology.
In practice, in such long-term processes, the differentiation from their anthropological
groundings of different artistic modes are complexely interwoven with non-artistic cul-
tural traditions and social factors, which may block certain anthropologically given
potentialities: in China, for example, the place of painting in the identity of the literati
blocked the autonomisation of sculpture as an artistic form in its own right. It remained
embedded in religious culture and interwoven with other artistic techniques – chasing,
enamelwork, jewellery – with a different expressive logic than sculpture per se. Bourdieu
simply universalises historically specific western experience as the definition of the
essence of art.

10 Bourdieu 1996, 141–73, quotations, 157 and 170. Cf. p. 87 on understanding artistic
choices in terms of 'the differential signification that characterises them within the space
of compossible choices'.

11 Bourdieu 1996, 87–8.

12 Bourdieu 1996, 103. This 'unknowing poetics', the artistic *habitus,* is the mirror image of
Panofsky's *Kunstwollen.*

PART ONE

Classical sociological theory and the sociology of art

INTRODUCTION

SOCIOLOGY CAN BE CHARACTERISED as a problem-oriented and generalising discipline, in contrast to art history which is object-oriented and particularising. These differing orientations imply a fundamentally different relationship to 'theory'. In sociology, theory plays a central role in the discipline, whilst in art history it is often regarded as an optional extra. No sociology undergraduate programme, let alone MA programmes, would be without required courses in 'classical' and contemporary sociological theory. By contrast, even today, prestigious graduate programmes in art history may lack any core theory education shared by all their students, in the belief that the real business of art history is a matter of period specialities and first-hand knowledge of the objects. Art-historical theory also has a character very different from sociological theory. It is essayistic and often of a rather ephemeral character, whereas sociological theorising is systematic and part of a cumulative tradition.

The different character of the two disciplines is particularly marked in their relationship to their founding fathers. The classics of art-historical theory – Winckelmann, Hegel, Taine, Riegl, Wölfflin, Panofsky – are largely unread by practising art historians. They are seldom mentioned in most normal art-historical research, except in passing dismissive caricatures of positions – Taine and milieu theory, Riegl and evolutionism, Wölfflin and formalism. Serious scholarly engagement with these texts is limited to primarily historiographic exercises, placing the authors and their ideas in their cultural and intellectual context (Iversen 1993; Holly 1984). Critical rereadings such as Podro's (1982) study of the German idealists are relatively rare, and there is little evidence to suggest that they significantly affect the wider practice of art-historical research.

In sociology, careful reading and rereading of a stable, but not fixed, canon of theoretical texts plays a central role in the socialisation of students into the discipline, and of individual and collective redefinition of research orientations and objectives.[1] A familiarity with the works of Marx, Weber, Durkheim and (increasingly) Simmel is held to provide an understanding of the key intellectual problems of sociology – the origins of modernity, the nature of social action, the bases of social solidarity and of conflict, the role of material interests and cultural values in social life – and some of the most fundamental tools for grappling with those problems in whatever thematic area or geographical region of specialisation. This shared and continuously revived intellectual heritage thus serves to integrate the discipline. But far from engendering disciplinary closure, the classics provide a structured basis for debate, disagreement and theoretical change. Theorists such as Weber, Marx and Durkheim take distinctive positions on what are the key characteristics of modernity or the most important determinants of action (cultural values, material interests) and social order (aggregation of individual choices, patterning of action based on membership in collectivities). The existence and continuous development of this theoretical core provides a coherent framework for exploring the compatibility between sociological and other theoretical orientations, and for selectively and judiciously building the insights of other disciplines – evolutionary biology, cognitive psychology, psychonalysis, structuralist and post-structuralist theories of culture and signification – into a continuously reconstructed sociology.[2] This facilitates a rather more balanced relationship between continuity and change, disciplinary integrity and interdisciplinarity, than the often uncritical 'trendy' assimilation or mindless 'traditionalist' rejection of fashionable new theories characteristic of less theoretically mature disciplines such as art history or archaeology.

There is no reason to think that this difference in relationship to theory is intellectually intrinsic to the disciplines. On the contrary, it seems likely that it is in part a function of the differing institutional bases of sociology and art history (and the disruption of the critical idealist tradition in the 1930s and 1940s), as discussed in the introduction. Taine, Riegl, Wölfflin and Panofsky certainly deal with problems as fundamental to the history of art as those of Weber, Marx, Durkheim and Simmel to sociology: the nature and bases of aesthetic meaning and art-historical interpretation, the relationship between the work of art and the viewer, the bases of the organisation of artistic form and the principles of the transformation of such patterns of organisation, the relationship between art and culture or society – all intellectual problems relevant to art historians whatever their period or regional specialisation. The creation of a truly interdisciplinary sociology of art will certainly involve a return to these classic art-historical theorists and an integration of their insights and perspectives into the research programmes of sociology. Only on this basis will it be possible to construct an intellectual platform for the kind of cumulative and generalising intellectual development in the sociology of art that has characterised the field of sociology more generally.

The readings in Part One are all from classical sociological theorists, each of whom formulated a distinctive position on the key problems of sociological thought, and by implication distinctive accounts of the relationship between art (and other

forms of culture) and social structure. Throughout the course of this reader, it should become clear to what extent later writers define and elaborate their own positions by aligning themselves with or distancing themselves from various positions held by these key theorists. Although I offer brief introductory sketches of these thinkers' main lines of thought, readers should bear in mind not only that the writings of these theorists are vastly richer and more complex than such sketches can allow, but also – by virtue of the function of these works in the disciplinary matrix of sociology – their interpretation is hotly contested.

Karl Marx

Marx's distinctive sociological perspective draws on three intellectual traditions: the German idealism of Hegel, English classical economics and French socialist thought. On this basis, he constructed a 'materialist' theory of history characterised by a set of interlinked assumptions. First, 'man' is defined primarily by his relationship to nature, which he masters through labour in order to produce the means to sustain himself. Second, men enter into co-operative relations in order to secure sustenance from and security against nature, and these material relations of production constitute the basis of any social order. The idealism of Hegel is inverted by drawing on the more materialist ideas of English economic theory and French socialism. French socialism and Hegelianism provide a collectivist correction to the individualism of classical economic theory.

The selected readings provide succinct statements of the Marxist theory of history, and its implications for the analysis and understanding of cultural production. The first group (Chapter 1a) defines Marx's key concepts: base (forces of production, relations of production), superstructure and the dynamic interrelationships of these components of social structure (antagonism/contradiction, transformation/ revolution). The second group (Chapter 1b) develops a general theory of ideology and ideological production. They emphasise that material experiences are the basis on which ideas are erected as a cultural reflex, and the way in which ideologies often invert material reality, like a *camera obscura*, thus functioning to legitimate inequality. The control of the dominant class over the means of cultural production ensures that in the last instance the relative autonomy of specialised cultural producers in complex societies has only a phantom existence. The final group (Chapter 1c) explores the role of cultural traditions within a materialist framework. The problem of the perennial value of Greek art, long after the demise of the material conditions which gave rise to it, suggests the possibility of a lack of correspondence between aesthetic and social development. Marx's analysis of the use of past cultural forms in revolutionary situations – for example of Roman Republican imagery by French revolutionaries – points towards a more active, constitutive role of culture in social change, and opens up the question of the limits within which visual expressive culture is 'determined' by the social base.

The legacy of Marxism to the history and sociology of art is considerable. The most familiar strand is the social history of art of Hauser (1951), Antal (1948) and

Schapiro (1939), where traditional iconographic and stylistic analyses are contextual-ised in contemporary conditions of material life and changing class structures. Art as an expression of specific class ideals and interests replaces traditional ideas of art as an expression of national or period spirit. A more theoretically ambitious programme was developed first by Lukács, then his succesors in the Frankfurt School (see below, pp. 147–8, for further discussion of the Frankfurt School). Lukács (1923) sought to draw out the Hegelian components in Marxist thought, and in particular to develop a concept of ideology not simply as an epiphenomenon of the base but as a more pervasive cultural system, 'dialectically' related to the social base, in other words acting back upon and conditioning the base's development (cf. Hamilton 1974, 144ff.). Both Lukács and his successors in the Frankfurt School were particularly concerned with the idea of art as the last residue of human freedom. Art, they sug-gested, had the potentiality to perform a critical and hence emancipatory function in the development and transformation of capitalist society, in particular through 'real-ist' forms of representation which penetrated bourgeois ideology and revealed the truly exploitative and inegalitarian character of modern industrial society (Swinge-wood 1987, 55ff.; Arato and Gebhardt 1982). The empirical work of the Frankfurt School concentrated on literature, and has been most influential in the work of literary theorists such as Raymond Williams (1977, 1981) and Terry Eagleton (1976). But it has also been crucial in the formulation of the projects of Marxist sociologists and social historians of art such as Janet Wolff (1981) and T. J. Clarke (1973a, 1973b, 1985). Their work develops the Frankfurters' attention to the specificity of art by exploring how social structures and cultural codes are *mediated* through visual repre-sentation, rather than straightforwardly reproduced or reflected. Relatively few soci-ologists of art would today identify themselves as Marxists. Nevertheless, there is a strongly materialist orientation to most contemporary sociology of art, seeking as it does to reduce manifest cultural meaning systems – whether the content or style of art works, or the values that animate high cultural 'ideologies' – to more fundamental social bases: the structure of the organisations through which culture is produced, or the status interests of the consumers of high culture.

Max Weber

Like Marx, Weber sought to understand the nature and origins of capitalism. Writing a generation after Marx, however, Weber's cultural and sociological horizons were somewhat different. Like all intellectuals of his generation, Weber was deeply influ-enced by Nietzsche's account of the autonomy of the human will to power, and the intersection between power relations and the socio-genesis of moral orders. At the same time, the massive expansion of the German state in the late nineteenth century, and the commonalities between capitalist enterprises and state bureaucracies in the organisation of action and social relationships, suggested to Weber that modern west-ern capitalism was simply the economic component of a much more far-reaching social and cultural phenonenon, namely 'rationalisation'.

Weber sees economic action in capitalist enterprises as one example of a more

widespread type of action, namely 'rational action', in which means are selected on the basis of the best available knowledge in terms of their efficiency to achieve a particular end, rather than because the particular means are sanctioned by tradition or mandated according to a particular value orientation. 'Rationalisation' is the process whereby a domain comes to be organised more and more systematically in terms of such calculable mean–ends rationality. The modern west is unique in the range and pervasiveness of the rationalisation of all domains of life: the economy, political organisation, theology, music, science. This level of rationalisation is also characteristic of the visual arts of the west, manifested in the Gothic vault, as a rationalised calculable means of distributing the weight of a roofing system, and central vanishing point perspective in painting (Chapter 2a). The strength of the impulse behind western rationalism, and its peculiarly instrumental world-mastering character, Weber attributed to the development of a worldly concept of 'vocation' in Protestant thought which gave a positive moral character to systematic acquisitive activity which had previously been merely tolerated (Weber 1904/5).

In order to understand the uniqueness of western rationalism and capitalism, and to clarify the role played by Protestantism in its genesis, Weber undertook a series of studies of the economic ethics of the world religions – Judaism, Hindusim and Buddhism in India, Confucianism and Taoism in China (1916, 1916/17, 1917/19). In particular, he sought to show how these religions shaped the systematisation of patterns of life conduct in ways which were antithetical to the development of the same kind of full-fledged modern capitalism as was created in the west, despite the fact that structural conditions (levels of urbanisation, use of money, communications systems) in late medieval India and China were on the face of it more favourable to the development of capitalism than those in the west. In the posthumously published *Economy and Society* (1922), these studies were developed into a wide-ranging analysis of how patterns of action were systematically shaped by social, economic, political and cultural conditions, retaining a particular focus on factors which impeded or promoted rationalisation, and the varying forms taken by rationalisation processes in different social and cultural settings.

It is in this context that Weber gave consideration to questions of the sociology of art. Weber's only major study of art is *The Rational and Social Foundations of Music* (1912). In this study he draws a distinction between *polyvocality*, in which multiple voices are related to each other on a basis more complex than unison or the octave, and true *polyphony*, in which 'several voices of equal standing run side by side, harmonically linked in such a way that the progression of each voice is accommodated to the progression of the other and is, thus, subject to certain rules' (Weber 1912, 68). Weber's primary concern was to discover why it was only in the west that rational calculable systems of harmonic and polyphonic music developed out of polyvocal music which characterised not only the west but other cultures such as ancient Greece and medieval Japan. In trying to answer this question, he explores the role of systems of notation in musical rationalisation, the role of religion in stereotyping and thus formalising certain tone series associated with particular gods, the influence of the structure of guild organisations of musicians and the standardisation of musical instruments. Although Weber never gave the same extended consideration to the visual

arts, he does consider them in similar terms in the context of his studies in the soci-
ology of religion (Chapter 2b, 2c). He examines the role of magical stereotyping in
primitive religions in the formation of style, and of receptiveness to the content of art
in the formation of religious community. He explores the tensions which emerge
between art and more rationalised 'intellectualised' text-based religions when religion
and art are increasingly grasped as independent spheres of values in complex societies
with differentiated cultural systems, and the rapprochements between art and religion
made in such phenomena as mysticism. Although brief, these passages are hugely
suggestive of the kinds of comparative study of the social and cultural dynamics of
artistic rationalisation which would bring the sociology of art to the same level of
sophistication as other fields in the sociology of culture.

Georg Simmel

Simmel is perhaps the most intellectually elusive of the generation of classical socio-
logical theorists. Both his marginal position (excluded until shortly before his death
from securing a chair on account of his Jewish ethnicity and socialist sympathies) and
the poorly institutionalised status of sociology in Germany in the late nineteenth
and early twentieth centuries afforded Simmel the freedom to range in his lectures and
writings over themes that would now be considered quite distinct: history of phil-
osophy, aesthetics, epistemology, sociology (Etzkorn 1968). The early reception of
Simmel in English-speaking sociology in the twentieth century emphasised the appar-
ently more specifically sociological aspects of his work: interaction, conflict, struc-
tures of inequality and domination. More recently, there has been a considerable
revival of interest in his work, in part because his attention to aesthetic issues can be
(perhaps anachronistically) interpreted as anticipating important themes of post-
modern theory (Frisby 1981, 1986; Weinstein and Weinstein 1993). Both approaches
in certain respects misread Simmel in complementary ways. Both treat aesthetic
issues as issues of surface: for the reductionist strand in sociology aesthetics is epi-
phenomena (superficial effects, determined by an underlying social and economic
base); for the postmodernists, influenced by structuralist theories of language and
culture, representational surface is all there is, and the search for an underlying reality
is misplaced. What seems to me interesting about Simmel is that he treats aesthetic
form as a generative deep phenomenon within the social order and conversely, socio-
logical principles of ordering as aesthetically generative from within art rather than as
external determinants.

 Simmel, deeply influenced by both Nietzsche and contemporary neo-Kantian
thought, was fascinated by the interrelationship between life and form, energy and the
patterns by which such energy is controlled and shaped (Davis 1973). Like Weber, he
regarded the growing autonomy of economic life as one component of a more general
process in which all cultural forms – art, science, sociability itself – were becoming
increasingly autonomous. He regarded modernity as being characterised by an
increasing imbalance between the 'subjective culture' of the individual, and the
'objective culture' of the increasingly autonomous and self-organising social and

cultural domains – economy, politics, art, science. The growing dominance of objective culture threatened subjective culture. As Schiller and Weber had noted, it broke down the integration of the individual as a value in himself, both through the conflicting demands that each of the domains of objective culture placed on the individual, and through corresponding shifts in educational ideals, from the formation of 'man' 'as a personal inner value' to modern instrumental and vocational training for a specific functional task (Simmel 1907, 449). Furthermore, the growth of objective culture made it more difficult for individuals to form a personal relationship with the material objects with which they surrounded themselves in everyday life. In part, this difficulty is a function of the sheer quantity of the objects; in part of the increasing objectification of relationships of production and consumption: the relationship of the modern consumer to mass-manufactured objects is a wholly external one in comparison with older traditions of the custom-made work, where the owner's subjective and personal needs enter more intimately into the shaping of the final product (Simmel 1907, 457–60).

Simmel sees such distinctively modern phenomena as fashion and the contemporary sense of style as products of the advance of objective culture. The styles – including the clothing styles – of such great civilizations as Greece and China were relatively slow-changing and relatively homogeneous, grounded in the value-orientations and way of life of the dominant elites of those societies. That kind of personal relationship to style and clothing is no longer possible in the context of the modern fashion system which operates according to its own autononmous logic, irrespective of the consumer's capacity to invest the forms of fashion with subjective value. Similarly, the stylistic pluralism in gardens, furniture and interior design made available through books and design industry – from Chinese to Moroccan, Swedish to Japanese – abstracts form from its life context, making us self-consciously aware of 'style as an independent factor with an autonomous life', at the same time as it becomes increasingly difficult to invest any particular style with subjective meaning (1907, 461–4; 1904).

Simmel's conception of 'form' extends beyond the rather limited meaning the word has in contemporary aesthetics and art history, being nearer to an Aristotelian sense of some underlying formative principle than the art-historical concept of sensuous appearance. He suggested that one of the primary goals of general sociology was to discover the formal properties of social life, in abstraction from the particular interests and contents through which social life was realised in concrete historical instances. Simmel explored the differing structure of interaction in dyadic and triadic relationships, in relations of superordination and subordination, and such fundamental forms of relationship as trust and faithlessness, secrecy and openness, gratitude and ingratitude. His project – exploring the fundamental formal ordering principles of social life – is not dissimilar to Wölfflin's exploration of the fundamental dimensions within which pictorial order might be constructed. Simmel, however, differs from Wölfflin in insisting on the mutual embedding of the sociological and the aesthetic in these constitutive forms. In an essay 'On aesthetic quantities' (1903b), thinking along similar lines to Wölfflin's empathetic account of architecture in *Renaissance and Baroque* (1888), Simmel explores the relationship between the simple size of a painting, the proportion of our visual field it fills and a sociologically determined sense of

the propriety of according varying levels of aesthetic importance to different subject matters. In a number of essays (1903a; 1908), Simmel gives a marvellously sensitive account of the role of the face, first in constructing, regulating and shaping the character of social interactions, and second, by analogical transference, in structuring the shape of engagement with works of visual art. In a sense, these essays provide the sociological and phenomenological ground for Riegl's more purely aestheticising account of structures of beholding in *Holländische Gruppenporträt* (*Dutch Group Portraits*) (1902). The selected reading, from an essay entitled 'Sociological aesthetics' (1896), explores the social functions of symmetry in social structure and group organisation, and in particular symmetrical stylisation of social life in socialist and other utopias, in contrast with more individualistic aesthetic ideals characteristic of bourgeois modernity.

Emile Durkheim

Emile Durkheim's sociology sought to address the breakdown of the old moral order which characterised the birth of modern society, and to illuminate and promote a new moral order appropriate to the new conditions of social life. His first study, *The Division of Labour in Society* (1893), described the evolution of morality and the forms of social solidarity in the transition from simple to complex societies. Members of simple societies, Durkheim suggests, are characterised by their similarity to each other, each performing similar roles within groups which duplicate each other and are related to each other by mere juxtaposition, with a relatively concrete set of moral norms regulating interaction – 'mechanical solidarity'. In modern societies with a very high division of labour, by contrast, people are related to each other through difference and functional interdependence, and their shared morality takes the form of abstract or generalised values rather than specific concrete norms of conduct – 'organic solidarity'. Where some, such as economists and utilitarians, argued that modern societies, unlike traditonal communities, were totally atomised and characterised only by individual pursuit of self-interest, Durkheim showed that even such apparently totally individualised relationships as those entered into on the basis of a contract were underwritten by 'non-contractual elements of contract', taken-for-granted rules limiting what could be agreed or disposed of by contract, for example that a worker could not contract himself into slavery. The basis of these non-contractual elements of contract were, according to Durkheim, certain truths held to be self-evident and sacred within the collective conscience of the moral community, most notably the value of the individual and freedom. These values were guaranteed above all by the state and celebrated in the cultic acts of the civic religion of French state and civic ceremonials such as Bastille Day.

Durkheim's later studies all extend these early explorations into the nature, functioning and bases of moral order. His final great study – *The Elementary Forms of Religious Life* (1912) – shifts the focus of attention from the changing nature of moral order, and the conditions which promote or erode social solidarity, to fundamental questions about the mechanisms by which attachment to the group and its

constitutive values is created in the first place. Durkheim selected Australian Abo-
riginal religious life for the purposes of this study, on the grounds that the practices of
people living in the simplest known societies would reveal the phenomena in question
in their clearest aspect and their most fundamental form. For the purposes of a
sociology of art, the most important part of this study is Durkheim's account of the
role played by totemic representations in ritual and everyday life amongst the Abori-
gines. Here Durkheim develops an account of signification and communication which
explains how group sentiments can be shared by individuals, and in particular the
crucial place of practices of material representation in such processes. Communica-
tive interaction grounded in material representation is seen as the fundamental basis
of the social order. The first selection (Chapter 4a) describes the nature and use of
totemic representations within the group and ritual life of the Aborigines and other
simple societies. Of particular importance is the emphasis Durkheim places on the
'arbitrary' or socially conventional meaning applied to representations of groups'
totems. The value of such totems, both the actual animals which function as the sym-
bols of groups and the material representations of such animals in sculptures or body-
paintings, has less to do with the actual animals in question, or of the resemblance of
figural representations to those animals, than with the place of any such totemic sign in
the whole system of signs which distinguishes and relates groups both to each other and
to the natural environment in which they live. This account of the conventional char-
acter of signs anticipates (and may have influenced) the influential structuralist theory
of language developed by the Swiss linguist Ferdinand de Saussure (1917; Layton
1991, 94). The linguistic model of structuralism has provided a hugely influential
paradigm in anthropology, above all through the work of Claude Lévi-Strauss, who also
used structuralist methods in the analysis of art (1958a,b, 1975), and in cultural
studies more widely, including art history (Bal and Bryson 1991). Structuralism pro-
vided a rigorous model for decoding cultural texts as languages with their own internal
structure and coherence, irreducible to either external referents or to some expression
of an underlying social base. In this respect, it had strong parallels with formalism in
art history, but, like iconography, was also strongly oriented to questions of meaning,
not just stylistic description (Argan 1975; Hasenmueller 1978).

From as early as the 1960s structuralism was criticised for its formalism and its
inability to address questions of power. Thinkers deeply influenced by structuralist
ideas, such as Barthes and Foucault, sought to address these criticisms by developing
what are known as 'post-structuralist' theories which seek to go beyond purely lin-
guistic models of cultural analysis. Foucault, in particular, developed the concept of
'discourse' to show how linguistic utterances or texts could not only be decoded as
having a meaning but also had particular social effects, creating and defining social
relationships, in particular relationships of power and domination. Medical texts seek-
ing to describe and analyse madness in the nineteenth century, for example, did not
merely make madness an object of scientific knowledge, they defined also the relation-
ship between medicine and the putatively insane as one of authority and power, legit-
imating the development of a whole network of psychiatric institutions and medical
disciplines within which a population of marginal people was incarcerated and con-
trolled (Foucault 1973). From a sociological perspective, much post-structuralist

thought still seems too heavily shaped by the model of language, and not sufficiently so to allow the relative autonomy of the social order from culture, and indeed the extent to which culture is socially shaped and constructed (Frank 1989). To use Mannheim's terms, post-structuralism makes 'genetic' interpretation 'immanent', seeing relationships of power and solidarity as simply effects of language or discourse. The second selection from Durkheim's *Elementary Forms* (Chapter 4b) suggests how the power of structuralist models of culture might have been combined with a proper respect for more specifically sociological levels of argument. In particular, Durkheim shows that totemic signs do not simply assist in the classification of distinct but related social groups and their relationship to the natural environment, as the strongly cognitive slant of classic structuralism would suggest (Lévi-Strauss 1962). They function also to sustain sentiments or feelings of shared communal membership. Indeed, the very efficacy of totemic symbols as systems of classification and representation depends upon their periodic intensification and renewal in the intensive ritual interactions of religious festivals. Such intensive social interaction and the psychological enthusiasm or 'collective effervescence' to which it gives rise, not only promotes the internalisation of these systems of representation in individual personalities, it endows them with a moral and affective meaning which derives from society itself. Society creates, gives force to and renews the symbolic languages it uses; it is not simply an effect or creature of language.

Durkheimian sociology, in both its original functionalist and its later structuralist versions, has been hugely influential in the anthropology of art (Layton 1991, 93–9; Munn 1964). Within the sociology of art the only significant follower of Durkheim was Pierre Francastel whose work has had an oddly marginal status in both the history and sociology of art (Burke 1971). Francastel takes his inspiration from Durkheim's studies of symbolic classification in arguing, against Marxists such as Antal, that art is not merely an expression of class ideology or an epiphenomenon of social structure but an operative system of representation which acts reciprocally on society with its own specific effects. Like Durkheim, Francastel (1960, 1965) argues that the representational schemas which constitute artistic languages are derived from properties of social structure, in particular characteristic modes of interaction between individual humans and between humans and nature, and the characteristic patterns of motivation to which such structures give rise. Unlike the structuralists, however, Francastel is deeply insistent on the specificity of visual art, reliant on particular means of representation – line, colour, light, volume, relief, shade – quite distinct from those of language, and hence distinctive in its mode of material action within society. Francastel maintained close links with the *Annales* school of historians, led by Lucien Febvre and Fernand Braudel (Burke 1990), but within art history, the sociology of art and cultural studies he seems to have suffered neglect as a result of his criticisms of the dominant paradigms of iconography, structuralism and Marxism. Duvignaud (1972) draws on Durkheimian ideas in seeking to establish an account of the artistic sign as a mediator between human–nature systems and human–human systems, and also in his suggestion that artistic creativity is most intense in periods of *anomie*, when traditional norms are no longer functioning. Most recently a new lease of life to Durkheimian sociology of art has been given by Karen Cerulo's (1995) superb study of the

relationship between the structure of national identity symbols such as flags and national anthems and the development of the international political system during imperialist and post-colonial periods.

Notes

1 My account of the disciplinary function of classical sociological theory follows that of Alexander 1987.
2 See for example: Parsons 1964 (sociology and psychoanalysis), Lidz and Lidz 1976 (sociology and Piaget's cognitive psychology), Schwartz 1981 (sociology and structuralism), Wuthnow 1989 (sociology and post-structuralist cultural analysis).

Karl Marx

MARXISM AND ART HISTORY

(a) SOCIAL BEING AND SOCIAL CONSCIOUSNESS

Extract from Preface to *A Contribution to the Critique of Political Economy*. From *Marx and Engels on Literature and Art*. Moscow, Progress Publishers, 1976, pp. 41–2. Original publication 1859.

IN THE SOCIAL PRODUCTION of their life, men enter into definite relations that are indispensable and independent of their will, relations of production which correspond to a definite stage of development of their material productive forces. The sum total of these relations of production constitutes the economic structure of society, the real foundation, on which rises a legal and political superstructure and to which correspond definite forms of social consciousness. The mode of production of material life conditions the social, political and intellectual life process in general. It is not the consciousness of men that determines their being, but, on the contrary, their social being that determines their consciousness. At a certain stage of their development, the material productive forces of society come in conflict with the existing relations of production, or – what is but a legal expression for the same thing – with the property relations within which they have been at work hitherto. From forms of development of the productive forces these relations turn into their fetters. Then begins an epoch of social revolution. With the change of the economic foundation the entire immense superstructure is more or less rapidly transformed. In considering such transformations a distinction should always be made between the material transformation of the economic conditions of production, which can be determined with the precision of natural science, and the legal, political, religious, aesthetic or philosophic – in short, ideological forms in which men become conscious of this conflict and fight it out. Just as our opinion of an individual is not based on what he thinks of himself, so can we not judge of such a period of transformation by its own consciousness; on the contrary, this consciousness must be explained rather from the contradictions of material life, from the

existing conflict between the social productive forces and the relations of produc-
tion. No social order ever perishes before all the productive forces for which there is
room in it have developed; and new, higher relations of production never appear
before the material conditions of their existence have matured in the womb of the
old society itself. Therefore mankind always sets itself only such tasks as it can solve;
since, looking at the matter more closely, it will always be found that the task itself
arises only when the material conditions for its solution already exist or are at least
in the process of formation. In broad outline Asiatic, ancient, feudal, and modern
bourgeois modes of production can be designated as progressive epochs in the
economic formation of society. The bourgeois relations of production are the last
antagonistic form of the social process of production – antagonistic not in the sense
of individual antagonism, but of one arising from the social conditions of life of the
individuals; at the same time the productive forces developing in the womb of
bourgeois society create the material conditions for the solution of that antagonism.
This social formation brings, therefore, the prehistory of human society to a close.

(b) ART AND IDEOLOGY

Extracts from *The German Ideology*. From *Marx and Engels on Literature and Art*.
Moscow, Progress Publishers, 1976, pp. 42–4, 70–3. Original publication 1845/6.

THE PRODUCTION OF IDEAS, of conceptions, of consciousness, is at first
directly interwoven with the material activity and the material intercourse of
men – the language of real life. Conceiving, thinking, the mental intercourse of men
at this stage still appear as the direct efflux of their material behaviour. The same
applies to mental production as expressed in the language of the politics, laws,
morality, religion, metaphysics, etc., of a people. Men are the producers of their
conceptions, ideas, etc., that is, real, active men, as they are conditioned by a
definite development of their productive forces and of the intercourse correspond-
ing to these, up to its furthest forms. Consciousness [*das Bewusstsein*] can never be
anything else than conscious being [*das bewusste Sein*], and the being of men is their
actual life-process. If in all ideology men and their relations appear upside-down as
in a *camera obscura*, this phenomenon arises just as much from their historical life-
process as the inversion of objects on the retina does from their physical life-process.

In direct contrast to German philosophy which descends from heaven to earth,
here it is a matter of ascending from earth to heaven. That is to say, not of setting
out from what men say, imagine, conceive, nor from men as narrated, thought of,
imagined, conceived, in order to arrive at men in the flesh; but of setting out from
real, active men, and on the basis of their real life-process demonstrating the devel-
opment of the ideological reflexes and echoes of this life-process. The phantoms
formed in the brains of men are also, necessarily, sublimates of their material

life-process, which is empirically verifiable and bound to material premises. Moral-ity, religion, metaphysics, and all the rest of ideology as well as the forms of consciousness corresponding to these, thus no longer retain the semblance of independence. They have no history, no development; but men, developing their material production and their material intercourse, alter, along with this their actual world, also their thinking and the products of their thinking. It is not consciousness that determines life, but life that determines consciousness. For the first manner of approach the starting-point is consciousness taken as the living individual; for the second manner of approach, which conforms to real life, it is the real living individuals themselves, and consciousness is considered solely as *their* consciousness.

This manner of approach is not devoid of premises. It starts out from the real premises and does not abandon them for a moment. Its premises are men, not in any fantastic isolation and fixity, but in their actual, empirically perceptible process of development under definite conditions. As soon as this active life-process is described, history ceases to be a collection of dead facts, as it is with the empiricists (themselves still abstract), or an imagined activity of imagined subjects, as with the idealists.

Where speculation ends, where real life starts, there consequently begins real, positive science, the expounding of the practical activity, of the practical process of development of men. Empty phrases about consciousness end, and real knowledge has to take their place. When the reality is described, a self-sufficient philosophy [*die selbständige Philosophie*] loses its medium of existence. At the best its place can only be taken by a summing-up of the most general results, abstractions which are derived from the observation of the historical development of men. These abstrac-tions in themselves, divorced from real history, have no value whatsoever. They can only serve to facilitate the arrangement of historical material, to indicate the sequence of its separate strata. But they by no means afford a recipe or schema, as does philosophy, for neatly trimming the epochs of history. On the contrary, the difficulties begin only when one sets about the examination and arrangement of the material – whether of a past epoch or of the present – and its actual presentation. [. . .]

The ideas of the ruling class are in every epoch the ruling ideas: i.e., the class which is the ruling *material* force of society is at the same time its ruling *intellectual* force. The class which has the means of material production at its disposal, consequently also controls the means of mental production, so that the ideas of those who lack the means of mental production are on the whole subject to it. The ruling ideas are nothing more than the ideal expression of the dominant material relations; the dominant material relations grasped as ideas; hence of the relations which make the one class the ruling one, therefore, the ideas of its dominance. The individuals composing the ruling class possess among other things consciousness, and therefore think. Insofar, therefore, as they rule as a class and determine the extent and compass of an historical epoch, it is self-evident that they do this in its whole range, hence among other things rule also as thinkers, as producers of ideas, and regulate the production and distribution of the ideas of their age: thus their ideas are the ruling ideas of the epoch. For instance, in an age and in a country where royal power, aristocracy and bourgeoisie are contending for domination and where, therefore,

domination is shared, the doctrine of the separation of powers proves to be the dominant idea and is expressed as an 'eternal law'.

The division of labour, which we already saw above as one of the chief forces of history up till now, manifests itself also in the ruling class as the division of mental and material labour, so that inside this class one part appears as the thinkers of the class (its active, conceptive ideologists, who make the formation of the illusions of the class about itself their chief source of livelihood), while the others' attitude to these ideas and illusions is more passive and receptive, because they are in reality the active members of this class and have less time to make up illusions and ideas about themselves. Within this class this cleavage can even develop into a certain opposition and hostility between the two parts, but whenever a practical collision occurs in which the class itself is endangered they automatically vanish, in which case there also vanishes the appearance of the ruling ideas being not the ideas of the ruling class and having a power distinct from the power of this class. The existence of revolutionary ideas in a particular period presupposes the existence of a revolutionary class; about the premises of the latter sufficient has already been said above.

If now in considering the course of history we detach the ideas of the ruling class from the ruling class itself and attribute to them an independent existence, if we confine ourselves to saying that these or those ideas were dominant at a given time, without bothering ourselves about the conditions of production and the producers of these ideas, if we thus ignore the individuals and world conditions which are the source of the ideas, then we can say, for instance, *that during* the time that the aristocracy was dominant, the concepts honour, loyalty, etc., were dominant, during the dominance of the bourgeoisie the concepts freedom, equality, etc. The ruling class itself on the whole imagines this to be so. This conception of history, which is common to all historians, particularly since the eighteenth century, will necessarily come up against the phenomenon that ever more abstract ideas hold sway, i.e., ideas which increasingly take on the form of universality. For each new class which puts itself in the place of one ruling before it is compelled, merely in order to carry through its aim, to present its interest as the common interest of all the members of society, that is, expressed in ideal form: it has to give its ideas the form of universality, and present them as the only rational, universally valid ones. The class making a revolution comes forward from the very start, if only because it is opposed to a *class*, not as a class but as the representative of the whole of society, as the whole mass of society confronting the one ruling class. It can do this because initially its interest really is as yet mostly connected with the common interest of all other non-ruling classes, because under the pressure of hitherto existing conditions its interest has not yet been able to develop as the particular interest of a particular class. Its victory, therefore, benefits also many individuals of other classes which are not winning a dominant position, but only insofar as it now enables these individuals to raise themselves into the ruling class. When the French bourgeoisie overthrew the rule of the aristocracy, it thereby made it possible for many proletarians to raise themselves above the proletariat, but only insofar as they became bourgeois. Every new class, therefore, achieves domination only on a broader basis than that of the class ruling previously; on the other hand the opposition of the non-ruling class to the new ruling class then develops all the more sharply and profoundly. Both these things

determine the fact that the struggle to be waged against this new ruling class, in its turn, aims at a more decided and radical negation of the previous conditions of society than could all previous classes which sought to rule.

This whole appearance, that the rule of a certain class is only the rule of certain ideas, comes to a natural end, of course, as soon as class rule in general ceases to be the form in which society is organised, that is to say, as soon as it is no longer necessary to represent a particular interest as general or the 'general interest' as ruling.

(c) HISTORICAL DEVELOPMENT AND CULTURAL TRADITIONS

Extracts from *Grundrisse* and from *18th Brumaire*. From *Marx and Engels on Literature and Art*. Moscow, Progress Publishers, 1976, pp. 82–4, 79–81. Original publications 1857/8, 1852.

THE UNEQUAL DEVELOPMENT OF *material production and e.g., that of art*. The concept of progress is on the whole not to be understood in the usual abstract form. Modern art, etc. This disproportion is not as important and difficult to grasp as within concrete social relations, e.g., in education. Relations of the United States to Europe. However, the really difficult point to be discussed here is how the relations of production as legal relations take part in this uneven development. For example the relation of Roman civil law (this applies in smaller measure to criminal and constitutional law) to modern production.

This conception appears to be an inevitable development. But vindication of chance. How? (Freedom, etc., as well.) (Influence of the means of communication. World history did not always exist; history as world history is a result.)

The starting point is of course the naturally determined factors; both subjective and objective. Tribes, races, etc.

As regards art, it is well known that some of its peaks by no means correspond to the general development of society; nor do they therefore to the material substructure, the skeleton as it were of its organisation. For example the Greeks compared with modern [nations], or else Shakespeare. It is even acknowledged that certain branches of art, *e.g.*, the *epos*, can no longer be produced in their epoch-making classic form after artistic production as such has begun; in other words, that certain important creations within the compass of art are only possible at an early stage in the development of art. If this is the case with regard to different branches of art within the sphere of art itself, it is not so remarkable that this should also be the case with regard to the entire sphere of art and its relation to the general development of society. The difficulty lies only in the general formulation of these contradictions. As soon as they are reduced to specific questions they are already explained.

Let us take, for example, the relation of Greek art, and that of Shakespeare, to the present time. We know that Greek mythology is not only the arsenal of Greek art, but also its basis. Is the conception of nature and of social relations which underlies Greek imagination and therefore Greek [art] possible when there are self-acting mules, railways, locomotives and electric telegraphs? What is a Vulcan compared with Roberts and Co., Jupiter compared with the lightning conductor, and Hermes compared with the *Crédit mobilier*? All mythology subdues, controls and fashions the forces of nature in the imagination and through imagination; it disappears therefore when real control over these forces is established. What becomes of Fama side by side with Printing House Square? Greek art presupposes Greek mythology, in other words that natural and social phenomena are already assimilated in an unintentionally artistic manner by the imagination of the people. This is the material of Greek art, not just any mythology, *i.e.*, not every unconsciously artistic assimilation of nature (here the term comprises all physical phenomena, including society); Egyptian mythology could never become the basis of or give rise to Greek art. But at any rate [it presupposes] a mythology; on no account however a social development which precludes a mythological attitude towards nature, *i.e.*, any attitude to nature which might give rise to myth; a society therefore demanding from the artist an imagination independent of mythology.

Regarded from another aspect: is Achilles possible when powder and shot have been invented? And is the *Iliad* possible at all when the printing press and even printing machines exist? Is it not inevitable that with the emergence of the press bar the singing and the telling and the muse cease, that is the conditions necessary for epic poetry disappear?

The difficulty we are confronted with is not, however, that of understanding how Greek art and epic poetry are associated with certain forms of social development. The difficulty is that they still give us aesthetic pleasure and are in certain respects regarded as a standard and unattainable ideal.

An adult cannot become a child again, or he becomes childish. But does the naïveté of the child not give him pleasure, and does not he himself endeavour to reproduce the child's veracity on a higher level? Does not the child in every epoch represent the character of the period in its natural veracity? Why should not the historical childhood of humanity, where it attained its most beautiful form, exert an eternal charm because it is a stage that will never recur? There are rude children and precocious children. Many of the ancient peoples belong to this category. The Greeks were normal children. The charm their art has for us does not conflict with the immature stage of the society in which it originated. On the contrary its charm is a consequence of this and is inseparably linked with the fact that the immature social conditions which gave rise, and which alone could give rise, to this art cannot recur. [. . .]

MEN MAKE THEIR OWN history, but they do not make it just as they please; they do not make it under circumstances chosen by themselves, but under circumstances directly encountered, given and transmitted from the past. The tradition of all the dead generations weighs like a nightmare on the brain of the living. And just when they seem engaged in revolutionising themselves and things, in creating something that has never yet existed, precisely in such periods of revo-

lutionary crisis they anxiously conjure up the spirits of the past to their service and borrow from them names, battle cries and costumes in order to present the new scene of world history in this time-honoured disguise and this borrowed language. Thus Luther donned the mask of the Apostle Paul, the Revolution of 1789 to 1814 draped itself alternately as the Roman republic and the Roman empire, and the Revolution of 1848 knew nothing better to do than to parody, now 1789, now the revolutionary tradition of 1793 to 1795. In like manner a beginner who has learnt a new language always translates it back into his mother tongue, but he has assimilated the spirit of the new language and can freely express himself in it only when he finds his way in it without recalling the old and forgets his native tongue in the use of the new.

Consideration of this conjuring up of the dead of world history reveals at once a salient difference. Camille Desmoulins, Danton, Robespierre, Saint-Just, Napoleon, the heroes as well as the parties and the masses of the old French Revolution, performed the task of their time in Roman costume and with Roman phrases, the task of unchaining and setting up modern *bourgeois* society. The first ones knocked the feudal basis to pieces and mowed off the feudal heads which had grown on it. The other created inside France the conditions under which alone free competition could be developed, parcelled landed property exploited and the unchained industrial productive power of the nation employed; and beyond the French borders he everywhere swept the feudal institutions away, so far as was necessary to furnish bourgeois society in France with a suitable up-to-date environment on the European Continent. The new social formation once established, the antediluvian Colossi disappeared and with them resurrected Romanity – the Brutuses, Gracchi, Publicolas, the tribunes, the senators, and Caesar himself. Bourgeois society in its sober reality had begotten its true interpreters and mouthpieces in the Says, Cousins, Royer-Collards, Benjamin Constants and Guizots; its real military leaders sat behind the office desks, and the hogheaded Louis XVIII was its political chief. Wholly absorbed in the production of wealth and in peaceful competitive struggle, it no longer comprehended that ghosts from the days of Rome had watched over its cradle. But unheroic as bourgeois society is, it nevertheless took heroism, sacrifice, terror, civil war and battles of peoples to bring it into being. And in the classically austere traditions of the Roman republic its gladiators found the ideals and the art forms, the self-deceptions that they needed in order to conceal from themselves the bourgeois limitations of the content of their struggles and to keep their enthusiasm on the high plane of the great historical tragedy. Similarly, at another stage of development, a century earlier, Cromwell and the English people had borrowed speech, passions and illusions from the Old Testament for their bourgeois revolution. When the real aim had been achieved, when the bourgeois transformation of English society had been accomplished, Locke supplanted Habakkuk.

Thus the awakening of the dead in those revolutions served the purpose of glorifying the new struggles, not of parodying the old; of magnifying the given task in imagination, not of fleeing from its solution in reality; of finding once more the spirit of revolution, not of making its ghost walk about again.

Max Weber

ART AND CULTURAL RATIONALIZATION

(a) MAGICAL RELIGION, SALVATION RELIGION AND THE EVOLUTION OF ART

Extract from *Zwischenbetrachtung: Gesammelte Aufsätze zur Religionssoziologie*, vol. 1, Tübingen, 1920/1, pp. 436–73. Originally published *Archiv für Sozialwissenschaft und Sozialpolitik,* 1915. From 'The religious rejections of the world and their directions', in H. Gerth and C. Wright Mills (eds), *From Max Weber: Essays in Sociology.* New York, Oxford University Press, 1946, pp. 340–3.

THE RELIGIOUS ETHIC OF brotherliness stands in dynamic tension with any purposive-rational conduct that follows its own laws. In no less degree, this tension occurs between the religious ethic and 'this-worldly' life-forces, whose character is essentially non-rational or basically anti-rational. Above all, there is tension between the ethic of religious brotherliness and the spheres of esthetic and erotic life.

Magical religiosity stands in a most intimate relation to the esthetic sphere. Since its beginnings, religion has been an inexhaustible fountain of opportunities for artistic creation, on the one hand, and of stylizing through traditionalization, on the other. This is shown in a variety of objects and processes: in idols, icons, and other religious artifacts; in the stereotyping of magically proved forms, which is a first step in the overcoming of naturalism by a fixation of 'style'; in music as a means of ecstasy, exorcism, or apotropaic magic; in sorcerers as holy singers and dancers; in magically proved and therefore magically stereotyped tone relations – the earliest preparatory stages in the development of tonal systems; in the magically proved dance-step as one of the sources of rhythm and as an ecstasy technique; in temples and churches as the largest of all buildings, with the architectural task becoming

stereotyped (and thus style-forming) as a consequence of purposes which are established once for all, and with the structural forms becoming stereotyped through magical efficacy; in paraments and church implements of all kinds which have served as objects of applied art. All these processes and objects have been displayed in connection with the churches' and temples' wealth flowing from religious zeal.

For the religious ethic of brotherliness, just as for *a priori* ethical rigorism, art as a carrier of magical effects is not only devalued but even suspect. The sublimation of the religious ethic and the quest for salvation, on the one hand, and the evolution of the inherent logic of art, on the other, have tended to form an increasingly tense relation. All sublimated religions of salvation have focused upon the meaning alone, not upon the form, of the things and actions relevant for salvation. Salvation religions have devalued form as contingent, as something creaturely and distracting from meaning. On the part of art, however, the naive relation to the religious ethic of brotherliness can remain unbroken or can be repeatedly restored as long and as often as the conscious interest of the recipient of art is naively attached to the content and not to the form as such. The relationship between a religious ethic and art will remain harmonious as far as art is concerned for so long as the creative artist experiences his work as resulting either from a charisma of 'ability' (originally magic) or from spontaneous play.

The development of intellectualism and the rationalization of life change this situation. For under these conditions, art becomes a cosmos of more and more consciously grasped independent values which exist in their own right. Art takes over the function of a this-worldly salvation, no matter how this may be interpreted. It provides a *salvation* from the routines of everyday life, and especially from the increasing pressures of theoretical and practical rationalism.

With this claim to a redemptory function, art begins to compete directly with salvation religion. Every rational religious ethic must turn against this inner-worldly, irrational salvation. For in religion's eyes, such salvation is a realm of irresponsible indulgence and secret lovelessness. As a matter of fact, the refusal of modern men to assume responsibility for moral judgments tends to transform judgments of moral intent into judgments of taste ('in poor taste' instead of 'reprehensible'). The inaccessibility of appeal from esthetic judgments excludes discussion. This shift from the moral to the esthetic evaluation of conduct is a common characteristic of intellectualist epochs; it results partly from subjectivist needs and partly from the fear of appearing narrow-minded in a traditionalist and Philistine way.

The ethical norm and its 'universal validity' create a community, at least in so far as an individual might reject the act of another on moral grounds and yet still face it and participate in the common life. Knowing his own creaturely weakness, the individual places himself under the common norm. In contrast with this ethical attitude, the escape from the necessity of taking a stand on rational, ethical grounds by resorting to esthetic evaluations *may* very well be regarded by salvation religion as a very base form of unbrotherliness. To the creative artist, however, as well as to the esthetically excited and receptive mind, the ethical norm as such may easily appear as a coercion of their genuine creativeness and innermost selves.

The most irrational form of religious behavior, the mystic experience, is in its innermost being not only alien but hostile to all form. Form is unfortunate and inexpressible to the mystic because he believes precisely in the experience of exploding

all forms, and hopes by this to be absorbed into the 'All-oneness' which lies beyond any kind of determination and form. For him the indubitable psychological affinity of profoundly shaking experiences in art and religion can only be a symptom of the diabolical nature of art. Especially music, the most 'inward' of all the arts, can appear in its purest form of instrumental music as an irresponsible *Ersatz* for primary religious experience. The internal logic of instrumental music as a realm not living 'within' appears as a deceptive pretension to religious experience. The well-known stand of the Council of Trent may in part have stemmed from this sentiment. Art becomes an 'idolatry,' a competing power, and a deceptive bedazzlement; and the images and the allegory of religious subjects appear as blasphemy.

In empirical, historical reality, this psychological affinity between art and religion has led to ever-renewed alliances, which have been quite significant for the evolution of art. The great majority of religions have in some manner entered such alliances. The more they wished to be universalist mass religions and were thus directed to emotional propaganda and mass appeals, the more systematic were their alliances with art. But all genuine virtuoso religions have remained very coy when confronting art, as a consequence of the inner structure of the contradiction between religion and art. This holds true for virtuoso religiosity in its active asceticist bent as well as in its mystical turn. The more religion has emphasized either the supra-worldliness of its God or the otherworldliness of salvation, the more harshly has art been refuted.

(b) THE TENSIONS BETWEEN ART AND ETHICAL RELIGION

Extracts from *Wirtschaft und Gesellschaft: Grundriss der verstehenden Soziologie.* Tübingen, 1922. From G. Roth (ed.), *Economy and Society.* Berkeley, University of California Press, 1968, pp. 607–10.

JUST AS ETHICAL RELIGION, especially if it preaches brotherly love, enters into the deepest inner tensions with the strongest irrational power of personal life, namely sexuality, so also does ethical religion enter into a strong polarity with the sphere of art. Religion and art are intimately related in the beginning. That religion has been an inexhaustible spring for artistic expressions is evident from the existence of idols and icons of every variety, and from the existence of music as a device for arousing ecstasy or for accompanying exorcism and apotropaic cultic actions. Religion has stimulated the artistic activities of magicians and sacred bards, as well as the creation of temples and churches (the greatest of artistic productions), together with the creation of religious paraments and church vessels of all sorts, the chief objects of the arts and crafts. But the more art becomes

an autonomous sphere, which happens as a result of lay education, the more art tends to acquire its own set of constitutive values, which are quite different from those obtaining in the religious and ethical domain.

Every unreflectively receptive approach to art starts from the significance of the *content*, and that may induce formation of a community. But the conscious discovery of uniquely esthetic values is reserved for an intellectualist civilization. This development causes the disappearance of those elements in art which are conducive to community formation and conducive to the compatibility of art with the religious will to salvation. Indeed, religion violently rejects as sinful the type of salvation within the world which art *qua* art claims to provide. Ethical religions as well as true mysticisms regard with hostility any such salvation from the ethical irrationalities of the world. The climax of this conflict between art and religion is reached in authentic asceticism, which views any surrender to esthetic values as a serious breach in the rational systematization of the conduct of life. This tension increases with the advance of intellectualism, which may be described as quasi-esthetic. The rejection of responsibility for ethical judgement and the fear of appearing bound by tradition, which come to the fore in intellectualist periods, shift judgments whose intention was originally ethical into an esthetic key. Typical is the shift from the judgement 'reprehensible' to the judgement 'in poor taste.' But this unappealable subjectivity of all judgments about human relationships that actually comes to the fore in the cult of estheticism, may well be regarded by religion as one of the profoundest forms of idiosyncratic lovelessness conjoined with cowardice. Clearly there is a sharp contrast between the esthetic attitude and religio-ethical norms, since even when the individual rejects ethical norms he nevertheless experiences them humanly in his knowledge of his own creatureliness. He assumes some such norm to be basic for his own conduct as well as another's conduct in the particular case which he is judging. Moreover, it is assumed in principle that the justification and consequences of a religio-ethical norm remain subject to discussion. At all events, the esthetic attitude offers no support to a consistent ethic of fraternalism, which in its turn has a clearly anti-esthetic orientation.

The religious devaluation of art, which usually parallels the religious devaluation of magical, orgiastic, ecstatic, and ritualistic elements in favor of ascetic, spiritualistic, and mystical virtues, is intensified by the rational and literary character of both priestly and lay education in scriptural religions. But it is above all authentic prophecy that exerts an influence hostile to art, and that in two directions. First, prophecy obviously rejects orgiastic practices and usually rejects magic in general. Thus, the primal Jewish fear of images and likenesses, which originally had a magical basis, was given a spiritualistic interpretation by Hebrew prophecy and transformed in relation to a concept of an absolute and transcendental god. Second, somewhere along the line there arose the opposition of prophetic faith, which is centrally oriented to ethics and religion, to the work of human hands, which in the view of the prophets could promise only illusory salvation. The more the god proclaimed by the prophets was conceived as transcendental and sacred, the more insoluble and irreconcilable became this opposition between religion and art.

On the other hand, religion is continually brought to recognize the undeniable 'divinity' of artistic achievement. Mass religion in particular is frequently and directly dependent on artistic devices for the required potency of its effects, and it is

inclined to make concessions to the needs of the masses, which everywhere tend toward magic and idolatry. Apart from this, organized mass religions have frequently had connections with art resulting from economic interests, as, for instance, in the case of the traffic in icons by the Byzantine monks, the most decisive opponents of the caesaropapist Imperial power which was supported by an army that was iconoclastic because it was recruited from the marginal provinces of Islam, still strongly spiritualistic at that time. The imperial power, in turn, attempted to cut off the monks from this source of income, hoping thus to destroy the economic strength of this most dangerous opponent to its plans for domination over the church.

Subjectively too, there is an easy way back to art from every orgiastic or ritualistic religion of emotionalism, as well as from every mystic religion of love that culminates in a transcendence of individuality – despite the heterogeneity of the ultimate meanings involved. Orgiastic religion leads most readily to song and music; ritualistic religion inclines toward the pictorial arts; religions enjoining love favor the development of poetry and music. This relationship is demonstrated by all our experience of Hindu literature and art; the joyous lyricism of the Sufis, so utterly receptive to the world; the canticles of St. Francis; and the immeasurable influences of religious symbolism, particularly in mystically formed attitudes. Yet particular empirical religions hold basically different attitudes toward art, and even within any one religion diverse attitudes toward art are manifested by different strata, carriers, and structural forms. In their attitudes toward art, prophets differ from mystagogues and priests, monks from pious laymen, and mass religions from sects of virtuosi. Sects of ascetic virtuosi are naturally more hostile to art on principle than are sects of mystical virtuosi. But these matters are not our major concern here. At all events, any real inner compromise between the religious and the esthetic attitudes in respect to their ultimate (subjectively intended) meaning is rendered increasingly difficult once the stages of magic and pure ritualism have been left behind.

In all this, the one important fact for us is the significance of the marked rejection of all distinctively esthetic devices by those religions which are rational, in our special sense. These are Judaism, ancient Christianity, and – later on – ascetic Protestantism. Their rejection of esthetics is either a symptom or an instrument of religion's increasingly rational influence upon the conduct of life. It is perhaps going too far to assert that the second commandment of the Decalogue is the decisive foundation of actual Jewish rationalism, as some representatives of influential Jewish reform movements have assumed. But there can be no question at all that the systematic prohibition in devout Jewish and Puritan circles of uninhibited surrender to the distinctive form-producing values of art has effectively controlled the degree and scope of artistic productivity in these circles, and has tended to favor the development of intellectualist and rational controls over life.

(c) ART AND RATIONALIZATION IN THE WESTERN WORLD

Extracts from *Archiv für Sozialwissenschaft und Sozialpolitik*, revised version, 1920/1, *Gesammelte Aufsätze zur Religionssoziologie*. From *The Protestant Ethic and the Spirit of Capitalism*. London: George Allen & Unwin, 1930, pp. 13–17, 25–6. Original publication 1904.

A **PRODUCT OF MODERN** European civilization, studying any problem of universal history, is bound to ask himself to what combination of circumstances the fact should be attributed that in Western civilization, and in Western civilization only, cultural phenomena have appeared which (as we like to think) lie in a line of development having *universal* significance and value.

Only in the West does science exist at a stage of development which we recognize to-day as valid. Empirical knowledge, reflection on problems of the cosmos and of life, philosophical and theological wisdom of the most profound sort, are not confined to it, though in the case of the last the full development of a systematic theology must be credited to Christianity under the influence of Hellenism, since there were only fragments in Islam and in a few Indian sects. In short, knowledge and observation of great refinement have existed elsewhere, above all in India, China, Babylonia, Egypt. But in Babylonia and elsewhere astronomy lacked – which makes its development all the more astounding – the mathematical foundation which it first received from the Greeks. The Indian geometry had no rational proof; that was another product of the Greek intellect, also the creator of mechanics and physics. The Indian natural sciences, though well developed in observation, lacked the method of experiment, which was, apart from beginnings in antiquity, essentially a product of the Renaissance, as was the modern laboratory. Hence medicine, especially in India, though highly developed in empirical technique, lacked a biological and particularly a biochemical foundation. A rational chemistry has been absent from all areas of culture except the West.

The highly developed historical scholarship of China did not have the method of Thucydides. Machiavelli, it is true, had predecessors in India; but all Indian political thought was lacking in a systematic method comparable to that of Aristotle, and indeed, in the possession of rational concepts. Not all the anticipations in India (School of Mimamsa), nor the extensive codification especially in the Near East, nor all the Indian and other books of law, had the strictly systematic forms of thought, so essential to a rational jurisprudence, of the Roman law and of the Western law under its influence. A structure like the canon law is known only to the West.

A similar statement is true of art. The musical ear of other peoples has probably been even more sensitively developed than our own, certainly not less so. Polyphonic music of various kinds has been widely distributed over the earth. The co-operation of a number of instruments and also the singing of parts have existed elsewhere. All our rational tone intervals have been known and calculated. But

rational harmonious music, both counterpoint and harmony, formation of the tone material on the basis of three triads with the harmonic third; our chromatics and enharmonics, not interpreted in terms of space, but, since the Renaissance, of harmony; our orchestra, with its string quartet as a nucleus, and the organization of ensembles of wind instruments; our bass accompaniment; our system of notation, which has made possible the composition and production of modern musical works, and thus their very survival; our sonatas, symphonies, operas; and finally, as means to all these, our fundamental instruments, the organ, piano, violin, etc.; all these things are known only in the Occident, although programme music, tone poetry, alteration of tones and chromatics, have existed in various musical traditions as means of expression.

In architecture, pointed arches have been used elsewhere as a means of decoration, in antiquity and in Asia; presumably the combination of pointed arch and cross-arched vault was not unknown in the Orient. But the rational use of the Gothic vault as a means of distributing pressure and of roofing spaces of all forms, and above all as the constructive principle of great monumental buildings and the foundation of a *style* extending to sculpture and painting, such as that created by our Middle Ages, does not occur elsewhere. The technical basis of our architecture came from the Orient. But the Orient lacked that solution of the problem of the dome and that type of classic rationalization of all art – in painting by the rational utilization of lines and spatial perspective – which the Renaissance created for us. There was printing in China. But a printed literature, designed *only* for print and only possible through it, and above all, the Press and periodicals, have appeared only in the Occident. Institutions of higher education of all possible types, even some superficially similar to our universities, or at least academies, have existed (China, Islam). But a rational, systematic, and specialized pursuit of science, with trained and specialized personnel, has only existed in the West in a sense at all approaching its present dominant place in our culture. Above all is this true of the trained official, the pillar of both the modern state and of the economic life of the West. He forms a type of which there have heretofore only been suggestions, which have never remotely approached its present importance for the social order. Of course the official, even the specialized official, is a very old constituent of the most various societies. But no country and no age has ever experienced, in the same sense as the modern Occident, the absolute and complete dependence of its whole existence, of the political, technical, and economic conditions of its life, on a specially trained *organization* of officials. The most important functions of the everyday life of society have come to be in the hands of technically, commercially, and above all legally trained government officials.

Organization of political and social groups in feudal classes has been common. But even the feudal state or *rex et regnum* [king and kingdom] in the Western sense has only been known to our culture. Even more are parliaments of periodically elected representatives, with government by demagogues and party leaders as ministers responsible to the parliaments, peculiar to us, although there have, of course, been parties, in the sense of organizations for exerting influence and gaining control of political power, all over the world. In fact, the state itself, in the sense of a political association with a rational, written constitution, rationally ordained law, and an administration bound to rational rules or laws, administered by trained officials, is

known, in this combination of characteristics, only in the Occident, despite all other approaches to it.

And the same is true of the most fateful force in our modern life, capitalism. The impulse to acquisition, pursuit of gain, of money, of the greatest possible amount of money, has in itself nothing to do with capitalism. This impulse exists and has existed among waiters, physicians, coachmen, artists, prostitutes, dishonest officials, soldiers, nobles, crusaders, gamblers, and beggars. One may say that it has been common to all sorts and conditions of men at all times and in all countries of the earth, wherever the objective possibility of it is or has been given. It should be taught in the kindergarten of cultural history that this naïve idea of capitalism must be given up once and for all. Unlimited greed for gain is not in the least identical with capitalism, and is still less its spirit. Capitalism *may* even be identical with the restraint, or at least a rational tempering, of this irrational impulse. But capitalism is identical with the pursuit of profit, and forever *renewed* profit, by means of continuous, rational, capitalistic enterprise. For it must be so: in a wholly capitalistic order of society, an individual capitalistic enterprise which did not take advantage of its opportunities for profit-making would be doomed to extinction.

[. . .]

Now the peculiar modern Western form of capitalism has been, at first sight, strongly influenced by the development of technical possibilities. Its rationality is to-day essentially dependent on the calculability of the most important technical factors. But this means fundamentally that it is dependent on the peculiarities of modern science, especially the natural sciences based on mathematics and exact and rational experiment. On the other hand, the development of these sciences and of the technique resting upon them now receives important stimulation from these capitalistic interests in its practical economic application. It is true that the origin of Western science cannot be attributed to such interests. Calculation, even with decimals, and algebra have been carried on in India, where the decimal system was invented. But it was only made use of by developing capitalism in the West, while in India it led to no modern arithmetic or book-keeping. Neither was the origin of mathematics and mechanics determined by capitalistic interests. But the *technical* utilization of scientific knowledge, so important for the living conditions of the mass of people, was certainly encouraged by economic considerations, which were extremely favourable to it in the Occident. But this encouragement was derived from the peculiarities of the social structure of the Occident. We must hence ask, from *what* parts of that structure was it derived, since not all of them have been of equal importance?

Among those of undoubted importance are the rational structures of law and of administration. For modern rational capitalism has need, not only of the technical means of production, but of a calculable legal system and of administration in terms of formal rules. Without it adventurous and speculative trading capitalism and all sorts of politically determined capitalisms are possible, but no rational enterprise under individual initiative, with fixed capital and certainty of calculations. Such a legal system and such administration have been available for economic activity in a comparative state of legal and formalistic perfection only in the Occident. We must hence inquire where that law came from. Among other circumstances, capitalistic

interests have in turn undoubtedly also helped, but by no means alone nor even principally, to prepare the way for the predominance in law and administration of a class of jurists specially trained in rational law. But these interests did not themselves create that law. Quite different forces were at work in this development. And why did not the capitalistic interests do the same in China or India? Why did not the scientific, the artistic, the political, or the economic development there enter upon that path of rationalization which is peculiar to the Occident?

For in all the above cases it is a question of the specific and peculiar rationalism of Western culture. Now by this term very different things may be understood [. . .]. There is, for example, rationalization of mystical contemplation, that is of an attitude which, viewed from other departments of life, is specifically irrational, just as much as there are rationalizations of economic life, of technique, of scientific research, of military training, of law and administration. Furthermore, each one of these fields may be rationalized in terms of very different ultimate values and ends, and what is rational from one point of view may well be irrational from another. Hence rational-izations of the most varied character have existed in various departments of life and in all areas of culture. To characterize their differences from the view-point of cultural history it is necessary to know what departments are rationalized, and in what direction. It is hence our first concern to work out and to explain genetically the special peculiarity of Occidental rationalism, and within this field that of the modern Occidental form. Every such attempt at explanation must, recognizing the fundamental importance of the economic factor, above all take account of the economic conditions. But at the same time the opposite correlation must not be left out of consideration. For though the development of economic rationalism is partly dependent on rational technique and law, it is at the same time determined by the ability and disposition of men to adopt certain types of practical rational conduct. When these types have been obstructed by spiritual obstacles, the development of rational economic conduct has also met serious inner resistance. The magical and religious forces, and the ethical ideas of duty based upon them, have in the past always been among the most important formative influences on conduct.

Georg Simmel

SYMMETRY AND SOCIAL ORGANIZATION

Extract from *Sociological Aesthetics*. Originally published *Die Zukunft* 17 (1896), 204–16. From K. P. Etzkorn (ed.), *Georg Simmel: The Conflict in Modern Culture and Other Essays*. New York, Teachers College Press, 1968, pp. 71–6.

[. . .]

THE ORIGIN OF ALL aesthetic themes is found in symmetry. Before man can bring an idea, meaning, harmony into things, he must first form them symmetrically. The various parts of the whole must be balanced against one another, and arranged evenly around a center. In this fashion man's form-giving power, in contrast to the contingent and confused character of mere nature, becomes most quickly, visibly, and immediately clear. Thus, the first aesthetic step leads beyond a mere acceptance of the meaninglessness of things to a will to transform them symmetrically. As aesthetic values are refined and deepened, however, man returns to the irregular and asymmetrical. It is in symmetrical formations that rationalism first emerges. So long as life is still instinctive, affective and irrational, aesthetic redemption from it takes on such a rationalistic form. Once intelligence, reckoning, balance have penetrated it, the aesthetic need once again changes into its opposite, seeking the irrational and its external form, the asymmetrical.

The lower level of the aesthetic drive finds expression in the building of systems which arrange objects into symmetric pictures. Thus, for example, the penance-books of the sixth century arranged sins and punishments in systems of mathematical precision and balanced structure. Hence the first attempt to master intellectually the totality of moral errors was cast in the form of a scheme which was as mechanical, rational, and symmetric as possible. Once these errors were brought under the yoke of the system, the mind could grasp them the most quickly and with the least resistance. The system breaks down as soon as man has intellectually mastered the

proper meaning of the object and need no longer derive it only from its relations with others; at this point, therefore, there is a weakening of the aesthetic will to symmetry, with which the elements were previously arranged.

It is possible to discover through an analysis of the role of symmetry in social life how apparently purely aesthetic interests are called forth by materialistic purposes, and how, on the other hand, aesthetic motives affect forms which seem to obey only functional purposes. For example, in a variety of older cultures we find the coordination of ten members of groups into special social units – for military, taxable, juridical, and other purposes – which in turn frequently form a higher unit, the hundred, by the combination of ten such groups. The reason for this symmetrical construction of groups was certainly the advantage of easier survey, demarcation, and control. The peculiarly stylized society which grew from this type of organization developed on account of its mere utility. But the meaning of 'the hundred' extended beyond its utility. Thus 'hundreds' frequently contained more or less than one hundred individuals. During the Middle Ages, for example, the Senate of Barcelona was called the 'one hundred' even though it numbered approximately two hundred members. This deviation from the original organizational rationality demonstrates a transition from use value to aesthetic value, to the charm of symmetry and architectural forms in social life, while the fiction of technical rationality is still being maintained.

This tendency to organize all of society symmetrically and equally structured according to general principles is shared by all despotic forms of social organization. Justus Moeser wrote in 1772:

> The gentlemen of the Central Administrative Department would like to reduce everything to simple rules. In this fashion we remove ourselves from the true plan of nature, which shows its wealth in variety, and we clear the way for despotism, which will coerces everything under a few rules.

Symmetrical organizations facilitate the ruling of many from a single point. Norms can be imposed from above with less resistance and greater effectiveness in a symmetrical organization than in a system whose inner structure is irregular and fluctuating. For this reason Charles V (1519–1556) intended to level out all unequal and peculiar political structures and privileges in the Netherlands and to restructure them into an organization which would be comparable in all parts. A historian of the epoch writes 'that he hated the old licenses and stubborn privileges, which disturbed his ideas of symmetry'. Egyptian pyramids have correctly been designated as symbols of the political organization of great Oriental despots. They represent the completely symmetrical structure of a society whose elements in the upward direction rapidly decline in number while their amounts of power increase until they meet in the pinnacle which rules equally over the whole.

Even though this form of organization derived its rationality from the needs of despotism, it generates a formal, purely aesthetic meaning. This charm of symmetry, with its internal equilibration, its external unity, and its harmonic relationship of all parts to its unified center, is one of the purely aesthetic forces which attracts many intelligent people to autocracy, with its unlimited expression of the unified will of the state. This is why genuinely liberal forms of the state tend towards asymmetry.

Macaulay, the inspired liberal, points directly to this feature as the proper strength of British constitutional life.

> We do not think about its symmetry but a great deal about its utility. We never remove an anomaly only because it is an anomaly. We never set our norms for a wider area than is demanded by the special case with which we are dealing at the moment. These are the rules which taken as a whole have governed the proceedings of our 250 parliaments from King John to Queen Victoria.

Here the ideal of symmetry and logical closure, which gives meaning to everything from one single point, is rejected in favor of another ideal, which permits each element to develop independently according to its own conditions. The whole, of course, thus looks disorganized and irregular. Nevertheless, in addition to all concrete motives, there is an aesthetic charm even in this lack of symmetry, in this liberation of the individual. This overtone can easily be heard in the words of Macaulay. It derives from the feeling that this form of organization brings the inner life of the state, to its most typical expression and its most harmonic form.

The influence of aesthetic forces upon social facts is most vivid in modern conflicts between socialistic and individualistic tendencies. Without any doubt, certain ideas of socialism are based on aesthetic values. That society as a whole should become a work of art in which every single element attains its meaning by virtue of its contribution to the whole; that a unified plan should rationally determine all of production, instead of the present rhapsodic haphazardness by which the efforts of individuals benefit or harm society; that the wasteful competition and the fight of individuals against individuals should be replaced by the absolute harmony of work – all these ideas of socialism no doubt meet aesthetic interests. Whatever else one may have against it, these ideas at any rate refute the popular opinion that socialism both begins and ends exclusively in the needs of the stomach. The social question therefore is not only an ethical question, but also an aesthetic one.

Quite apart from its consequences for the individual, the rational organization of society has a high aesthetic attraction. It aims to make the totality of lives in the whole organization into a work of art, which at present can hardly be accomplished for the life of an individual. The more we learn to appreciate composite forms, the more readily we will extend aesthetic categories to forms of society as a whole. Consider, for example, the aesthetic appeal of machines: the absolute purposiveness and reliability of motions, the extreme reduction of resistance and friction, the harmonic integration of the most minute and the largest parts, provides machines with a peculiar beauty. The organization of a factory and the plan of the socialistic state only repeats this beauty on larger scales. This peculiar interest in harmony and symmetry by which socialism demonstrates its rationalistic character, and by which it aims to stylize social life, is expressed purely externally by the fact that socialistic utopias are always set up according to principles of symmetry. Towns or buildings are arranged either in circular or quadratic form. The layout of the capital is mathematically constructed in the Sun-State of Campanella, as are the work assignments for the citizens and the gradations of their rights and duties. This general trait of socialistic plans attests to the deep power of attraction in the idea of an harmonic, internally

balanced organization of human activity overcoming all resistance of irrational individuality. This interest, a purely aesthetic one, independent of all material consequences, has probably always been important in determining the social forms of life.

The attractiveness of beauty is sometimes described as a saving of thought, an unravelling of a maximum number of images with minimum effort. If this is so, then the symmetrical construction of social groups, as it is desired by socialism, will fulfill these postulates. On the other hand, an individuated society, characterized by heterogeneous interests and irreconcilable tendencies, embracing many series of development which have been commenced and interrupted innumerable times (since they were only carried on by individuals), presents to the mind a restless, uneven image, which continuously requires new nervous exertion and effort for its understanding. But a socialistic and balanced society through its organic unity, its symmetrical arrangement and mutual coordination of movements in common centers, provides for the observing mind a maximum of insight. To understand the social picture here requires a minimum of intellectual effort. This fact in its aesthetic significance would seem to figure decisively in the intellectual appeal of socialism.

In aesthetics, symmetry means the dependence of individual elements on their mutual interdependence with all others, but also self-containment within the designated circle. Asymmetrical arrangements permit broader individual rights, more latitude for the free and far-reaching relations of each element. The internal organization of socialism takes this into consideration; thus it is no accident that all historical approximations to socialism occurred only within strictly closed groups which declined all relations to outside powers. This containment, which is appropriate for the aesthetic character of symmetry as well as for the political character of the socialistic state, suggests the general argument that because of continuous international intercourse socialism could never come to power in a single country but only uniformly in the whole civilized world.

The power of aesthetic valuation is demonstrated by the fact that it can also be applied equally well in support of the opposite social ideal. Beauty, as it is actually felt today, has an almost exclusively individualistic character. Essentially it is based on individual traits, in contrast to the general characteristics and conditions of life. Truly romantic beauty is based to a large extent on the opposition and isolation of the individual from what is common and valid for everybody. This is true even if we disavow individualism on ethical grounds. It is aesthetically attractive to think of the individual not only as a member of a larger whole, but as a whole in its own right, which as such no longer fits into any symmetric organization. Even the most perfect social mechanism is only a mechanism, and so lacks the freedom which, regardless of one's philosophical interpretations, is the *sine qua non* of beauty. Thus, of the worldviews which have become prominent during recent times, those of Rembrandt and Nietzsche are most decidedly individualistic, and are supported by distinctly aesthetic motives. Indeed, the individualism of this contemporary view of beauty extends so far that even flowers, and especially modern garden flowers, are no longer bound into bundles. On the contrary, they are arranged individually, or several of them at most are bound together rather loosely. Thus every single garden flower is seen as an individual in itself; they are all aesthetic individualities, which cannot be coordinated into symmetrical unity. By contrast, wild flowers, which are less developed and somehow arrested in their evolution, form delightful bunches.

Emile Durkheim

SOCIAL STRUCTURE, MATERIAL CULTURE AND SYMBOLIC COMMUNICATION

(a) SYMBOLIC MEANING AND OBJECTIFICATION

From *The Elementary Forms of the Religious Life,* trans. J. W. Swain. London, George Allen & Unwin; New York, The Free Press, 1965, pp. 134–40, 148–9. Original publication 1920.

BUT THE TOTEM IS not merely a name; it is an emblem, a veritable coat-of-arms whose analogies with the arms of heraldry have often been remarked. In speaking of the Australians, Grey says, 'each family adopts an animal or vegetable as their crest and sign,' and what Grey calls a family is incontestably a clan. Also Fison and Howitt say, 'the Australian divisions show that the totem is, in the first place, the badge of a group'. Schoolcraft says the same thing about the totems of the Indians of North America. 'The totem is in fact a design which corresponds to the heraldic emblems of civilized nations, and each person is authorized to bear it as a proof of the identity of the family to which it belongs. This is proved by the real etymology of the word, which is derived from *dodaim*, which means village or the residence of a family group.' Thus when the Indians entered into relations with the Europeans and contracts were formed between them, it was with its totem that each clan sealed the treaties thus concluded.

The nobles of the feudal period carved, engraved and designed in every way their coats-of-arms upon the walls of their castles, their arms, and every sort of object that belonged to them; the blacks of Australia and the Indians of North America do the same thing with their totems. [. . .]

Wherever the society has become sedentary, where the tent is replaced by the house, and where the plastic arts are more fully developed, the totem is engraved

upon the woodwork and upon the walls. This is what happens, for example, among the Haida, the Tsimshian, the Salish and the Tlinkit. 'A very particular ornament of the house, among the Tlinkit,' says Krause, 'is the totemic coat-of-arms.' Animal forms, sometimes combined with human forms, are engraved upon the posts at the sides of the door of entry, which are as high as 15 yards; they are generally painted with very bright colours. However, these totemic decorations are not very numerous in the Tlinkit village; they are found almost solely before the houses of the chiefs and rich men. They are much more frequent in the neighbouring tribe of the Haida; here there are always several for each house. With its many sculptured posts arising on every hand, sometimes to a great height, a Haida village gives the impression of a sacred city, all bristling with belfries or little minarets. Among the Salish, the totem is frequently represented upon the interior walls of the house. Elsewhere, it is found upon the canoes, the utensils of every sort and the funeral piles.

The preceding examples are taken exclusively from the Indians of North America. This is because sculpture, engravings and permanent figurations are not possible except where the technique of the plastic arts has reached a degree of perfection to which the Australian tribes have not yet attained. Consequently the totemic representations of the sort which we just mentioned are rare and less apparent in Australia than in America. However, cases of them are cited. Among the Warramunga, at the end of the burial ceremonies, the bones of the dead man are interred, after they have been dried and reduced to powder; beside the place where they are deposited, a figure representing the totem is traced upon the ground. Among the Mara and the Anula, the body is placed in a piece of hollow wood decorated with designs characteristic of the totem. In New South Wales, Oxley found engravings upon the trees near the tomb where a native was buried to which Brough Smyth attributes a totemic character. The natives of the Upper Darling carve totemic images upon their shields. According to Collins, nearly all the utensils are covered with ornaments which probably have the same significance; figures of the same sort are found upon the rocks. These totemic designs may even be more frequent than it seems, for, owing to reasons which will be discussed below, it is not always easy to see what their real meaning is.

These different facts give us an idea of the considerable place held by the totem in the social life of the primitives. However, up to the present, it has appeared to us as something relatively outside of the man, for it is only upon external things that we have seen it represented. But totemic images are not placed only upon the walls of their houses, the sides of their canoes, their arms, their utensils and their tombs; they are also found on the bodies of the men. They do not put their coat-of-arms merely upon the things which they possess, but they put it upon their persons; they imprint it upon their flesh, it becomes a part of them, and this world of representations is even by far the more important one.

In fact, it is a very general rule that the members of each clan seek to give themselves the external aspect of their totem. At certain religious festivals among the Tlinkit, the person who is to direct the ceremonies wears a garment which represents, either wholly or in part, the body of the animal whose name he bears. These same usages are also found in all the North-West of America. They are found again among the Minnitaree, when they go into combat, and among the Indians of

the Pueblos. Elsewhere, when the totem is a bird, men wear the feathers of this bird on their heads. Among the Iowa, each clan has a special fashion of cutting the hair. In the Eagle clan, two large tufts are arranged on the front of the head, while there is another one behind; in the Buffalo clan, they are arranged in the form of horns. Among the Omaha, analogous arrangements are found: each clan has its own head-dress. In the Turtle clan, for example, the hair is all shaved off, except six bunches, two on each side of the head, one in front, and one behind, in such a way as to imitate the legs, the head and the tail of the animal.

But it is more frequently upon the body itself that the totemic mark is stamped: for this is a way of representation within the capacity of even the least advanced societies. It has sometimes been asked whether the common rite of knocking out a young man's two upper teeth at the age of puberty does not have the object of reproducing the form of the totem. The fact is not established, but it is worth mentioning that the natives themselves sometimes explain the custom thus. For example, among the Arunta, the extraction of teeth is practised only in the clans of the rain and of water; now according to tradition, the object of this operation is to make their faces look like certain black clouds with light borders which are believed to announce the speedy arrival of rain, and which are therefore considered things of the same family. This is a proof that the native himself is conscious that the object of these deformations is to give him, at least conventionally, the aspect of his totem. Among these same Arunta, in the course of the rites of sub-incision, certain gashes are cut upon the sisters and the future wife of the novice; scars result from these, whose form is also represented upon a certain sacred object of which we shall speak presently and which is called the *churinga*; as we shall see, the lines thus drawn upon the *churinga* are emblematic of the totem. Among the Kaitish, the euro is believed to be closely connected with the rain, the men of the rain clan wear little ear-rings made of euro teeth. Among the Yerkla, during the initiation the young man is given a certain number of slashes which leave scars; the number and form of these varies with the totems. An informer of Fison mentions the same fact in the tribes observed by him. According to Howitt, a relationship of the same sort exists among the Dieri between certain arrangements of scars and the water totem. Among the Indians of the North-West, it is a very general custom for them to tattoo themselves with the totem.

But even if the tattooings which are made by mutilations or scars do not always have a totemic significance, it is different with simple designs drawn upon the body: they are generally representations of the totem. It is true that the native does not carry them every day. When he is occupied with purely economic occupations, or when the small family groups scatter to hunt or fish, he does not bother with all this paraphernalia, which is quite complicated. But when the clans unite to live a com-mon life and to assist at the religious ceremonies together, then he must adorn himself. As we shall see, each of the ceremonies concerns a particular totem, and in theory the rites which are connected with a totem can be performed only by the men of that totem. Now those who perform, who take the part of officiants, and sometimes even those who assist as spectators, always have designs representing the totem on their bodies. One of the principal rites of initiation, by which a young man enters into the religious life of the tribe, consists in painting the totemic symbol on his body. It is true that among the Arunta the design thus traced does not always and

necessarily represent the totem of the initiated, but these are exceptions, due, undoubtedly, to the disturbed state of the totemic organization of this tribe. Also, even among the Arunta, at the most solemn moment of the initiation, which is its crown and consecration, when the neophyte is allowed to enter the sanctuary where all the sacred objects belonging to the clan are preserved, an emblematic painting is placed upon him; this time, it is the totem of the young man which is thus represented. The bonds which unite the individual to his totem are even so strong that in the tribes on the North-west coast of North America, the emblem of the clan is painted not only upon the living but also upon the dead: before a corpse is interred, they put the totemic mark upon it.

[. . .]

But if we are seeking to understand how it comes that these totemic representations are so sacred, it is not without interest to see what they consist in.

Among the Indians of North America, they are painted, engraved or carved images which attempt to reproduce as faithfully as possible the external aspect of the totemic animal. The means employed are those which we use to-day in similar circumstances, except that they are generally cruder. But it is not the same in Australia, and it is in the Australian societies that we must seek the origin of these representations. Although the Australian may show himself sufficiently capable of imitating the forms of things in a rudimentary way, sacred representations generally seem to show no ambitions in this line: they consist essentially in geometrical designs drawn upon the churinga, the nurtunja, rocks, the ground, or the human body. They are either straight or curved lines, painted in different ways, and the whole having only a conventional meaning. The connection between the figure and the thing represented is so remote and indirect that it cannot be seen, except when it is pointed out. Only the members of the clan can say what meaning is attached to such and such combinations of lines. Men and women are generally represented by semicircles, and animals by whole circles or spirals, the tracks of men or animals by lines of points, etc. The meaning of the figures thus obtained is so arbitrary that a single design may have two different meanings for the men of two different totems, representing one animal here, and another animal or plant there. This is perhaps still more apparent with the nurtunja and waninga. Each of them represents a different totem. But the few and simple elements which enter into their composition do not allow a great variety of combinations. The result is that two nurtunja may have exactly the same appearance, and yet express two things as different as a gum tree and an emu. When a nurtunja is made, it is given a meaning which it keeps during the whole ceremony, but which, in the last resort, is fixed by convention.

These facts prove that if the Australian is so strongly inclined to represent his totem, it is in order not to have a portrait of it before his eyes which would constantly renew the sensation of it; it is merely because he feels the need of representing the idea which he forms of it by means of material and external signs, no matter what these signs may be. We are not yet ready to attempt to understand what has thus caused the primitive to write his idea of his totem upon his person and upon different objects, but it is important to state at once the nature of the need which has given rise to these numerous representations.

(b) SYMBOLIC OBJECTS, COMMUNICATIVE INTERACTION AND SOCIAL CREATIVITY

From *The Elementary Forms of the Religious Life*, trans. J. W. Swain. London, George Allen & Unwin; New York, The Free Press, 1965, pp. 236–64. Original publication 1920.

THUS THE TOTEM IS before all a symbol, a material expression of something else. But of what?

From the analysis to which we have been giving our attention, it is evident that it expresses and symbolizes two different sorts of things. In the first place, it is the outward and visible form of what we have called the totemic principle or god. But it is also the symbol of the determined society called the clan. It is its flag; it is the sign by which each clan distinguishes itself from the others, the visible mark of its personality, a mark borne by everything which is a part of the clan under any title whatsoever, men, beasts or things. So if it is at once the symbol of the god and of the society, is that not because the god and the society are only one? How could the emblem of the group have been able to become the figure of this quasi-divinity, if the group and the divinity were two distinct realities? The god of the clan, the totemic principle, can therefore be nothing else than the clan itself, personified and represented to the imagination under the visible form of the animal or vegetable which serves as totem.

But how has this apotheosis been possible, and how did it happen to take place in this fashion?

[. . .]

The life of the Australian societies passes alternately through two distinct phases. Sometimes the population is broken up into little groups who wander about independently of one another, in their various occupations; each family lives by itself, hunting and fishing, and in a word, trying to procure its indispensable food by all the means in its power. Sometimes, on the contrary, the population concentrates and gathers at determined points for a length of time varying from several days to several months. This concentration takes place when a clan or a part of the tribe is summoned to the gathering, and on this occasion they celebrate a religious ceremony, or else hold what is called a corrobbori in the usual ethnological language.

These two phases are contrasted with each other in the sharpest way. In the first, economic activity is the preponderating one, and it is generally of a very mediocre intensity. Gathering the grains or herbs that are necessary for food, or hunting and fishing are not occupations to awaken very lively passions. The dispersed condition in which the society finds itself results in making its life uniform,

languishing and dull. But when a corrobbori takes place, everything changes. Since the emotional and passional faculties of the primitive are only imperfectly placed under the control of his reason and will, he easily loses control of himself. Any event of some importance puts him quite outside himself. Does he receive good news? There are at once transports of enthusiasm. In the contrary conditions, he is to be seen running here and there like a madman, giving himself up to all sorts of immoderate movements, crying, shrieking, rolling in the dust, throwing it in every direction, biting himself, brandishing his arms in a furious manner, etc. The very fact of the concentration acts as an exceptionally powerful stimulant. When they are once come together, a sort of electricity is formed by their collecting which quickly transports them to an extraordinary degree of exaltation. Every sentiment expressed finds a place without resistance in all the minds, which are very open to outside impressions; each re-echoes the others, and is re-echoed by the others. The initial impulse thus proceeds, growing as it goes, as an avalanche grows in its advance. And as such active passions so free from all control could not fail to burst out, on every side one sees nothing but violent gestures, cries, veritable howls, and deafening noises of every sort, which aid in intensifying still more the state of mind which they manifest. And since a collective sentiment cannot express itself collect-ively except on the condition of observing a certain order permitting co-operation and movements in unison, these gestures and cries naturally tend to become rhythmic and regular; hence come songs and dances.

[. . .]

A still more violent scene at which these same observers [Spencer and Gillen, the ethnologists who were Durkheim's primary source of knowledge of Australian aboriginal religion] assisted was in connection with the fire ceremonies among the Warramunga.

Commencing at nightfall, all sorts of processions, dances and songs had taken place by torchlight; the general effervescence was constantly increasing. At a given moment, twelve assistants each took a great lighted torch in their hands, and one of them holding his like a bayonet, charged into a group of natives. Blows were warded off with clubs and spears. A general mêlée followed. The men leaped and pranced about, uttering savage yells all the time; the burning torches continually came crashing down on the heads and bodies of the men, scattering lighted sparks in every direction. 'The smoke, the blazing torches, the showers of sparks falling in all directions and the masses of dancing, yelling men,' say Spencer and Gillen, 'formed altogether a genuinely wild and savage scene of which it is impossible to convey any adequate idea in words.'

One can readily conceive how, when arrived at this state of exaltation, a man does not recognize himself any longer. Feeling himself dominated and carried away by some sort of an external power which makes him think and act differently than in normal times, he naturally has the impression of being himself no longer. It seems to him that he has become a new being: the decorations he puts on and the masks that cover his face figure materially in this interior transformation, and to a still greater extent, they aid in determining its nature. And as at the same time all his companions feel themselves transformed in the same way and express this sentiment by their cries, their gestures and their general attitude, everything is just as though

he really were transported into a special world, entirely different from the one where he ordinarily lives, and into an environment filled with exceptionally intense forces that take hold of him and metamorphose him. How could such experiences as these, especially when they are repeated every day for weeks, fail to leave in him the conviction that there really exist two heterogeneous and mutually incomparable worlds? One is that where his daily life drags wearily along; but he cannot penetrate into the other without at once entering into relations with extraordinary powers that excite him to the point of frenzy. The first is the profane world, the second, that of sacred things.

[. . .]

But the explanation is still incomplete. We have shown how the clan, by the manner in which it acts upon its members, awakens within them the idea of external forces which dominate them and exalt them; but we must still demand how it happens that these forces are thought of under the form of totems, that is to say, in the shape of an animal or plant.

It is because this animal or plant has given its name to the clan and serves it as emblem. In fact, it is a well-known law that the sentiments aroused in us by something spontaneously attach themselves to the symbol which represents them. For us, black is a sign of mourning; it also suggests sad impressions and ideas. This transference of sentiments comes simply from the fact that the idea of a thing and the idea of its symbol are closely united in our minds; the result is that the emotions provoked by the one extend contagiously to the other. But this contagion, which takes place in every case to a certain degree, is much more complete and more marked when the symbol is something simple, definite and easily representable, while the thing itself, owing to its dimensions, the number of its parts and the complexity of their arrangement, is difficult to hold in the mind. For we are unable to consider an abstract entity, which we can represent only laboriously and con-fusedly, the source of the strong sentiments which we feel. We cannot explain them to ourselves except by connecting them to some concrete object of whose reality we are vividly aware. Then if the thing itself does not fulfil this condition, it cannot serve as the accepted basis of the sentiments felt, even though it may be what really aroused them. Then some sign takes its place; it is to this that we connect the emotions it excites. It is this which is loved, feared, respected; it is to this that we are grateful; it is for this that we sacrifice ourselves. The soldier who dies for his flag, dies for his country; but as a matter of fact, in his own consciousness, it is the flag that has the first place. It sometimes happens that this even directly determines action. Whether one isolated standard remains in the hands of the enemy or not does not determine the fate of the country, yet the soldier allows himself to be killed to regain it. He loses sight of the fact that the flag is only a sign, and that it has no value in itself, but only brings to mind the reality that it represents; it is treated as if it were this reality itself.

Now the totem is the flag of the clan. It is therefore natural that the impressions aroused by the clan in individual minds – impressions of dependence and of increased vitality – should fix themselves to the idea of the totem rather than that of the clan: for the clan is too complex a reality to be represented clearly in all its complex unity by such rudimentary intelligences. More than that, the primitive does

not even see that these impressions come to him from the group. He does not know that the coming together of a number of men associated in the same life results in disengaging new energies, which transform each of them. All that he knows is that he is raised above himself and that he sees a different life from the one he ordinarily leads. However, he must connect these sensations to some external object as their cause. Now what does he see about him? On every side those things which appeal to his senses and strike his imagination are the numerous images of the totem. They are the waninga and the nurtunja, which are symbols of the sacred being. They are churinga and bull-roarers, upon which are generally carved combinations of lines having the same significance. They are the decorations covering the different parts of his body, which are totemic marks. How could this image, repeated everywhere and in all sorts of forms, fail to stand out with exceptional relief in his mind? Placed thus in the centre of the scene, it becomes representative. The sentiments experienced fix themselves upon it, for it is the only concrete object upon which they can fix themselves. It continues to bring them to mind and to evoke them even after the assembly has dissolved, for it survives the assembly, being carved upon the instruments of the cult, upon the sides of rocks, upon bucklers, etc. By it, the emotions experienced are perpetually sustained and revived. Everything happens just as if they inspired them directly. It is still more natural to attribute them to it for, since they are common to the group, they can be associated only with something that is equally common to all. Now the totemic emblem is the only thing satisfying this condition. By definition, it is common to all. During the ceremony, it is the centre of all regards. While generations change, it remains the same; it is the permanent element of the social life. So it is from it that those mysterious forces seem to emanate with which men feel that they are related, and thus they have been led to represent these forces under the form of the animate or inanimate being whose name the clan bears.

When this point is once established, we are in a position to understand all that is essential in the totemic beliefs.

Since religious force is nothing other than the collective and anonymous force of the clan, and since this can be represented in the mind only in the form of the totem, the totemic emblem is like the visible body of the god. Therefore, it is from it that those kindly and dreadful actions seem to emanate, which the cult seeks to provoke or prevent; consequently, it is to it that the cult is addressed. This is the explanation of why it holds the first place in the series of sacred things.

[. . .]

We are now able to explain the origin of the ambiguity of religious forces as they appear in history, and how they are physical as well as human, moral as well as material. They are moral powers because they are made up entirely of the impressions this moral being, the group, arouses in those other moral beings, its individual members; they do not translate the manner in which physical things affect our senses, but the way in which the collective consciousness acts upon individual consciousnesses. Their authority is only one form of the moral ascendancy of society over its members. But, on the other hand, since they are conceived of under material forms, they could not fail to be regarded as closely related to material things. Therefore they dominate the two worlds. Their residence is in men, but at the same time they are the vital principles of things. They animate minds and discipline them,

but it is also they who make plants grow and animals reproduce. It is this double nature which has enabled religion to be like the womb from which come all the leading germs of human civilization. Since it has been made to embrace all of reality, the physical world as well as the moral one, the forces that move bodies as well as those that move minds have been conceived in a religious form. That is how the most diverse methods and practices, both those that make possible the continuation of the moral life (law, morals, beaux-arts) and those serving the material life (the natural, technical and practical sciences), are either directly or indirectly derived from religion.

[. . .]

That an emblem is useful as a rallying-centre for any sort of a group it is superfluous to point out. By expressing the social unity in a material form, it makes this more obvious to all, and for that very reason the use of emblematic symbols must have spread quickly when once thought of. But more than that, this idea should spontaneously arise out of the conditions of common life; for the emblem is not merely a convenient process for clarifying the sentiment society has of itself: it also serves to create this sentiment; it is one of its constituent elements.

In fact, if left to themselves, individual consciousnesses are closed to each other; they can communicate only by means of signs which express their internal states. If the communication established between them is to become a real communion, that is to say, a fusion of all particular sentiments into one common sentiment, the signs expressing them must themselves be fused into one single and unique resultant. It is the appearance of this that informs individuals that they are in harmony and makes them conscious of their moral unity. It is by uttering the same cry, pronouncing the same word, or performing the same gesture in regard to some object that they become and feel themselves to be in unison. It is true that individual representations also cause reactions in the organism that are not without importance; however, they can be thought of apart from these physical reactions which accompany them or follow them, but which do not constitute them. But it is quite another matter with collective representations. They presuppose that minds act and react upon one another; they are the product of these actions and reactions which are themselves possible only through material intermediaries. These latter do not confine themselves to revealing the mental state with which they are associated; they aid in creating it. Individual minds cannot come in contact and communicate with each other except by coming out of themselves; but they cannot do this except by movements. So it is the homogeneity of these movements that gives the group consciousness of itself and consequently makes it exist. When this homogeneity is once established and these movements have once taken a stereotyped form, they serve to symbolize the corresponding representations. But they symbolize them only because they have aided in forming them.

Moreover, without symbols, social sentiments could have only a precarious existence. Though very strong as long as men are together and influence each other reciprocally, they exist only in the form of recollections after the assembly has ended, and when left to themselves, these become feebler and feebler; for since the group is now no longer present and active, individual temperaments easily regain the upper hand. The violent passions which may have been released in the heart of a

crowd fall away and are extinguished when this is dissolved, and men ask themselves with astonishment how they could ever have been so carried away from their normal character. But if the movements by which these sentiments are expressed are connected with something that endures, the sentiments themselves become more durable. These other things are constantly bringing them to mind and arousing them; it is as though the cause which excited them in the first place continued to act. Thus these systems of emblems, which are necessary if society is to become conscious of itself, are no less indispensable for assuring the continuation of this consciousness.

So we must refrain from regarding these symbols as simple artifices, as sorts of labels attached to representations already made, in order to make them more manageable: they are an integral part of them. Even the fact that collective sentiments are thus attached to things completely foreign to them is not purely conventional: it illustrates under a conventional form a real characteristic of social facts, that is, their transcendence over individual minds. In fact, it is known that social phenomena are born, not in individuals, but in the group. Whatever part we may take in their origin, each of us receives them from without. So when we represent them to ourselves as emanating from a material object, we do not completely misunderstand their nature. Of course they do not come from the specific thing to which we connect them, but nevertheless, it is true that their origin is outside of us. If the moral force sustaining the believer does not come from the idol he adores or the emblem he venerates, still it is from outside of him, as he is well aware. The objectivity of its symbol only translates its externalness.

Thus social life, in all its aspects and in every period of its history, is made possible only by a vast symbolism. The material emblems and figurative representations with which we are more especially concerned in our present study, are one form of this; but there are many others. Collective sentiments can just as well become incarnate in persons or formulæ: some formulæ are flags, while there are persons, either real or mythical, who are symbols.

PART TWO

The social production of art

ART, INSTITUTIONS AND THE PRODUCTION OF CULTURE

THE DOMINANT IDEA OF the artist in the modern west imagines an isolated *creator*, who produces works of art as an expression of a unique and individual *aesthetic* vision, which forms the basis of the value of a work of art. Classical sociological theory was centrally concerned with criticising the individualistic account of human life of which this idea of the creative artist is one strand. Recent work in the 'production of culture' perspective has shown how even apparently isolated artists, such as contemporary easel-painters, are deeply embedded in systems of social relationships. Social relationships and social interests shape opportunities for doing innovative work. They shape the success of artists, the critical esteem they enjoy and the material rewards they receive for their work. Correspondingly, art styles are as much a function of social interests which shape the ways in which artists interact with other art-world participants as they are of a desire for individual aesthetic expression or communication.

Rather than focusing on individual artists or objects, sociologists have chosen to think in terms of 'art worlds' as their primary unit of analysis. An art world consists of 'all those people and organisations whose activity is necessary to produce the kinds of events and objects which that world characteristically produces' (Becker 1976, 41). Students of such popular cultural forms as recorded country music have long recognised how the varying interests and aptitudes of long chains of decision-makers or 'gatekeepers' both within and outside record-production companies – singers, songwriters, musicians, sound engineers, recording technicians, commercial directors, disc jockeys, advertisers – affect the style, content and format of recorded songs, as well as changing levels of musical innovation over time (Hirsch 1972, Peterson and

Berger 1975, Ryan and Peterson 1982). Similar perspectives have been applied to the production of visual art. They illuminate both processes of artistic innovation and how actors within art worlds seek to control the unpredictability of their environments in order to advance interests which are as much material and political as aesthetic.

Marcia Bystryn (1978) has analysed the postwar New York avant-garde art market as an 'industry system'. The focal organisation of this system is the gallery, with artists as the 'input sector' and gatekeepers, such as critics and museum curators, as the 'output sector', filtering the products which reach the consumer or collector. Bystryn describes a division of labour between galleries dealing in cheap but high-risk unrecognised artists and galleries dealing in established artists, with distinctive selection, filtering and output processes. This division of labour, she argues, produces a harmony between apparently anomic innovation – essential to ensure buyers' confidence in the market as genuinely avant-garde – and sufficient order to permit the rational investment strategies which underpin not only the continued financial interest of dealers in the system but also their willingness to take risks with new talent.

Much of the work within the production of culture perspective has a strongly polemical character, seeking to desacralise art and to replace art-historical and aesthetic accounts of art with explanations couched in purely sociological terms. Such radical, some might say hopelessly reductionistic, sociological challenges to art history are well represented by Mulkay and Chaplin's (1982) exploration of the success of the abstract expressionist painter. Systematic content analysis of reviews of early Jackson Pollock exhibitions show, Mulkay and Chaplin argue, that Pollock's success was achieved in the absence of any early critical consensus concerning his artistic achievement or aesthetic merit. What distinguished him from other artists was the sustained support of the influential critic Clement Greenberg in alliance with the wealthy gallery owner Peggy Guggenheim. Greenberg saw in Pollock an artist who could realise the dominance of abstraction in avant-garde art (which Greenberg had predicted some years previously), thus enhancing his own authority as a critic. Guggenheim was looking for a distinctively innovative artist whose successful promotion would establish the importance of the new avant-garde gallery she had recently opened. Pollock's eventual entry into the art-historical canon was thus less a function of autonomous developments within artistic culture itself than of the collective action of a network of wealthy and influential promoters, motivated by their own particularistic institutional projects. The difficulty with such narrowly sociological approaches is that they simply invert the perceived weaknesses of art history: an exclusive focus on the art object is replaced by the virtual elimination of art as object or material representation in its own right.

Other work within a broadly production-based perspective has been much more open to the importance of the properly cultural dimensions of art which have been the focus of art history as a discipline. This has contributed to more sophisticated understanding of the relationship between style and society than such overly oppositional studies as those of Mulkay and Chaplin allow. Vera L. Zolberg (1980) has explored how the material properties of systems of artistic expression may constrain the ways organisations process them, giving rise to the relatively high degree of innovation in visual art sponsored by museums as opposed to the conservatism of symphony

orchestras, for example. Other work has built on ideas from the social history of art –
particularly those of Marxist scholars such as Hauser and Antal – which saw art
styles as reflections of social structure, the expression of the values of the patrons of
works of art or the ideologies of dominant groups. Studies in the production of culture
add a further level of analysis to the social history of art by showing how organisa-
tional contexts within which art is produced – and the working practices associated
with them – mediate between ideological inputs, whether of states or classes, and
artistic outcomes such as iconographic contents or expressive styles (Peterson 1976,
13; Berezin 1991). Rosenblum (1978a,b) shows that the distinctive styles of news-,
advertising- and fine-arts-photographs are 'a function of the structural character-
istics and constraints associated with the typical situations' in which the photographs
are made rather than a function of the messages or group ideologies they might seek
to communicate.

PRODUCTION PERSPECTIVES IN ART HISTORY AND THE SOCIOLOGY OF ART

In certain respects one might see the production of culture perspective in sociology as
an extension of the already considerable tradition of research into patronage systems,
academies and markets carried out within mainstream art history (Pevsner 1940,
Montias 1982, Wackernagel 1938, Haskell 1980). In one of the classic studies of
patronage, for example, Haskell (1980) explores the intersections between changing
market structures and patterns of patronage in shaping artistic programmes in Bar-
oque Italy. Papal and princely dominance of markets restricted the access of religious
orders to leading painters, affecting the degree to which the Jesuits were able to
realise any integrated programmes in the artistic decoration of their churches.

Some of the most exciting recent work in art history has drawn upon sociological
models, or extended early sociological work in the production perspective by giving it a
more cultural turn. Baxandall (1980) suggests that the changing status of sculptors in
early modern Germany – from stonemasons directly employed by the church to lime-
wood sculptors in independent workshops producing self-standing monuments – is
'registered' in the forms of the sculpture. He gives careful consideration to the con-
ditions of trade and to the strategies the sculptors adopted in order to improve their
market position within the constraints of an oligopolistic guild system. Some sought to
create monopolies through 'vertical integration' – controlling all the stages of produc-
tion from acquiring wood to the final painting of an image – or 'horizontal integration'
(dominating sculptural production in an entire region). Others pursued a course of
'product differentiation', creating a distinctive personal style and product which they
could monopolise (102–20). Nicholas Green (1987, 1989) has developed White and
White's (1965) classic sociological study of the nineteenth-century French art market.
He shows how the institutional frameworks analysed by White and White were them-
selves embedded in developing cultural discourses on the nature of the artist's role
and in such emergent cultural practices as art criticism as well as the new promotional
culture of the art market.

Nevertheless, there remain important differences of emphasis and theoretical outlook between art historians' and sociologists' work in this area, and – at least from the viewpoint of sociologists – it might be argued that the new contextual agenda of art history could be pushed even further by taking on board sociological perspectives in a more systematic way. Even the most sociologically oriented art historians often rely on unexplicated concepts of 'aesthetic quality' and 'individual genius' in selecting the art they chose to study and explaining it. Only 'outstanding individuals', Baxandall argues, produce 'very good works of art . . . complex and co-ordinated enough to register in their forms the kind of cultural circumstance sought here' (1980, 10). It is only against the background of routine production, however, that one can possibly gain an analytic grasp on the relationships between social structure, production organisation, work processes and unusual aesthetic outcomes such as radical change or varying levels of semantic richness in works of art.

Against this background, sociological contributions complement and extend the range of art-historical work on patronage and art production in several crucial respects. First, since sociologists often come at art from a primary interest in organisations or social stratification, considerations of aesthetic quality and value do not to the same degree shape the works of art they select for study. Consequently, they investigate a range of art forms and production systems which art historians do not normally study: 'picture painters' mass-producing cheap and unoriginal paintings to be sold at craft fairs (McCall 1977) and hung in the homes of ordinary people or local businesses rather than elite collectors (Halle 1989, Martorella 1990); graffiti ranging from tags to murals, decorating the walls of disused buildings and subway cars, both before and after a brief period of official art world recognition when such work was displayed and sold in leading New York galleries (Lachmann 1988).

Second, since the focus of sociology is on how different types of production system affect aesthetic outcomes – rather than seeing questions of social organisation as merely a background or context designed to enrich interpretative understanding of particular works of art – there is a strong comparative thrust to work in the production of culture perspective. In addition to studying how production systems change over time (Crane 1987), or generic variations in production systems within a single medium (Rosenblum 1978a, 1978b, Greenfeld 1984), sociologists have also compared organisations producing artistic culture with those producing religious and scientific culture (Heirich 1976, Crane 1976, Zolberg 1990, 62ff., 184ff.). Only through such comparisons is it possible to begin to determine in what (if anything) the specificity of art consists: to what extent is it different or similar in the ways it is produced, in its social functioning, or in its processes of change and development to other cultural systems.

Such comparisons both demand and permit the development of relatively abstract conceptual frameworks and typologies – for example of different kinds of reward systems in culture-producing organisations (Crane 1976), or typical patterns according to which the roles of cultural producers are structured within different types of organisations (Becker 1976). This is not merely jargon, but is closely related to the strongly generalising character of sociology, in contrast to art history's more particularistic concern with rich interpretations of particular images. Once mastered, such

frameworks can easily be transposed across different empirical domains, allowing analysts to see structural and functional parallels between, at first sight, quite different areas and to highlight with much greater precision the key differences between production systems which lead to different kinds of artistic product.

Some art historians have argued that the development of the 'new art history' – strongly influenced by structuralist linguistics and post-structuralist cultural analysis – has taken place very much at the expense of social history of art and systematic analysis of art institutions (Wolff 1992, 8; Nochlin 1988). Conversely, the production-of-culture perspective has been criticised for its sociological reductionism (Tuchmann 1983, Peterson 1994, 184). Rather than simply rejecting art history, recent work in the production of culture has pursued a more interdisciplinary strategy. Like the new art history, it draws upon post-structuralist perspectives to open up the issues of culture and agency, without however giving up the generalising analytic power afforded by a perspective rooted in the sociology of organisations. David Brain has developed Foucault's conceptions of discourses and disciplinary institutions in a study of the social production of architecture in New Deal America (1989, 1994 – extract in Chapter 11). Whereas early studies in the production of culture used organisational perspectives to deconstruct the myth of aesthetic autonomy, Fine (1992) has used a comparative study of the work process in different kinds of restaurants, from haute cuisine to fast food, to show that there is a sensory and aesthetic dimension to all work. Different balances between structural and cultural factors – client concern for a 'quality product', the materials available to workers for producing that product, 'aesthetic conventions based on occupational standards', and the capacity of management to rationalise and routinise the production process – give rise to distinctive kinds of cultural agency, and varying levels of aestheticisation of the cultural product. By integrating a concern with style and form into organisational analysis, Fine opens up interesting perspectives for a much stronger interdisciplinary programme in the history and sociology of art. Aesthetic questions, it seems, are as inescapable for sociologists (even hard-headed organisational analysts) as sociological ones are for art historians.

Each of the three selected readings approaches the question of cultural production from a distinctive theoretical perspective: Marxism, symbolic interactionism and practice theory. Raymond Williams (Chapter 5) seeks to open up Marxist analyses of art through an exploration of the concept of 'production' itself. The purely economic conception of productive forces characteristic of Marxism, Williams argues, lies at the root of the base–superstructure model of the relationship between art and society. From such models flow reductionistic conceptions of art as either ideological epiphenomena of the economic base or simple 'reflections' of society. Such conceptions reify both economic systems and art, treating each as discrete self-sufficient objects of radically different orders. The formalism of some traditional art history and the reductionism of much sociology of art, Williams would see as two faces of the historical process of the emergence of capitalism. On the one hand, economic practices were abstracted out of their broader social context as a particular specialised domain. On the other, certain cultural practices such as art and aesthetics which did not immediately lend themselves to capitalistic forms of organisation were marginalised. The

problem, Williams suggests, is that Marx was simply not materialist enough. Ideo-logical epiphenomena such as legal systems, works of art and states are as much materially produced as cars and factories. The concept of 'mediation' points towards a focus on processes of material cultural production as a way of linking the aesthetic concerns of art history with the social-organisational concern of Marxism and sociology.

Howard S. Becker (Chapter 6) works within a distinctive American tradition of sociological theory known as 'symbolic interactionism'. In contrast to Marxists or functionalists, symbolic interactionists lay emphasis on the relative fragility of social structure. In every single interaction, actors recreate social structure anew, according to the definition which they give to the situation in which they interact. Like other social worlds, art worlds are 'negotiated' orders in which the privileged status of 'artist' is not naturally determined by artistic technologies but socially constructed and subject to continual renegotiation. The dividing line between the artist, who is credited as author of a work of art, and the 'support personnel' – canvas makers, paint manufacturers, gallery-owners – without whom no art could be produced, is an arbitrary, socially conventional one. Why, Becker asks, do architects not normally have to build what they design, whereas the artistic status of recent sculptors who do no more than send paper-written specifications to bronze foundries has been called into question?

Where art historians more normally are interested in conventions as cultural meaning systems, Becker explores the significance of artistic conventions for the ways in which art world participants interact with each other in the process of artistic production. Conventions make co-operation possible. Artists who produce con-ventional sizes of painting or sculpture can be sure that they will fit into the con-ventional display spaces in museums, galleries or collectors' homes. Conventional notations for translating different kinds of brush strokes into engraved lines permitted multiple engravers to co-operate in the production of a single plate, and consumers to compare original paintings on the basis of standardised reproductions.

Ways of working, patterns of training, forms of equipment, divisions of labour all crystallise around conventions. The material and social interests bound up with such conventional ways of doing things constitute a powerful source of resistance to any straightforward adjustment of art styles to fit social needs or reflect cultural changes. Much of the heat in recent aesthetic debates is generated through the embedding of conventions in social relationships and the material interests that flow from them. Earthworks were initially rejected by dominant interests within the art world in part because, according to Becker, earthworks – as immovable objects – threatened con-ventional ways of appropriating art and attributing value to it, namely through display in museums, galleries or private collections. This undermined the role of dealers, museum curators and collectors in the attribution of aesthetic value within the avant-garde art world. Only when ways of reinserting these objects in established networks of evaluation and appropriation had been devised – through the display and sale of autographed photographs or plans of the earthworks for example – could they be accepted as fully legitimate works of art.

In Bourdieu's sociology of artistic production (Chapter 7), more structural

concepts – 'fields', 'positions' and the '*habitus*' of agents or actors – replace interactionist conceptions of networks of interacting individuals. The *habitus* consists in an actor's enduring disposition to perceive the social and cultural world and generate social and cultural practices according to schemata acquired during long processes of socialisation and enculturation in family and school, processes profoundly shaped by the actors' position within class structure. The concept of 'field' is used by Bourdieu to articulate the relative autonomy of a sphere of cultural production, like that of art, from the broader political, economic and social structures within which it is situated. Fields consist in sets of 'positions' which bring with them both various levels of the 'capital' proper to a particular field and a corresponding set of social and cultural interests specific to that position within a field. For example the position of the academician in the field of painting in nineteenth-century France afforded a certain prestige, or 'symbolic capital', which could be transformed into commissions and pupils in an expanding workshop, and a certain vested interest in the academic organisation of the world of painting, academic classifications of the hierarchy of genres, and particular ways of classifying and evaluating one's own and others' artistic performances. The production of art, the 'creative project', takes place through the intersection of *habitus* with position in the context of a field. Producing a painting involves taking up a cultural position within the possible space of cultural position-takings objectively given within a field. The cultural position or stance taken depends partly on the interests inscribed in the agent's social position in the field, partly on the basis of the agent's *habitus*. Of course the range of cultural positions which can be taken or responded to by an artist depends on the history of the field, the development of particular styles, manners, representational schemata and so on. Taking up a position defines the artist in relation to other artists and their positions both artistic and social within a field, and of course it modifies the relationships between those social and aesthetic positions.

Whilst this analytic apparatus might seem complex and abstract it has a number of advantages over both traditional art history and many other sociological accounts of the production of culture. First, the concepts of positions and position-takings overcome the conventional opposition between internalist art-historical readings of art and externalist sociological accounts. Second, by using concepts – field, position, *habitus* – which can equally be applied to other social domains, Bourdieu is able to make a particularly neat job of placing the field of artistic production within the wider social formation. In particular, he can articulate the structural logic or the homologies through which the differential positions of consumers within the field of power – for example, intellectuals high in cultural capital but with little economic capital, as opposed to financiers with the inverse distribution of capital – map onto consumption of the cultural products of similarly positioned (dominated versus dominant) agents within particular fields of cultural production, such as painting. Yet because the effects of such patterns of public support or patronage (whether direct or mediated through the market), or changes in those patterns, are always refracted through the specific logic of the field of cultural production, the danger of the short-circuited analysis where art works are seen as the direct expression of the interests of the social groups who sponsor them is avoided.

Although on one level Bourdieu is fiercely critical of art history, on another he is both respectful of it and indebted to it. His account of positions and position-takings aims to be scrupulously attentive to the specific autonomy of aesthetic practices rooted in the historicity of the field of production. Moreover not only his sociology of art but his whole sociological theory owes a great deal to sustained engagement with the work of art historians, most notably Panofsky, from whom Bourdieu's key concept, *habitus,* was appropriated (cf. Bourdieu 1967). He argues that one can understand the individual artist or a particular work of art in its individuality only through a totalising analysis of the structure of the artistic field and its historical trajectory embodied in the inherited repertoire of artistic practices. Consequently, approaches to art through the individual artist or groups of patrons are ruled out: 'the subject of a work of art is not the artist or a social group but the field of artistic production in its entirety'.

Raymond Williams

MARXISM AND THE SOCIAL PRODUCTION OF ART

(a) PRODUCTIVE FORCES

From *Marxism and Literature*. Oxford, Oxford University Press, 1977, pp. 90–4.

UNDERLYING ANY ARGUMENT ABOUT 'base' and 'superstructure', or about the nature of 'determination', is a decisive concept: that of 'productive forces'. It is a very important concept in Marx, and in all subsequent Marxism. But it is also a variable concept, and the variations have been exceptionally important for Marxist cultural theory.

The central difficulty is that all the key words – *produce*, *product*, *production*, *productive* – went through a specialized development in the course of the development of capitalism. Thus to analyse capitalism was at once to see it as a distinct process of 'production' and to refer it to a general process, of which it is a particular historical kind. The difficulty is that the general process is still most readily defined in the specific and limiting terms of capitalist production. Marx was perfectly clear about the distinction between 'production in general' and 'capitalist production'. Indeed it was the claim of the latter, through its political economy, to the universality of its own specific and historical conditions, that he especially attacked. But the history had happened, in the language as in so much else. What is then profoundly difficult is that Marx analysed 'capitalist production' in and through its own terms, and at the same time, whether looking to the past or the future, was in effect compelled to use many of the same terms for more general or historically different processes. As he himself wrote:

> 'Production in general' is an abstraction, but it is a rational abstraction, in so far as it singles out and fixes the common features, thereby saving us repetition. Yet these general or common features discovered by comparison constitute something very complex, whose constituent elements have different destinations . . . All the stages of production have certain

destinations in common, which we generalize in thought: but the so-called general conditions of all production are nothing but abstract conceptions which do not go to make up any real stage in the history of production.

(*Grundrisse*, 85)

It must be added that the concept of 'material production' is similarly abstract, but also similarly rational for particular purposes. As an abstraction (for example, in bourgeois political economy) it can be separated from other categories such as consumption, distribution, and exchange; and all these can be separated both from the social relations, the form of society, within which they are specifically and variably interrelating activities, and further, from the personal activities which are their only concrete modes of existence. But in capitalist society 'material production' is a specific form, determined and understood in the forms of capital, wage-labour, and the production of commodities. That this 'material production' has itself been produced, by the social development of particular forms of production, is then the first thing to realize if we are trying to understand the nature of even this production, in which, because of actual historical developments,

material life generally appears as the aim while the production of this material life, labour (which is now the only possible but . . . negative form of personal activity) appears as the means.

(*German Ideology*, 66)

Moreover, in capitalist society

The productive forces appear to be completely independent and severed from the individuals and to constitute a self-subsistent world alongside the individuals.

(*German Ideology*, 65)

What then is a 'productive force'? It is all and any of the means of the production and reproduction of real life. It may be seen as a particular kind of agricultural or industrial production, but any such kind is already a certain mode of social co-operation and the application and development of a certain body of social knowledge. The production of this specific social co-operation or of this specific social knowledge is itself carried through by productive forces. In all our activities in the world we produce not only the satisfaction of our needs but new needs and new definitions of needs. Fundamentally, in this human historical process, we produce ourselves and our societies, and it is within these developing and variable forms that 'material production', then itself variable, both in mode and scope, is itself carried on.

But if this is really Marx's basic position, how did it happen that a more limited definition of 'productive forces', and with it a separation and abstraction of 'material production' and the 'material' or 'economic' 'base', came not only to predominate in Marxism but to be taken, by almost everyone else, as defining it. One reason is

the course of a particular argument. It was not Marxism, but the systems with which it contended and continues to contend, which had separated and abstracted various parts of this whole social process. It was the assertion and explanation of political forms and philosophical and general ideas as independent of, 'above', the material social process, that produced a necessary kind of counter-assertion. In the flow of polemic this was often overstated, until it came to repeat, in a simple reversal of terms, the kind of error it attacked.

But there are deeper reasons than this. If you live in a capitalist society, it is capitalist forms that you must analyse. Marx lived, and we live, in a society in which indeed 'the productive forces appear to . . . constitute a self-subsistent world'. Thus in analysing the operation of productive forces which are not only perceived as, but in central ways really are, of this kind, it is easy, within the only available language, to slip into describing them as if they were universal and general, and as if certain 'laws' of their relations to other activities were fundamental truths. Marxism thus often took the colouring of a specifically bourgeois and capitalist kind of material-ism. It could isolate 'productive forces' as 'industry' (even at times as 'heavy industry'), and here again the evidence of language is significant. It was in the 'Industrial Revolution' that 'industry' changed from being a word which described the human activity of assiduous effort and application to a word which predomin-antly describes productive institutions: a 'self-subsistent world'. Of course these were capitalist institutions, and 'production' itself was eventually subordinated to the capitalist element, as now in descriptions of the 'entertainment industry' or the 'holiday industry'. The practical subordination of all human activities (with a saving clause for certain activities which were called 'personal' or 'aesthetic') to the modes and norms of capitalist institutions became more and more effective. Marxists, insisting on this and protesting against it, were caught in a practical ambivalence. The insistence, in effect, diluted the protest. It is then often said that the insistence was 'too materialist', a 'vulgar materialism'. But the truth is that it was never materialist enough.

What any notion of a 'self-subsistent order' suppresses is the material char-acter of the productive forces which produce such a version of production. Indeed it is often a way of suppressing full consciousness of the very nature of such a society. If 'production', in capitalist society, is the production of commodities for a market, then different but misleading terms are found for every other kind of production and productive force. What is most often suppressed is the direct material production of 'politics'. Yet any ruling class devotes a significant part of material production to establishing a political order. The social and political order which maintains a capitalist market, like the social and political struggles which created it, is necessarily a material production. From castles and palaces and churches to prisons and workhouses and schools; from weapons of war to a controlled press: any ruling class, in variable ways though always materially, pro-duces a social and political order. These are never superstructural activities. They are the necessary material production within which an apparently self-subsistent mode of production can alone be carried on. The complexity of this process is especially remarkable in advanced capitalist societies, where it is wholly beside the point to isolate 'production' and 'industry' from the comparably material produc-tion of 'defence', 'law and order', 'welfare', 'entertainment', and 'public opinion'.

In failing to grasp the material character of the production of a social and political order, this specialized (and bourgeois) materialism failed also, but even more conspicuously, to understand the material character of the production of a cultural order. The concept of the 'superstructure' was then not a reduction but an evasion.

Yet the difficulty is that if we reject the idea of a 'self-subsistent world' of productive (industrial) forces, and describe productive forces as all and any activities in the social process as a whole, we have made a necessary critique but, at least in the first instance, lost edge and specificity. To go beyond this difficulty will be a matter for later argument; we have first to specify the negative effects, in cultural analysis, of the specialized version of 'productive forces' and 'production'. We can best specify them in Marx himself, rather than in the many later examples. There is a footnote in the *Grundrisse* in which it is argued that a piano-maker is a productive worker, engaged in productive labour, but that a pianist is not, since his labour is not labour which reproduces capital. The extraordinary inadequacy of this distinction to advanced capitalism, in which the production of music (and not just its instruments) is an important branch of capitalist production, may be only an occasion for updating. But the real error is more fundamental.

In his sustained and brilliant analysis of capitalist society, Marx was working both with and beyond the categories of bourgeois political economy. His distinction of 'productive labour' was in fact developed, in this note, from Adam Smith. It still makes sense (or can be revised to make sense) in those bourgeois terms. Production is then work on raw materials to make commodities, which enter the capitalist system of distribution and exchange. Thus a piano is a commodity; music is (or was) not. At this level, in an analysis of capitalism, there is no great difficulty until we see that a necessary result is the projection (alienation) of a whole body of activities which have to be isolated as 'the realm of art and ideas', as 'aesthetics', as 'ideology', or, less flatteringly, as 'the superstructure'. None of these can then be grasped as they are; as real practices, elements of a whole material social process; not a realm or a world or a superstructure, but many and variable productive practices, with specific conditions and intentions. To fail to see this is not only to lose contact with the actuality of these practices, as has repeatedly occurred in forms of analysis derived from the terms of this specialized (industrial) materialism. It is to begin the whole difficult process of discovering and describing relations between all these practices, and between them and the other practices which have been isolated as 'production', as 'the base', or as the 'self-subsistent world', in an extremely awkward and disabling position. It is indeed to begin this most difficult kind of work head down and standing on one foot. Such feats of agility are not impossible, and have indeed been performed. But it would be more reasonable to get back on both feet again, and to look at our actual productive activities without assuming in advance that only some of them are material.

(b) FROM REFLECTION TO MEDIATION

From *Marxism and Literature*. Oxford, Oxford University Press, 1977, pp. 95–100

THE USUAL CONSEQUENCE OF the base–superstructure formula, with its specialized and limited interpretations of productive forces and of the process of determination, is a description – even at times a theory – of art and thought as 'reflection'. The metaphor of 'reflection' has a long history in the analysis of art and ideas. Yet the physical process and relationship that it implies have proved compatible with several radically different theories. Thus art can be said to 'reflect the real world', holding 'the mirror up to nature', but every term of such a definition has been in protracted and necessary dispute. Art can be seen as reflecting not 'mere appearances' but the 'reality' behind these: the 'inner nature' of the world, or its 'constitutive forms'. Or art is seen as reflecting not the 'lifeless world', but the world as seen in the mind of the artist. The elaboration and sophistication of arguments of these kinds are remarkable.

Materialism appears to constitute a fundamental challenge to them. If the real world is material, it can indeed be seen in its constitutive forms, but these will not be metaphysical, and reflection will be necessarily of a material reality. This can lead to the concept of 'false' or 'distorted' reflection, in which something (metaphysics, 'ideology') prevents true reflection. Similarly, the 'mind of the artist' can be seen as itself materially conditioned; its reflection is then not independent but itself a material function.

Two versions of this materialism became dominant in Marxist thinking. First, there was the interpretation of consciousness as mere 'reflexes, echoes, phantoms, and sublimates'; this was discussed in relation to one of the concepts of ideology. But as a necessary complement to this reductive account, an alternative interpretation of consciousness as 'scientific truth', based on real knowledge of the material world, was strongly emphasized. This alternative could be extended relatively easily to include accounts of 'knowledge' and 'thought', but for obvious reasons it left 'art' relatively neglected and exposed. Within this version the most common account of art was then a positivist theory, in which the metaphor of 'reflection' played a central role. The true function of art was defined in terms of 'realism' or less often 'naturalism' – both nineteenth-century terms themselves much affected by related concepts of science. Art reflected reality; if it did not it was false or unimportant. And what was reality? The 'production and reproduction of real life', now commonly described as 'the base', with art part of its 'superstructure'. The ambiguity is then obvious. A doctrine about the real world expressed in the materialism of objects leads to one kind of theory of art: showing the objects (including human actions as objects) 'as they really are'. But this can be maintained, in its simplest form, only by knowing 'the base' as an object: the development already discussed. To know the 'base' as a process at once complicates the object-reflection model which had appeared so powerful.

This complication was fought out in rival definitions of 'realism' and

'naturalism'. Each term had begun as a secular and radical emphasis on human social knowledge. Naturalism was an alternative to supernaturalism; realism to a deliberately falsifying ('romanticizing', 'mythmaking', 'prettifying') art. Yet the enclosure of each concept within a special doctrine of 'the object as it really is' reduced their radical challenge. The making of art was incorporated into a static, objectivist doctrine, within which 'reality', 'the real world', 'the base', could be *separately* known, by the criteria of scientific truth, and their 'reflections' in art then judged by their conformity or lack of conformity with them: in fact with their positivist versions.

It was at this point that a different materialist theory became necessary. For it was only in very simple cases that the object–reflection model could be actually illustrated or verified. Moreover, there was already a crucial distinction between 'mechanical materialism' – seeing the world as objects and excluding activity – and 'historical materialism' – seeing the material life process as human activity. The simplest theories of 'reflection' were based on a mechanical materialism. But a different account appeared possible if 'the real world', instead of being isolated as an object, was grasped as a material social *process*, with certain inherent qualities and tendencies. As earlier in idealism, but now with altered specification, art could be seen as reflecting not separated objects and superficial events but the essential forces and movements underlying them. This was in turn made the basis for distinction between 'realism' (dynamic) and 'naturalism' (static).

Yet it is quickly evident that this is radically incompatible with any doctrine of 'reflection', except in one special and influential adaptation. The movement from abstract objectivism to this sense of objectified process was decisive. But the sense of objectified process can be almost at once rendered back to its original abstract and objectivist condition, by a definition of the already known (scientifically discovered and attested) 'laws' of this process. Art can then be defined as 'reflecting' these laws. What is already *and otherwise* known as the basic reality of the material social process is reflected, of course in its own ways, by art. If it is not (and the test is available, by comparison of this given knowledge of reality with any actual art produced), then it is a case of distortion, falsification, or superficiality: not art but ideology. Rash extensions were then possible to new categorical distinctions: not progressive art but reactionary art; not socialist art but bourgeois or capitalist art; not art but mass culture; and so on almost indefinitely. The decisive theory of art as reflection, not now of objects but of real and verifiable social and historical processes, was thus extensively maintained and elaborated. The theory became at once a cultural programme and a critical school.

It has of course been heavily attacked from older and often more substantial positions. It has been widely identified as a damaging consequence of a materialist outlook. But once again, what is wrong with the theory is that it is not materialist enough. The most damaging consequence of any theory of art as reflection is that, through its persuasive physical metaphor (in which a reflection simply occurs, within the physical properties of light, when an object or movement is brought into relation with a reflective surface – the mirror and then the mind), it succeeds in suppressing the actual work on material – in a final sense, the material social process – which is the making of any artwork. By projecting and alienating this material process to '*reflection*', the social and material character of artistic activity – of that artwork

which is at once 'material' and 'imaginative' – was suppressed. It was at this point that the idea of reflection was challenged by the idea of 'mediation'.

'Mediation' was intended to describe an active process. Its predominant general sense had been an act of intercession, reconciliation, or interpretation between adversaries or strangers. In idealist philosophy it had been a concept of reconciliation between opposites, within a totality. A more neutral sense had also developed, for interaction between separate forces. The distinction between 'mediate' and 'immediate' had been developed to emphasize 'mediation' as an indirect connection or agency between separate kinds of act.

It is then easy to see the attraction of 'mediation' as a term to describe the process of relationship between 'society' and 'art', or between 'the base' and 'the superstructure'. We should not expect to find (or always to find) directly 'reflected' social realities in art, since these (often or always) pass through a process of 'mediation' in which their original content is changed. This general proposition, however, can be understood in several different ways. The change involved in mediation can be simply a matter of indirect expression: the social realities are 'projected' or 'disguised', and to recover them is a process of working back through the mediation to their original forms. Relying mainly on the concept of 'ideology' as (class-based) distortion, this kind of reductive analysis, and of 'stripping', 'laying bare' or 'unmasking', has been common in Marxist work. If we remove the elements of mediation, an area of reality, and then also of the ideological elements which distorted its perception or which determined its presentation, will become clear. (In our own time this sense of mediation has been especially applied to 'the media', which are assumed to distort and present 'reality' in ideological ways.)

Yet this negative sense of 'mediation', which has been heavily supported by psychoanalytical concepts such as 'repression' and 'sublimation', and by 'rationalization' in a sense close to the negative sense of 'ideology', has coexisted with a sense which offers to be positive. This is especially the contribution of the Frankfurt School. Here the change involved in 'mediation' is not necessarily seen as distortion or disguise. Rather, all active relations between different kinds of being and consciousness are inevitably mediated, and this process is not a separable agency – a 'medium' – but intrinsic to the properties of the related kinds. 'Mediation is in the object itself, not something between the object and that to which it is brought' (T.W. Adorno, 'Thesen zur Kunstsoziologie', *Kölner Zeitschrift für Soziologie und Sozialpsychologie*, XIX, 1 (March 1967)). Thus mediation is a positive process in social reality, rather than a process added to it by way of projection, disguise, or interpretation.

It is difficult to be sure how much is gained by substituting the metaphor of 'mediation' for the metaphor of 'reflection'. On the one hand it goes beyond the passivity of reflection theory; it indicates an active process, of some kind. On the other hand, in almost all cases, it perpetuates a basic dualism. Art does not reflect social reality, the superstructure does not reflect the base, *directly*; culture is a mediation of society. But it is virtually impossible to sustain the metaphor of 'mediation' (*Vermittlung*) without some sense of separate and pre-existent areas or orders of reality, between which the mediating process occurs whether independently or as determined by their prior natures. Within the inheritance of idealist philosophy the process is usually, in practice, seen as a mediation between categories, which have

been assumed to be distinct. Mediation, in this range of use, then seems little more than a sophistication of reflection.

Yet the underlying problem is obvious. If 'reality' and 'speaking about reality' (the 'material social process' and 'language') are taken as categorically distinct, concepts such as 'reflection' and 'mediation' are inevitable. The same pressure can be observed in attempts to interpret the Marxist phrase 'the production and repro-duction of real life' as if production were the primary social (economic) process and 'reproduction' its 'symbolic' or 'signifying' or 'cultural' counterpart. Such attempts are either alternatives to the Marxist emphasis on an inherent and constitutive 'practical consciousness', or, at their best, ways of specifying its actual operations. The problem is different, from the beginning, if we see language and signification as indissoluble elements of the material social process itself, involved all the time both in production and reproduction. The forms of actual displacement and alienation experienced in class societies have led to recurrent concepts of isolated relations between 'separate' orders: 'reflection' from idealist thought through naturalism to a positivist kind of Marxism; 'mediation' from religious thought through idealist philosophy to Hegelian variants of Marxism. To the extent that it indicates an active and substantial process, 'mediation' is always the less alienated concept. In its modern development it approaches the sense of inherent constitutive consciousness, and is in any case important as an alternative to simple reductionism, in which every real act or work is methodically rendered back to an assumed primary category, usually specified (self-specified) as 'concrete reality'. But when the process of medi-ation is seen as positive and substantial, as a necessary process of the making of meanings and values, in the necessary form of the general social process of significa-tion and communication, it is really only a hindrance to describe it as 'mediation' at all. For the metaphor takes us back to the very concept of the 'intermediary' which, at its best, this constitutive and constituting sense rejects.

Howard S. Becker

ART AS COLLECTIVE ACTION

From *American Sociological Review* 39 (1974), 767–76.

A DISTINGUISHED SOCIOLOGICAL TRADITION holds that art is social in character, this being a specific instance of the more general proposition that knowledge and cultural products are social in character or have a social base. A variety of language has been used to describe the relations between art works and their social context. Studies have ranged from those that attempted to correlate various artistic styles and the cultural emphases of the societies they were found in to those that investigated the circumstances surrounding the production of particular works. Both social scientists and humanistic scholars have contributed to this literature. (A representative sample of work can be found in Albrecht, Barnett and Griff, 1970.)

Much sociological writing speaks of organizations or systems without reference to the people whose collective actions constitute the organization or system. Much of the literature on art as a social product does the same, demonstrating correlations or congruences without reference to the collective activities by which they came about, or speaking of social structures without reference to the actions of people doing things together which create those structures. My admittedly scattered reading of materials on the arts, the available sociological literature, (especially Blumer, 1966, and Strauss *et al.*, 1964), and personal experience and participation in several art worlds have led me to a conception of art as a form of collective action.

[. . .]

Cooperation and cooperative links

Think, with respect to any work of art, of all the activities that must be carried on for that work to appear as it finally does. For a symphony orchestra to give a concert,

for instance, instruments must have been invented, manufactured and maintained, a notation must have been devised and music composed using that notation, people must have learned to play the notated notes on the instruments, times and places for rehearsal must have been provided, ads for the concert must have been placed, publicity arranged and tickets sold, and an audience capable of listening to and in some way understanding and responding to the performance must have been recruited. A similar list can be compiled for any of the performing arts. With minor variations (substitute materials for instruments and exhibition for performance), the list applies to the visual and (substituting language and print for materials and publication for exhibition) literary arts. Generally speaking, the necessary activities typically include conceiving the idea for the work, making the necessary physical artifacts, creating a conventional language of expression, training artistic personnel and audiences to use the conventional language to create and experience, and providing the necessary mixture of those ingredients for a particular work or performance.

Imagine, as an extreme case, one person who did all these things: made everything, invented everything, performed, created and experienced the result, all without the assistance or cooperation of anyone else. In fact, we can barely imagine such a thing, for all the arts we know about involve elaborate networks of cooperation. A division of the labor required takes place. Typically, many people participate in the work without which the performance or artifact could not be produced. A sociological analysis of any art therefore looks for that division of labor. How are the various tasks divided among the people who do them?

Nothing in the technology of any art makes one division of tasks more 'natural' than another. Consider the relations between the composition and performance of music. In conventional symphonic and chamber music, the two activities occur separately; although many composers perform, and many performers compose, we recognize no necessary connection between the two and see them as two separate roles which may occasionally coincide in one person. In jazz, composition is not important, the standard tune merely furnishing a framework on which the performer builds the improvisation listeners consider important. In contemporary rock music, the performer ideally composes his own music; rock groups who play other people's music (Bennett, 1972) carry the derogatory title of 'copy bands'. Similarly, some art photographers always make their own prints; others seldom do. Poets writing in the western tradition do not think it necessary to incorporate their handwriting into the work, leaving it to printers to put the material in readable form, but Oriental calligraphers count the actual writing an integral part of the poetry. In no case does the character of the art impose a natural division of labor; the division always results from a consensual definition of the situation. Once that has been achieved, of course, participants in the world of art regard it as natural and resist attempts to change it as unnatural, unwise or immoral.

Participants in an art world regard some of the activities necessary to the production of that form of art as 'artistic', requiring the special gift or sensibility of an artist. The remaining activities seem to them a matter of craft, business acumen or some other ability less rare, less characteristic of art, less necessary to the success of the work, and less worthy of respect. They define the people who perform these

special activities as artists and everyone else as (to borrow a military term) support personnel. Art worlds differ in how they allocate the honorific title of artist and in the mechanisms by which they choose who gets it and who doesn't. At one extreme, a guild or academy (Pevsner, 1940) may require long apprenticeship and prevent those it does not license from practicing. At the other, the choice may be left to the lay public that consumes the work, whoever they accept being ipso facto an artist. An activity's status as art or non-art may change, in either direction. Kealy (1974) notes that the recording engineer has, when new technical possibilities arose that artists could use expressively, been regarded as something of an artist. When the effects he can produce become commonplace, capable of being produced on demand by any competent worker, he loses that status.

How little of the activity necessary for the art can a person do and still claim the title of artist? The amount the composer contributes to the material contained in the final work has varied greatly. Virtuoso performers from the Renaissance through the nineteenth century embellished and improvised on the score the composer provided (Dart, 1967, and Reese, 1959), so it is not unprecedented for contemporary composers to prepare scores which give only the sketchiest directions to the performer (though the counter-tendency, for composers to restrict the interpretative freedom of the performer by giving increasingly detailed directions, has until recently been more prominent). John Cage and Karlheinz Stockhausen (Wörner, 1973) are regarded as composers in the world of contemporary music, though many of their scores leave much of the material to be played to the decision of the player. Artists need not handle the materials from which the artwork is made to remain artists; architects seldom build what they design. The same practice raises questions, however, when sculptors construct a piece by sending a set of specifications to a machine shop; and many people balk at awarding the title of artist to authors of conceptual works consisting of specifications which are never actually embodied in an artifact. Marcel Duchamp outraged many people by insisting that he created a valid work of art when he signed a commercially produced snowshovel or signed a reproduction of the Mona Lisa on which he had drawn a mustache, thus classifying Leonardo as support personnel along with the snowshovel's designer and manufacturer. Outrageous as that idea may seem, something like it is standard in making collages, in which the entire work may be constructed of things made by other people. The point of these examples is that what is taken, in any world of art, to be the quintessential artistic act, the act whose performance marks one as an artist, is a matter of consensual definition.

Whatever the artist, so defined, does not do himself must be done by someone else. The artist thus works in the center of a large network of cooperating people, all of whose work is essential to the final outcome. Wherever he depends on others, a cooperative link exists. The people with whom he cooperates may share in every particular his idea of how their work is to be done. This consensus is likely when everyone involved can perform any of the necessary activities, so that while a division of labor exists, no specialized functional groups develop. This situation might occur in simple communally shared art forms like the square dance or in segments of a society whose ordinary members are trained in artistic activities. A well-bred nineteenth century American, for instance, knew enough music to take part in performing the parlor songs of Stephen Foster just as his Renaissance

counterpart could participate in performing madrigal. In such cases, cooperation occurs simply and readily.

When specialized professional groups take over the performance of the activities necessary to an art work's production, however, their members tend to develop specialized aesthetic, financial and career interests which differ substantially from the artist's. Orchestral musicians, for instance, are notoriously more concerned with how they sound in performance than with the success of a particular work; with good reason, for their own success depends in part on impressing those who hire them with their competence (Faulkner, 1973a, 1973b). They may sabotage a new work which can make them sound bad because of its difficulty, their career interests lying at cross-purposes to the composer's.

Aesthetic conflicts between support personnel and the artist also occur. A sculptor friend of mine was invited to use the services of a group of master lithographic printers. Knowing little of the technique of lithography, he was glad to have these master craftsmen do the actual printing, this division of labor being customary and having generated a highly specialized craft of printing. He drew designs containing large areas of solid colors, thinking to simplify the printer's job. Instead, he made it more difficult. When the printer rolls ink on to the stone, a large area will require more than one rolling to be fully inked and may thus exhibit roller marks. The printers, who prided themselves on being the greatest in the world, explained to my friend that while they could print his designs, the areas of solid color could cause difficulty with roller marks. He had not known about roller marks and talked of using them as part of his design. The printers said, no, he could not do that, because roller marks were an obvious sign (to other printers) of poor craftsmanship and no print exhibiting roller marks was allowed to leave their shop. His artistic curiosity fell victim to the printers' craft standards, a neat example of how specialized support groups develop their own standards and interests.

My friend was at the mercy of the printers because he did not know how to print lithographs himself. His experience exemplified the choice that faces the artist at every cooperative link. He can do things the way established groups of support personnel are prepared to do them; he can try to make them do it his way; he can train others to do it his way; or he can do it himself. Any choice but the first requires an additional investment of time and energy to do what could be done less expensively if done the standard way. The artist's involvement with and dependence on cooperative links thus constrains the kind of art he can produce.

[. . .]

Artists often create works which existing facilities for production or exhibition cannot accommodate. Sculptors build constructions too large and heavy for existing museums. Composers write music which requires more performers than existing organizations can furnish. Playwrights write plays too long for their audience's taste. When they go beyond the capacities of existing institutions, their works are not exhibited or performed: that reminds us that most artists make sculptures which are not too big or heavy, compose music which uses a comfortable number of players, or write plays which run a reasonable length of time. By accommodating their conceptions to available resources, conventional artists accept the constraints arising from their dependence on the cooperation of members of the existing art world.

Wherever the artist depends on others for some necessary component he must either accept the constraints they impose or expend the time and energy necessary to provide it some other way.

To say that the artist must have the cooperation of others *for the artwork to occur as it finally does* does not mean that he cannot work without that cooperation. The artwork, after all, need not occur as it does, but can take many other forms, including those which allow it to be done without others' help. Thus, though poets do depend on printers and publishers (as cummings' example indicates), one can produce poetry without them. Russian poets whose work circulates in privately copied typescripts do that, as did Emily Dickinson (Johnson, 1955). In both cases, the poetry does not circulate in conventional print because the artist would not accept the censorship or rewriting imposed by those who would publish the work. The poet either has to reproduce and circulate his work himself or not have it circulated. But he can still write poetry. My argument thus differs from a functionalism that asserts that the artist must have cooperation, ignoring the possibility that the cooperation can be foregone, though at a price.

The examples given so far emphasize matters more or less external to the art work–exhibition space, printing or musical notation. Relations of cooperation and constraint, however, penetrate the entire process of artistic creation and composition, as will become clear in looking at the nature and function of artistic conventions.

Conventions

Producing art works requires elaborate modes of cooperation among specialized personnel. How do these people arrive at the terms on which they will cooperate? They could, of course, decide everything fresh on each occasion. A group of musicians could discuss and agree on such matters as which sounds would be used as tonal resources, what instruments might be constructed to make those sounds, how those sounds would be combined to create a musical language, how the language would be used to create works of a particular length requiring a given number of instruments and playable for audiences of a certain size recruited in a certain way. Something like that sometimes happens in, for instance, the creation of a new theatrical group, although in most cases only a small number of the questions to be decided are actually considered anew.

People who cooperate to produce a work of art usually do not decide things afresh. Instead, they rely on earlier agreements now become customary, agreements that have become part of the conventional way of doing things in that art. Artistic conventions cover all the decisions that must be made with respect to works produced in a given art world, even though a particular convention may be revised for a given work. Thus, conventions dictate the materials to be used, as when musicians agree to base their music on the notes contained in a set of modes, or on the diatonic, pentatonic or chromatic scales with their associated harmonies. Conventions dictate the abstractions to be used to convey particular ideas or experiences, as when painters use the laws of perspective to convey the illusion of three dimensions or photographers use black, white and shades of gray to convey the interplay of light and color. Conventions dictate the form in which materials and abstractions will be

combined, as in the musical use of the sonata form or the poetic use of the sonnet. Conventions suggest the appropriate dimensions of a work, the proper length for a musical or dramatic event, the proper size and shape of a painting or sculpture. Conventions regulate the relations between artists and audience, specifying the rights and obligations of both.

Humanistic scholars – art historians, musicologists and literary critics – have found the concept of the artistic convention useful in accounting for artists' ability to produce art works which produce an emotional response in audiences. By using such a conventional organization of tones as a scale, the composer can create and manipulate the listener's expectations as to what sounds will follow. He can then delay and frustrate the satisfaction of those expectations, generating tension and release as the expectation is ultimately satisfied (Meyer, 1956, 1973; Cooper and Meyer, 1960). Only because artist and audience share knowledge of and experience with the conventions invoked does the artwork produce an emotional effect. Smith (1968) has shown how poets manipulate conventional means embodied in poetic forms and diction to bring poems to a clear and satisfying conclusion, in which the expectations produced early in the lyric are simultaneously and satisfactorily resolved. Gombrich (1960) has analyzed the visual conventions artists use to create the illusion for viewers that they are seeing a realistic depiction of some aspect of the world. In all these cases (and in others like stage design, dance, and film), the possibility of artistic experience arises from the existence of a body of conventions that artists and audiences can refer to in making sense of the work.

Conventions make art possible in another sense. Because decisions can be made quickly, because plans can be made simply by referring to a conventional way of doing things, artists can devote more time to actually doing their work. Conventions thus make possible the easy and efficient coordination of activity among artists and support personnel. Ivins (1953), for instance, shows how, by using a conventional-ized scheme for rendering shadows, modeling and other effects, several graphic artists could collaborate in producing a single plate. The same conventions made it possible for viewers to read what were essentially arbitrary marks as shadows and modeling. Seen this way, the concept of convention provides a point of contact between humanists and sociologists, being interchangeable with such familiar socio-logical ideas as norm, rule, shared understanding, custom or folkway, all referring in one way or another to the ideas and understandings people hold in common and through which they effect cooperative activity. [. . .]

Though standardized, conventions are seldom rigid and unchanging. They do not specify an inviolate set of rules everyone must refer to in settling questions of what to do. Even where the directions seem quite specific, they leave much unset-tled which gets resolved by reference to customary modes of interpretation on the one hand and by negotiation on the other. A tradition of performance practice, often codified in book form, tells performers how to interpret the musical scores or dramatic scripts they perform. Seventeenth century scores, for instance, contained relatively little information; but contemporary books explained how to deal with questions of instrumentation, note values, extemporization and the realization of embellishments and ornaments. Performers read their music in the light of all these customary styles of interpretation and thus were able to coordinate their activities (Dart, 1967). The same thing occurs in the visual arts. Much of the content,

symbolism and coloring of Italian Renaissance religious painting was conventionally given; but a multitude of decisions remained for the artist, so that even within those strict conventions different works could be produced. Adhering to the conventional materials, however, allowed viewers to read much emotion and meaning into the picture. Even where customary interpretations of conventions exist, having become conventions themselves, artists can agree to do things differently, negotiation making change possible.

Conventions place strong constraints on the artist. They are particularly constraining because they do not exist in isolation, but come in complexly interdependent systems, so that making one small change often requires making changes in a variety of other activities. A system of conventions gets embodied in equipment, materials, training, available facilities and sites, systems of notation and the like, all of which must be changed if any one segment is.

[. . .]

Similarly, conventions specifying what a good photograph should look like are embodied not only in an aesthetic more or less accepted in the world of art photography (Rosenblum, 1973), but also in the acceptance of the constraints built into the neatly interwoven complex of standardized equipment and materials made by major manufacturers. Available lenses, camera bodies, shutter speeds, apertures, films, and printing paper all constitute a tiny fraction of the things that could be made, a selection that can be used together to produce acceptable prints; with ingenuity they can also be used to produce effects their purveyors did not have in mind. But some kinds of prints, once common, can now only be produced with great difficulty because the materials are no longer available. Specifically, the photosensitive material in conventional papers is a silver salt, which produces a characteristic look. Photographers once printed on paper sensitized with platinum salts, until it went off the market in 1937 (Newhall, 1964, p. 117). You can still make platinum prints, which have a distinctively softer look, but only by making your own paper. Not surprisingly, most photographers accept the constraint and learn to maximize the effects that can be obtained from available silver-based materials. They likewise prize the standardization and dependability of mass-produced materials; a roll of Kodak Tri-X film purchased anywhere in the world has approximately the same characteristics and will produce the same results as any other roll, that being the opportunity that is the obverse of the constraint.

The limitations of conventional practice, clearly, are not total. One can always do things differently if one is prepared to pay the price in increased effort or decreased circulation of one's work. The experience of composer Charles Ives exemplifies the latter possibility. He experimented with polytonality and polyrhythms before they became part of the ordinary performer's competence. The New York players who tried to play his chamber and orchestral music told him that it was unplayable, that their instruments could not make those sounds, that the scores could not be played in any practical way. Ives finally accepted their judgement, but continued to compose such music. What makes his case interesting is that, according to his biographers (Cowell and Cowell, 1954), though he was also bitter about it, he experienced this as a great liberation. If no one could play his music, then he no longer had to write music that musicians could play, no longer had to

accept the constraints imposed by the conventions that regulated cooperation between contemporary composer and player. Since, for instance, his music would not be played, he never needed to finish it; he was quite unwilling to confirm John Kirkpatrick's pioneer reading of the *Concord Sonata* as a correct one because that would mean that he could no longer change it. Nor did he have to accommodate his writing to the practical constraints of what could be financed by conventional means, and so he wrote his Fourth Symphony for three orchestras. (That impracticality lessened with time; Leonard Bernstein premiered the work in 1958 and it has been played many times since.)

In general, breaking with existing conventions and their manifestations in social structure and material artifacts increases the artist's trouble and decreases the circulation of his work, on the one hand, but at the same time increases his freedom to choose unconventional alternatives and to depart substantially from customary practice. If that is true, we can understand any work as the product of a choice between conventional ease and success and unconventional trouble and lack of recognition, looking for the experiences and situational and structural elements that dispose artists in one direction or the other.

Interdependent systems of conventions and structures of cooperative links appear very stable and difficult to change. In fact, though arts sometimes experience periods of stasis, that does not mean that no change or innovation occurs (Meyer, 1967). Small innovations occur constantly, as conventional means of creating expectations and delaying their satisfaction become so well-known as to become conventional expectations in their own right. Meyer (1956) analyzes this process and gives a nice example in the use of vibrato by string instrument players. At one time, string players used no vibrato, introducing it on rare occasions as a deviation from convention which heightened tension and created emotional response by virtue of its rarity. String players who wished to excite such an emotional response began using vibrato more and more often until the way to excite the emotional response it had once produced was to play without vibrato, a device that Bartok and other composers exploited. Meyer describes the process by which deviations from convention become accepted conventions in their own right as a common one.

Such changes are a kind of gradualist reform in a persisting artistic tradition. Broader, more disruptive changes also occur, bearing a marked resemblance to political and scientific revolutions (Kuhn, 1962). Any major change necessarily attacks some of the existing conventions of the art directly, as when the Impressionists or Cubists changed the existing visual language of painting, the way one read paint on canvas as a representation of something. An attack on convention does not merely mean an attack on the particular item to be changed. Every convention carries with it an aesthetic, according to which what is conventional becomes the standard by which artistic beauty and effectiveness is judged. A play which violates the classical unities is not merely different, it is distasteful, barbaric and ugly to those for whom the classical unities represent a fixed criterion of dramatic worth. An attack on a convention becomes an attack on the aesthetic related to it. But people do not experience their aesthetic beliefs as merely arbitrary and conventional; they feel that they are natural, proper and moral. An attack on a convention and an aesthetic is also an attack on a morality. The regularity with which audiences greet major changes in dramatic, musical and visual conventions with

vituperative hostility indicates the close relation between aesthetic and moral belief (Kubler, 1962).

An attack on sacred aesthetic beliefs as embodied in particular conventions is, finally, an attack on an existing arrangement of ranked statuses, a stratification system. Remember that the conventional way of doing things in any art utilizes an existing cooperative network, an organized art world which rewards those who manipulate the existing conventions appropriately in light of the associated sacred aesthetic. Suppose that a dance world is organized around the conventions and skills embodied in classical ballet. If I then learn those conventions and skills, I become eligible for positions in the best ballet companies; the finest choreographers will create ballets for me that are just the kind I know how to dance and will look good in; the best composers will write scores for me; theaters will be available; I will earn as good a living as a dancer can earn; audiences will love me and I will be famous. Anyone who successfully promotes a new convention in which he is skilled and I am not attacks not only my aesthetic but also my high position in the world of dance. So the resistance to the new expresses the anger of those who will lose materially by the change, in the form of aesthetic outrage.

Others than the artist have something invested in the status quo which a change in accepted conventions will lose them. Consider earthworks made, for instance, by a bulldozer in a square mile of pasture. Such a sculpture cannot be collected (though a patron can pay for its construction and receive signed plans or photographs as a document of his patronage), or put in museums (though the mementos the collector receives can be displayed). If earthworks become an important art form, the museum personnel whose evaluations of museum-collectable art have had important consequences for the careers of artists and art movements lose the power to choose which works will be displayed, for their museums are unnecessary for displaying those works. Everyone involved in the museum-collectable kind of art (collectors, museum curators, galleries, dealers, artists) loses something. We might say that every cooperative network that constitutes an art world creates value by the agreement of its members as to what is valuable (Levine, 1972; Christopherson, 1974). When new people successfully create a new world which defines other conventions as embodying artistic value, all the participants in the old world who cannot make a place in the new one lose out.

Every art world develops standardized modes of support and artists who support their work through those conventional means develop an aesthetic which accepts the constraints embedded in those forms of cooperation. Rosenblum (1973) has shown that the aesthetic of photographers varies with the economic channels through which their work is distributed in the same way that their customary work styles do, and Lyon (1974) has analyzed the interdependence of aesthetic decisions and the means by which resources are gathered in a semi-professional theater group. One example will illustrate the nature of the dependence. The group depended on volunteer help to get necessary work done. But people volunteered for non-artistic kinds of work largely because they hoped eventually to get a part in a play and gain some acting experience. The people who ran the company soon accumulated many such debts and were constrained to choose plays with relatively large casts to pay them off.

Conclusion

If we focus on a specific artwork, it proves useful to think of social organization as a network of people who cooperate to produce that work. We see that the same people often cooperate repeatedly, even routinely, in similar ways to produce similar works. They organize their cooperation by referring to the conventions current among those who participate in the production and consumption of such works. If the same people do not actually act together in every case, their replacements are also familiar with and proficient in the use of the same conventions, so that the cooperation can go on without difficulty. Conventions make collective action simpler and less costly in time, energy and other resources; but they do not make unconventional work impossible, only more costly and more difficult. Change can occur, as it often does, whenever someone devises a way to gather the greater resources required. Thus, the conventional modes of cooperation and collective action need not recur because people constantly devise new modes of action and discover the resources necessary to put them into practice.

To say all this goes beyond the assertion that art is social and beyond demonstrations of the congruence between forms of social organization and artistic styles or subjects. It shows that art is social in the sense that it is created by networks of people acting together, and proposes a framework in which differing modes of collective action, mediated by accepted or newly developed conventions, can be studied. It places a number of traditional questions in the field in a context in which their similarity to other forms of collective action can be used for comparative theoretical work.

[. . .]

Collective actions and the events they produce are the basic unit of sociological investigation. Social organization consists of the special case in which the same people act together to produce a variety of different events in a recurring way. Social organization (and its cognates) are not only concepts, then, but also empirical findings. Whether we speak of the collective acts of a few people – a family or a friendship – or of a much larger number – a profession or a class system – we need always to ask exactly who is joining together to produce what events. To pursue the generalization from the theory developed for artistic activities, we can study social organizations of all kinds by looking for the networks responsible for producing specific events, the overlaps among such cooperative networks, the way participants use conventions to coordinate their activities, how existing conventions simultaneously make coordinated action possible and limit the forms it can take, and how the development of new forms of acquiring resources makes change possible.

References

Albrecht, Milton C., James H. Barnett and Mason Griff (eds) (1970) *The Sociology of Art and Literature: A Reader*. New York: Praeger Publishers.
Bennett, H.S. (1972) *Other People's Music*. Unpublished doctoral dissertation, Northwestern University.

Blumer, Herbert (1966) 'Sociological implications of the thought of George Herbert Mead.' *American Journal of Sociology* 71:535–44.

Christopherson, Richard (1974) 'Making art with machines: photography's institutional inadequacies.' *Urban Life and Culture* 3(1):3–34.

Cooper, Grosvenor W. and Leonard B. Meyer (1960) *The Rhythmic Structure of Music.* Chicago: University of Chicago Press.

Cowell, Henry and Sidney Cowell (1954) *Charles Ives and His Music.* New York: Oxford University Press.

Dart, Thurston (1967) *The Interpretation of Music*, 4th ed. London: Hutchinson.

Faulkner, Robert R. (1973a) 'Orchestra interaction: some features of communication and authority in an artistic organization.' *Sociological Quarterly* 14:147–57.

—— (1973b) 'Career concerns and mobility motivations of orchestra musicians.' *Sociological Quarterly*. 14:334–49.

Gombrich, E.H. (1960) *Art and Illusion.* New York: Bollingen.

Ivins, W. (1953) *Prints and Visual Communication.* Cambridge: MIT Press.

Johnson, Thomas (1955) *Emily Dickinson.* Cambridge: Harvard University Press.

Kealy, Edward (1974) *The Real Rock Revolution: Sound Mixers, their Work, and the Aesthetics of Popular Music Production.* Unpublished doctoral dissertation, Northwestern University.

Kubler, George (1962) *The Shape of Time.* New Haven: Yale University Press.

Kuhn, Thomas (1962) *The Structure of Scientific Revolution.* Chicago: University of Chicago Press.

Levine, Edward M. (1972) 'Chicago's art world.' *Urban Life and Culture* 1:292–322.

Lyon, Eleanor (1974) 'Work and play: resource constraints in a small theater'. *Urban Life and Culture* 3(1):71–97.

Meyer, L.B. (1956) *Emotion and Meaning in Music.* Chicago: University of Chicago.

—— (1967) *Music, the Arts and Ideas.* Chicago: University of Chicago.

—— (1973) *Explaining Music.* Berkeley: University of California.

Newhall, Beaumont (1964) *The History of Photography.* New York: Museum of Modern Art.

Pevsner, Nikolaus (1940) *Academies of Art: Past and Present.* Cambridge: Cambridge University Press.

Reese, Gustave (1959) *Music in the Renaissance.* Revised ed. New York: W. W. Norton.

Rosenblum, Barbara (1973) *Photographers and their Photographs.* Unpublished doctoral dissertation, Northwestern University.

Smith, B.H. (1968) *Poetic Closure*, Chicago: University of Chicago Press.

Strauss, Anselm L. *et al.* (1964) *Psychiatric Ideologies and Institutions.* New York: Free Press.

Wörner, Karl H. (1973) *Stockhausen: Life and Work.* Berkeley: University of California Press.

Pierre Bourdieu

BUT WHO CREATED THE 'CREATORS'?

From *Sociology in Question*. London, Sage, 1993, pp. 139–48.

SOCIOLOGY AND ART DO not make good bedfellows. That's the fault of art and artists, who are allergic to everything that offends the idea they have of themselves: the universe of art is a universe of belief, belief in gifts, in the uniqueness of the uncreated creator, and the intrusion of the sociologist, who seeks to understand, explain, account for what he finds, is a source of scandal. It means disenchantment, reductionism, in a word, vulgarity or (it amounts to the same thing) sacrilege: the sociologist is someone who, just as Voltaire expelled kings from history, wants to expel artists from the history of art. [. . .]

The first received idea is that sociology can give an account of cultural consumption but not of cultural production. Most general accounts of the sociology of cultural products accept this distinction, which is a purely social one. It tends in fact to reserve a separate, sacred space and a privileged treatment for the work of art and its uncreated 'creator', while abandoning to sociology the consumers, that's to say the inferior, even repressed aspect (especially as regards its economic dimension) of intellectual and artistic life. And research aimed at determining the social factors of cultural practice (visits to museums, theatres or concerts, etc.) gives apparent confirmation to this distinction, which is based on no theoretical foundation. In fact, as I shall try to show, the most specific feature of production, that is to say the production of value, cannot be understood unless one takes into account simultaneously the space of producers and the space of consumers.

Second received idea: that sociology – and its favoured instrument, statistics – belittles and crushes, flattens and trivializes artistic creation; that it sets the great and the small on the same footing, at all events fails to grasp what makes the genius

of the greatest artists. Here too, and probably more clearly, the sociologists have largely proved their critics right. I shall not dwell on literary statistics, which, both in the inadequacy of its methods and the poverty of its results, dramatically confirms the most pessimistic views of the guardians of the literary temple. I shall hardly discuss the tradition of Lukács and Goldmann, which tries to relate the content of the literary work to the social characteristics of the class that is assumed to be its privileged audience. This approach, which, in its most caricatural forms, subordinates the writer or artist to the constraints of a milieu or the direct demands of a clientele, succumbs to a naïve teleology or functionalism, directly deducing the work from the function that is alleged to be socially assigned to it. Through a kind of *short circuit*, it abolishes the specific logic of the space of artistic production.

In fact, on this point too, the 'believers' are entirely right in opposition to reductive sociology when they insist on the autonomy of the artist and in particular, on the autonomy that results from the specific history of art. It is true that, as Malraux put it, 'art imitates art' and that works of art cannot be explained purely in terms of demand, that is, in terms of the aesthetic and ethical expectations of the various fractions of the audience. But that does not mean that one is confined to the *internal history of art*, the sole authorized complement of the *internal reading of the work of art*.

The sociology of art and literature in its ordinary form in fact forgets what is essential, namely the universe of artistic production, a social universe having its own traditions, its own laws of functioning and recruitment, and therefore its own history. The autonomy of art and the artist, which the hagiographic tradition accepts as self-evident in the name of the ideology of the work of art as 'creation' and the artist as uncreated creator, is nothing other than the (relative) autonomy of what I call a *field*, an autonomy that is established step by step, and under certain conditions, in the course of history. The specific object of the sociology of cultural works is neither the individual artist (or any purely statistical set of individual artists), nor the relationship between the artist (or, which amounts to the same thing, the artistic school) and any particular social group conceived either as the efficient cause or determining principle of the contents and forms of expression or as the final cause of artistic production, that is, as a demand, with the history of contents and forms being *directly* attached to the history of the dominant groups and their struggles for domination. In my view, the sociology of cultural products must take as its object the whole set of relationships (objective ones and also those effected in the form of interactions) *between the artist and other artists*, and beyond them, the whole set of agents engaged in the production of the work, or, at least, of the *social value* of the work (critics, gallery directors, patrons, etc.). It is opposed both to a positivist description of the social characteristics of the producers (early upbringing, education, etc.) and to a sociology of reception which (as Antal does for the Italian art of the fourteenth and fifteenth centuries) directly relates works to the conception of life of the different fractions of the audience of patrons, that is, to 'society considered in its capacity for reception with respect to art'. In fact, most of the time, these two perspectives merge, as if it were assumed that artists are predisposed by their social origin to sense and satisfy a certain social demand (it is remarkable that, in terms of this logic, the analysis of the *content* of works of art takes precedence – it

is even true of Antal – over analysis of the *form*, that is, of what *specifically* belongs to the producer).

[. . .]

The sociology of works of art, as I conceive it, rejects these different ways of ignoring *production* itself. It takes as its object the field of cultural production and inseparably from this, the relationship between the field of production and the field of consumers. The social determinisms of which the work of art bears the traces are exerted partly through the producer's *habitus*, referring back to the social conditions of his production as a social subject (family, etc.) and as a producer (schooling, professional contacts, etc.), and partly through the social demands and constraints inscribed in the *position* he occupies in a particular, more or less autonomous, field of production.

What is called 'creation' is the encounter between a socially constituted *habitus* and a particular position that is already instituted or *possible* in the division of the labour of cultural production. The labour through which the artist makes his work and inseparably from this, makes himself as an artist (and when it is part of the demands of the field, as an original, individual artist) can be described as the dialectical relationship between his 'post', which often exists prior to him and outlives him (entailing obligations, such as 'the artist's life', attributes, traditions, modes of expression, etc.), and his *habitus*, which more or less totally predisposes him to occupy that post or – and this may be one of the prerequisites inscribed in the post – more or less completely to transform it.

In short, the producer's *habitus* is never entirely the product of his post – except perhaps in some craft traditions where family training (and therefore the condition-ings of the class of origin) and professional training are completely merged with one another. Conversely, one can never move directly from the social characteristics of the producer – his social origin – to the characteristics of his product: the dispos-itions linked to a particular social origin – plebeian or bourgeois – may express themselves in very different forms, while conserving a family resemblance, in differ-ent fields. One only has to compare, for examples, the two parallel couples of the plebeian and the patrician, Rousseau and Voltaire or Dostoevsky and Tolstoy. If the post makes the *habitus* (more or less completely), a *habitus* that is made in advance (more or less completely) for the post (through the mechanisms determining voca-tion and co-option) helps to make the post. And this is probably increasingly true, the greater the distance between its social conditions of production and the social demands inscribed in the post and also the greater the degree of liberty and space for innovation explicitly inscribed in the post. There are those who are made for taking up ready-made positions and those who are made for making new positions. Explaining this would require a long analysis, and I simply want to indicate here that it's especially when trying to understand intellectual or artistic revolutions that one needs to remember that the autonomy of the field of production is a partial au-tonomy which does not exclude dependence. Specific revolutions, which overthrow the power relations within a field, are only possible in so far as those who import new dispositions and want to impose new positions find, for example, support outside the field, in the new audiences whose demands they both express and produce.

Thus, the originating subject of a work of art is neither an individual artist – the

apparent cause – nor a social group (such as the banking and commercial bour-
geoisie that rose to power in Quattrocento Florence, according to Antal, or the
noblesse de robe, in Goldmann's theory). Rather, it is the *field of artistic production as a
whole* (which stands in a relation of relative autonomy, greater or lesser depending
on the period and the society, with respect to the groups from which the consumers
of its products are recruited, i.e. the various fractions of the ruling class). Sociology
or social history cannot understand anything about a work of art, least of all what
makes its *singularity*, when it takes as its object an author or a work in isolation. In
fact, all single-author studies that try to get beyond hagiography and anecdote are
led to consider the field of production as a whole, but because they generally fail to
take on that work of constructing the field as an explicit project, they most often do
so in an imperfect and partial way. And contrary to what might be thought, stat-
istical analysis does no better, since, in grouping authors in broad pre-constructed
categories (schools, generations, genres, etc.), it destroys all the pertinent differ-
ences whereas a preliminary analysis of the structure of the field would show that
certain positions (especially the *dominant* ones, such as the position Sartre occupied
in the French intellectual field between 1945 and 1960) may only have *place for one*,
and that the corresponding classes may contain just one person, which is a challenge
for statistics.

So the subject of the work is a *habitus* in relationship with a 'post', a position,
that is, with a field. To show this and I hope, demonstrate it, I'd need to reproduce
here the analyses I've devoted to Flaubert, in which I tried to show how the real key
to the Flaubertian project, which Sartre tries desperately, and interminably, to
understand, lies outside the individual, Flaubert, in the objective relationship
between, on the one hand, a *habitus* shaped in certain social conditions (defined by
the 'neutral' position of the professions, the 'capacities' as they were called, within
the dominant class and by Gustave's position, as a child, within his family, in terms
of his birth rank and his relation to the educational system) and on the other hand, a
particular position in the field of literary production, this itself being situated in a
particular position in the field of the dominant class.

To be a little more specific: Flaubert, as an advocate of art for art's sake,
occupies a *neutral* position in the literary field, defined by a twofold negative re-
lationship (which he experienced as a twofold refusal), to 'social art' on the one hand
and 'bourgeois art' on the other. This field, itself located in a *dominated* position in
the field of the dominant class (hence the denunciation of the 'bourgeois' and the
recurrent dream of a clerisy on which the artists of the time generally agreed), is
thus organized in accordance with a structure homologous with that of the dominant
class as a whole (this homology being, as we shall see, the principle of an automatic,
and not cynically pursued, adjustment of the products to the various categories of
consumers).

This would need to be developed. But it is immediately clear that, on the basis
of such an analysis, one *understands* the logic of some of the most fundamental
properties of Flaubert's *style*. I'm thinking, for example, of *discours indirect libre*,
which Bakhtin interprets as the mark of an ambivalent relationship to the groups
whose thoughts he relates, a kind of hesitation between the temptation to identify
with them and the concern to keep his distance. I'm also thinking of the chiastic
structure that reappears obsessively in his novels, and even more clearly in his drafts,

in which Flaubert expresses, in a transformed and 'negated' form, the dual relation-
ship of twofold negation which sets him, as an artist, against both the 'bourgeois'
and the 'populace', and as a 'pure' artist, against 'bourgeois art' and 'social art'.

Having thus established Flaubert's 'post', his position in the division of literary
labour (and therefore in the division of the work of domination), we can turn back
again to the social conditions of production of the *habitus* and ask what Flaubert had
to be in order to occupy and (simultaneously) produce the 'post' of 'art for art's
sake' and *create* the Flaubert position. We can try to establish what are the pertinent
features of the social conditions of the production of Gustave (e.g. the role of 'idiot
of the family' so well analysed by Sartre) which will enable us to understand how he
was able to fulfil and make the post of Flaubert.

Contrary to what the functionalist approach would suggest, the adjustment of
production to consumption results mainly from the structural homology between
the space of production (the artistic field) and the field of consumers (i.e. the field of
the dominant class). The internal divisions of the field of production are reproduced
in an automatically (and also to some extent consciously) differentiated supply
which meets the automatically (and also consciously) differentiated demands of the
various categories of consumers. Thus, quite apart from any pursuit of adjustment
or any direct subordination to a demand expressly formulated (through commissions
or patronage), each class of clients can find products to its taste and each class of
producers has some chance of finding consumers for its products, at least in the long
run (which may sometimes mean posthumously).

In fact, most acts of production function in accordance with a logic in which
two birds are killed with one stone. When a producer, for example the theatre critic
of *Le Figaro*, produces products adjusted to the taste of his audience (which is almost
always the case – he says so himself), it's not that he has tried to flatter the taste of
his readers (we can believe him when he says this), or obeyed aesthetic or political
directives, or responded to warnings from his editor, his readers or the government
(all of which are presupposed by formulae such as 'capitalist lackey' or 'spokesman
of the bourgeoisie', of which the standard theories are more or less subtly euphem-
ized versions). In fact, having chosen *Le Figaro*, because it felt right for him, and
having been chosen by its editors because he felt right for them, he only has to give
free rein to his taste (which, in the theatre, has clear political implications), or rather
to his distastes (taste almost always being a distaste for other people's tastes), to the
loathing he feels for the plays (as he well knows) his colleague and rival at *Le Nouvel
Observateur* will infallibly enjoy, in order to satisfy, as if by a miracle, the taste of his
readers (who are to the readers of *Le Nouvel Observateur* as he is to its theatre critic).
And he will bring them in addition something that is expected of a professional,
namely an intellectual's riposte to another intellectual, a critique, which will
reassure the 'bourgeois', of the highly sophisticated arguments with which the
intellectuals justify their taste for the avant-garde.

The correspondence that is established *objectively* between the producer (artist,
critic, journalist, philosopher, etc.) and his audience is clearly not the product of a
conscious pursuit of adjustment, conscious and self-interested transactions and cal-
culated concessions to the demands of the audience. Nothing can be understood
about a work of art, not even its informative content, its themes and theses or what
is loosely called its 'ideology', by relating it directly to a group. This relationship

functions only as an additional and almost accidental extra, through the relationship that a producer has – on the basis of his position in the space of positions constituting the field of production – with the space of the aesthetic and ethical postures that are effectively possible at a given moment, in view of the relatively autonomous history of the artistic field. This space of aesthetic and ethical positions, which is the product of a historical accumulation, is the common system of references in relation to which all those who enter the field are objectively defined. What makes the unity of an epoch is not so much a common culture as the common set of problems, which is nothing other than the set of aesthetic/ethical 'positions' attached to the set of positions marked out in the field. There is no other criterion of the existence of an intellectual, an artist or a school than his or its capacity to win recognition as holding a position in the field, a position in relation to which the others have to situate and define themselves; and the 'problem area' of the time is nothing other than the set of these *relations* between positions, which are also, necessarily, relations between aesthetic and ethical 'positions'. Concretely, that means that the emergence of an artist, a school, a party or a movement as a position within a field (an artistic, political or any other field) is marked by the fact that its existence 'poses problems' for the occupiers of the other positions, that the theses it puts forward become an object of struggles, that these theses provide one of the terms of the major oppositions around which the struggle is organized (for example, left/right, clear/obscure, scientism/anti-scientism, etc.).

Thus the proper object of a science of art, literature or philosophy can be nothing other than this structure of two inseparable spaces, the space of the products and the space of the producers (artists or writers, and also critics, publishers, etc.), which are like two translations of the same sentence. The autonomizing of works is unjustifiable both theoretically and practically. For example, any attempt at a sociological analysis of a discourse which is restricted to the work itself is denied the necessary movement which swings back and forth between the thematic or stylistic features of the work which reveal the social position of the producer (his/her interests, view of society, etc.) and the characteristics of the social position of the producer which cast light on his/her stylistic 'choices', and vice versa. In short, for a full understanding of even the most strictly 'internal' features of the work, one has to abandon the opposition between internal analysis (linguistic or any other) and external analysis.

[. . .]

It is true that 'art imitates art', or, more precisely, that art is born of art, and usually the art with which it contrasts. And the autonomy of the artist finds its basis not in the miracle of his creative genius but in the social product of the social history of a relatively autonomous field – methods, techniques, styles, etc. By defining the means and the limits of the thinkable, the history of the field causes what happens in the field to be never the direct *reflection* of external constraints or demands, but rather a symbolic expression, *refracted* by the whole specific logic of the field. The history that is deposited in the very structure of the field and also in the *habitus* of the agents in the prism which intervenes between the world external to the field and the work of art, causing all external events – economic crisis, political reaction, scientific revolution – to undergo refraction.

To conclude, I would like to complete the circle and return to the starting-point, the antinomy between art and sociology, and take seriously, not the denunciation of scientific sacrilege, but what is implied in that denunciation, that is, the sacred character of art and the artist. I think that the sociology of art has to take as its object not only the social conditions of production of the producers (i.e. the social determinants of the training or selection of artists) but also the social conditions of production of the field of production as the site of work tending (and not *aiming*) to produce the artist as a producer of sacred objects, fetishes; or, which amounts to the same thing, producing the work of art as an object of belief, love and aesthetic pleasure.

To make things clearer, I'll take the example of *haute couture*, which provides an enlarged image of what happens in the world of painting. We know that the magic of the designer's label, stuck on any object, perfume, shoes or even, it's a real example, a bidet, can multiply its value in an extraordinary way. This is indeed a magical, alchemical act, since the social nature and value of the object are changed without any change in its physical or (thinking of perfume) its chemical nature. Painting, since Duchamp, has provided countless examples, of which you are all aware, of magical acts which, like those of the couturier, so clearly owe their value to the social value of the person who produces them that the question to ask is not what the artist creates, but who creates the artist, that is, the transmuting power that the artist exercises. It's the question that Marcel Mauss came round to when, in despair, after seeking all the possible foundations of the magician's power, he finally asks who makes the magician. You may raise the objection that Duchamp's urinal and bicycle (and we've seen better still, since then) are exceptional limiting cases. But one only has to analyse the relationship between the 'authentic' original and the fake, the replica or the copy, or again the effects of *attribution* (the main, if not exclusive aim of traditional art history, which perpetuates the tradition of the connoisseur and the expert) on the social and economic value of the work, to see that what makes the value of the work is not the rarity (the uniqueness) of the product but the rarity of the producer, manifested by the *signature*, the equivalent of the designer label, that is, the collective belief in the value of the producer and his product. I'm thinking of Warhol, who, moving on from the example of Jasper Johns and his Ballantine's beer bottle in bronze, signs fifteen-cent cans of Campbell's soup and sells them at six dollars.

The analysis would need to be spelled out in more detail. Here I shall simply point out that one of the main tasks of art history would be to describe the genesis of a field of artistic production capable of producing the artist as such (as opposed to the craftsman). This would not mean raising yet again, as has been done, obsessively, in the social history of art, the question of when and how the artist emerged from the status of craftsman. It means describing the economic and social conditions of the constitution of an artistic field capable of underpinning belief in the quasi-godlike powers attributed to the modern artist. In other words, it's not just a matter of destroying what Walter Benjamin called 'the fetish of the name of the master'. (That's one of the easy acts of sacrilege by which sociology has too often been tempted. Like black magic, sacrilegious inversion contains a form of recognition of the sacred. The joys of desacralizing prevent one from taking seriously, and there-fore explaining, the fact of sacralization and the sacred.) The point is to take note of

the fact that the name of the master is indeed a fetish and to describe the social conditions of possibility of the figure of the artist as master, that is, as the producer of the fetish of the work of art. In a word, the aim would be to describe the historical constitution of the field of artistic production, which as such, produces belief in the value of art and in the value-creating power of the artist. And that would give a basis for what I posited at the beginning, namely that the 'subject' of artistic production and its product is not the artist but the whole set of agents who are involved in art, are interested in art, have an interest in art and the existence of art, who live on and for art, the producers of works regarded as artistic (great and small, famous – i.e. 'celebrated' – or unknown), critics, collectors, go-betweens, curators, art historians, and so on.

So we've come full circle. And we are caught inside.

PART THREE

The sociology of the artist

THE LIVES AND DEATH OF THE CREATIVE ARTIST

The nature of the 'artist' has been a central preoccupation of art history writing from the inauguration of the western art-historical tradition in Vasari's *The Lives of the Artists*. Vasari sought to codify a new image of the artist as at once intellectually qualified master of design and divinely inspired original creator. This image of the artist was reformulated in the Romantic period, laying emphasis on creativity at the expense of academic rules and theory (Honour 1979, 245–76; Wolff 1987). It underlies the privileged status of the artist enshrined in the laws of *droit moral* which protect the position of artists in the modern art market (Fyfe 1985, 1986, Harris 1970, Moulin 1983). The idea of the artist as creator, the ultimate source and origin of the meaning of all his or her works of art, is a major determinant both of academic art-historical practice, in which the monograph on an individual artist remains the dominant scholarly genre, and of representations of the artist within public and popular culture, whether in films about artists or in blockbuster exhibitions on cultural heroes such as Monet (Pollock 1983, Barker *et al.* 1999).

It has long been recognised that the development of this conception of the artist is a historical and culturally specific phenomenon. Early art-historical studies of the artist portray this development largely as a teleological unfolding of an authentic conception of the artist implicit in certain strands of classical Greek and early Christian thought (Panofsky 1924, Blunt 1940). Others, even where they recognise the 'discovery' of our modern conception of the artist as a relatively recent phenomenon, tend to assimilate visual artists from other cultures and times to our own model, by exploring other cultures' stories about sculptors and painters in terms of supposedly typical artistic traits or patterns of extreme behaviour characteristic of the artist type: the artist as 'melancholic' or 'magician', the artist as 'miser' or 'wastrel', 'celibate' or

'sodomite' (Kris and Kurz 1934, Wittkower and Wittkower 1963). These idealist and essentialist accounts of the artist have been criticised within art history. Formalist art historians, such as Riegl and Wölfflin, advocated an 'art history without names' in which the historical development of styles was seen as a largely immanent process in which individual artists played no great role (Hauser 1958, 119–276). More recently, art historians influenced by structuralist linguistics have developed similar arguments. They suggest that the meaning of works of art depends more on shared languages of visual representation than any original artistic intention. Such individual artistic intention itself presupposes a shared visual language as the medium within which artistic individuality is articulated (Barthes 1968, Rees and Borzello 1986, Preziosi 1989, 27–33).

Sociological work on the artist has similarly sought to decentre and desacralise the figure of the artist by revealing the mundane material underpinnings of the ideology of the creative artist (Zolberg 1990, 107–35). The Marxist social historian of art Arnold Hauser (Chapter 8) argues that the development of the concept of creative genius in Renaissance Italy is simply a reflection of the enhanced market value of artists in a context where an expanding range of patrons – church, state, aristocratic elite, bourgeoisie – competed for their services. He has been followed by sociologists such as Wolff (1981, 10–12; 1987) and Adler (1975, 360–2). They maintain that the concept of the artist as autonomous creator is an ideological relic of the eighteenth and nineteenth centuries. As other forms of work became increasingly subjected to the disciplinary organisation of the various factory systems of early capitalism, the relatively solitary character of artistic work could easily be represented as a free and unconstrained form of life, radically opposed to alienated labour. This was facilitated by the interstitial position of artists during this period, freed from the constraints of the disappearing systems of aristocratic patronage, but not yet integrated into the emergent market systems of capitalist production.

This desacralising perspective has been extended to analysis of the modern art world in ethnographic studies of the contemporary art market and art schools. In one of the most influential studies in postwar sociology of art, Raymonde Moulin argued that the world of fine art, and the role of the fine-art painter, is indistinguishable from that of the industrial production of mass culture (1967). Dealers play the role of capitalist entrepreneurs to the painter's proletarian. They make contracts with artists to monopolise their output over a period of time. Artists are paid according to the size of each painting with bonuses for high output, 'much as the blue-collar worker is paid extra for overtime' (117). Correspondingly, far from encouraging free creative activity, the avant-garde tradition of the new, with its demand for constant radical innovation, imposes on artistic workers 'particularly virulent forms' of occupational hazards and alienating experiences characteristic of working life in contemporary capitalist societies – over-specialisation, rapid obsolesence of skills, commodification of the self to fit the market (Adler 1975, 362–3).

Recently, this strongly materialistic line of analysis has been subject to some criticism. Peter Burke (1994, 17) suggests that the very fact of protest against the effects of the market or bureaucratic patronage on art represents a qualitative change in the cultural situation of artists, who are at least perceived as ideally

transcending the market, even if in practice they do not. Nathalie Heinich, in her study of 'the Van Gogh effect' (Chapter 9), accepts the constructed nature of the modern conception of the artist, but chooses to 'bracket' the historical and material foundations of this conception and questions of its authenticity or ideological nature. This allows her to develop a 'phenomenological' approach to the modern cult of the artist describing such social and cultural practices as touristic pilgrimages to artists' birthplaces, relic collecting in museum shops, penitential gazing on artistic masterpieces as acts of atonement for our forebears' failure to recognise the genius of Vincent. These practices sustain our faith in the artist as creator and our experience of the world of art as an embodiment of transcendent values.

STATUS AND ROLE IN THE SOCIOLOGY OF ARTISTS

Alongside these polemical materialist attacks on modern art-world ideology, a long-standing tradition of sociological work has been less hostile to the idea of the artist as such. Some of this work has a strongly realistic conception of the artist, defining the artist's role analytically in terms of a specialised concern with one particular strand of cultural traditions, namely expressive culture, in contrast to scientists, for example, who specialise in the production of cognitive culture (Parsons 1951, 408–14; cf. Chapter 18). Most work, however, takes for granted the idea of the artist in much the same way as conventional art history, but explores the varying ways in which this role is defined and enacted both over time and within different contexts in contemporary societies, laying particular emphasis on the varying status of artists.

'Role' and 'status' are two of the most fundamental concepts of sociological analysis. The concept of status describes the position of an actor within social structure, in particular in so far as this position is ranked as superior or inferior to other positions. The concept of role describes patterned expectations about and performances of action by groups of actors interacting with each other. The concepts are thus complementary. Howard Becker (1982, 226–71) constructs a typology of artistic roles in the modern world. 'Integrated professionals' are trained within and accept the expectations and evaluations of the professional art world. 'Mavericks', such as the American composer Charles Ives, although trained as professional artists, reject art-world expectations and the constraints and rewards concomitant with them. For 'folk artists', like quilters, their artistic role is normally only a subordinate role within their full range of roles within a community, and the community is not a specifically artistic one as in the case of the professional artist. Correspondingly, there are greater constraints on the time and materials available for their artistic work, and its success is often evaluated according to implicit local and social criteria rather than 'reasoned public application of explicit critical criteria' characteristic of the professional art world. While each of these art worlds defines the role of the artist and evaluates artistic performance in distinctive ways, they are all in turn defined in relationship to the dominant definition of the artist, that of the creative artist of the professional art world, and ranked accordingly. Art history itself, of course, plays a part in maintaining

this system of ranking through its choices of what kind of artists to write about. The canonical creative artists are painters and sculptors, not quilters.

The concept of role draws particularly close attention to the fact that the artists never act in isolation but always in the context of interaction in social relationships. Norbert Elias uses his 'figurational sociology' to analyse the transition from 'crafts-man's art' to 'artist's art' in western culture as part of a long-term 'civilising process' (Chapter 10). In traditional societies, art is produced by low-status craftsmen for high-status patrons, whether members of an elite or whole communities. In accord-ance with the power differential between patron and craftsman, these patrons deter-mine the form of the artwork in terms of the specific social function of the work in question and communal traditions of design, at the expense of any expression of the craftman's personal fantasy. The integration of such traditional societies into larger units in processes of state-formation both reduces the power of local elites and widens and renders more anonymous the range of patrons sponsoring works of art, more often produced for a market than for a specific client. This entails not simply more freedom for the artist, emancipated from close external controls by patrons, but also greater internalised self-control on the part of the artist. Only a strong artistic con-science, regulating artists' relationship to their inherited traditions, allows them to create a work of art which represents an individuated innovation on the inherited artistic repertoire, at the same time as neither lapsing into kitsch nor being so idio-syncratic as to fail to communicate at all with a potential audience. As Elias suggests, the attraction of this figurational approach to the artist's role is twofold. First, it integrates the history of art within a broader history of societal development, charac-terised by Elias as a 'civilising-process' of state-formation, social democratisation and increasing levels of self-restraint based on internalised self-controls in place of external coercion (Elias 1978, 1983). Second, the analytic framework is pitched at a sufficient level of generality to permit comparison of similar processes in other his-torical contexts, for example the changing role of artists in post-colonial Africa as tribal units are integrated into national states.

The capacity to perform a role presupposes training in the technical aspects of that role as well as socialisation into a motivational commitment to the role. Both social historians of art and sociologists have looked at the different ways in which artists are recruited and trained in different social and organisational settings and the different class origins of such artists: monastic artists in cloisters as opposed to the masons of cathedrals, petit-bourgeois artisans in the guilds of the late-medieval period, as opposed to academic artists from merchant or bourgois backgrounds from the sixteenth to the nineteenth century (Griff 1968, Gimpel 1970, Martindale 1972, Warnke 1985, Burke 1994). In the modern art world, art historians have been primar-ily concerned with the few successful avant-garde artists who make an innovative contribution to the extension of the western artistic tradition. Sociologists by contrast have focused on earlier stages in artists' careers, in art schools. Strauss (1970) looks at how the occupational identities of fine artists, commercial artists and art educators are formed in art school. The enhanced status and autonomy associated with the avant-garde artistic role have made both transmission of artistic skills and the forma-tion of artists' occupational identity more difficult. The tradition of the new offers 'no

unifying body of theory or guiding standards of practice', nor is there any consensus about the core craft skills which used to be characteristic of workshop training (Adler 1975, 367; Goldstein 1996, 272–93). Correspondingly, art students look to their teachers primarily for therapeutic reassurance that what they are doing is art, although little confidence is placed in that reassurance, since the ground of teachers' authority is as evanescent as the success of the latest modish style (Adler 1975, 365–74).

RETHINKING CREATIVITY: THE QUESTION OF ARTISTIC AGENCY

The changing status of the artist between the medieval period and the modern era has been centrally tied up with processes of 'professionalisation' which redefine both the role of the artist and the artist's claims to prestige through changes in patterns of recruitment, training and socialisation (Moulin 1983, Menger and Moulin 1983). Sociologists have shown how visual artists from the Renaissance onwards have pursued similar strategies of professionalisation to those pursued by other occupations: the formalisation of knowledge on a theoretical basis, setting their 'professional' knowledge apart from everyday knowledge as the basis for a claim to special prestige, creating organisations which support privileged access to opportunities of employment and privileged working conditions (see Freidson 1986a on the professions in general, 1986b on the case of artists). The clearest example of this is the set of processes which led to the formation of the Florentine Academy under the leadership of Vasari. The pictorial problems generated by Renaissance naturalism stimulated artists to write theoretical treatises to analyse these problems and communicate their solutions. Artistic skill was redefined in terms of its most intellectual component, design, which separated fine artists from mere handicraftsmen, and provided a basis for academic artists' claim to be treated with the same level of respect as other intellectuals like the humanists. These cultural advances were underpinned by favourable social context. In particular, the emergent modern states developing at the courts of Italy and northern Europe were interested in securing access to sufficiently highly trained artists to meet the new needs of the state for artistic self-projection (see Fyfe 1985, 400; Kempers 1992, Warnke 1985, on the widespread foundation of academies during the eighteenth century as part of a process of the extension of the power of the state in the domain of culture).

 These studies of professionalisation have a dual interest in rethinking the question of artistic creativity. First, they show that the idea of the artist as creator is not just an ideology but has been built into the ways in which the role and pictorial practice of artists is socially and culturally constructed in post-medieval western culture and society. Kempers (1992, 209ff.) suggests that the monumental narratives, which were to become the hallmark of academic painting in a tradition originating with Raphael's Vatican frescoes, placed new technical demands on painters. The combination of historical narratives with contemporary portraits and political allegories required not only heightened inventiveness on the part of visual artists but also increased powers of composition to integrate the elements into an aesthetically compelling whole. This was

a more complex task than that required in producing fourteenth-century altar pieces, and also one in which it was more difficult for patrons to specify in detail the final appearance of the picture (as opposed to its component contents). Correspondingly, painters' briefs were less specific than formerly. The historical, theoretical and technical training received by artists in academies served to rationalise and reconstruct artistic agency – the capacity of artists to intervene in the process of the production of pictures in a way which significantly affected the final artistic outcome – and thus enhanced the creative powers at the disposal of the state.

Second, these studies suggest that the development of this creative role is not a straightforward story of artistic success and increased autonomy. Almost always, certain practitioners of visual arts lose status and autonomy as part and parcel of the same process by which others enhance their status and autonomy. The organisation of cultural production becomes increasingly class-structured. Gordon Fyfe (1985) has shown how the hegemonic model of the painter and sculptor as creative artist in the Royal Academy of the eighteenth and nineteenth centuries served to marginalise other pictorial artists such as reproductive engravers and print-makers. Notwithstanding the creative capacities involved in translating the brushwork of paintings into the linear schemata of engravings, not to speak of designing original prints, engravers were excluded from full membership of the Royal Academy and the privileges and protections within the marketplace which this would have afforded. Whilst painters' works became known and their reputations enhanced largely through the circulation of engravings after them (for which they enjoyed copyright fees), engraving workshops were increasingly colonised by emergent art capital. This lead to a progressive deskilling of engravers, who became specialised in the technically proficient and rapid execution of single components – for example draperies or leaves – in highly capitalised workshops characterised by a marked division of labour in plate production. Profitable and accurate reproduction of the pictorial details of the paintings of the great masters, enhancing their esteem and public awareness of their artistic individuality, was realised at the expense of the elimination of a sense of and capacity for individual pictorial expression amongst an increasingly alienated and exploited artistic underclass of engravers.

In the final reading of Part Three, David Brain (Chapter 11) explores the development of modernism in architectural design in 1930s America. He argues that the characteristic means and features of modernist design – standardised parts, elimination of surface ornament, geometrical form – were formulated in response to apparently conflicting demands. Federal housing projects associated with the New Deal required houses which cost no more than absolutely necessary. The dominant design tradition in American architecture was *beaux arts*, exploiting a rich repertoire of classical ornament for individual elite patrons. State housing seemed at first sight the kind of project which required only engineers and builders, and could dispense with the luxury of architectural design. By translating the demands of the federal housing projects into a problem of architectural design articulated in terms of the basic housing needs of 'the modern *citizen*', American architects mediated between economic constraints, political ideology and technical rationality. They developed an aesthetic which reconstructed architects' agency in such a way as to maintain their capacity for

authoritative architectural design even in the, at first sight, unpromising domain of public-sector housing. With its emphasis on questions of material agency, this recent strand of sociological work has opened the way for a sophisticated integration of sociological studies of artistic status, with art-historical concerns with formal analysis of style and design in art and architecture.

Arnold Hauser

THE SOCIAL STATUS OF THE RENAISSANCE ARTIST

From *The Social History of Art, vol. II: Renaissance, Mannerism, Baroque*. London, Routledge, 1951, pp. 46–57, 61–3.

THE INCREASED DEMANDS FOR works of art in the Renaissance leads to the ascent of the artist from the level of the petty bourgeois artisan to that of the free intellectual worker, a class which has previously never had any roots but which now began to develop into an economically secure and socially consolidated, even though by no means uniform group. The artists of the early Quattrocento are still entirely small folk; they are regarded as higher-grade craftsmen and their social origins and education do not make them any different from the petty bourgeois elements of the guilds. Andrea del Castagno is a peasant's son, Paolo Uccello the son of a barber, Filippo Lippi the son of a butcher, the Pollaiuoli the sons of a poulterer. They are named after the occupation of their father, their birthplace or their master, and they are treated as familiarly as domestics. They are subject to the rules of the guild, and it is by no means their talent which entitles them to practise as professional artists, but the course of instruction completed according to guild regulations. Their education is based on the same principles as that of the ordinary craftsmen; they are trained not in schools, but in workshops, and the instruction is practical, not theoretical. After having acquired the rudiments of reading, writing and arithmetic, they are apprenticed to a master while still children and they usually spend many years with him. We know that even Perugino, Andrea del Sarto and Fra Bartolommeo were apprenticed for eight to ten years. Most of the artists of the Renaissance, including Brunelleschi, Donatello, Ghiberti, Uccello, Antonio Pollaiuolo, Verrocchio, Ghirlandaio, Botticelli and Francia, started in the goldsmith's workshop, which has rightly been called the art school of the century. Many sculptors begin work with stonemasons and ornamental carvers just as their

medieval predecessors had done. Even when he is received into the Luke Guild, Donatello is still described as a 'goldsmith and stonemason', and what he himself thinks about the relation between art and craft is best shown by the fact that he plans one of his last and most important works, the group of Judith and Holofernes, as a decoration for the fountain in the courtyard of the Palazzo Riccardi. But the leading artists' shops of the early Renaissance introduce, despite their still fundamentally artisan-like organization, more individual teaching methods. That applies, above all, to the workshop of Verrocchio, Pollaiuolo and Ghirlandaio in Florence, of Francesco Squarcione in Padua and Giovanni Bellini in Venice, of which the leaders are just as important and famous as teachers as they are as artists. Apprentices no longer enter the first workshop that they come across, but go to a particular master, by whom they are received in greater numbers the more famous and sought after he is as an artist. For these boys are, if not always the best, at least the cheapest source of labour; and that is probably the main reason for the more intensive art education which is to be observed from now on, not the masters' ambition to be considered good teachers.

The course of instruction begins, still following the medieval tradition, with all kinds of odd jobs, such as the preparation of colours, repairing brushes and the priming of the pictures; it then extends to transferring the individual compositions from the cartoon to the panel, the execution of the various parts of garments and the less important parts of the body, and finishes with the completion of whole works from mere sketches and instructions. Thus the apprentice develops into the more or less independent assistant, who must be differentiated, however, from the pupil. For not all the assistants of a master are his own pupils, and not all pupils remain with their teacher as assistants. The assistant is often on the same level as the master, but also often merely an impersonal tool in the hands of the workshop-owner. As a consequence of the various combinations of these possibilities and the frequent co-operation of the master, the assistants and the pupils, there arises not only a mixture of styles which is difficult to analyse, but sometimes even an actual balancing of the individual differences, a communal form, on which, above all, the tradition of craftsmanship has a decisive influence. The circumstance which is famil- iar – whether it is truth or fiction – from artists' biographies of the Renaissance, that the master gives up painting because one of his pupils has outstripped him (Cimabue–Giotto, Verrocchio–Leonardo, Francia–Raphael), must either represent a later stage of development in which the workshop community was already in process of dissolution, or, as for example in the case of Verrocchio and Leonardo, there must be a more realistic explanation than is given in the anecdotes about these artists. Verrocchio probably stops painting and restricts himself to the execution of plastic works, after he has convinced himself that he can safely entrust the painting commissions to an assistant like Leonardo.

The artist's studio of the early Renaissance is still dominated by the communal spirit of the masons' lodge and the guild workshop; the work of art is not yet the expression of an independent personality, emphasizing his individuality and exclud- ing himself from all extraneous influences. The claim independently to shape the whole work from the first stroke to the last and the inability to co-operate with pupils and assistants are first noticeable in Michelangelo, who, in this respect too, is the first modern artist. Until the end of the fifteenth century the artistic labour

process still takes place entirely in collective forms. In order to cope with extensive undertakings, above all, great works of sculpture, factory-like organizations are started with many assistants and handymen. Thus in Ghiberti's studio up to twenty assistants are employed during the work on the Baptistry doors, which are among the greatest tasks to be commissioned in the Quattrocento. Of the painters, Ghirlandaio and Pinturicchio maintain a whole staff of assistants while they are working on their great frescoes. Ghirlandaio's workshop, in which above all his brothers and brother-in-law are engaged as permanent collaborators, is, along with the studios of the Pollaiuoli and the della Robbia, one of the great family businesses of the century. There also exist owners of studios who are more businessmen than artists, and who usually accept commissions only in order to have them carried out by a suitable painter. Evangelista da Predis in Milan seems to have been one of these. For a time, he also employed Leonardo. Apart from these business-like forms of collective labour, we encounter in the Quattrocento the partnership of two usually still young artists, running a common workshop, because they cannot afford the expense of an independent undertaking. Thus, for example, Donatello and Michelozzo, Fra Bartolommeo and Albertinelli, Andrea del Sarto and Franciabigio, work together. Everywhere we still find superpersonal forms of organization preventing the atomization of artistic work. The tendency to intellectual amalgamation makes itself felt both in the horizontal and in the vertical direction. The representative personalities of the age form long uninterrupted successions of names which, as, for example, in the case of the master–pupil sequence: Fra Angelico – Benozzo Gozzoli – Cosimo Rosselli – Piero di Cosimo – Andrea del Sarto – Pontormo – Bronzino, make the main development seem to be that of an absolutely continuous tradition.

The spirit of craftsmanship which dominates the Quattrocento is expressed, above all, in the fact that the artists' studios often take on minor orders of a purely technical nature. From the records of Neri di Bicci we learn what a vast amount of handicraft goods is produced in one busy painter's workshop; apart from pictures, armorial bearings, flags, shop signs, tarsia-works, painted wood-carvings, patterns for carpet weavers and embroiderers, decorative objects for festive occasions and many other things are turned out. Even after he has become a distinguished painter and sculptor, Antonio Pollaiuolo runs a goldsmith's workshop and in his studio, apart from sculpture and goldsmith work, cartoons for tapestries and sketches for engravings are drafted. Even at the height of his career, Verrocchio takes on the most varied terracotta work and wood-carving. For his patron Martelli, Donatello makes not only the well-known coat of arms but also a silver mirror. Luca della Robbia manufactures majolica tiles for churches and private houses, Botticelli draws patterns for embroideries and Squarcione is the owner of an embroidery workshop. Of course, one must discriminate both according to the stage of historical development and the standing of the individual artists and not run away with the idea that Ghirlandaio and Botticelli painted shop signs for the baker or the butcher round the corner; such orders will no longer have been executed in their workshop at all. On the other hand, the painting of guild flags, wedding chests and bridal plates was not felt to be a degrading occupation for the artist. Botticelli, Filippino Lippi, Piero di Cosimo, are active as painters of *cassoni* right into the period of the Cinquecento. A fundamental change in the generally accepted criteria of artistic work does not begin to make itself felt until the period of Michelangelo. Vasari no longer considers the

acceptance of mere handicraft work compatible with the self-respect of an artist. This stage also signifies the end of the dependence of artists on the guilds. The outcome of the proceedings of the Genoese painters' guild against the painter Giovanni Battista Poggi, who was to be prevented from practising his art in Genoa, because he had not undergone the prescribed seven-years course of instruction there, is of symptomatic importance. The year 1590, in which this case took place and which brought the fundamental decision that the guild statutes were not binding on artists who did not keep an open shop, brings to a close a development of nearly two hundred years.

The artists of the early Renaissance are also economically on an equal footing with the petty bourgeois tradesman. Their situation is in general not brilliant, but neither is it exactly precarious. No artist is as yet in a position to live like a lord, but, on the other hand, there exists nothing that one could call an artistic proletariat. It is true that in their income-tax declarations the painters are constantly complaining about their difficult financial circumstances, but such documents can certainly not be considered the most trustworthy of historical sources. Masaccio asserts that he cannot even pay his apprentice, and we know for a fact that he died poor and in debt. According to Vasari, Filippo Lippi could not buy himself a pair of stockings, and in his old age, Paolo Uccello complains that he owns nothing, cannot work any longer and has a sick wife. Those artists were still best off who were in the service of a court or a patron. For example, Fra Angelico received fifteen ducats a month at the curia, at a time when on 300 a year one could live in grand style in Florence, where the cost of living was anyhow somewhat lower. It is characteristic that prices remained in general on a medium level and that even the well-known masters were not much better paid than the average artist and the higher-grade craftsman. Person-alities like Donatello probably received somewhat higher fees, but 'fancy prices' were still non-existent. Gentile da Fabriano received 150 florins for his 'Adoration of the Magi', Benozzo Gozzoli 60 for an altar-piece, Filippo Lippi 40 for a Madonna, but Botticelli already received 75 for his. Ghiberti drew a fixed salary of 200 florins a year while he was working on the doors of the Baptistry, whereas the Chancellor of the Signoria received 600 florins out of which he was also obliged to pay four clerks. In the same period, a good copyist of manuscripts received 30 florins in addition to full board. Artists were, accordingly, not exactly badly paid, even though not any-thing like so well as the famous literati and university teachers, who often received 500 to 2000 florins per annum. The whole art market still moved within com-paratively narrow limits; the artists had to demand interim payments during the work and even the employer could often pay for the materials only by instalments. The princes also had to fight against shortage of ready money, and Leonardo complains repeatedly to his patron Ludovico Moro about not having received his fee. The handicraft character of artistic work was expressed not least in the fact that the artists were in receipt of a regular wage from their employers. In the case of larger-scale artistic undertakings, all cash expenditure, that is to say, both the cost of the materials, the wages and often even the board and lodging of the assistants and apprentices, was borne by the employer, and the master himself was paid according to the time spent on the work. Wage-work remained the general rule in painting until the end of the fifteenth century; only later was this method of compensation limited to purely artisan jobs, such as restorations and copying.

As the artistic profession breaks away from pure craftsmanship, all the conditions set down in work contracts are gradually altered. In a contract with Ghirlandaio, dated 1485, the price of the colours to be used is still particularized; but according to a contract with Filippino Lippi, dated 1487, the artist already has to bear the cost of the materials, and a similar agreement is made with Michelangelo in 1498. It is, of course, impossible to draw an absolute dividing-line here, but the change occurs, at any rate, towards the end of the century, and is again connected most conspicuously with the person of Michelangelo. In the Quattrocento it was still the general custom to require the artist to provide a guarantor to stand surety for the observance of the contract; with Michelangelo this guarantee becomes a mere formality. Thus, in one case, the writer of the contract himself acts as a guarantor for both sides. The other obligations binding on the artist are defined more and more loosely and vaguely in the contracts. In a contract of the year 1524, Sebastiano del Piombo is left free to choose any subject he likes for a painting, on the sole condition that it shall not be the picture of a saint; and in 1531, the same collector orders a work from Michelangelo and it is left entirely to the artist to decide whether it shall be a painting or a piece of sculpture.

From the very beginning, artists were better placed in Renaissance Italy than in other countries, not so much as a result of the more highly developed forms of urban life – the bourgeois milieu in itself offered them no better opportunities than the ordinary craftsmen – but because the Italian princes and despots were better able to use and appreciate their gifts than foreign rulers. The fact that the Italian artists were less dependent on the guilds, which was the basis of their favoured position, is above all the result of their being frequently employed at the courts. In the North the master is tied to one city, but in Italy the artist often moves from court to court, from city to city, and this nomadic life already leads to a certain relaxation of guild regulations, which are based on local conditions and are only workable within local limits. As the princes attached importance to attracting to their courts not only highly skilled masters in general, but also particular artists who were often foreign to the locality, the latter had to be freed from the restrictions of guild statutes. They could not be forced to take local craft regulations into consideration in the execution of their commissions, to apply for a labour permit from the local guild authority and to ask how many assistants and apprentices they were allowed to employ. After they had finished their work for one employer, they went with their assistants into the employment and protection of another and again enjoyed the same exceptional rights. These travelling court painters were beyond the reach of the guilds from the very outset. But the privileges which artists enjoyed at the courts could not remain without effect on the way they were treated in the towns, particularly as the same masters were often employed in both places and the towns had to keep pace with the competition of the courts if they wanted to attract the best artists. The emancipation of the artists from the guilds is, therefore, not the result of their own heightened self-respect and the acknowledgement of their claim to be considered on an equal footing with the poets and scholars, but results from the fact that their services are needed and have to be competed for. Their self-respect is merely the expression of their market-value.

The social ascent of the artists is expressed first of all in the fees they receive. In the last quarter of the fifteenth century relatively high prices begin to be paid

in Florence for fresco paintings. In 1485, Giovanni Tornabuoni agrees to pay Ghirlandaio a fee of 1,100 florins for painting the family chapel in S. Maria Novella. For his frescoes in S. Maria sopra Minerva in Rome, Filippino Lippi receives 2,000 gold ducats, which corresponds approximately to the same sum in florins. And Michelangelo receives 3,000 ducats for the paintings on the ceiling of the Sistine Chapel. Towards the end of the century several artists are already doing well financially; Filippino Lippi even amasses a considerable fortune. Perugino owns houses, Benedetto da Maiano an estate. Leonardo draws an annual salary of 2,000 ducats in Milan and in France he receives 35,000 francs per annum. The celebrated masters of the Cinquecento, especially Raphael and Titian, enjoy a considerable income and lead a lordly life. Michelangelo's way of life is outwardly modest, it is true, but his income, too, is high, and when he refuses to accept payment for his work in S. Peter's, he is already a wealthy man. In addition to the increasing demand for works of art and the general rising of prices, the fact that round the turn of the century the papal curia comes more into prominence on the art market, and becomes a more serious rival to the Florentine public interested in art, must have had the biggest influence on the ascending scale of artists' fees. A whole series of artists now move from Florence to magnanimous Rome. Naturally, those left behind profit from the high offers of the papal court – that is to say, only the more distinguished artists really profit, those whom an effort is made to keep back. The prices paid to the others lag considerably behind the fees paid in the best market, and now, for the first time, there begin to be real differences in the payments made to artists.

The emancipation of the painters and sculptors from the fetters of the guilds and their ascent from the level of the artisan to that of the poet and scholar has been attributed to their alliance with the humanists; the humanists' support for them, on the other hand, has been explained by the fact that the literary and artistic monuments of antiquity formed an indivisible unity in the eyes of these enthusiasts, and that they were convinced that the poets and artists of classical antiquity were held in equal regard. In fact, they would have considered it unthinkable that the creators of the works which they regarded with a common reverence because of their common origin should have been judged differently by their contemporaries. And they made their own age – and the whole of posterity right into the nineteenth century – believe that the artist, who had never been anything more than a mere mechanic in the eyes of antiquity, shared the honours of divine favour with the poet. There is no question that the humanists were very useful to the artists of the Renaissance in their efforts to achieve emancipation; the humanists confirmed them in the position they had won for themselves thanks to the favourable market, and they gave them the weapons with which to assert their claims against the guilds, and partly also against the resistance of the conservative, artistically inferior and therefore, vulnerable elements in their own ranks. But the protection of the literati was by no means the reason for the social ascent of the artist; it was rather itself merely a symptom of the development which followed from the fact that – as a consequence of the rise of new seigniories and principalities, on the one hand, and the growth and enriching of the towns, on the other – the disproportion between supply and demand on the art market became ever smaller and began to achieve a perfect balance. It is a well-known fact that the whole guild movement had its origin in the attempt to prevent such a disproportion in the interest of the producers; the guild authorities only

connived at the infringement of their statutes when shortage of work no longer seemed a menace. The artists owed their independence not to the goodwill of the humanists, but to the fact that this danger became increasingly insignificant. They also desired the friendship of the humanists, not in order to break the resistance of the guilds, but to justify the economic position they had already won for themselves in the eyes of the humanistically-minded upper class and in order to enlist the scientific advisers, whose help they needed in their fashioning of marketable mytho-logical and historical subjects. For the artists the humanists were the guarantors of their intellectual status, and the humanists themselves recognized the value of art as a means of propaganda for the ideas on which their own intellectual supremacy was based. It was this mutual relationship which first gave rise to that conception of the unity of the arts which we take for granted, but which was unknown before the Renaissance. Plato is not the only one to make a fundamental distinction between the visual arts and poetry; even in the later years of classical antiquity and the Middle Ages, it occurred to no one to assume that there was any closer relationship between art and poetry than there was between science and poetry or between philosophy and art.

Medieval literature on art was limited to recipe books. No hard-and-fast line of any kind was drawn between art and craft in these practical manuals. Even Cennino Cennini's treatise on painting was still dominated by the ideas of the guilds and based on the guild conception of excellence in craftsmanship; he exhorted the artists to be industrious, obedient and persevering, and saw in the 'imitation' of the paragons the most certain way to mastery. All this was on the old medieval-traditionalist lines. The replacing of the imitation of the masters by the study of nature is first accomplished theoretically by Leonardo da Vinci, but he was merely expressing the victory of naturalism and rationalism over tradition which had been won long since in practice. His theory of art, which is based on the study of nature, shows that in the interim the relationship between master and pupil has completely changed. The emancipation of art from the spirit of pure craftsmanship had to begin with the alteration of the old system of apprenticeship and the abolition of the teaching monopoly of the guilds. As long as the right to practise as a professional artist was conditional on apprenticeship under a guild master, neither the influence of the guilds nor the supremacy of the craft tradition could be broken. The educa-tion of the rising generation in art had to be transferred from the workshop to the school, and practical had to yield partly to theoretical instruction, in order to remove the obstacles which the old system put in the way of young talent. Of course, the new system gradually created new ties and new obstacles. The process begins by the authority of the masters being replaced by the ideal of nature, and ends with the finished body of doctrine represented by academic instruction, in which the place of the old discredited models is taken by new, just as strictly limited, but from now on scientifically based ideals. Incidentally, the scientific method of art education begins in the workshops themselves. Already in the early Quattrocento apprentices are made familiar with the rudiments of geometry, perspective and anatomy in addition to the practical instruction, and introduced to drawing from life and from puppets. The masters organize courses in their workshops and this institution gives rise, on the one hand, to the private academies with their combination of practical and theoretical instruction, and on the other, to the public academies in which the

old workshop community and craft tradition are abolished and replaced by a purely intellectual teacher–pupil relationship. Workshop instruction and the private academies maintain themselves through the whole Cinquecento, but they gradually lose their influence on the formation of style.

The scientific conception of art, which forms the basis of instruction in the academies, begins with Leon Battista Alberti. He is the first to express the idea that mathematics is the common ground of art and the sciences, as both the theory of proportions and of perspective are mathematical disciplines. He is also the first to give clear expression to that union of the experimental technician and the observing artist which had already been achieved in practice by Masaccio and Uccello. Both try to comprehend the world empirically and to derive rational laws from this experience of the world; both endeavour to know and to control nature; both are distinguished from the purely contemplative, scholastically confined university teacher by reason of their creative activity – a *poiein*. But if the technician and the natural scientist now has a claim to be considered an intellectual on the basis of his mathematical knowledge, the artist, who is often identical with the technician and the scientist, may also well expect to be distinguished from the craftsman and to have the medium in which he expresses himself regarded as one of the 'free arts'.

[. . .]

The fundamentally new element in the Renaissance conception of art is the discovery of the concept of genius, and the idea that the work of art is the creation of an autocratic personality, that this personality transcends tradition, theory and rules, even the work itself, is richer and deeper than the work and impossible to express adequately within any objective form. This idea remained foreign to the Middle Ages, which recognized no independent value in intellectual originality and spontaneity, recommended the imitation of the masters and considered plagiarism permissible, and which was, at the most, superficially touched but in no sense dominated by the idea of intellectual competition. The idea of genius as a gift of God, as an inborn and uniquely individual creative force, the doctrine of the personal and exceptional law which the genius is not only permitted to but must follow, the justification of the individuality and wilfulness of the artist of genius – this whole trend of thought first arises in Renaissance society, which, owing to its dynamic nature and permeation with the idea of competition, offers the individual better opportunities than the authoritarian culture of the Middle Ages, and which, owing to the increased need for publicity felt by the holders of power, creates a greater demand in the art market than the supply had had to meet in the past. But just as the modern idea of competition reaches back deep into the Middle Ages, so the medieval idea of art as determined by objective, superpersonal factors continues to have an after-effect for a long time and the subjectivist conception of artistic activity makes only very slow progress even after the end of the Middle Ages. The individualistic conception of the Renaissance, therefore, requires correction in two directions. Burckhardt's thesis is not, however, to be dismissed out of hand, for if strong personalities already existed in the Middle Ages, yet to think and act individually is one thing and to be conscious of one's individuality, to affirm and deliberately to intensify it, is another. One cannot speak of individualism in the modern sense of the term until a reflexive individual consciousness takes the place of

a mere individual reaction. The self-recollection of individuality does not begin until the Renaissance, but the Renaissance does not itself begin with the self-recollecting individuality. The expression of personality in art had been sought after and appreciated long before anyone had realized that art was based no longer on an objective What but on a subjective How. Long after it had become a self-confession, people still continued to talk about the objective truth in art, although it was precisely the self-expressionism in art which enabled it to win through to general recognition. The power of personality, the intellectual energy and spontaneity of the individual, is the great experience of the Renaissance; genius as the embodiment of this energy and spontaneity becomes the ideal, in which it finds the supreme expression of the nature of the human mind and its power over reality.

The development of the concept of genius begins with the idea of intellectual property. In the Middle Ages both this conception and the desire for originality are lacking; both are directly interrelated. As long as art is nothing but the representation of the Divine and the artist only the medium through which the eternal, supernatural order of things is made visible, there can be no question of autonomy in art nor of the artist actually owning his work. The obvious suggestion is to connect the idea of intellectual property with the beginnings of capitalism, but to do so would only be misleading. The idea of intellectual productivity and intellectual property follows from the disintegration of Christian culture. As soon as religion ceases to control and unite within itself all the spheres of spiritual life, the idea of the autonomy of the various forms of intellectual expression appears, and an art which bears its meaning and purpose within itself becomes conceivable. In spite of all attempts to base the whole of culture, including art, on religion, no later age has ever succeeded in restoring the cultural unity of the Middle Ages and depriving art of its autonomy. Even when it is placed in the service of extra-artistic purposes, art now remains enjoyable and significant in itself. But if one ceases to regard the separate intellectual moulds as so many different forms of one and the same truth, then the idea also occurs of making their individuality and originality the criterion of their value. The Trecento is still completely under the spell of *one* master – Giotto – and of his tradition; but in the Quattrocento individualistic efforts begin to make their mark in all directions. Originality becomes a weapon in the competitive struggle. The social process now seizes on an instrument which it has not itself produced, but which it adapts to its purposes and of which it heightens the effectiveness. As long as the opportunities on the art market remain favourable for the artist, the cultivation of individuality does not develop into a mania for originality – this does not happen until the age of mannerism, when new conditions on the art market create painful economic disturbances for the artist. But the ideal of the 'original genius' itself does not appear until the eighteenth century, when, in the transition from private patronage to the free, unprotected market, artists have to wage a sterner fight for their material existence than ever before.

Natalie Heinich

THE VAN GOGH EFFECT

From *The Glory of Van Gogh: An Anthropology of Admiration*. Princeton, Princeton University Press, 1996, pp. 140–50.

HOW DID VAN GOGH become a saint? It happened in six stages: his work was made into an enigma, his life into a legend, his fate into a scandal, his paintings were put up for sale and exhibited, and the places he went, as well as the objects he touched, were made into relics. In accounting for all of this, I have drawn on several disciplines and explored a range of theoretical issues. This was necessary, for van Gogh does not belong only to art history and criticism, which are concerned with the construction of artistic greatness. He belongs equally to the history of religion, which is concerned with the sacrificial construction of greatness; to the biographical and hagiographical tradition, which is concerned with systems of admiration and heroization; to psychiatry, psychology, and anthropology, which are concerned with deviance and singularity; to economics, which is concerned with the monetarization of the value attributed to the work; and to the sociology of religion, which is concerned with the status of relics, pilgrimages, and atonement. Although the combination of these many approaches flies in the face of the scientific practice of empirical monographs and theoretical modeling, it nevertheless fits the specific case of van Gogh, whose singularity also consists in connecting heterogeneous (especially artistic and religious) traditions by crystallizing different dimensions of experience.

Van Gogh embodies far more than a new artistic tendency. He embodies a new model of the artist. The ordinary way of seeing artistic creation has not been the same since van Gogh. This singular figure has been raised up in being caught up by, and caught within, the community. But the community has also been transformed thereby. This deviant individual has fundamentally renewed the way not only his

own place, but those of his successors and even predecessors, are perceived. He marks a turning point, an aesthetic, historical, and ethical rereading of art. In other words, he is the origin of a new paradigm in the Kuhnian sense. His existence redefines the ordinary meaning of normal, establishing a boundary between a traditional and a modern concept of the artist.

An artistic paradigm

The legend of van Gogh has become the founding myth of the accursed artist: his degeneration in the present proves his future greatness, while bearing witness to the pettiness of the world ('society'), which is guilty of not having recognized him. He has become a model, in the dual sense of an example to be followed, and a pattern determining the configuration of values. Thanks to him, it is possible to exalt the misery of many artists whose lives were wrecked by poverty and alcohol (Utrillo, Modigliani), by sex (Toulouse-Lautrec), by madness (Camille Claudel), and more generally, by the misguided ways of bohemia, from Montmartre to Montparnasse. To be sure, this 'bohemia' antedated van Gogh in the art world; but through him it became an obligatory image, a myth, a stereotype.

By virtue of this 'van Gogh effect', the properties attributed to him are transferred onto other artists, and not just those who came after him. The same procedure is applied to the past, which is retrospectively reinterpreted according to the theme of 'blindness in the face of painting'. The following text illustrates how the van Gogh paradigm makes it possible to reread great sections of art history through the prism of the motif of incomprehension.

> The fatal break which *always* exists between *genius* and *society* takes on its most dramatic form with van Gogh, and also its most impassioned one. People often fail to appreciate the *suffering* involved in the birth of a work of art. In admiring it, in vaunting its qualities, they think they are '*rehabilitating*' their victim, whereas all they are doing is *damning his tormentors even more. We are responsible for van Gogh's 'madness,'* just as we are for *the fall of Rembrandt*, who was discredited and abandoned by all, *for the morbid obsessions of Goya, for Delacroix's ravings, for Lautrec's degeneration*, for the *curse on Pascin*, for *Utrillo's martyrdom*, for *the 'unexplained' death of Nicolas de Staël*. Torrents of remorse cascade from century to century, impelled by Christ's 'Why hast thou forsaken me?' They echo most tragically in the night where man, elaborating his own universe, tries to impose it on the society which gave birth to him. Thus, Van Gogh does not represent a pathological problem which will no doubt give rise to endless commentary, but more accurately a sociological problem, as a study of his life and work confirms.[1]

Not only is this rereading of the past an effect of the paradigm shift, but it also contributes to effecting that shift, since the recurrence of the motif of incomprehension bears witness to its permanence, and thus points to its universality. Such

naturalization by way of dehistoricization and universalization comes across quite clearly in this other text, which was explicitly meant for a popular audience.

> This is not a *new problem*, as some might think. It must be remembered that it is *eternal*. Many people believe that the divorce between artist and audience is a recent phenomenon . . . Indeed, the break became apparent in the early days of what has improperly been called 'impressionism'; but the phenomenon as such goes back a lot further. If we were to draw up a list of all the great artists throughout history who died in poverty because of their contemporaries' *complete failure* to understand them, we would be overwhelmed.[2]

Besides its temporal extension in the history of painting, the new 'Vangoghian' paradigm has come to be applied retrospectively in other disciplines. This is especially true of the motif of the unfinished work of art. Each field of artistic expression seems to have at least one typical example of this, which is celebrated in the same manner as van Gogh is. In music one thinks of Mozart, who died at the age of 35, in poetry of Rimbaud, dead at 37 (and whose dates of birth and death, 1854–1891, coincide almost exactly with van Gogh's), and in cinema of Vigo, dead at 29. They were all creators prevented from completing their work by a premature death. They were all victims of illness or, directly or indirectly, of their social environment's incomprehension. A shroud of mystery surrounds their birth (van Gogh and his dead brother), the origin of their talent (Mozart the child genius), an episode of their life (Rimbaud in Abyssinia), or the fate of their life's work (the loss of the original version of *L'Atalante*, before it was reconstructed by its admirers). During their lifetime, they had to face adversity (hatred, jealousy, or incomprehension). But someone (father, brother, friend, producer) had confidence in them, and a small circle of the elect recognized them while they were still alive, granting them esoteric success in the absence of any success in the marketplace. At any rate, their work proved strongest, and posterity celebrated its triumph, since they were rehabilitated after their death, precipitating pilgrimages (distribution of their works, biographical inflation, and visits to their gravesides).

In these various incarnations of the prophetic artist, the Christlike image of a persecuted and as yet unrecognized savior does not suggest the poverty of a prophet as much as the dereliction of an ignored and abandoned creator. Van Gogh has not just become the 'model' of this image, in Scheler's sense of the term, he is virtually its eponym. As one journalist put it in an interview: 'Christ said: in what beggar will you recognize me? Van Gogh said: in what artist will you recognize me?'

> No one has been more completely ignored . . . He is almost too perfect an embodiment of the artist who garners only contempt during his lifetime, and whose work is universally acclaimed today . . . Vincent van Gogh was congenitally destined not to be understood. He is a man who spent his life not being understood, and not just with regard to his art.[3]

Far from being the cause or source of these upheavals, which in many respects were already germinating before him, van Gogh was no more than a particularly

successful embodiment of them. However, the constitution of his legend, and its propagation to a very broad audience, made him an exceptional vehicle for the exemplary achievement of transformations that had hitherto remained potential, confidential, or conflictual. Van Gogh really does represent a paradigm therefore. On the one hand, he crystallizes, if not a consensus, at the very least a new norm, a new *doxa* where representations of the artist are concerned. On the other hand, this representation can be generalized, transposed to other artists in the past and the future, as well as other disciplines. Having established this, it is necessary to restate what constitutes the novelty of van Gogh, what makes him a modern figure, how he marks a break with the traditional standards of artistic excellence.

A new order

A first characteristic of this new order is the personalization of artistic greatness. The importance ascribed to the signature is one of the most visible symptoms of this. Little by little, radical innovations have come to be regarded as normal. For example, artists place their own particular stamp on their works. Similarly, their intimate lives are displayed in the public sphere through the publication of their letters or the proliferation of biographies. Simultaneously, the interiority of the creator becomes the origin and guarantee of creativity in principle and not by accident.

As a corollary of this personalization, abnormality comes to be accepted, even valued. This extends from the mere assertion of originality to the systematic transgression of the norm, of 'what is done' according to the codes, conventions, or canons of representation. It is then inevitable that creators cease to conceive their work as a replication or manipulation of canons inherited from established traditions, and instead relate it to the interiority of determinations independent of the common law. To be sure, the exceptional is nothing new in art history, which has seen many extraordinary creative personalities. Michelangelo is one of the earliest and most famous examples of this. What has changed with the Vangoghian paradigm is that abnormality is no longer valued as an exception, but as the rule. The normalization of the abnormal is an *a priori* principle of excellence that applies to every artist. Henceforth, normality in art consists of being outside of the norms. What is beyond the norm is systematized *as* a norm crystallized around the case of van Gogh, and from now on dictates that what 'is not done' is what *is to be done*. The passage from an ethic of conformity to one of rarity thus comes to hold true for common sense, and not just for specialists who have written about van Gogh's work.

One of the many consequences of this paradoxical phenomenon is the extraordinary economic exploitation of everything that remains of the artist, in the shape of works and relics. The price explosion on the art market does not just affect those who were 'sacrificed' – among whom van Gogh ranks first – but also, from Renoir to Picasso, many representatives of the new art world, in which excellence, once recognized, is measured in the absolute terms of singularity rather than in relation to the competition, and in which it is thereby sanctioned in the immensity of a world beyond the norms – the norms of the market.

Another corollary of this 'negative normalization' is the way that the notion of

beauty is discredited as a standard for evaluating the quality of works of art. On the one hand, beauty can no longer be measured according to a common scale of values. On the other hand, it becomes a secondary end when the expression of an artist's own personality, creative process, or experimentation counts for a lot more than the production of delightful objects for the consumer. This relative dismissal of the criterion of beauty marks a change in the nature of evaluation. The latter now focuses on an earlier phase of the creative process, on the producer instead of the spectator. Henceforth, the work is to be judged less in function of the spectator's feelings, and more in function of what the producer was 'trying to say'.

This phenomenon is limited, however, to the scholarly sphere of the modernist discourse on art, the only place where specialists jettison the traditional arguments around beauty. The latter remains an essential ingredient of the ordinary process of evaluation. This points to another important consequence of the new application of the ethic of rarity to art, namely the break between specialists and the uninitiated, scholarly discourse and common sense. That break occurred in van Gogh's day and has only become worse, culminating in today's relegation of artistic avant-gardes to a ghetto. But in addition to ascribing value to code-breaking and to artistic exploration beyond the norms, scholars seek to dissociate themselves from the emphasis on personalities preferred by humanist psychologists, and instead ascribe primacy to the works themselves, as formalist aesthetes do. The latter tend to be interested exclusively in the intrinsic characteristics of a work. They view it as a vehicle less for experiencing beauty or expressing a personality than for experimenting with a technique specific to the medium in question, or for reflecting on broader phenomena.

Contemporary incomprehension and misappreciation are a necessary effect of breaking away from the canons. As such they have become an almost inevitable image, much used in advertising to get people to buy popularizing books (see Box, p. 127). This motif has become so basic that recognition which comes too quickly provokes suspicion, irritation in the face of institutions' zeal in rehabilitating artists and their work, or nostalgia for an era when 'sacred fear' still existed. The logical, though seemingly paradoxical, outcome of ascribing value to rarity is that the initiates roundly condemn popular understanding of van Gogh and infatuation with him. 'Reproductions of van Gogh are in greatest demand. There is hardly a home without a reproduction of one van Gogh painting or another. You will admit that such general success, following on such total incomprehension, presents a real problem . . . This attitude of smug admiration is relatively recent . . . It could create misunderstandings even more tragic than that in which van Gogh perished.'[4]

Finally, the logic of rarity and the necessity of incomprehension entail that the moment of success or consecration must be displaced onto posterity. All genuinely innovative creators can only clash with the common outlook, with their contemporaries' *doxa*, because they contravene the accepted norms. This will continue until such time as the common outlook has changed (in part because of their efforts) and they can draw recognition from it. But that often happens too late for them to profit from it during their lifetime. In today's art world, success becomes ever more undeniable the longer public demand is deferred. In the world of commerce, by contrast, success must be great *and* swift. The value of immediate *notoriety*, which could always be discredited as an indicator of conformity, gives way to the value

EXPLOITATION OF THE MOTIF OF
INCOMPREHENSION IN ADVERTISING

'Until the end of the nineteenth century, the impressionists were all despised . . . Nowadays, it is understood that they prevented the death of the art of painting, and ushered the latter into the Twentieth Century' (for a book on the impressionists).

'You will have recognized those childlike signatures. They belong to the impressionists, who rank among the very greatest, but who were despised, even hated during their lifetimes . . . Although hungering for recognition, they were not recognized, and remained orphans of their time, few of them ever knowing fame or fortune. When Monet lived in Vetheuil, he would sometimes trade a painting for a basket of eggs . . . in order to eat, and to be able to keep on painting the Seine! Indeed, who would have staked so much as a penny on the future of such painters, whose works were shot down in flames by the critics? Today, their works are worth tens of millions of dollars. There is a mystery. *You will find the key to this mystery in the book, The Impressionists.* Page after page will reveal the gigantic gulf separating those painters from their predecessors, so different were they. You will discover the rich creativity through which these artists revolutionized our way of seeing the world, and you will understand why they were rejected for so long' (for a publication devoted to art).

'Van Gogh, too, was criticized' (for a line of bras).

ascribed by posterity, in which the encounter with a mass audience is deferred till later. Hence, immediate success only has credibility if it involves a small circle of initiates (brief time, restricted space), while large-scale common recognition only has credibility through the mediation of time (long time, extended space).

Such displacement from present to posterity is essential to any kind of avant-garde, because immediate success could only sanction living up to the norms, reproducing accepted traditions, and therefore the inability to transform the latter. Because of its very self-evidence, it may be that insufficient attention is paid today to the importance of this paradoxical inversion which, by extending the temporality of reference, makes it possible to construct excellence by way of ignorance, and to transmute the blackest instances of failure into proof of value or, at least, into favorable arguments. The world of modern art, more than any other, has thus become the place where, in conformity with the Gospels, the last always have good reason to hope that they will one day be first.

The new Vangoghian paradigm quite literally embodies a series of shifts in artistic value, from work to man, from normality to abnormality, from conformity to rarity, from success to incomprehension, and finally, from (spatialized) present to (temporalized) posterity. These are, in sum, the principal characteristics of the order of singularity in which the art world is henceforth ensconced. That is the essence of the great artistic revolution of modernity, the paradigm shift embodied by van Gogh.

The test of posterity

The displacement of the moment of achievement to posterity is a *test*, in every sense of the term. To begin with, it demands the ascetic disposition (the 'patience' of martyrs) that makes it possible to bear the pain or vacuousness of the present. Once the test has been accepted, it rules out the innocence that guarantees the authenticity of sacrifice. Van Gogh, after all, lived without knowing what an 'accursed artist' was, since he himself so to speak created that role before the play had even been written, before his life had been turned into a legend. But *after* van Gogh, no artist can ignore that suffering and failure could meta-morphose into a form of martyrdom, into glorious testimony to his faith in the greatness of his as-yet-unrecognized art. The same difference exists, if the expression is permitted, between heresy before heresy (that of Manet or van Gogh, who worked in a world not yet reconstructed in the 'tradition of the new'), and heresy after heresy, represented by a Picasso, a Duchamp, or a Dali, who were able from the start to constitute renewal as a paradigmatic value, and not a merely particular, or even momentary, consequence of a lone individual's work. No artists today could be innovators without seeking to be so, any more than they could sacrifice themselves innocently, and therefore authentically, to their art, as van Gogh did in an era when (if I may speak thus) 'it was not done'. That innocence is lost, at any rate, and that loss became irreversible after van Gogh. For that reason, we *cannot* return to van Gogh, to paraphrase Artaud while contradicting him.

Despite these pitfalls, the test of posterity is a key dimension of the new artistic paradigm, for it retrospectively transforms into truth what was only an exploration in the eyes of the artist, and into necessity what was experienced as highly uncertain, what was open to doubt and error. Every judgement after the fact confers the value of necessity on a historical moment, by framing it in an evolutionary process that is seen as what *had to happen*, simply because *it did*, that is, as the truth of history, the truth of art. Hence impressionism and van Gogh had to be stages in the development of painting for it to be what it is in the eyes of posterity. From this ex-post perspective, each painter's endeavors appear as a search for this or that truth, as a movement that could only lead to this or that point. 'Art' is thus seen as the very opposite of random; it is regarded instead as the object of an ineluctable and mysterious truth, while artists are construed as its prophets, or at least precursors, both visionary and blind.

Teleological reconstruction in posterity also contributes to the development of collective guilt, which is born of the gap or dissymmetry between the moment when the truth was uttered and the moment when it was heard. As it only occurs after the fact, the revelation of the singular one's greatness grants him the anticipatory role of a prophet or precursor, and turns his curse into a form of prediction. The act of deviation becomes a power of anticipation, and anticipation a power of renewal. Whether he is in the avant-garde without being aware of it, or whether he is consciously or unconsciously working at being part of it, the deviant creator who cuts himself off from tradition takes on the risk of failure, while having a chance of becoming the founder of a new tradition for posterity – as well as the victim of fresh incomprehension. But the test of success is delayed till much later. That is why great

creators, in the order of singularity through which modern art is evolving, are great precisely to the extent that they are *ahead*.

A religion of art?

Symmetrically, 'society' (with its representatives in the specialized world of dealers, historians, critics, curators) is at fault with respect to creators to the extent that it is *late*. Being late is the temporal form of indebtedness, whereas being ahead is the form of the gift, in the dual sense of a 'gift' from nature to the talented artist, and a 'gift' from the creator to his art in the form of abnegation and the sacrifice of immediate rewards. The motif of guilt becomes a cliche, and 'the culpable in-difference of official circles' is repeatedly and regularly stigmatized. The attribution of guilt and the passage to posterity combine to transform the error committed by the artist's contemporaries, and especially art galleries, into a fault perpetrated against the artist, with the concomitant consequences, that is, debt, redemption, atone-ment. Hence, with the new paradigm, guilt bursts on to the artistic scene for the first time in history.

This innovation provides a good illustration of how sacrifice opens up a gulf between the world of the artists that has potentially been made sacred, and the profane world of their admirers. Van Gogh embodies precisely such a consecration, in both senses of the word (sacralization and apotheosis). It is a consecration of art as a sphere into which expectations traditionally taken up by religion may henceforth be projected. The 'tension' between 'ethical religiosity' and 'aesthetics' analyzed by Max Weber, is replaced by a religious investment in aesthetics. As people desert the churches to fill the galleries, art is no longer an instrument, but instead an object of sacralization.

The religious organization of the artistic world comes in many forms today. Widely circulated reproductions are but substitutes for the pious images sold at the door, in those places where the ordinary person can experience the presence of the originals, preserved as relics. Similarly, immortality has become the concern of galleries and museums, those modern temples that people like best to visit on Sundays, when admission is free for everyone, just like in church. The Van Gogh Hospital, recently inaugurated as a place of culture in Arles, has been described by an official in the very words that would be used to describe a place of worship: 'permanent', 'dedicated' to contemporary creation, and 'open' to the general public.

The curator's profession also takes on the guise of a modern, secular form of the religious bureaucracy described by Max Weber. The poverty traditionally associated with the job may partly be attributed to its feminization and bourgeois origins. But it seems to have as much to do with a spirit of priesthood, by virtue of which the curator is the least self-interested of people, and is wholly devoted to the common good of art. Similarly, the most modern attempts at popularization by opening up galleries to new publics sometimes seem like a kind of proselytizing with religious overtones. Finally, it seems impossible not to regard the current inflation in pur-chases by state-owned galleries as an echo of the trauma inflicted on the profession by mistakes about paintings, which became offenses against artists committed several generations ago.

Today, as in the Middle Ages, lighting for artworks in Italian churches is still provided by the faithful, who drop a hundred lira into an electrical device to illuminate a work of art for a minute or two. Similarly, the fund recently set up to enable the state to purchase a painting by Georges de La Tour illustrates how the faithful participate in enriching the treasure of liturgical objects. Art is henceforth the emblem, and even the core, of the nation's heritage. The state can ban exports of works of art, just as much as order the restitution of an artist's remains, as in the recent 'affair of state', when Belgium refused to return David's ashes to France. Art is no longer a private affair, but pertains to the general interest; any privatization of great works may thus be condemned. 'Art belongs to all, and no one may prevent anyone else from creating', according to a jewelry advertisement warning against forgeries.

'We earlier asked what our expectations of art are today. But the answer is simple: all that we expected of religion in former times. And we expect painters to be saints.' In the scholarly world, painting has become the primary site of theological investment. For instance, a recent work explicitly applies the themes of dedication and redemption, atonement, and sacralization to the painter's activity.

While certain religious tendencies are displaced onto a certain art world, 'religion' does not for all that subsume 'art', any more than there is any identity of the two areas. This is demonstrated by the condemnations leveled at such displacement, which have compelled me to disengage from any critical dimension by treating the common practices and scholarly denunciation of art and religion symmetrically. Indeed, it is not my purpose here to 'disclose' that van Gogh, or artists generally, are treated as saints. To a great extent, common sense already guesses it, while the scholarly world has already argued that it is so. But this only describes part of the phenomenon. To be content with tying admiration for the artist to veneration for the saint would be to neglect to ask why the former does not explicitly take on a religious guise, why this saint is not a canonical, but a 'lay' saint, made and appropriated by the laity. Why, for example, does no one, to our knowledge, pray to Saint Vincent van Gogh? Neither would we understand the function of applying the most traditionally religious forms of celebration to an object that is not religious. That function is one of distantiation with respect to religion. This is illustrated by the art lover's denunciation of the reductionist violence of sociologists, who deny the specifically secular nature of the aesthetic investment, in order to highlight the religious backdrop of 'love of art'.

Reactions to sociological analysis (e.g., embarrassment or laughter at the use of the term 'pilgrimage' in connection with the centenary exhibitions) must be taken into account if we are to understand that love of art is far from being an illusion about its own (religious) nature; rather, it allows people to be made sacred without being canonized. To put it another way, it makes it possible not to throw away the baby of veneration with the bathwater of religion. It reconciles attachment to objects of admiration that are initially noncanonical, and then are canonized by the community of art lovers, with detachment from the canonical forms of religion. This rejection of all instituted authority (whether in the form of the artistic tradition or the church) is a way of reconstituting, on a new basis, a community that is 'reauthenticated' because it is directed against the recognized forms of acknowledged faith. That is why van Gogh comes across as a Protestant saint.

References to religion here are in no way metaphorical. I have not proceeded 'as though' art were 'a kind of' religion, fabricating a rhetorical trope, weaving a metaphorical thread, which could not be faulted any more than it could be taken seriously. The religious model is no mystification, no lie or illusion dissimulating the truth about the object. It is a historical fact, as much because, in general, the Christian religion precedes modern painting, as because, in particular, van Gogh the preacher precedes van Gogh the artist. The religious model is not, however, an explanatory matrix or key, any more than it is a metaphor or a mystification. Indeed, before the case of van Gogh could be explained in terms of religious saintliness, the latter would at least have to be defined with some precision, something theologians and anthropologists admit is far from having been done. Any reduction of love of art to religious veneration would lead to burying the question rather than answering it. What should be done instead is to take advantage of the process of displacement or decontextualization of religious behaviors toward the artistic domain, in order to bring out the fundamental components of what is called 'saintliness' in a religious context, and 'heroism' or 'genius' elsewhere. Depending on its extent and context, it is a phenomenon pertaining to love, admiration, celebration, veneration, or idolatry.

To understand the van Gogh effect, we therefore had to extricate ourselves from the *a priori* categories of 'religion' and 'art', and to regard them not as given facts, but as mental constructs, which organize the perception of phenomena that, under various forms, are common to different universes. Their shape and definition vary historically, as the case of van Gogh remarkably illustrates. Voragine's model, which has guided this narrative of secular sanctification, is consequently neither a simple metaphor, nor a pure literary artifice. Deviation, renewal, reconciliation, and pilgrimage are the major stages through which a community embraces a singular individual, binds itself to that person by gift and debt, and by that mediation consolidates itself through shared guilt toward a redeemer who is to be redeemed.

Notes

1 Pierre Cabanne, *Van Gogh* (Paris, Aimery Somogy, 1973), pp. 237–238. Emphasis added.
2 Bob Claessens, *L'Incompréhension devant l'art. Un exemple: Vincent Van Gogh* (Brussels, 1973), p. 5. Emphasis added.
3 Claessens, *L'Incompréhension devant l'art*, pp. 5, 9, 10.
4 Claessens, *L'Incompréhension devant l'art*, pp. 7–8. In the same spirit, Claessens denounces the 'misunderstanding' underlying the popularity of the great artists Giorgione, Titian, and Rubens: 'Their case was perhaps more tragic still . . . Their success was above all based on a misunderstanding; they were admired for what was least great about them. People were attached to the minor aspects of their works; their true contribution was not understood. Cocteau, in a lesson of heroism to artists, was so right to say: "If the public criticizes something in you, cultivate it; it is you." '

Norbert Elias

CRAFTSMEN'S ART AND ARTISTS' ART

From *Mozart: Portrait of a Genius*. Cambridge, Polity Press, 1993, pp. 42–9.

IN DECIDING TO QUIT his service in Salzburg and entrust his future to the favour of Viennese good society without a permanent post, Mozart was taking a very unusual step for a musician of his rank at that time. But it was of the utmost importance for his musical production. For the canon of music production by court artists who worked for a particular employer, according to his instructions and needs, differed strikingly, on account of the specific social figuration in which their music had its function, from the new canon which gradually formed as music production by relatively free artists competing for a mainly anonymous public became the rule. To express this in traditional terms: with the changed social position and function of music makers, the style and character of their music also changed. The special quality of Mozart's music undoubtedly stems from the uniqueness of his gift. But the way this gift expressed itself in his works is very closely bound up with the fact that he, a court musician, took the step to 'freelance' status in a sense too early, at a time when social development allowed such a step but was not quite ready for it institutionally.

However, the difficulty and recklessness of this step emerge clearly only if it is seen in the wider context of the development leading from craftsmen's art to artists' art, from art production for particular patrons, usually social superiors, to production for the anonymous market, for a public which is by and large the artist's equal. Mozart's social existence, the peculiarity of his social fate, shows very clearly that the switch from craftsmen's art to 'free' artistic creation was not an abrupt event. What took place in reality was a process with many intermediate stages, the central phase of transformation occurring later in the case of music, as can be seen, than in the case of literature and painting. Mozart's life is easier to understand if is it

seen as a micro-process within the central transformation period of this macro-process.

To point out that what is usually called the 'history' of art is not just a kaleidoscopic sequence of change, an unstructured succession of styles or even a fortuitous accumulation of 'great' men, but a definite, ordered sequence, a structured process going in a certain direction and closely bound up with the overall social process, is not to imply a hidden heteronomous valuation. It is not to suggest that the art of 'free' artists for a market of unknown customers is better or worse than that of craftsmen produced for patrons. From the standpoint of our present-day feelings the change in the artist's position under discussion here may well have been a change 'for the better' for the people concerned. But that does not mean it was such for their works. In the course of the changing relationship between those who produce art and those who need and buy it, the structure of art changes, not its value.

As Mozart's revolt in the sphere of music represented a step forward in the transition from the employed to the 'free' artist, it is worthwhile to consider one or two aspects of the change in the position of the artist and the structure of art that this unplanned process brought with it. This can be done best if the artist and his customers are imagined standing on the two pans of a scale, like weights. This implies that the relationship between artists and consumers, no matter how many intermediate links there may be between them, involves a specific power balance. With the transition from craftsmen's art to artists' art this balance changes.

In the phase of craftsmen's art the patrons' canon of taste as a framework for artistic creation had preponderance over the personal fantasy of every artist. Individual imagination was channelled strictly according to the taste of the established patron class. In the phase of artists' art those creating art are in general socially equal to the public which enjoys and buys art. In the case of their leading cadres, their specialist establishment in a given country, artists as the moulders of taste and the vanguard of art are more powerful than their public. With their innovative models they can lead the established canon of art in new directions, and the broad public may then slowly learn to see with their eyes and hear with their ears.

The direction taken by this change in the relationship between art producers and art consumers and *pari passu* in the structure of art certainly does not exist in isolation. It is one strand in the wider development of the social units which provide the framework of reference for artistic creation at a given time. And it can be observed only where the development of the social framework is moving in the corresponding direction, that is, in conjunction with a growing differentiation and individualisation of many other social functions, or with the displacement of the court aristocracy by a professional bourgeois public as the upper class, and thus as the recipients and consumers of works of art. On the other hand, such a change in the relation of art producers to art consumers is by no means strictly tied to the particular sequence of events in Europe. A change in a similar direction is found, for example, in the alteration in the craftsmen's art of African tribes as they reach a higher stage of integration, where the previous tribal units merge into state units. Here too craft production, perhaps of an ancestral figure or a mask, slowly frees itself from dependence on a particular buyer or a particular occasion within a village, and changes into production for a market of anonymous people, such as the tourist market or the international art market mediated by dealers.

Wherever social processes of the kind just sketched take place, specific changes in the canon of art-creation and correspondingly, in the structural quality of art-works are discernible. These latter changes are always linked to a social change affecting the people bound together as art producers and consumers. Unless the connection between them is clarified the two sets of changes can at best be superficially described, but hardly explained or made comprehensible.

[. . .]

To get a clearer picture of this process we should imagine two positions within it which are polar opposites, two stages very far apart in the structural change under-gone by the relationship between the producers and consumers of art. In one case, where a craftsman-artist works for a particular client known to him, the product is usually created for a specific purpose prescribed by society. It might be a public festivity or a private ritual – whatever it is, the creation of an art product requires the personal fantasy of the producer to be subordinated to a social canon of art-making sanctified by tradition and secured by the power of the art recipient. In this case, therefore, the form of the artwork is shaped less by its function for the individual producer and more by its function for the client and user, in keeping with the structure of the power-ratio.

Here, the art users do not comprise an accumulation of individual art con-sumers, each of whom is relatively highly individualised, embodying in isolation from the others the instrument, as it were, with which the artwork resonates. Rather, art is attuned to recipients who, even independently of the occasion on which art works are presented, form a fairly tightly knit group. The artwork derives its place and function for the group from fixed occasions when they come together – for example, at an opera performance. Not the least of the art-work's functions, therefore, is as a means for the society to display itself, both as a group and as individuals within a group. The decisive instrument with which the work resonates is not so much individuals in themselves – each alone with his or her feelings – but many individual people integrated into a group, people whose feelings are largely mobilised by and orientated towards their being together. At these earlier stages the social occasions for which art-works were produced were not, as in our day, dedi-cated specially to the enjoyment of art. Human works in earlier times had a less specialised function in a wider social context – for example, as images of gods in temples, as adornment for the tombs of dead kings, as music for banquets and dancing. Art was 'utility art' before it became 'art'.

When, in conjunction with a push towards broader democratisation and the corresponding widening of the art market, the balance of power between art pro-ducers and art consumers gradually tilts in favour of the former, we finally reach a situation of the kind which can be observed in some branches of art in the twentieth century – especially in painting but also in elite music and even in popular music. In this case the dominant social canon of art is so constituted that the individual artist has far greater scope for self-regulated, individual experimentation and improvisa-tion. In manipulating the symbolic forms of his art, he is far more free than the craft artist to follow his own personal understanding of their sequential patterns, their expressiveness and his own highly individualised feelings and taste. Here the work of art depends in large measure on individuals' self-questioning as to what pleases them

personally in their materialised fantasies and experiments, and on their ability sooner or later to awaken a resonance in other people through these symbolic structures. The collective pressure of tradition and the tightly knit local society on the production of the artwork is reduced; the self-constraint by the individual art producer's conscience increases.

The same applies to the resonance produced by the work. The occasions on which works of art – such as organ music at a religious service or paintings as palace ornamentation – are addressed to groups of people assembled for other purposes grow less frequent in the fields of painting, music and literature.[1] At this stage the work of art is directed more than previously at a public of isolated individuals – such as the loosely integrated multiplicity of a metropolitan concert audience or the mass of visitors to a museum, each of whom goes alone, or at most in isolated couples, from picture to picture. Securely insulated from each other, each of them questions himself or herself as to the resonance of the work, asking if they personally like it and what they feel about it. In both the production and the reception of art an important part is played not only by highly individualised feelings but by a high degree of self-observation. Both bear witness to a high level of self-awareness. In some works, such as Picasso's variations on Velasquez's painting of the Spanish Infanta, the problem of artistic self-awareness is clearly involved in the shaping of the work. In such cases the art recipient's awareness that his or her own individual response is a relevant aspect of every work is particularly pronounced.[2]

In this phase of the development of art, therefore, individual artists (Picasso, Schoenberg) or even small groups of artists (expressionists, atonalists) have greater importance as leaders of artistic taste. Again and again a few artists rush far ahead of the canon of art understanding in their field and – whatever the difficulties of reception may be – they do not fail as a result. The word has got round that artists are prone to 'wild' or at least unusual behaviour, that they invent new forms that the public at first fails to perceive as such and therefore to understand; this is almost a part of the artist's job.

Of course, to begin with it is often very difficult to distinguish between successful and unsuccessful innovations in art. The enticingly wide scope for individual invention opens the door to failed experiments and unformed fantasies. In other words, the more differentiated, relatively developed societies have cultivated a comparatively high tolerance for highly individualised ways of further developing the existing art canon; this facilitates experimentation and the breaching of stale conventions and can thus help to enrich the artistic pleasures available through seeing and hearing. Admittedly, this is not without costs and risks. De-routinisation can itself congeal into convention. But in general the difficulties of communication that artistic innovations entail are more easily absorbed. They may give rise to conflicts; but there are social agencies (art historians, journalists, critics, essayists) who try to bridge the gaps, to soften the impact of artistic adventures and ease the transition to unfamiliar ways of hearing and seeing. If many artistic experiments turn out to be no more than stimulants or failures, experimentation has value in itself, although only a limited number of innovators pass the test of repeated acceptance by several generations.

Among the most interesting unanswered questions of our time is that of the structural characteristics on the basis of which the products of a particular person

survive the selection process of a series of generations and are gradually absorbed into the canon of socially accepted works of art, while those of other people lapse into the shadowy world of forgotten works.

Notes

1 In architecture, and therefore sculpture, they are more prevalent, although examples like Le Corbusier or the Bauhaus show that in certain phases of the development of architecture innovative specialists can play a very important role as pace-setters for public taste.

2 The development indicated by the use of the terms 'objective' and 'subjective' to characterise different musical styles is of relevance here. It has two preconditions: first, a shift in the balance of power in favour of artists, allowing them to use their music to a higher degree as a means of expressing individual feelings; and second, a change in the structure of the music-loving public, involving an increase of individualisation. The recipients of 'subjective' music, too, were more concerned than at the time of 'objective' musical styles that music should arouse, give voice to their very personal feelings, and perhaps to suppressed feelings.

David Brain

MATERIAL AGENCY AND THE ART OF ARTIFACTS

From 'Cultural production as society in the making: architecture as an exemplar of the social construction of cultural artifacts', in D. Crane (ed.), *The Sociology of Culture*. Oxford, Basil Blackwell, 1994, pp. 203–16.

The art of artifacts

ONE OF THE CONSEQUENCES of investigation of the social construction of technological artifacts is an awareness that artifacts are profoundly under-determined by social processes or technical considerations. This underdetermined quality of artifacts has provided the grist for interpretation. Interpretive approaches begin, as Baxandall (1985: 14–15) notes, with the assumption that '[t]he maker of a picture or other historical artefact is a man addressing a problem of which his product is a finished and concrete solution'. For any work, it is presumed, one should be able to sort out the ways in which it was historically determined, the frameworks of meaning it embodies, and the specific meanings invested in it by actors with a pragmatic stake in a particular context (Baxandall 1985; Griswold 1987).

Paradoxically, such accounts often imply a kind of determinism insofar as they locate the sources of a specific project, and the specificity of its execution, in environmental contingencies, while at the same time they highlight the precise ways in which the project or product is underdetermined by its circumstances. Faced with objective constraints and operating within a framework of cultural presuppositions, the creative subject makes choices that reveal both a rational intent and a particular style of action. Against the background of imputed rational intent, an interpretive approach illuminates the agent of cultural production as a particular subjectivity. Interpretation traces the putative author's steps in producing a meaningful object, but takes for granted the skills and practices which enable the agent of cultural

production to shape available material into a particular kind of response to the heterogeneous conditions of the brief – or, for that matter, to recognize a particular brief in a complex array of conditions which might support any number of cultural productions.

In the world of artifacts, we are confronted with a play of qualities that present themselves as intentional (as the trace, expression, or purposeful act of a subjective capacity), and those that present themselves as natural or unintentional (as objective circumstance, as accident, or as noise). Bourdieu has referred to the 'permanent teleological character' of things. Where interpretive approaches have sought to capture the teleology in 'thick description', – and structural approaches have sought to identify its determining conditions, my argument leads to the question of how this 'teleological character' is registered. By what practices is the boundary between the intentional and the contingent marked in the material of the object itself, and what articulations of the social world are thereby implicated in the structuring of artifacts? The distinction between the subjectively intended and the objectively given is achieved, not found. It is an accomplishment that is far from automatic or natural, perhaps especially when it seems so.

The fit between form and function, or form and intention, or form and meaning, relies on a practical sense that underlies any intentional adjustment of an artifact or technology to the 'objective' demands of a task, by determining the mutual configuration of task and technique. Form is given to function with what Bourdieu calls 'the arbitrariness of culture', but in a manner that is rooted in the practical experience of a socially constructed world. The transcription of function or meaning into form involves a system of representation: even technical solutions to technical problems might be seen as not only solving the problem but representing themselves as solutions, in a particular interpretive context. Furthermore, the fitting of form to function is carried out with a rhetorical flourish that represents the intentional quality of the artifact, a practical rhetoric that utilizes what Foucault calls 'enunciative modalities' to refer back to an agent. This practical rhetoric operates in the gap between rational intent and the thing itself, as a modulation of the residue of arbitrariness in any form, and establishes the status of the object, the status of the author, and in this way, the character of the social world as a domain of practical action.

This, I argue, is the 'art' of artifacts. What we recognize in both technical artifacts and works of art is a pattern of intention that refers to a domain of possible intentions, and our interpretive (as well as practical) grasp of this pattern depends on the way the artifact makes its intentional quality manifest. The 'artful' quality of the object depends on the practical rhetoric with which the inscription of the author's status is effected. Bourdieu notes that artistic production 'always contains something "ineffable" ' (Bourdieu 1990: 34). I suggest that this 'ineffable' quality is a fundamental aspect of the effect of signification. These aspects of the object cannot be interpreted directly as an expression of an intention because they are the condition for recognizing the object as intentional. In the inscription of patterns of intention in the world of things, in the qualities of artfulness that carry the rhetorical freight of this inscription, the authority of the subject is enacted and objectified. As technological artifacts are stabilized, they may come to look more and more like purely technical engineering, and typically, to carry less and less representation of

their authorship. The key difference between technical design and artistic produc-
tion is that the latter involves particular rhetorical practices that represent distinct
modes of intentionality.

In the arts, the specialization of aesthetic practices gives particular ritual
emphasis to the inscribed author. In science, on the other hand, a great deal of
energy is devoted to eliding the presence of an author in the finished product of
scientific truth while allowing the author to remain useful as a point of reference for
'science in action' (Latour 1987). The modalities of authorship inscribed in artifacts
focus our interpretive attention, organize our capacities for self-conscious cultural
creation, and embed our creations (as well as the act of creation) in a social world.
They make it possible to recognize objective possibilities for subjective action in the
world of artifacts. At the same time, they represent an inscription of a moral order, a
configuration of relations between author and audience, and an authorization of an
agent to undertake responsibility for a certain kind of representation.

Art offers a particularly clear and historically significant illustration of the social
character of cultural production. Practical modalities in the work itself refer to the
fact of an agent's involvement in the text, mark the work's status in an institutional
field, and frame possibilities for interpretation. Abstracted from their original social
settings, the interpretive practices associated with an 'aesthetic disposition' have
provided a paradigm for the embodiment of a theoretically informed practice in a
specifically qualified and authorized agent. In this sense, an aesthetic disposition can
be incorporated into a variety of practices, as a general strategy for translating the
demands of a field of operation into capacities and dispositions of authorized sub-
jects. Aside from its function as a means of social distinction, art is a ritualized and
abstracted enactment of a form of agency that can be transposed to other practices –
not just to those related to making social distinctions between the classes, but to the
construction of other forms of cultural authority.

The practical logic of modernism

The analytical framework outlined above suggests an understanding of the trans-
formative impact of 'modernism' on architectural design in the USA that runs
counter to the usual critical and historical accounts. Standard critical histories of
architecture tend to focus on the evolution of paradigmatic architectural forms, a
process reconstructed as cycles of creative innovation and stylistic elaboration.
Social histories of architecture reveal the impact of social, economic, and political
factors on the development of both ideas about architecture and architectural forms.
My analysis attempts to fill the gap between a history of architectural ideas which
focuses on their immanent logic, and a history of architectural developments which
emphasizes their determination by broader social and historical forces. Architects
have mediated between the external exigencies of social structures, economic con-
straints, political processes, and the organization of space and materials in the
production of built form. As a discipline, architectural design is sustained by a
specific structure of cultural agency that has been embedded in the social structure
of the profession.

Since the historical argument is complex, this chapter focuses on only one

aspect of it: the way architects responded to the task of translating the social problem of housing into an *architectural* problem in the context of the federally subsidized housing programs of the New Deal. In responding to the demands of these programs, architects accomplished two things at once. First, they enlisted government agencies, housing reformers, academics, planners, political constituencies, the prevailing winds, the angle of sunlight on building sites, construction techniques, and European formal paradigms in the actor network that enabled them to give form to these projects. At the same time, they institutionalized a new mode of design and redefined their own capacities as agents under new conditions: designing housing for an abstractly defined user group, in service to a bureaucratic agency within a democratic state, against the background of a market system in crisis. In this context, they were able not only to respond to the changing circumstances of the profession, but to reconstruct their own authority in a practice that could represent itself as rational and dictated by the demands of the task at hand.

As the discipline of design was first formed in the United States, the problem of professionalizing design was not simply the problem of monopolizing building technology, which architects have never been able to do, but of constructing a relatively autonomous domain of architectural judgement with a distinctive niche in the division of labor. The ability of an occupational group to translate an inchoate demand into a definite service depended on their active articulation of a distinctive form of work, and the ability, embodied in the work itself, to sustain a framework of interpretation which gave specific cultural content to professional design. The routine work of producing drawings provided techniques for visualizing and manipulating architectural forms, and the practical site on which a particular occupational group was able to isolate the composition of architectural statements as a distinct practice. Anchored in the craft of drawing, this practice derived its content and legitimacy from reference to elite cultural traditions, but emphasized the forms of judgement required to adapt historical models to modern needs – to produce an *artful* yet uniquely *appropriate* composition.

The abstraction of a formal aesthetic provided the basis for defining a disciplined practice across diverse building tasks. Over the course of the nineteenth century, architects elaborated a domain of judgments regarding the visual qualities of architectural form, abstracting a coherent and rationalized practice from a canon of traditional styles and anchoring it in professional institutions. A rhetoric of architectural form associated architectural design simultaneously with a structure of justification and the authoritative judgement of a specially equipped individual. The concrete practices of design linked the immediate reality of architectural work to the reproduction of the boundaries of a professional jurisdiction and a durable market for professional services.

Even as the discipline of design was consolidated, however, it incorporated contradictions that it would finally confront in the first part of [the twentieth] century. Between 1890 and 1929, changes in the building industry, in the real estate market, and in the needs of an urban and commercial society, took a great deal of control over the physical form of buildings out of the architect's hands. The industrial production of new building materials and technological development in the area of mechanical services opened new architectural possibilities for which there were no governing precedents, while the economic demands of high-density urban

land use called for structures which were taller and less functionally specific. The problem was made more pressing by the growing scale and complexity of urban building, and by the emergence of new building types: the office building, the department store, the apartment building. New urban building tasks strained the architects' ability to adapt historical styles to bigger and higher structures, and at many points severed the already strained logical connections between building purposes and varieties of stylistic expression. In the late nineteenth century, the elite core of professional architecture was dominated by Beaux-Arts design practices that reflected the duality in the architects' situation (Brain 1989). The discipline provided by the canon of historical styles, the rules of composition, and planning principles of Beaux-Arts design, enabled architects to produce disciplined and authoritative architectural statements, but had very little to do with the conditions to which the architect was increasingly expected to respond. Beaux-Arts design reflected with painful clarity the disjuncture between rational planning at the level of the building's function, and the persistent historicism at the level of architectural form.

In the first two decades of the twentieth century, the profession split into two distinct factions. From within Beaux-Arts orthodoxy, which maintained an emphasis on precedent, there was concern to articulate a relationship between modern building needs and the historical styles. The traditional architect argued for discipline, but it was a discipline rooted in traditions that remained vulnerable to the whims of client taste and fashion. Others sought to escape the historical styles altogether, as all too obviously inappropriate to modern needs, and called for the formation of a distinctively modern style. However, experimentation with 'modern' styles only emphasized the arbitrariness of form, whereas the stripping of historical ornament raised doubts as to what would be left that was distinctively 'architectural'. At first, European modernism simply added to the eclecticism of the period (Benevolo 1977: 638). The link between form and function had no more apparent necessity than there had been with the historical styles. Throughout the 1920s, most of the profession seems to have given very little attention to contemporary European developments, except to note technical achievements or to disparage their architectural qualities.

Threats to the status and jurisdiction of professional architects posed by engineers, builders, and manufacturers in the 1920s were translated into the disciplinary problem of defining the relationship between aesthetic practice and technical rationality. What the discipline needed was a rhetoric of architectonic expression which could replace historical reference, representing both the fit between form and function, and their own agency. The achievement of an effectively modern mode of design was simultaneously a sociological and an architectural problem, since it would entail not only a new vocabulary of building forms, but the incorporation of new modalities of design into the institutional arrangements that sustained the coherence and status of a discipline, and the professional status of the architect. The public housing projects of the New Deal provided a context in which a new mode of design could be anchored in the practical realities of the profession.

In the first three decades of the twentieth century, the architecture of urban housing responded in direct and obvious ways to the economic demands of urban real estate. Moderate-cost housing presented a challenge to the architect, who had to work within tight budgets and respond to housing reformers' standards for the

provision of space, light, air, and privacy. These limits were reflected in a simplifica-
tion of ornament, a focus on site planning, and a kind of 'gadgeteering' approach to
design. As a design problem, the architectural quality of these projects resided in the
way they translated economy into clever spatial arrangements and efficient archi-
tectural gestures (a few projecting brick courses, some terracotta pieces). However,
these projects did not essentially challenge the status of the architects' discipline.
They could include a nod toward the architectural sufficient to establish respect-
ability, and the restriction of ornament could be read as an appropriate expression of
middle-class thrift. The simplification of architectural elements was not a denial of
their value, but a recognition of their differential appropriateness.

Whereas the problem of designing moderately priced housing for the middle
classes had involved a moderation of architectural expression that could be intelli-
gibly incorporated within a discipline that relied on the Beaux-Arts conception of
a hierarchy of styles and building tasks, federally subsidized urban housing made it
painfully clear that the distinctively architectural expertise of the Beaux-Arts
architect was largely irrelevant. As the buildings were stripped to unornamented
blocks whose forms were determined by various strategies for arranging basic
apartment plans around a service core, the remnants of the Beaux-Arts aesthetic
appeared only in the formal symmetry of apartment blocks arranged around
central axes. The Beaux-Arts architect, operating at the level of scale demanded
by the large housing project, could only treat the project as a kind of civic
monument.

Public housing raised the fundamental question of the discipline with particular
urgency: how to couple rationalized techniques with an aesthetic discipline that
materialized the practical authority of the architect. In the late nineteenth century,
architects had turned the distinction between architecture and 'mere building' to
their advantage. They responded to criticism and jurisdictional challenges by claim-
ing to represent a distinctive sphere of cultural concerns (Wright 1980: 63). During
the Depression, however, the significance of such a distinction shifted. Public hous-
ing could not be defined as an architectural problem, within the practical, ideo-
logical, and aesthetic framework of nineteenth-century design, with its dependence
on historicism for its justification of form. If architecture were something more than
mere building, then it seemed we could not afford it. Architectural statements were
also inappropriate for political and ideological reasons. In publicly subsidized hous-
ing, there was no room for decorative elaboration, the imposition of a formal ideal,
or traditional rhetorical flourishes. As a result, these projects constituted a serious
threat to the theoretical core of the discipline and the practical status of the
profession.

For this very reason, however, the public housing programs provided an ideal
site for working out the practical terms of a new mode of translation of building
function into architectural form. First, these projects were an opportunity to design
for an ideal rather than a real client, a user with abstract qualities and needs which
could be expressed in quantifiable terms. Alfred Kastner called attention to this in
1938, in a discussion of the role of the architect in housing. In the past, the profes-
sion 'revolved around the dominant thought that the juicy plums come from the
rich' (Kastner 1938: 228). A necessary reorientation would have to shift the basic
definition of architecture from a 'Decorative Art' to a 'Social Art'. This would

require a 'methodical approach' rather than 'the old line of eye-appealing façadism' (Kastner 1938: 229). 'Houses can be designed, as they should be: from the inside out according to the physical and psychological needs of the tenants' (Kastner 1938: 234). These needs are basic and obvious – light, air, quiet, exercise – and with the creative intelligence of the designer, require no extraordinary expense to fulfill. The modern architect designed not for the cultivated few, or for the cultural uplift of the masses, but for the human needs of the modern citizen, defined in terms of common rights and basic needs.

This notion represented a dramatic shift in the representation of human needs in architectural form, a shift which also required abstraction from the traditional relationship of patronage. In the context of the federal housing program, with the state as the client and an abstractly defined 'user,' it was possible to associate architectural form with human needs and the public good, and for the architect to define both in abstract terms, rather than in accordance with the tastes and expressed desires of the client. In this setting, architects were able to reinvent the people for whom they designed (see Montgomery 1989) and to give new significance to their authority as technical experts.

Second, the scale of the projects made it possible to relocate the aesthetic object inscribed in built form. This relocation is indicated by the way aesthetic questions – traditionally tied to questions of taste – were displaced from the center in the discussions of housing design. Catherine Bauer, a well-known housing reformer, noted that elements of modern housing are defined by a set of minimum standards for the provision of basic needs: decency, health, amenity, and comfort and convenience. New building forms 'grow, on the one hand, out of the new standards and materials and methods and functions, and are related just as clearly on the other to that quickening and renewal of aesthetic sensibility which we call "modern" in the best twentieth-century painting and sculpture and photography' (Bauer 1934: 148). The key task, however, is to link a form which is organic (unfolding from within) to a visible order which is legible from without.

One point where the new synthesis of functional form and visual order emerges is in a changing conception of standardization. Against those who resisted public housing programs on the grounds that they impose an unwanted standardization on American living, Bauer argued that we have always had standardization – standard lots, standard plans, but 'in an excessively wasteful and ugly and unproductive form'. In contrast, 'functional' standardization would open up important new opportunities for design:

> For the first time, it is possible to build up groups and balanced masses and rhythms merely out of the varied forms required for specific functions. Standardized parts, instead of creating dull uniformity, become a positive force in creating a unified whole. Meaningless surface ornament, once applied to distract the eye from the unbearable bleakness and monotony underneath, becomes not only unnecessary but ridiculous. Good materials, simple lines, and geometric forms become, when combined with carefully designed and planted open spaces, all the elements necessary to an authentic modern architecture.
>
> (Bauer 1934: 164)

This statement of what can be recognized as a modernist orientation extols the virtues of standardization as the starting point rather than the unfortunate lack of design, replacing reliance on 'meaningless surface ornament' with an aesthetic that draws its force from the apparent fit of formal arrangements to the logic of functions. The crucial change lies not in the new formal images imported from Europe, but in their new practical significance. Strikingly, the discussions of housing design by Bauer and others used forms associated with European modernism with little or no comment. Aesthetic qualities appear both directly in the discussion, and implicitly in the illustrating images, as *indicators* of the functional quality of good design, rather than as its central intention or crucial accomplishment. In this respect, American architects and housing reformers took advantage of the 'symbolic objectivity' of European modernism when they invoked its images (Jordy 1963).

Third, association with a federal program anchored the emergent design practices in bureaucratic as well as technical rationality. The historical peculiarity of the modernist association of certain formal images with functional principles was effectively 'black boxed' [sic] by its institutional incorporation into the practical guidelines of the Public Works Administration (PWA), and the bureaucratic standardization later imposed by the Federal Housing Authority. This incorporation is evident in the design guidelines published by the PWA in 1935 (published both as a pamphlet, and as a major part of one issue of *Architectural Record* (March 1935)). These guidelines were presented as suggestions to architects submitting proposals to the PWA, and as labor-saving devices that would allow the local architect to submit preliminary plans without extensive research or excessive design time. The architect was provided with guidelines for neighborhood location, orientation, density, site planning, and a repertoire of unit plans for solving a variety of spatial puzzles. Particular emphasis, however, was put on the site plan as an orderly arrangement of buildings responsive to the need for an economy of land use, the functional arrangement of buildings and open spaces, and an appropriate orientation to the sun and prevailing winds.

There was considerable variation in the quality and character of the projects as some architects adapted more easily to the new modality than others. The point is not that these projects had an effect because of their consistently modern style, or their paradigmatic quality as monumental buildings. Public housing provided a practical site in which modernist design could make relevant and persuasive claims. Over the course of a decade, these projects helped to effect a dramatic inversion of the discipline of design. Whereas multiple family urban housing represented the lower limit of the architectural for the nineteenth-century architect, public housing could now represent the epitome of architecture as technology, as a means for accomplishing a socially significant task. In the context of PWA housing projects, the technical gadgetry of late nineteenth-century and early twentieth-century apartment design was reworked into architecture.

Whereas the framework of justification of historicist design had imposed formal ideals that penetrated building from the top down, modernist design reversed this relationship. In the former case, architecture dwindled into mere building as one moved down the hierarchy of building functions from public monument to utility shed, from Newport mansions to the working class house. Modernist design made it possible to recognize the domain of the architectural the moment a lintel is set across two posts, enabling Architecture (as cultural object and as practical

intervention) to permeate 'mere building' in a way that it could not have done before. Even the apparent failures of many of the designs (as architecture or as housing) were understood as an indication of the need to perfect modernist practices rather than question modernist assumptions.

Beaux-Arts design was a rationalization of historicist design, but its rationalism was at the level of functional planning while the formal constraints of the historical styles prevented a detailed articulation of aesthetic form and functional intent. In modernist design, the rhetorical aspects of design were located in construction techniques, in a set of strategies for solving spatial problems posed by a particular conception of a social problem, and in formal arrangements that operated at a particular level of scale: the level at which standardization and repetition could be modulated for effect. The aesthetic quality of these designs was located in the use of repetitive elements, and the modulations of forms within a system of regular, standardized parts. It was at this level that the 'modern' architect established the logical relations that enabled the design to represent the fitting of form to function, and it was at this level that the architect represented the formal ideals of the discipline. In this way, it became possible to produce buildings that not only looked modern, but were, as the modernists liked to claim, 'authentically' modern/and authoritatively designed.

It has often been pointed out that American architects took up the forms of European modernism without the spirit, or the left-wing utopian ideology, with which it had been associated. The modernism that took root in American architectural practice was pragmatically rather than ideologically motivated. The images and forms associated with European modernism were selectively incorporated into the discipline as a particular response by the profession to the practical and disciplinary problems of professional design in the United States. These problems came to a head during the Depression, although they have a long history. In the first decades of the twentieth century, architects recognized the need for an architecture that could register both its authority and its appropriateness to modern conditions. European modernism offered forms that were aggressively modern, but its integration of form and function was initially regarded as either anti-architectural or unconvincing for most American architects. The practical incorporation of certain modernist forms and images into both critical discourse and bureaucratic practices surrounding the problem of subsidized housing, created a field in which these forms came to appear as self-evidently motivated. The public housing programs of the [1930s] provided a context of public authority and limitations without which modernist design could not have been construed as a coherent mode of representation or incorporated into the institutional framework of the profession. In these federal programs, it was possible to locate architectural judgement at a level where the formal rhetoric of European modernism could operate. The constriction of the market by broader economic conditions gave them a particular urgency and enabled publicly subsidized projects to occupy a dominant place in the profession. After this insertion of European modernist design into the heart of socially progressive American architecture, it could represent modern conditions and rational purposes with an effective rhetorical force. In the following decades, the aesthetic possibilities of modernist modes of design were elaborated, refined, and qualified, but they remained anchored in the articulation with technical rationality achieved during the [1930s].

Conclusion

This brief sketch of the practical logic of 'modernism' in American architecture was intended to illustrate the way the stabilization of a particular kind of artifact can imply the construction of a particular form of cultural agency. The peculiar dilemma of a modern architecture was to reconstruct design as technical response to factual problems, while at the same time keeping the gap open between form and function necessary for the construction of architectural modalities that sustain authorship. Although architects sought some recognition as technical experts, they could not reduce architecture to mere technology without undermining the social and historical foundations of the discipline of architectural design. In the course of translating the social problem of public housing into an 'architectural' problem to which they could provide a solution, architects reconstituted their own authority as agents, reconstructed the practice of design in a manner that both addressed contemporary conditions and incorporated new modalities of authorship, and relocated the object of their discipline (architecture) in the social technology of building. This account of modernism builds on an interpretive construction of the intentions of modernist design and the significance of modernist forms, but differs in a crucial way from a straight interpretive account: the 'objective intentions' apparent in modernist architecture are indicators of a practical logic that governs the mutual configuration of the object and agent of architectural production. [. . .]

References

Bauer, C. 1934. *Modern Housing*. Cambridge, MA: The Riverside Press.
Baxandall, M. 1985. *Patterns of Intention: on the Historical Explanation of Pictures*. New Haven, CT: Yale University Press.
Benevolo, L. 1977. *History of Modern Architecture*. Cambridge, MA: MIT Press.
Bourdieu, P. 1990. *The Logic of Practice*. Stanford, CA: Stanford University Press.
Brain, D. 1989. 'Discipline and style: the Ecole des Beaux-Arts and the social production of an American architecture', *Theory and Society* 18: 807–68.
Griswold, W. 1987. 'A methodological framework for the sociology of culture', *Sociological Methodology* 14: 1–35.
Jordy, W. 1963. 'The symbolic essence of modern European architecture of the twenties and its continuing influence', *Journal of the Society of Architectural Historians* XXII.3: 177–87.
Kastner, A. 1938. 'The architect's place in current housing', pp. 225–36 in *Housing Yearbook*. Chicago: National Association of Housing Officials.
Latour, B. 1987. *Science in Action*. Cambridge, MA: Harvard University Press.
Montgomery, R. 1989. 'Architecture invents new people', pp. 260–81 in R. Ellis and D. Cuff eds. *Architects' People*. New York: Oxford University Press.
Wright, G. 1980. *Moralism and the Model Home*. Chicago, IL: University of Chicago Press.

Museums and the social construction of high culture

INTRODUCTION

Recent work in art history, the sociology of art and material cultural studies has sought to give the same level of attention to the reception and consumption of cultural objects as has traditionally been given to their production and to the analysis of their formal structure (Radway 1984, Freedberg 1989, Elsner 1995, Miller 1995, Shrum 1996). This involves research into the social backgrounds of audiences or spectators of cultural products, analysis of the settings in which the consumption of culture takes place, of the distinctive practices or etiquettes of reception, and of the varying social and cultural value attributed to such practices (Wolff 1981, 95–116; Thompson 1990, 146–62; Zolberg 1990, 136–61; Press 1994).

ART AND MASS CULTURE IN THE CRITICAL THEORY OF THE FRANKFURT SCHOOL

This new focus of research draws on and engages with much earlier precedents. At the turn of the century, Thorstein Veblen excoriated the conspicuous art consumption of American elites intent on marking their social status (1899). More importantly, members of the so-called 'Frankfurt School' – a group of scholars co-operating at the Institute of Social Research in Frankfurt during the 1930s to reconstruct a critical theory of society by integrating Marxism with psychoanalysis and phenomenology (Wiggershaus 1994) – tried to understand how the new technologies of cultural production and the social organisation of consumption in capitalist society affected art as a cultural realm (Lowenthal 1961, Jay 1973, 173–218; Arato and Gebhardt 1982). Walter Benjamin argued that the new technologies for mass production of imagery

– whether in cinema or printed art books – could help to democratise art by dissolving the aura attached to the idea of an 'original'. In traditional societies, according to Benjamin (1973; Arato and Gebhardt 1982, 209), art was often consumed in cultic and communal settings, amidst the pageantry and political ritual of courts or the religious ceremonies of churches. The uniqueness of the work and the mysteriousness of the setting created, on the one hand, distance between viewer and art object, on the other, passive identification with the ideological contents projected by the work. Technologies of mass production and such filmic techniques as montage would replace the authoritarian pacifying distance of traditional aura with a new active critical distance in relation to the contents of culture.

Theodor Adorno and Max Horkheimer, by contrast, argued that capitalist organisation of production and consumption threatened to dissolve the autonomy of art into a commodified and administered mass culture. The stereotyped formulae of mass-cultural products such as television sit-coms depend on direct response to discrete signals in the immediate context of their narratives. Genuine works of art require to be understood in terms of their structure as a whole. This entails an active construction of the aesthetic object by the viewer or reader, as demanded in the Kantian ideal of aesthetic response as involving a 'synthetic unity of apperception' (Horkheimer and Adorno 1947, 137ff.; Jay 1973, 187). According to Herbert Marcuse (1968), art in late-capitalist society was marginalised as a relaxing leisure activity, as opposed to genuine art which made demands on the viewer. High culture in late-capitalist society was part of an 'affirmative culture' which eroded subjects' capacity for critical aesthetic response and cultural reflection. In affirmative culture, art is increasingly packaged in ways which abstract it from social processes, celebrating abstract ideals of human genius and artistic creativity in the context of spectacular 'must-see' blockbuster exhibitions where the status-seeking consumer displaces the critical connoisseur (Horkheimer and Adorno 1947, 148).

Perhaps the most sophisticated reprise of this tradition is to be found in Jürgen Habermas's (1962) account of *The Structural Transformation of the Public Sphere*. In the selection (Chapter 12), Habermas analyses the construction of the key institutions of art criticism and consumption that are still with us today: public criticism of art in literary journals, the role of the critic, the development of the concept of the autonomous art object produced for a market rather than bespoke for church or court. He places the emergence of these key institutions and concepts in the context of the changing balance of power between court and town. The absolutist states became increasingly subject to critical scrutiny of a politically self-conscious bourgeois class within an autonomous public sphere constituted within the same social settings (coffee-houses, salons) and cultural practices (literary journalism, critical debate) that gave rise to modern art criticism.

ART LOVERS, CULTURAL CAPITAL AND SOCIAL STRATIFICATION

Notwithstanding the cultural criticism of the Frankfurt School, and the Mass Culture debate of the 1950s (Gans 1974, 1–65), it was only in the late 1960s and 1970s that art consumption became the object of systematic programmes of empirical

sociological research. This interest was in large part a response to the massive increase in state funding for the arts. In the United States, for example, this period saw the foundation of the National Endowment of the Arts, with a budget which grew from $2.5 million in 1965 to more than $100 million by the end of the 1970s, quite apart from the numerous state and local art agencies set up on the promise of matching federal funding (DiMaggio and Useem 1978a).

Defining art as a public good to be supported by the state raised the question of whether all members of the public benefited equally from the arts. Alongside some- what nebulous claimed economic impacts (happier and better workers, more tourists), there were clear social inequalities in access to the arts. Members of local elites dominated the boards of art institutions, and the upper middle class their audiences. Within the art world the debate was construed largely in terms of conflicts between aesthetic excellence and democratic access, and it was hoped that inequalities in access to the arts could be ameliorated by such measures as outreach programmes, improved publicity and arts education in public schools (DiMaggio and Useem 1978a). Sociological work, however, sought to place museum visiting and arts con- sumption in the context of a wider range of cultural practices, and suggested that inequalities in access to art were an important structural component in the reproduc- tion of class hierarchy in modern capitalist societies (DiMaggio and Useem 1978b, 1978c).

Pierre Bourdieu's account of high culture should be read in the context of a research programme concerned with social and cultural reproduction, and in particu- lar the role of educational systems in such processes (1973, 1977, 1984). Bourdieu was concerned to understand how classes still managed to reproduce themselves in the context of the ostensibly egalitarian educational systems of capitalist welfare states, with progressive tax regimes which undermined the direct transmission of economic capital between generations. He developed the concept of 'cultural capital' to analyse the cultural advantages which accrued to children of upper- and middle-class back- ground: a positive attitude to schooling; familiarity with and a capacity to meet the expectations of teachers in terms of styles of speech, writing and behaviour. Such inherited cultural capital enables upper-class students to gain the best returns on their investments in schooling, to accumulate 'academic capital' more efficiently than those less privileged, and to acquire a facility for transposing such academic capital – for example, the capacity for classifying literature by author, genre, period and school – into domains such as the visual arts with which formal education is little concerned. These cumulative, cross-generational advantages show themselves in rates of museum visiting, where not simply occupational status and educational status but also parents' educational status independently affect the frequency with which people visit art museums (DiMaggio and Useem 1978c).

Cultural capital exists alongside other forms of capital: the specifically academic capital represented by school and university diplomas; the social capital of networks of acquaintances and contacts. Individuals from different social backgrounds acquire different quantities of each capital and a different balance in their portfolio. These forms of capital can be cashed in on different markets within the differentiated fields of advanced capitalist societies. So, for example, of two graduates with the

same educational diplomas, one with higher levels of cultural capital, by virtue of a privileged class background, would be better placed to realise the value of her diploma and secure a well-paid position by virtue of her ability to communicate the right status signals of style, taste and cultivation, and to participate easily in the high cultural rituals of solidarity which generate class cohesion – receptions for corporately sponsored exhibitions, business entertainment at concerts or the opera.

Bourdieu's work is extraordinarily rich theoretically and defies easy summary – integrating concepts from Marxism, structuralism, field theory, phenomenology and Weberian sociology. Unusually amongst sociologists, he has seriously engaged with contemporary art-historical theory and sought to internalise its concepts within a distinctively sociological framework. He translated Panofsky's *Gothic Architecture and Scholasticism*, which he published with a postface elaborating the significance of Panofsky's study for the sociology of art, and in particular of the concept of *habitus* (see pp. 74–6 above) for articulating the relationship between predispositions inculcated through educational institutions and systems of aesthetic practices (1967). The extract in this section (Chapter 13) is one of Bourdieu's earlier accounts of the development of cultural competence in art consumption and of how such competence functions as cultural capital. Drawing on Panofsky's (1939) scheme of the levels of decoding involved in iconographic and iconological analysis, Bourdieu shows how art connoisseurship is predisposed to mark status distinctions by virtue of the long-term and imperceptible processes of familiarisation which it requires. He argues that connoisseurship lends itself to a charismatic ideology of taste as a gift of nature – the 'love of art' which distingushes the cultivated from barbarians – and that the morphology of the museum and the rules of etiquette which govern behaviour there reinforce the exclusion of the culturally dispossessed.

THE INSTITUTIONALISATION OF HIGH CULTURE

Bourdieu's work focuses on the relationship between class structure and cultural consumption, at the expense of considering either the organisations – museums, orchestras, theatre companies – which produce and mediate high culture, or how particular cultural products came to be valued as high culture and thus to confer prestige on their consumers. This gap has been filled in recent years through work by both art historians and sociologists on the creation of the familiar institution of the art museum. Art historians have concentrated primarily on the iconographic aspects of the modern museum, as an architectural monument and a system of display. Duncan and Wallach (1980, Duncan 1991, cf. McClennan 1994) have shown how the modern universal survey museum is constructed as a temple of art in which rituals of citizenship are enacted, which enhance visitors' affective attachment to the state. Walking through the museum, according to a script ordered by architecture and display installations, and commented on by the museum's own iconography, the viewer experiences the history of art as the development of a national tradition through the achievements of individual geniuses. The state endows the visitor-citizen with this patrimony in

return for affective commitment to the modern capitalist social order with its indi-
vidualistic and nationalistic values.

Sociologists, whilst they have not ignored issues of display, have directed their
attention to the organisational vehicles which permit the creation of museums as
institutions enduring over time, and to the classes which sponsored the institutional-
isation of art as high culture in museums. Paul DiMaggio (1982a, 1982b) has
explored the role of urban elites in late-nineteenth-century America in the creation of
the high cultural institutions which still dominate American cultural life today: the
Boston Museum of Fine Arts and the Boston Symphony Orchestra, the Philadelphia
Museum of Fine Art and the Philadelphia Orchestra, the Art Institute of Chicago, the
Metropolitan Museum – all founded within a few years of each other in the last third
of the nineteenth century. DiMaggio (Chapter 14) distinguishes three processes, each
of which he regards as prerequisites for the institutionalisation of high culture: *entre-
preneurship* – creating an organisational base for high culture; *classification* – creat-
ing boundaries between 'art' and 'entertainment'; and *framing* – the elaboration of a
normative etiquette for the appropriation of art. Following Durkheim, DiMaggio
argues that 'ritual boundaries emerge out of and reflect the ways in which social
groups organise themselves and categorise one another' (1982b, 303). In late-
nineteenth-century Boston, the elite social establishment, the Boston Brahmins, co-
operated in the creation of high culture as a sacred reserve over which they retained
monopolistic control and from which they derived social prestige. In this way, they
distinguished themselves from *nouveaux riches* and second-generation immigrants
who increasingly dominated local economic and political life. A dedicated art museum
was founded, in which 'true art' could be viewed free from the distractions of the
bearded women and mutants which competed for visitors' attention in contemporary
commercial museums. Guards and a programme of 'docents' or education officers
enforced civilised standards of behaviour on the part of visitors – hushed respect, no
touching – and encouraged the framing of aesthetic experience in aestheticist terms of
the inner joy of mystical contemplation. Control over this process was secured through
the organisational form which the Brahmins adopted for their project: the non-profit
corporation. This not only served to insulate art from the market but also ensured
Brahmin control of such institutions, free from any threat of interference by the state
or other classes.

DiMaggio's perspective has been extended to a range of different contexts, explor-
ing the institutionalisation of 'serious music' in Beethoven's Vienna (DeNora 1991),
bourgeois collecting and the creation of a museum culture in nineteenth-century
Manchester (Wolff 1982, Seed and Wolff 1984) and the full range of high cultural
institutions in America (Levine 1988). Both DiMaggio himself (1987) and Gordon
Fyfe (1986, 1998) have sought to formalise the framework used in the analysis of
processes of classification and framing in order to facilitate more systematic com-
parative analysis of different modes of display and institutional organisation, and their
relationship with social structure.

THE ART MUSEUM: SOCIAL ORGANISATION AND CULTURAL AGENT

The work of Bourdieu and DiMaggio, like that of Duncan and Wallach, emphasises the role of museums in the reproduction of the dominance of the culture of the ruling class. Other strands of sociological analysis have criticised this as a form of 'class essentialism', which does not allow sufficient weight to the museum as an organisation in its own right, with a certain autonomy which is partly constructed by playing off various constituencies of the museum – elites, the state, corporate sponsors – against each other. Gordon Fyfe (1996) has shown how the Tate Gallery, founded as the National Gallery of British Art, gradually secured autonomy from dominance by the Royal Academy, and became an important site for the promotion of modernism in British art. This involved a series of alliances between the Tate's directors and other key actors, including Treasury officials and the new art critics of the professional middle classes. They promoted their own taste (and class distinctiveness) at the expense of the financial and industrial capitalists who were the primary purchasers of academic subject painting, and the lower middle class who consumed such imagery in reproductions and school books.

Far from being static institutions, the museums created by cultural entrepreneurs such as the Boston Brahmins have been continuously reinvented through time. Art institutions proliferated in early twentieth-century America, with the establishment of associations such as the College Art Association, the American Association of Museums and the American Federation of Arts. The associations of this national 'organisational field' (DiMaggio 1991, 137) became an increasingly important point of reference for directors and curators of museums, as a counterweight to the influence of local elites who sponsored their institutions and dominated boards of trustees. Such associations defined standards for display, conservation and scholarship within museums. Museums depended on meeting such standards for their own legitimacy within the contemporary art world. Vera L. Zolberg (Chapter 15) explores how organisational processes within the broader art field and internal to museums themselves shape the roles of museums as collectors and conservators of objects, and as research and educational institutions, somewhat independently of the broad class-structural pressures and processes identified by Bourdieu and DiMaggio. In particular, she shows how the professionalisation of the role of the museum curator weakened the control of local elites over their museums. The role of curator, once filled by wealthy amateurs with the right social connections, was reserved to university-trained art historians, normally with a Ph.D. Organisational structures and acquisition policies were developed to protect curators from the influence of board members and ensure that only strictly professional standards guided collection and display, rather than the particularistic interests of local collectors. Intent on pursuing their own careers and accumulating prestige within the wider field of art organisations, curators preferred to invest their energies in systematising permanent displays according to the principles of art history taught in universities, rather than showcasing their patrons' not always high-quality collections in temporary exhibitions. Paradoxically, whilst undermining the direct control of social elites, this process of professionalisation served only to strengthen the boundary between high and popular culture (DiMaggio 1982b, 304ff.). Scientific legitimacy was added to arbitrary social classification. The interest of cur-

ators in the esteem of their peers in the broader field of high culture further marginal-ised the educational role of museums, strengthening the barriers between elite and popular culture, and the social-structural effects which flowed from them (Zolberg 1992).

In the second half of the twentieth century, art museums have faced problems generated by their own organisational growth, by the increasing complexity of their environment and by changes in social structure. Both the Great Depression and changes in tax laws have reduced the importance of individual philanthropists as funding sources, whilst charitable foundations, corporations and the state have taken their place. As museums have shifted the focus of their efforts from internal concerns such as research and conservation to goals designed to secure legitimacy and resources from external sources – exhibitions and audiences – management styles have changed (Alexander 1996a, 53). Traditional impresarios, appointed on the basis of local connections rather than specific arts or management expertise, are displaced by professional arts administrators, often with Masters' degrees in Arts Administra-tion. The new-style managers implement budgetary measures and financial systems which can show the kind of rational accountability expected by the new institutional funders: loss-making services are closed or franchised out; secondary 'profit centres' such as restaurants and gift stores proliferate. Growth becomes the primary goal of art institutions. Increased turnover and rising visitor numbers legitimate grant appli-cations from public funding bodies, generating growth which demonstrates the success of the administrator to trustees and promotes administrators' careers (Peterson 1986).

These issues are, of course, the subject of considerable journalistic coverage within the journals and gossip networks of the art world, sometimes erupting into the national press, as in the case of the reorganisation of the Victoria and Albert Museum in London in the 1980s. There is certainly a widespread perception amongst cultural elites – arts academics and museum curators – that the world of museums is becoming increasingly driven by economic agendas at the expense of their core goals of art-oriented or research-driven collection and display. The internal media of the arts world, however, offer at best anecdotal evidence, often drawing rather apocalyptic conclusions in response to an immediate crisis. Sociologists' theoretical perspectives on organisational analysis and their methodological tools provide systematic means for exploring these issues in a somewhat more detached, long-term perspective. A good example of such work is offered by Victoria Alexander's analysis of the relation-ship between changed patterns of funding and the frequency, formats and contents of exhibitions (1996a, 1996b, 1996c). At first sight one might expect the interests of corporate and public funders (state institutions, charitable foundations) in publicly accessible non-controversial shows to have marginalised both non-canonical and scholarly exhibitions. This, however, assumes that museums are simple transmitter-belts for the cultural interests of their financial backers. Alexander draws on a range of different organisational theories to show how museums and curators actively manage their environments, reshaping the often vague demands of financial sponsors, to secure a reasonable fit between the public goals of funders and the more internal scholarly goals of curators themselves.

REVALUING HIGH CULTURE

The debate over high culture remains active. Some work suggests that contemporary social changes – a shift from local urban elites to a geographically mobile national elite, the rise of managerialism in arts organisations and an increased concern for audiences, widening access to higher education – are eroding the boundaries established under very different circumstances in the nineteenth century (DiMaggio 1991, 141). Others question the role of high culture in transmitting elite status. Michelle Lamont (1992) has compared the means which the upper middle classes of America and France use to police their boundaries. Her work shows not only that moral and social criteria play a more significant role than Bourdieu's early work allowed, but also that in America socio-economic criteria are predominant and culture almost irrelevant. The importance attributed to high culture in Bourdieu's analysis may owe something to the particular social structure of France (geographic concentration of the elite, levels of economic inequality moderated by a strong welfare state) rather than being a characteristic feature of advanced capitalist society per se. David Halle (1989, 1991a, 1992) has taken research into art consumption out of the museum and into people's homes, where he has looked at the distribution of types of pictures in houses according to class. He suggests that the differences between groups noted by Bourdieu need to be placed against a background of a much broader shared taste which crosses class boundaries. Landscapes, for example, are the most popular subject matter for pictures in houses of all classes, and although people from an upper middle class much more often have abstract paintings than people from the working class, they read those paintings as imaginary landscapes, suggesting even here a shared pattern of taste.

The Frankfurt School very much took for granted the distinctiveness and the importance of the kinds of aesthetic experience associated with the institutions of high culture, and fought againt their erosion. The work of Bourdieu and DiMaggio has taken a much more strongly 'constructivist' approach to high culture, seeing the special status of these institutions and experiences as predominantly ideological, and understandable solely in terms of their function in the reproduction of class hierarchy. What we still lack is an adequate account of the social construction of the distinctive pleasure of art consumption which does not reduce it to status-seeking. There are sketches of such an account in art historians' descriptions of the museum's way of seeing (Alpers 1991; Greenblatt 1991), and in Ian Hunter's (1992) Foucauldian analysis of the aesthetic ethos as a 'technique of the self', a distinctively modern way of intensifying inward and imaginative experience as a way of fending off the constraining limitations of modern life. Sociologists since the 1970s have perhaps closed off this possibility by taking such a strongly constructivist position on art in opposition to the perceived essentialism of art historians. Interestingly, Talcott Parsons who adopted a more 'realist' conception of art, as expressive symbolism (Chapter 18), argues strongly against seeing an increased participation in art activities and museum visiting beginning in the 1950s as nothing more than a secondary symbol of status differentiation (Parsons and White 1961, 229). On the contrary, he argued that the 1960s saw what amounted to an 'expressive revolution' (Parsons 1974/78, 321),

manifested both in the counter-culture and in the massive expansion in institutionalised arts activities which occurred during the same period. He suggests that this heightened expressivity represents a functional counterpoint to the cognitive upgrading of so many aspects of contemporary life, marked by the increased role of science and highly rationalised forms of knowledge in numerous institutional domains (including art – professional arts administration, for example). Upgrading and refining of our expressive capacity permits us to cope on an affective level with an increasingly complex and demanding environment in a similar way to the cognitive upgrading secured through the intellectual disciplining of higher education (Parsons and Platt 1973).

Jürgen Habermas

ART CRITICISM AND THE INSTITUTIONS OF THE PUBLIC SPHERE

From *The Structural Transformation of the Public Sphere: An Inquiry into a Category of Bourgeois Society*, trans. T. Burger. Cambridge, Mass., MIT Press, 1989, pp. 32–43. Original publication 1962.

IN GREAT BRITAIN THE court had never been able to dominate the town as it had in the France of the Sun King. Nevertheless, after the Glorious Revolution a shift in the relationship between court and town can be observed similar to the one that occurred one generation later in the relationship between *cour* and *ville*. Under the Stuarts, up to Charles II, literature and art served the representation of the king. 'But after the Revolution the glory of the court grew dim. Neither the political position of the Crown, nor the personal temperament of those who wore it was the same as of old. Stern William, invalid Anne, the German Georges, farmer George, domestic Victoria, none of them desired to keep a court like Queen Elizabeth's. Henceforth the court was the residence of secluded royalty, pointed out from afar, difficult of access save on formal occasions of proverbial dullness.' The predomin- ance of the 'town' was strengthened by new institutions that, for all their variety, in Great Britain and France took over the same social functions: the coffee houses in their golden age between 1680 and 1730 and the *salons* in the period between regency and revolution. In both countries they were centers of criticism – literary at first, then also political – in which began to emerge, between aristocratic society and bourgeois intellectuals, a certain parity of the educated.

Around the middle of the seventeenth century, after not only tea – first to be popular – but also chocolate and coffee had become the common beverages of at least the well-to-do strata of the population, the coachman of a Levantine merchant opened the first coffee house. By the first decade of the eighteenth century London already had 3,000 of them, each with a core group of regulars. Just as Dryden,

surrounded by the new generation of writers, joined the battle of the 'ancients and moderns' at Will's, Addison and Steele a little later convened their 'little senate' at Button's; so too in the Rotary Club, presided over by Milton's secretary, Marvell and Pepys met with Harrington who here probably presented the republican ideas of his *Oceana*. As in the *salons* where 'intellectuals' met with the aristocracy, literature had to legitimate itself in these coffee houses. In this case, however, the nobility joining the upper bourgeois stratum still possessed the social functions lost by the French; it represented landed and moneyed interests. Thus critical debate ignited by works of literature and art was soon extended to include economic and political disputes, without any guarantee (such as was given in the *salons*) that such discussions would be inconsequential, at least in the immediate context. [. . .] The coffee house not merely made access to the relevant circles less formal and easier; it embraced the wider strata of the middle class, including craftsmen and shopkeepers. Ned Ward reports that the 'wealthy shopkeeper' visited the coffee house several times a day, this held true for the poor one as well.

In contrast, in France the *salons* formed a peculiar enclave. While the bourgeoisie, for all practical purposes excluded from leadership in state and church, in time completely took over all the key positions in the economy, and while the aristocracy compensated for its material inferiority with royal privileges and an ever more rigorous stress upon hierarchy in social intercourse, in the *salons* the nobility and the *grande bourgeoisie* of finance and administration assimilating itself to that nobility met with the 'intellectuals' on an equal footing. The plebeian d'Alembert was no exception; in the *salons* of the fashionable ladies, noble as well as bourgeois, sons of princes and counts associated with sons of watchmakers and shopkeepers. In the *salon* the mind was no longer in the service of a patron; 'opinion' became emancipated from the bonds of economic dependence. Even if under Philip the *salons* were at first places more for gallant pleasures than for smart discourse, such discussion indeed soon took equal place with the *diner*. Diderot's distinction between written and oral discourse sheds light on the functions of the new gatherings. There was scarcely a great writer in the eighteenth century who would not have first submitted his essential ideas for discussion in such discourse, in lectures before the *académies* and especially in the *salons*. [. . .]

In Germany at that time there was no 'town' to replace the courts' publicity of representation with the institutions of a public sphere in civil society. But similar elements existed, beginning with the learned *Tischgesellschaften* (table societies), the old *Sprachgesellschaften* (literary societies) of the seventeenth century. Naturally they were fewer and less active than the coffee houses and *salons*. They were even more removed from practical politics than the *salons*; yet, as in the case of the coffee houses, their public was recruited from private people engaged in productive work, from the dignitaries of the principalities' capitals, with a strong preponderance of middle-class academics. The *Deutsche Gesellschaften* ('German Societies'), the first of which was founded by Gottsched in Leipzig in 1727, built upon the literary orders of the preceding century. The latter were still convened by the princes but avoided social exclusiveness; characteristically, later attempts to transform them into knightly orders failed. As it is put in one of the founding documents, their intent was 'that in such manner an equality and association among persons of unequal social status might be brought about'. Such orders, chambers, and academies were

preoccupied with the native tongue, now interpreted as the medium of communi-
cation and understanding between people in their common quality as human beings
and nothing more than human beings. Transcending the barriers of social hierarchy,
the bourgeois met here with the socially prestigious but politically uninfluential
nobles as 'common' human beings. The decisive element was not so much the
political equality of the members but their exclusiveness in relation to the political
realm of absolutism as such: social equality was possible at first only as an equality
outside the state. The coming together of private people into a public was therefore
anticipated in secret, as a public sphere still existing largely behind closed doors. The
secret promulgation of enlightenment typical of the lodges but also widely practiced
by other associations and *Tischgesellschaften* had a dialectical character. Reason, which
through public use of the rational faculty was to be realized in the rational communi-
cation of a public consisting of cultivated human beings, itself needed to be pro-
tected from becoming public because it was a threat to any and all relations of
domination. As long as publicity had its seat in the secret chanceries of the prince,
reason could not reveal itself directly. Its sphere of publicity had still to rely on
secrecy; its public, even as a public, remained internal. The light of reason, thus
veiled for self-protection, was revealed in stages. [. . .]

[. . .]

However much the *Tischgesellschaften*, *salons*, and coffee houses may have differed
in the size and composition of their publics, the style of their proceedings, the
climate of their debates, and their topical orientations, they all organized discussion
among private people that tended to be ongoing; hence they had a number of
institutional criteria in common. *First*, they preserved a kind of social intercourse
that, far from presupposing the equality of status, disregarded status altogether. The
tendency replaced the celebration of rank with a tact befitting equals. The parity on
whose basis alone the authority of the better argument could assert itself against that
of social hierarchy and in the end can carry the day meant, in the thought of the day,
the parity of 'common humanity' ('*bloss Menschliche*'). *Les hommes*, private gentle-
men, or *die Privatleute* made up the public not just in the sense that power and
prestige of public office were held in suspense; economic dependencies also in
principle had no influence. Laws of the market were suspended as were laws of the
state. Not that this idea of the public was actually realized in earnest in the coffee
houses, the *salons*, and the societies; but as an idea it had become institutionalized
and thereby stated as an objective claim. If not realized, it was at least consequential.

Secondly, discussion within such a public presupposed the problematization of
areas that until then had not been questioned. The domain of 'common concern'
which was the object of public critical attention remained a preserve in which
church and state authorities had the monopoly of interpretation not just from the
pulpit but in philosophy, literature, and art, even at a time when, for specific social
categories, the development of capitalism already demanded a behavior whose
rational orientation required ever more information. To the degree, however, to
which philosophical and literary works and works of art in general were produced
for the market and distributed through it, these culture products became similar to
that type of information: as commodities they became in principle generally access-
ible. They no longer remained components of the Church's and court's publicity of

representation; that is precisely what was meant by the loss of their aura of extra-ordinariness and by the profaning of their once sacramental character. The private people for whom the cultural product became available as a commodity profaned it inasmuch as they had to determine its meaning on their own (by way of rational communication with one another), verbalize it, and thus state explicitly what precisely in its implicitness for so long could assert its authority. As Raymond Williams demonstrates, 'art' and 'culture' owe their modern meaning of spheres separate from the reproduction of social life to the eighteenth century.

Thirdly, the same process that converted culture into a commodity (and in this fashion constituted it as a culture that could become an object of discussion to begin with) established the public as in principle inclusive. However exclusive the public might be in any given instance, it could never close itself off entirely and become consolidated as a clique; for it always understood and found itself immersed within a more inclusive public of all private people, persons who – insofar as they were propertied and educated – as readers, listeners, and spectators could avail themselves via the market of the objects that were subject to discussion. The issues discussed became 'general' not merely in their significance, but also in their accessibility: everyone had to *be able* to participate. Wherever the public established itself institutionally as a stable group of discussants, it did not equate itself with *the* public but at most claimed to act as its mouthpiece, in its name, perhaps even as its educator – the new form of bourgeois representation. The public of the first generations, even when it constituted itself as a specific circle of persons, was conscious of being part of a larger public. Potentially it was always also a publicist body, as its discussions did not need to remain internal to it but could be directed at the outside world – for this, perhaps, the *Diskurse der Mahlern*, a moral weekly published from 1721 on by Bodmer and Breitinger in Zurich, was one among many examples.

[. . .]

The court aristocracy of the seventeenth century was not really a reading public. To be sure, it kept men of letters as it kept servants, but literary production based on patronage was more a matter of a kind of conspicuous consumption than of serious reading by an interested public. The latter arose only in the first decades of the eighteenth century, after the publisher replaced the patron as the author's commissioner and organized the commercial distribution of literary works.

[. . .]

The shift which produced not merely a change in the composition of the public but amounted to the very generation of the 'public' as such, can be categorically grasped with even more rigor in the case of the concert-going public than in the case of the reading and theater-going public. For until the final years of the eighteenth century all music remained bound to the functions of the kind of publicity involved in representation – what today we call occasional music. Judged according to its social function, it served to enhance the sanctity and dignity of worship, the glamor of the festivities at court, and the overall splendor of ceremony. Composers were appointed as court, church, or council musicians, and they worked on what was commissioned, just like writers in the service of patrons and court actors in the service of princes. The average person scarcely had any opportunity to hear music

except in church or in noble society. First, private *Collegia Musica* appeared on the scene; soon they established themselves as public concert societies. Admission for a payment turned the musical performance into a commodity; simultaneously, however, there arose something like music not tied to a purpose. For the first time an audience gathered to listen to music as such – a public of music lovers to which anyone who was propertied and educated was admitted. Released from its functions in the service of social representation, art became an object of free choice and of changing preference. The 'taste' to which art was oriented from then on became manifest in the assessments of lay people who claimed no prerogative, since within a public everyone was entitled to judge.

The conflict about lay judgment, about the public as a critical authority, was most severe in that field where hitherto a circle of connoisseurs had combined social privilege with a specialized competence: in painting, which was essentially painting for expert collectors among the nobility until here too the artists saw themselves forced to work for the market. To the same degree painters emancipated themselves from the constrictions of the guilds, the court, and the church; craftsmanship developed into an *ars liberalis*, albeit only by way of a state monopoly. In Paris the Academy of Art was founded in 1648 under Le Brun; in 1677, only three years after Colbert granted it similar privileges as the Académie Française, it opened its first *salon* to the public. During the reign of Louis XIV at most ten such exhibitions took place. They became regular only after 1737; ten years later La Font's famous reflections were published formulating for the first time the following principle: 'A painting on exhibition is like a printed book seeing the day, a play performed on the stage – anyone has the right to judge it.' Like the concert and the theater, museums institutionalized the lay judgment on art: discussion became the medium through which people appropriated art. The innumerable pamphlets criticizing or defending the leading theory of art built on the discussions of the *salons* and reacted back on them – art criticism as conversation. Thus, in the first half of the eighteenth century the *amateurs éclairés* formed the inner circle of the new art public. To the extent to which the public exhibitions received wider attention and going over the heads of the connoisseurs, presented works of art directly to a broader public, these could no longer maintain a position of control. Yet since their function had become indispensable, it was now taken over by professional art criticism. That the latter too had its proper origin in the *salon* is at once demonstrated by the example of its first and most significant representative. From 1759 on Diderot wrote his *Salon* (i.e., knowledgeable reviews of the periodic exhibitions at the Académie) for Baron de Grimm's *Literary Correspondence*, a newsletter inspired by Madame de Epinay's famous *salon* and produced for its use.

In the institution of art criticism, including literary, theater, and music criticism, the lay judgment of a public that had come of age, or at least thought it had, became organized. Correspondingly, there arose a new occupation that in the jargon of the time was called *Kunstrichter* (art critic). The latter assumed a peculiarly dialectical task: he viewed himself at the same time as the public's mandatary and as its educator. The art critics could see themselves as spokesmen for the public – and in their battle with the artists this was the central slogan – because they knew of no authority beside that of the better argument and because they felt themselves at one with all who were willing to let themselves be convinced by arguments. At the same

time they could turn against the public itself when, as experts combatting 'dogma' and 'fashion', they appealed to the ill-informed person's native capacity for judgment. The context accounting for this self-image also elucidated the actual status of the critic: at that time, it was not an occupational role in the strict sense. The *Kunstrichter* retained something of the amateur; his expertise only held good until countermanded; lay judgment was organized in it without becoming, by way of specialization, anything else than the judgment of one private person among all others who ultimately were not to be obligated by any judgment except their own. This was precisely where the art critic differed from the judge. At the same time, however, he had to be able to find a hearing before the entire public, which grew well beyond the narrow circle of the *salons*, coffee houses, and societies, even in their golden age. Soon the periodical (the handwritten correspondence at first, then the printed weekly or monthly) became the publicist instrument of this criticism.

As instruments of institutionalized art criticism, the journals devoted to art and cultural criticism were typical creations of the eighteenth century. 'It is remarkable enough,' an inhabitant of Dresden wrote in justified amazement, 'that after the world for millennia had gotten along quite well without it, toward the middle of the eighteenth century art criticism all of a sudden bursts on the scene.' On the one hand, philosophy was no longer possible except as critical philosophy, literature and art no longer except in connection with literary and art criticism. What the works of art themselves criticized simply reached its proper end in the 'critical journals'. On the other hand, it was only through the critical absorption of philosophy, literature, and art that the public attained enlightenment and realized itself as the latter's living process.

In this context, the moral weeklies were a key phenomenon. Here the elements that later parted ways were still joined. The critical journals had already become as independent from conversational circles as they had become separate from the works to which their arguments referred. The moral weeklies, on the contrary, were still an immediate part of coffee-house discussions and considered themselves literary pieces – there was good reason for calling them 'periodical essays'.

When Addison and Steele published the first issue of the *Tatler* in 1709, the coffee houses were already so numerous and the circles of their frequenters already so wide, that contact among these thousandfold circles could only be maintained through a journal. At the same time the new periodical was so intimately interwoven with the life of the coffee houses that the individual issues were indeed sufficient basis for its reconstruction. The periodical articles were not only made the object of discussion by the public of the coffee houses but were viewed as integral parts of this discussion; this was demonstrated by the flood of letters from which the editor each week published a selection. When the *Spectator* separated from the *Guardian* the letters to the editor were provided with a special institution: on the west side of Button's Coffee House a lion's head was attached through whose jaws the reader threw his letter. The dialogue form too, employed by many of the articles, attested to their proximity to the spoken word. One and the same discussion transposed into a different medium was continued in order to reenter, via reading, the original conversational medium. A number of the later weeklies of this genre even appeared without dates in order to emphasize the trans-temporal continuity, as it were, of the process of mutual enlightenment. In the moral weeklies, the intention of the self-

enlightenment of individuals who felt that they had come of age came more clearly to the fore than in the later journals. What a little later would become specialized in the function of art critic, in these weeklies was still art and art criticism, literature and literary criticism all in one. In the *Tatler*, the *Spectator*, and the *Guardian* the public held up a mirror to itself; it did not yet come to a self-understanding through the detour of a reflection on works of philosophy and literature, art and science, but through entering itself into 'literature' as an object. Addison viewed himself as a censor of manners and morals; his essays concerned charities and schools for the poor, the improvement of education, pleas for civilized forms of conduct, polemics against the vices of gambling, fanaticism, and pedantry and against the tastelessness of the aesthetes and the eccentricities of the learned. He worked toward the spread of tolerance, the emancipation of civic morality from moral theology and of practical wisdom from the philosophy of the scholars. The public that read and debated this sort of thing read and debated about itself.

Pierre Bourdieu

OUTLINE OF A SOCIOLOGICAL THEORY
OF ART PERCEPTION

From *International Social Science Journal* XX.4 (1968), 589–612.

[. . .]

2

ANY DECIPHERING OPERATION REQUIRES a more or less complex code which has been more or less completely mastered.

2.1 The work of art (like any cultural object) may disclose significations at different levels according to the deciphering stencil applied to it; the lower-level significations, that is to say the most superficial, remain partial and mutilated, and therefore erroneous, for such time as the higher-level significations which encompass and transfigure them, are lacking.

2.1.1 According to Panofsky, the most naïve beholder first of all distinguishes 'the primary or natural subject matter or meaning which we can apprehend from our practical experience', or in other words, 'the phenomenal meaning which can be subdivided into factual and expressional': this apprehension depends upon 'demonstrative concepts' which only identify the sensible qualities of the work (this is the case when a peach is described as velvety or lace as misty) or the emotional experience which these qualities arouse in the beholder (when colours are spoken of as harsh or gay). To reach 'the secondary subject matter which presupposes a familiarity with specific themes or concepts as transmitted through literary sources' and which may be called the 'sphere of the meaning of the significate' (*région du sens du signifié*), we must have 'appropriately characterizing concepts' which go beyond the simple designation of sensible qualities and grasping the stylistic characteristics of the work of art, constitute a genuine 'interpretation' of it. Within this secondary stratum, Panofsky distinguishes, on the one hand, 'the secondary or conventional meaning, the world of specific themes or concepts manifested in images, stories and

allegories' (when, for instance, a group of persons seated around a table according to a certain arrangement represents the Last Supper), the deciphering of which falls to iconography; and on the other hand, 'the intrinsic meaning or content', which the iconological interpretation can recapture only if the iconographical meanings and methods of composition are treated as 'cultural symbols', as expressions of the culture of an age, a nation or a class, and if an effort is made to bring out 'the fundamental principles which support the choice and presentation of the motifs as well as the production and interpretation of the images, stories and allegories and which give a meaning even to the formal composition and to the technical processes'. The meaning grasped by the primary act of deciphering is totally different according to whether it constitutes the whole of the experience of the work of art or becomes part of a unitary experience, embodying the higher levels of meaning. Thus, it is only starting from an iconological interpretation that the formal arrangements and technical methods and through them, the formal and expressive qualities, assume their full meaning and that the insufficiencies of a preiconographic or pre-iconological interpretation are revealed at the same time. In an adequate knowledge of the work, the different levels are linked up in an hierarchical system in which the embodying form becomes embodied in its turn, and the significate in its turn becomes significant.

2.1.2 Uninitiated perception, reduced to the grasping of primary significations, is a mutilated perception. Contrasted with what might be called – to borrow a phrase from Nietzsche – 'the dogma of the immaculate perception', foundation of the romantic representation of artistic experience, the 'comprehension' of the 'expressive' and as one might say, 'physiognomical' qualities of the work is only an inferior and mutilated form of the aesthetic experience, because, not being supported controlled and corrected by knowledge of the style, types and 'cultural symptoms', it uses a code which is neither adequate nor specific. [. . .]

2.1.3 Through sociological observation it is possible to reveal, effectively realized, forms of perception corresponding to the different levels which theoretical analysis frames by an abstract distinction. Any cultural asset, from cookery to dodecaphonic music by way of the Wild West film, can be a subject for apprehension ranging from the simple, actual sensation to scholarly appreciation. The ideology of the 'fresh eye' overlooks the fact that the sensation or affection stimulated by the work of art has not the same 'value' when it constitutes the whole of the aesthetic experience as when it forms part of an adequate experience of the work of art. It is therefore possible to distinguish, by abstraction, two extreme and opposite forms of aesthetic pleasure, separated by all the intermediate degrees, the *enjoyment* which accompanies aesthetic perception reduced to simple *aisthesis*, and the *delight* procured by scholarly savouring, and which presupposes, as a necessary but insufficient condition, adequate deciphering. Like painting, perception of painting is a mental thing, at least when it conforms to the norms of perception immanent in the work of art or, in other words, when the aesthetic intention of the beholder is identified with the objective intention of the work (which must not be identified with the artist's intention).

2.1.4 The most uninitiated perception is always inclined to go beyond the level of sensations and affections, that is to say *aisthesis* pure and simple: the assimilatory interpretation which tends to apply to an unknown and foreign universe the available schemes of interpretation, that is to say those which enable the familiar universe

to be apprehended as having meaning, becomes essential as a means of restoring the unity of an integrated perception. Those for whom the works of scholarly culture speak a foreign language are condemned to take into their perception and their appreciation of the work of art some extrinsic categories and values – those which organize their day-to-day perception and guide their practical judgement. The aesthetics of the different social classes are therefore, with certain exceptions, only one dimension of their ethics (or better, of their *ethos*): thus, the aesthetic preferences of the lower middle-class appear as a systematic expression of an ascetic disposition which is also expressed in other spheres of their existence.

2.2 The work of art considered as a symbolic asset (and not as an economic asset, which it may also be) only exists as such for a person who has the means to appropriate it, or in other words, to decipher it.

2.2.1 The degree of art competence of an agent is measured by the degree to which he masters the set of instruments for the appropriation of the work of art, available at a given time, that is to say the interpretation schemes which are the prerequisite for the appropriation of art capital or, in other words, the prerequisite for the deciphering of works of art offered to a given society at a particular time.

2.2.1.1 Art competence can be provisionally defined as the preliminary knowledge of the possible divisions into complementary classes of a universe on representations: a mastery of this kind of system of classification enables each element of the universe to be placed in a class necessarily determined in relation to another class, constituted itself by all the art representations consciously or unconsciously taken into consideration which do not belong to the class in question. The *style* proper to a period and to a social group is none other than such a class determined in relation to all the works of the same universe which it excludes and which are complementary to it. The *recognition* (or, as the art historians say when using the actual vocabulary of logic, the *attribution*) proceeds by *successive elimination* of the possibilities to which the class is – negatively – related and to which the possibility which has become a reality in the work concerned belongs. It is straightaway evident that the uncertainty concerning the different characteristics likely to be attributed to the work under consideration (authors, schools, periods, styles, subjects, etc.) can be removed by employing different codes, functioning as classification systems; it may be a case of a strictly artistic code which, by permitting the deciphering of specifically stylistic characteristics, enables the work concerned to be assigned to the class formed by the whole of the works of a period, a society, a school or an author ('that's a Cézanne'), or a code from everyday life which, in the form of previous knowledge of the possible divisions into complementary classes of the universe of significants and of the universe of significates, and of the correlations between the divisions of the one and the divisions of the other, enables the particular representation, treated as a sign, to be assigned to a class of significant and consequently makes it possible to know, by means of the correlations with the universe of the significates, that the corresponding significate belongs to a certain class of significates ('that's a forest'). In the first case the beholder is paying attention to the *manner of treating* the leaves or the clouds, that is to say to the stylistic indications, *locating* the possibility realized, characteristic of one class of works, by reference to the universe of stylistic possibilities; in the other case, he is treating the leaves or the clouds as indications or signals associated, according to the logic set forth above,

with significations transcendent to the representation itself ('that's a poplar', 'that's a storm').

2.2.1.2 Artistic competence is therefore defined as the previous knowledge of the strictly artistic principles of division which enable a representation to be located, through the classification of the *stylistic* indications which it contains, among the possibilities of representation constituting the universe of art and not among the possibilities of representation constituting the universe of everyday objects (or, more exactly, of implements) or the universe of signs, which would amount to treating it as a mere monument, in other words as a mere means of communication used to transmit a transcendental signification. The perception of the work of art in a truly aesthetic manner, that is to say as a significant which signifies nothing other than itself, does not consist, as is sometimes said, of considering it 'without connecting it with anything other than itself, either emotionally or intellectually', in short of giving oneself up to the work apprehended in its irreducible singularity, but of noting its *distinctive stylistic features* by relating it to the whole of the works forming the class to which it belongs, and to these works only. On the contrary, the taste of the working classes is determined, after the manner of what Kant describes in his *Critique of Judgement* as 'barbarous taste', by the refusal or the impossibility (one should say the impossibility-refusal) of operating the distinction between 'what is liked' and 'what pleases' and more generally, between 'disinterestedness', the only guarantee of the aesthetic quality of contemplation, and 'the interest of the senses' which defines 'the agreeable' or 'the interest of Reason': it requires that every image shall fulfil a function, if only that of a sign, this 'functionalistic' representation of the work of art being based on the refusal of gratuitousness, the idolatry of work or the placing of value on what is 'instructive' (as opposed to what is 'interesting') and also on the impossibility of placing each individual work in the universe of representations, in the absence of strictly stylistic principles of classification. It follows that a work of art which they expect to express unambiguously a signification transcendental to the significant form is all the more disconcerting to the most uninitiated in that (like the non-figurative arts) it does away more completely with the narrative and descriptive function.

2.2.1.3 The degree of artistic competence depends not only on the degree to which the available system of classification is mastered, but also on the degree of complexity or subtlety of this system of classification, and it is therefore measurable by the ability to operate a fairly large number of successive divisions in the universe of representations and through that, to determine rather fine classes. For anyone familiar only with the principle of division into Romanesque art and Gothic art, all Gothic cathedrals fall into the same class and for that reason, remain *indistinct*, whereas greater competence makes it possible to perceive differences between the styles of the 'early', middle, and 'late' periods, or even to recognize, within each of these styles, the works of a school or even of an architect. Thus, the apprehension of the features which constitute the *peculiarity* of the works of one period compared with those of another period or, within this class of the works of one school or group of artists compared with another, or again, of the works of one author compared with other works of his school or his period, or even a particular work of an author compared with his work as a whole – such apprehension is indissociable from that of *redundancies*, that is to say, from the grasping of typical treatments of the pictorial

matter which determine a style: in short, the grasping of resemblances presupposes implicit or explicit reference to the differences, and vice versa.

2.3 The art code as a system of possible principles of division into complementary classes of the universe of representations offered to a particular society at a given time is in the nature of a social institution.

2.3.1 Being an historically constituted system, founded on social reality, this set of instruments of perception whereby a particular society, at a given time, appropriates artistic wealth (and more generally, cultural wealth) does not depend upon individual wills and consciousnesses and forces itself upon individuals, often without their knowledge, determining the distinctions which they can make and those which escape them. Every period arranges art representations as a whole according to an institutional system of classification of its own, placing together works between which other periods drew a distinction, or distinguishing between works which other periods placed together, and individuals have difficulty in imagining other differences than those which the system of classification available to them allows them to imagine. [. . .] Berne Joffroy's historical study on the successive representations of the work of Caravaggio shows that the *public image* which the individuals of a specific period form of a work is, properly speaking, the product of the instruments of perception, historically constituted, and therefore historically changing, which are supplied to them by the society to which they belong: 'I know well what is said about attribution disputes: that they have nothing to do with art, that they are petty and that art is great . . . The idea that we form of an artist depends on the works attributed to him and whether we would or no, this general idea of him colours our view of each of his works.'[1] Thus, the history of the instruments for perception of the work is the essential complement of the history of the instruments for production of the work, to the extent that every work is, so to speak, done twice, by the originator and by the beholder, or rather, by the society to which the beholder belongs.

2.3.2 The modal readability of a work of art (in respect of a particular society in a given period) varies according to the divergence between the code which the work under consideration objectively requires and the code as an historically constituted institution; the readability of a work of art for a particular individual varies according to the divergence between the more or less complex and subtle code required by the work, and the competence of the individual, as determined by the degree to which the social code, itself more or less complex and subtle, is mastered. [. . .]

2.3.3 Since the works forming the art capital of a particular society at a given time call for codes of varying complexity and subtlety, and are therefore likely to be acquired more or less easily and more or less rapidly by institutionalized or non-institutionalized training, they are characterized by different levels of emission, so that the previous proposition (2.3.2) can be reformulated in the following terms: the readability of a work of art for a particular individual depends upon the *divergence between the level of emission*, defined as the degree of intrinsic complexity and subtlety, of the code required for the work, and the *level of reception* defined as the degree to which this individual masters the social code, which may be more or less adequate to the code required for the work. Each individual possesses a definite and limited capacity for apprehending the 'information' suggested by the work, a capacity which

depends on his knowledge of the generic code for the type of message concerned, be it the painting as a whole, or the painting of a particular period, school or author. When the message exceeds the possibilities of apprehension or, to be more precise, when the code of the work exceeds in subtlety and complexity the code of the beholder, the latter loses interest in what appears to him to be a medley without rhyme or reason, or a completely unnecessary set of sounds or colours. In other words, when placed before a message which is too rich for him, or 'overwhelming' as the theory of information expresses it, he feels completely 'out of his depth'.

2.3.4 It follows that to increase the readability of the work of art (or of a collection of works of art such as those exhibited in a museum) and to reduce the misunderstanding which results from the divergence, it is possible either to lower the level of emission or to raise the level of reception. The only way of lowering the level of emission of a work is to provide, together with the work, the code according to which the work is coded, in an expression (verbal or graphical), the code of which is already mastered (partially or completely) by the receiver, or which continuously delivers the code for his own deciphering, in accordance with the model of perfectly rational pedagogic communication. Incidentally, it is obvious that any action tending to lower the level of emission helps in fact to raise the level of reception.

2.3.5 In each period, the rules defining the readability of contemporary art are but a special application of the general law of readability. The readability of a contemporary work varies primarily according to the relationship which the creators maintain, in a given period, in a given society, with the code of the previous period: it is thus possible to distinguish, very roughly, *classical periods*, in which a style reaches its own perfection and which the creators exploit to the point of achieving and perhaps exhausting the possibilities provided by an inherited art of inventing, and *periods of rupture*, in which a new art of inventing is invented, in which a new form-generative grammar is engendered, out of joint with the aesthetic traditions of a time or an environment. The divergence between the social code and the code required for the works has clearly every chance of being less in classical periods than in periods of rupture, infinitely less, especially, than in the *periods of continued rupture*, such as the one we are now living through. The transformation of the instruments of art production necessarily precedes the transformation of the instruments of art perception and the transformation of the modes of perception cannot but operate slowly, because it is a matter of uprooting a type of art competence (product of the interiorization of a social code, so deeply implanted in habits and memories that it functions at sub-conscious level) and of substituting another for it, by a new process of interiorization, necessarily long and difficult. In periods of rupture, the inertia inherent in art competences (or, if preferred, in *habitus*) means that the works produced by means of art production instruments of a new type are bound to be perceived, for a certain time, by means of old instruments of perception, precisely those against which they have been created. Educated men who belong to culture at least as much as culture belongs to them, are always given to applying inherited categories to the works of their period and to ignoring for the same reason the irreducible novelty of works which carry with them the very categories of their own perception (as opposed to works which can be called academic, in a very wide sense, and which only put into operation a code, or, rather, a *habitus* which already exists). Everything opposes the devotees of culture, vowed to

the worship of the consecrated works of defunct prophets, as also the priests of culture, devoted, like the teachers, to the organization of this worship, to the cultural prophets, that is to say the creators who upset the routine of ritualized fervour, while they become in their turn the object of the routine worship of new priests and new devotees. [. . .]

3

Since the work of art only exists as such to the extent that it is perceived, or in other words deciphered, it goes without saying that the satisfactions attached to this perception – whether it be a matter of purely aesthetic enjoyment or of more indirect gratification, such as the *effect of distinction* (cf. 3.3) – are only accessible to those who are disposed to appropriate them because they *attribute a value to them*, it being understood that they can do this only if they have the means to appropriate them. Consequently, the need to appropriate wealth which, like cultural wealth, only exists as such for those who have received the means to appropriate it from their family environment and from the school, can appear only in those who can satisfy it, and it can be satisfied as soon as it appears.

3.1 It follows on the one hand that, unlike 'primary' needs, the 'cultural need' as a cultivated need increases in proportion as it is satisfied, because each new appropriation tends to strengthen the mastery of the instruments of appropriation (cf. 3.2.1), and consequently, the satisfactions attached to a new appropriation; on the other hand, it also follows that the consciousness of deprivation decreases in proportion as the deprivation increases, individuals who are most completely dispossessed of the means of appropriating works of art being the most completely dispossessed of the consciousness of this dispossession.

3.2 The inclination to appropriate cultural wealth is the product of general or specific education, institutionalized or not, which creates (or cultivates) art competence as a mastery of the instruments for appropriation of this wealth, and which creates the 'cultural need' by giving the means to satisfy it.

3.2.1 The repeated perception of works of a certain style encourages the unconscious interiorization of the rules which govern the production of these works. Like rules of grammar, these rules are not apprehended as such, and are still less explicitly formulated and formulatable: for instance, a lover of classical music may have neither consciousness nor knowledge of the laws obeyed by the sound-making art to which he is accustomed, but his auditive education is such that, having heard a dominant chord, he is induced urgently to await the tonic which seems to him the 'natural' resolution of this chord, and he has difficulty in apprehending the internal coherence of music founded on other principles. The unconscious mastery of the instruments of appropriation which are the basis of familiarity with cultural works is acquired by slow familiarization, a long succession of 'little perceptions', in the sense in which Leibniz uses these words. Connoisseurship is an 'art' which, like the art of thinking or the art of living, cannot be imparted entirely in the form of precepts or instruction, and apprenticeship to it presupposes the equivalent of prolonged contact between disciple and master in traditional education, that is to say repeated contact with the work (or with works of the same class). [. . .]

3.2.2 Familiarization by repeated perceptions is the privileged mode of acquiring the means of appropriating works of art because the work of art always appears as a concrete individuality which never allows itself to be deduced from principles and rules defining a style. As is seen from the facts in the case of the musical work, the most exact and best informed discursive translations cannot take the place of the execution, as a *hic et nunc* realization of the individual form, which is irreducible to any formula; the conscious or unconscious mastery of the principles and rules of the production of this form enables the coherence and the necessity of it to be apprehended by a symmetrical reconstruction of the creator's construction but, far from reducing the individual work to the general nature of a type, it renders possible the apperception and appreciation of the originality of each actualization or, rather, of each execution, in relation to the principles and rules according to which it was produced. Although the work of art always procures the twofold feeling of the unparalleled and the inevitable, the most inventive, most improvised and most original solutions can always be understood, *post festum*, in terms of the schemes of thought, perception and action (rules of composition, theoretical problems, etc.) which have given rise to the technical or aesthetic question to which this work corresponds, at the same time as they were guiding the creator in the search for a solution irreducible to schemes and thereby, unpredictable yet nonetheless in accordance, *a posteriori*, with the rules of a grammar of forms. [. . .]

3.2.3 Even when the educational institution makes little provision for art training proper (as is the case in France and many other countries), even when therefore it gives neither specific encouragement to cultural activities nor a body of concepts specifically adapted to plastic art works, it tends on the one hand to inspire a certain *familiarity* – conferring a feeling of belonging to the cultivated class – with the world of art, in which people feel at home and among themselves as the appointed addressees of works which do not deliver their message to the first-comer: on the other hand, they tend to inculcate (at least in France and in the majority of European countries, as secondary education level) a *cultivated disposition* as a durable and generalized attitude which implies recognition of the value of works of art and ability to appropriate them by means of generic categories. Although it deals almost exclusively with literary works, in-school learning tends to create on the one hand a transposable inclination to admire works approved by the school and a duty to admire and to love certain works or, rather, certain classes of works which gradually seem to become linked to a certain educational and social status; and on the other hand, an equally generalized and transposable aptitude for categorizing by authors, by genres, by schools and by periods, for the handling of educational categories of literary analysis and for the mastery of the code which governs the use of the different codes (cf. 2.3.5), giving at least a tendency to acquire equivalent categories in other fields and to store away the typical knowledge which, even though extrinsic and anecdotal, makes possible at least an elementary form of apprehension, however inadequate it may be. Thus, the first degree of strictly pictorial competence shows itself in the mastery of an arsenal of words making it possible to name differences and to apprehend them while naming them: these are the proper names of famous painters – da Vinci, Picasso, Van Gogh – which function as generic categories, because one can say about any painting or non-figurative object 'that suggests Picasso', or, about any work recalling nearly or distantly the manner of the

Florentine painter, 'that looks like a da Vinci'; there are also broad categories, like 'the Impressionists' (a school commonly considered to include Gauguin, Cézanne and Degas), the 'Dutch School', 'the Renaissance'. It is particularly significant that the proportion of subjects who think in terms of schools is very clearly growing as the level of education rises and that, more generally, generic knowledge which is required for the perception of differences and consequently for memorizing – proper names, and historical, technical or aesthetic concepts – are increasingly numerous and increasingly specific as we go towards the more educated beholders, so that the most adequate perception differs only from the least adequate in so far as the specificity, richness and subtlety of the categories employed are concerned. By no means contradicting these arguments is the fact that the less educated visitors to museums are, the more they tend to prefer the most famous paintings and those sanctioned by school teaching, whereas modern painters who have the least chance of being mentioned in schools are quoted only by those with the highest educational qualifications, living in the big cities. To be able to form discerning or so-called 'personal' opinions is again a result of the education received: ability to throw off school constraints is the privilege of those who have sufficiently assimilated school education to make their own the free attitude towards scholastic culture taught by a school so deeply impregnated with the values of the ruling classes that it accepts the fashionable depreciation of school instruction. The contrast between accepted, stereotyped and as Max Weber would say 'routinized' culture, and genuine culture, freed from school dissertations, has meaning only for an infinitely small minority of educated people for whom culture is second nature, endowed with all the appearances of talent, and the full assimilation of school culture is a prerequisite for going beyond it towards this 'free culture' – freed that is to say from its school origins – which the bourgeois class and its school regard as the value of values (cf. 3.3).

But the best proof that the general principles for the transfer of training also hold for school training lies in the fact that the practices of one single individual and, *a fortiori*, of individuals belonging to one social category or having a specific level of education, tend to constitute a system, so that a certain type of practice in any field of culture very probably implies a corresponding type of practice in all the other fields; thus, frequent visits to museums are almost necessarily associated with an equal amount of theatre-going and to a lesser degree, attendance at concerts. Similarly, everything seems to indicate that knowledge and preferences tend to form into constellations which are strictly linked to the level of education, so that a typical structure of preferences in painting is most likely to be linked to a structure of preferences of the same type in music or literature.

3.2.4 Owing to the particular status of the work of art and the specific logic of the training which it implies, art education which is reduced to a dissertation (historical, aesthetic or other) on the works is necessarily at secondary level: like the teaching of the mother tongue, literature or art education (that is to say 'the humanities' of traditional education) necessarily presuppose, without ever, or hardly ever, being organized in the light of this preliminary, that individuals are endowed with a previously acquired competence and with a whole capital of experience unequally distributed among the various social classes (visits to museums or monuments, attending concerts, lectures, etc.).

3.2.4.1 In the absence of a methodical and systematic effort, involving the

mobilization of all available means from the earliest years of school onwards, to procure for all those attending school a direct contact with the works or, at least, an approximative substitute for that experience (by showing reproductions or reading texts, organizing visits to museums or playing records, etc.), art education can be of full benefit only to those who owe to their family circle the competence acquired by slow and imperceptible familiarization, because it does not give explicitly to all what it implicitly demands from all. While it is true that only the school can give the continuous and prolonged, methodical and uniform training capable of *mass production*, if I may use that expression, of competent individuals, provided with schemes of perception, thought and expression which are prerequisites for the appropriation of cultural wealth, and endowed with that generalized and permanent inclination to appropriate this wealth which is the mark of devotion to culture, the fact remains that the effectiveness of this moulding action is directly dependent upon the degree to which those undergoing it fulfil the preliminary conditions for adequate reception: the influence of school activity is all the stronger and more lasting when it is carried on for a longer time (as is shown by the fact that the decrease of cultural activity with age is less marked when the duration of schooling was longer), when those upon whom it is exercised have greater previous competence, acquired through early and direct contact with works (which is well known to be more frequent always as one goes higher up the social scale) and finally when a propitious cultural atmosphere sustains and relays its effectiveness. Thus, arts students who have received a homogeneous and homogenizing training for a number of years and who have been constantly selected according to the degree to which they conform to school requirements, remain separated by systematic differences, both in their pursuit of cultural activities and in their cultural preferences, depending upon whether they come from a more or less cultivated milieu and for how long this has been so; their knowledge of the theatre (measured according to the average number of plays that they have seen on the stage) or of painting is greater if their father or grandfather (or *a fortiori*, both of them) belongs to a higher occupational category and further, in respect of a fixed value of each of these variables (the category of the father or of the grandfather), the other tends, per se, to hierarchize the scores. By reason of the slowness of the acculturation process, subtle differences linked with the length of time that they have been in contact with culture continue therefore to separate individuals who are apparently equal in respect of social success and even of educational success. Cultural nobility also has its quarterings.

3.2.4.2 Only an institution like the school, the specific function of which is methodically to develop or create the inclinations which produce an educated man and which lay the foundations, quantitatively and consequently qualitatively, of a constant and intense pursuit of culture, could offset (at least partially) the initial disadvantage of those who do not receive from their family circle the encouragement to undertake cultural activities and the competence presupposed in any dissertation on works, on condition and only on condition that it employs every available means to break down the endless series of cumulative processes to which any cultural education is condemned. For if the apprehension of a work of art depends, in its intensity, its modality and in its very existence, on the beholder's mastery of the generic and specific code of the work, that is to say on his competence, which he owes partly to school training, the same thing applies to the

pedagogic communication which is responsible, among other functions, for transmitting the code of works of scholarly culture (at the same time as the code according to which it effects this transmission), so that the intensity and modality of the communication are here again a function of culture (as a system of schemes of perception, expression and historically constituted and socially conditioned thinking) which the receiver owes to his family circle and which is more or less close to scholarly culture and the linguistic and cultural models according to which the school effects the transmission of this culture. Considering that the direct experience of works of scholarly culture and the institutionally organized acquisition of culture which is a prerequisite for adequate experience of such works are subject to the same laws (cf. 2.3.2, 2.3.3 and 2.3.4), it is obvious how difficult it is to break the sequence of the cumulative effects which cause cultural capital to attract cultural capital: in fact, the school has only to give free play to the objective machinery of cultural diffusion without working systematically to give to all, in and through the pedagogical message itself, what is given to some through family inheritance, that is to say the instruments which condition the adequate reception of the school message, for it to redouble and entrench by its approval the socially conditioned inequalities of cultural competence, by treating them as natural inequalities, or in other words as inequalities of gifts.

3.3 Charismatic ideology is based on parenthesizing the relationship, evident as soon as it is revealed, between art competence and education, which alone is capable of creating both the inclination to recognize a value in cultural wealth and the competence which gives a meaning to this inclination by making it possible to appropriate such wealth. Since their art competence is the product of an imperceptible familiarization and an automatic transferring of aptitudes, members of the privileged classes are naturally inclined to regard as a gift of nature a cultural heritage which is transmitted by a process of unconscious training. But, in addition, the contradictions and ambiguities of the relationship which the most cultured among them maintain with their culture are both encouraged and permitted by the paradox which defines the 'realization' of culture as *becoming natural*: culture being achieved only by negating itself as such, that is to say as artificial and artificially acquired, so as to become second nature, a *habitus*, a possession turned into being, the virtuosi of the judgement of taste seem to reach an experience of aesthetic grace so completely freed from the constraints of culture and so little marked by the long, patient training of which it is the product that any reminder of the conditions and the social conditionings which have rendered it possible seems to be at once obvious and shocking. It follows that the most experienced connoisseurs are the natural champions of charismatic ideology, which concedes to the work of art a magical power of conversion capable of awakening the potentialities latent in a few of the elect, and which contrasts authentic experience of a work of art as an 'affection' of the heart or immediate enlightenment of the intuition with the laborious proceedings and cold comments of the intelligence, ignoring the social and cultural conditions underlying such an experience, and at the same time treating as a birthright the virtuosity acquired through long familiarization or through the exercises of a methodical training; silence concerning the social prerequisites for the appropriation of culture or, to be more exact, for the acquisition of art competence in the sense of mastery of all the means for the specific appropriation of works of art is a

self-seeking silence because it is what makes it possible to legitimatize a social privilege by pretending that it is a gift of nature.

To remember that culture is not what one is but what one has, or, rather what one has become; to remember the social conditions which render possible aesthetic experience and the existence of those beings – art lovers or 'people of taste' – for whom it is possible; to remember that the work of art is given only to those who have received the means to acquire the means to appropriate it and who could not seek to possess it if they did not already possess it, in and through the possession of means of possession as an actual possibility of effecting the taking of possession; to remember, lastly, that only a few have the real possibility of benefiting by the theoretical possibility, generously offered to all, of taking advantage of the works exhibited in museums, all this is to bring to light the hidden mobile of the effects of the majority of culture's social uses.

The parenthesizing of the social conditions which render possible culture and culture become nature, cultivated nature, having all the appearances of grace or a gift and yet acquired, so therefore 'deserved', is the condition precedent of charismatic ideology which makes it possible to confer on culture and in particular on 'love of art' the all-important place which they occupy in middle-class 'sociodicy'. The bourgeoisie find naturally in culture as cultivated nature and culture that has become nature the only possible principle for the legitimation of their privilege: being unable to invoke the right of birth (which their class, through the ages, has refused to the aristocracy) or Nature which, according to 'democratic' ideology, represents universality, that is to say the ground on which all distinctions are abolished, or the aesthetic virtues which enabled the first generation of bourgeois to invoke their merit, they can resort to cultivated nature and culture become nature, to what is sometimes called 'class', through a kind of tell-tale slip, to 'education', in the sense of a product of education which seems to owe nothing to education, to *distinction*, grace which is merit and merit which is grace, an unacquired merit which justifies unmerited acquisitions, that is to say inheritance. To enable culture to fulfil its primary ideological function of class co-optation and legitimation of this mode of selection, it is necessary and enough that the link between culture and education, which is simultaneously obvious and hidden, be forgotten, disguised, and denied. The unnatural idea of inborn culture, of a gift of culture, bestowed on certain people by Nature, is inseparable from blindness to the functions of the institution which ensures the profitability of the cultural heritage and legitimizes its transmission while concealing that it fulfils this function: the school in fact is the institution which, through its outwardly irreproachable verdicts, transforms socially conditioned inequalities in regard to culture into inequalities of success, interpreted as inequalities of gifts which are also inequalities of merit. Plato records, towards the end of *The Republic*, that the souls who are to begin another life must themselves choose their lot among 'patterns of life' of all kinds and that, when the choice has been made, they must drink of the water of the river Lethe before returning to earth. The function which Plato attributes to the water of forgetfulness devolves, in our societies, on the university which, in its impartiality, though pretending only to recognize students as equal in rights and duties, divided only by inequalities of gifts and of merit, in fact confers on individuals degrees judged according to their cultural heritage, and therefore according to their social status.

By symbolically shifting the essential of what sets them apart from other classes from the economic field to that of culture, or rather, by adding to strictly economic differences, namely those created by the simple possession of material wealth, differences created by the possession of symbolic wealth such as works of art, or by the pursuit of symbolic distinctions in the manner of using such wealth (economic or symbolic), in short, by turning into a fact of nature everything which determines their 'value', or to take the word in the linguistic sense, their *distinction* – a mark of difference which, according to the Littré, sets people apart from the common herd 'by the characteristics of elegance, nobility and good form' – the privileged members of middle-class society replace the difference between two cultures, historic products of social conditions, by the essential difference between two natures, a naturally cultivated nature and a naturally natural nature. Thus, the sacralizating [*sic*] of culture and art fulfils a vital function by contributing to the consecration of the social order: to enable educated men to believe in barbarism and persuade their barbarians within the gates of their own barbarity, all they must and need do is to manage to conceal themselves and to conceal the social conditions which render possible not only culture as second nature in which society recognizes human excellence or 'good form' as the 'realization' in a *habitus* of the aesthetics of the ruling classes, but also the legitimized predominance (or, if you like, the legitimacy) of a particular definition of culture. And in order that the ideological circle may be completely closed, all they have to do is to find in an essentialist representation of the bipartition of society into barbarians and civilized people, the justification of their right to conditions which produce the possession of culture and the dispossession of culture, an estate of 'nature' destined to appear based on the nature of the men who are condemned to it.

If such be the function of culture and if it be love of art which really determines the choice which separates, as by an invisible and insuperable barrier, those to whom it is given from those who have not received this grace, it can be seen that museums betray, in the smallest details of their morphology and their organization, their true function which is to strengthen the feeling of belonging in some and the feeling of exclusion in others. Everything, in these civic temples in which bourgeois society deposits its most sacred possessions, that is to say relics inherited from a past which is not its own, in these holy places of art, in which the chosen few come to nurture a faith of virtuosi while conformists and bogus devotees come and perform a class ritual, old palaces or great historic homes to which the nineteenth century added imposing edifices, built often in the Graeco-Roman style of civic sanctuaries, everything combines to indicate that the world of art is as contrary to the world of everyday life as the sacred is to the profane: the prohibition to touch the objects, the religious silence which is forced upon visitors, the puritan asceticism of the facilities, always scarce and uncomfortable, the almost systematic refusal of any instruction, the grandiose solemnity of the decoration and the decorum, colonnades, vast galleries, decorated ceilings, monumental staircases, both outside and inside, everything seems done to remind people that the transition from the profane world to the sacred world presupposes, as Durkheim says, 'A genuine metamorphosis', a radical spiritual change, that the bringing together of the worlds 'is always, in itself, a delicate operation which calls for precaution and a more or less complicated initiation', that 'it is not even possible unless the profane lose their specific

characteristics, unless they themselves become sacred to some extent and to some degree'.[2] Although the work of art, owing to its sacred nature, calls for particular dispositions or predispositions, it brings in return its consecration to those who satisfy its demands, to the small elite who are self-chosen by their aptitude to respond to its appeal.

The museum gives to all, as a public legacy, the monuments of a splendid past, instruments of the sumptuous glorification of the great figures of bygone ages: this is false generosity, because free entrance is also optional entrance, reserved for those who, endowed with the ability to appropriate the works, have the privilege of using this freedom and who find themselves consequently legitimized in their privilege, that is to say in the possession of the means of appropriating cultural wealth or, to borrow an expression of Max Weber in the *monopoly* of the handling of cultural wealth and of the institutional signs of cultural salvation (awarded by the school). Being the keystone of a system which can function only by concealing its true function, the charismatic representation of art experience never fulfils its function of mystifying so well as when it resorts to a 'democratic' language: to claim that works of art have power to awaken the grace of aesthetic enlightenment in any one, however culturally uninitiated he may be, to presume in all cases to ascribe to the unfathomable accidents of grace or to the arbitrary bestowal of 'gifts' aptitudes which are always the product of unevenly distributed education, and therefore to treat inherited aptitudes as personal virtues which are both natural and meritorious. Charismatic ideology would not be so strong if it were not the only outwardly irreproachable means of justifying the right of the heirs to the inheritance without being inconsistent with the ideal of formal democracy, and if, in this particular case, it did not aim at establishing in nature the sole right of the middle class to appropriate art treasures to itself, to appropriate them to itself *symbolically*, that is to say in the only legitimate manner, in a society which pretends to yield to all, 'democratically', the relics of an aristocratic past.

Notes

1 Berne Joffroy, *Le Dossier Carvage*, Paris, Editions de Minuit, 1959, p. 9.
2 Emile Durkheim, *Les Formes elementaires de la vie religieuse*, Paris, PUF, 1960, sixth edition, pp. 55–6.

Paul DiMaggio

CULTURAL ENTREPRENEURSHIP IN NINETEENTH-CENTURY BOSTON

The creation of an organizational base for high culture in America

From *Media, Culture and Society* 4 (1982), 33–50.

SOCIOLOGICAL AND POLITICAL DISCUSSIONS of culture have been predicated on a strong dichotomy between high culture – what goes on in museums, opera houses, symphony halls and theatres – and popular culture, of both the folk and commercial varieties. [. . .]

Yet high and popular culture can be defined neither by qualities inherent to the work of art, nor, as some have argued, by simple reference to the class character of their publics. The distinction between high and popular culture, in its American version, emerged in the period between 1850 and 1900 out of the efforts of urban elites to build organizational forms that, first, isolated high culture and second, differentiated it from popular culture. Americans did not merely adopt available European models. Instead they groped their way to a workable distinction. Not until two distinct organizational forms – the private or semi-private, non-profit cultural institution and the commercial popular-culture industry – took shape did the high/popular-culture dichotomy emerge in its modern form. Once these organizational models developed, the first in the bosom of elite urban status communities, the second in the relative impersonality of emerging regional and national markets, they shaped the rôle that cultural institutions would play, the careers of artists, the nature of the works created and performed, and the purposes and publics that cultural organizations would serve.

In this paper I will address only one side of this process of classification, the institutionalization of high culture and the creation of distinctly high-cultural organizations. While high culture could be defined only in opposition to popular culture, it is the process by which urban elites forged an institutional system embodying their ideas about the high arts that will engage us here. In order to grasp the extent to

which the creation of modern high-cultural institutions was a task that involved elites as an organic group, we will focus on that process in one American city. Boston in the nineteenth century was the most active center of American culture: and its elite – the Boston Brahmins – constituted the most well defined status group of any of the urban upper classes of this period. For this reason the processes with which I am concerned appear here in particularly clear relief.

When we look at Boston before 1850 we see a culture defined by the pulpit, the lectern and a collection of artistic efforts, amateurish by modern standards, in which effort rarely was made to distinguish between art and entertainment, or between culture and commerce. The arts in Boston were not self-conscious; they drew few boundaries. While intellectuals and ministers distinguished culture that elevated the spirit from that which debased it, there was relatively little agreement on what works or genres constituted which (see Hatch, 1962; Harris, 1966). Harvard's Pierian Sodality mixed popular songs with student compositions and works by European fine-arts composers. The Philharmonic Society played classical concerts, but also backed visiting popular vocalists. Throughout this period, most of Boston music was in the hands of commercial entrepreneurs. Gottlieb Graupner, the city's leading impresario in the 1830s, sold sheet music and instruments, published songs and promoted concerts at which religious, classical and popular tunes mingled freely. (One typical performance included a bit of Italian opera, a devotional song by Mrs Graupner, a piece by Verdi, 'Bluebell of Scotland' and 'The Origin of Common Nails', recited by Mr Bernard, a comedian.) The two exceptions, the Handel and Haydn Society and the Harvard Musical Association, founded in the 1840s and 1850s respectively, were associations of amateurs and professionals that appealed only to a relatively narrow segment of the elite.

The visual arts were also organized on a largely commercial basis in this era. In the 1840s, the American Art Union sold paintings by national lottery (Lynnes, 1953). These lotteries were succeeded, in Boston, New York and Philadelphia, by private galleries. Museums were modelled on Barnum's (Barnum, 1879; Harris, 1973): fine art was interspersed among such curiosities as bearded women and mutant animals, and popular entertainments were offered for the price of admission to a clientele that included working people as well as the upper middle class. Founded as a commercial venture in 1841, Moses Kemball's Boston Museum exhibited works by such painters as Sully and Peale alongside Chinese curiosities, stuffed animals, mermaids and dwarves. [. . .]

By 1910, high and popular culture were encountered far less frequently in the same settings. The distinction towards which Boston's clerics and critics had groped 50 years before had emerged in institutional form. The Boston Symphony Orchestra was a permanent aggregation, wresting the favor of Boston's upper class decisively from the commercial and co-operative ensembles with which it first competed. The Museum of Fine Arts, founded in 1873, was at the center of the city's artistic life, its exhibitions complemented by those of Harvard and the eccentric Mrs Gardner. Music and art critics might disagree on the merits of individual conductors or painters; but they were united in an aesthetic ideology that distinguished sharply between the nobility of art and the vulgarity of mere entertainment. The distinction between true art, distributed by not-for-profit corporations managed by artistic professionals and governed closely by prosperous and influential trustees, and

popular entertainment, sponsored by entrepreneurs and distributed via the market to whomever would buy it, had taken a form that has persisted to the present. So, too, had the social distinctions that would differentiate the publics for high and popular culture.

The sacralization of art, the definition of high culture and its opposite, popular culture, and the institutionalization of this classification, was the work of men and women whom I refer to as *cultural capitalists*. I use the term in two senses to describe the capitalists (and the professionals whose wealth came from the participation of their families in the industrial ventures – textiles, railroads and mining – of the day) who founded the museums and the symphony orchestras that embodied and elaborated the high-cultural ideal. They were capitalists in the sense that their wealth came from the management of industrial enterprises from which they extracted a profit, and cultural capitalists in that they invested some of these profits in the foundation and maintenance of distinctly cultural enterprises. They also – and this is the second sense in which I use the term – were collectors of what Bourdieu has called 'cultural capital', knowledge and familiarity with styles and genres that are socially valued and that confer prestige upon those who have mastered them (Bourdieu and Passeron, 1977, 1979). It was the vision of the founders of the institutions that have become, in effect, the treasuries of cultural capital upon which their descendants have drawn that defined the nature of cultural capital in American society.[1]

To create an institutional high culture, Boston's upper class had to accomplish three concurrent, but analytically distinct, projects: entrepreneurship, classification and framing. By entrepreneurship, I mean the creation of an organizational form that members of the elite could control and govern. By classification, I refer to the erection of strong and clearly defined boundaries between art and entertainment, the definition of a high art that elites and segments of the middle class could appropriate as their own cultural property; and the acknowledgement of that classification's legitimacy by other classes and the state. Finally, I use the term framing to refer to the development of a new etiquette of appropriation, a new relationship between the audience and the work of art.[2] The focus of this paper will be on the first of these three processes.

The predecessors: organizational models before the Gilded Age

By the close of the Civil War, Boston was in many ways the hub of America's cultural life. But, as Martin Green (1966) has illustrated, the unity of the city's economic and cultural elite, the relative vibrancy of Harvard and the vitality of the communal cultural associations of the elite – the Handel and Haydn Society, the Athenaeum, the Dante Circle, the singing clubs – made Boston unique among America's cities. Godkin called Boston 'the one place in America where wealth and the knowledge of how to use it are apt to coincide' (*ibid.*: 41).

Yet at the close of the Civil War, Boston lacked the organizational arrangements that could sustain a public 'high culture' distinct and insulated from more popular forms. As we have seen, the boundaries between high art and mass art were poorly drawn: artists and performers had not yet segmented elite and popular markets. It is not that the wealthy were uninterested in art. [. . .] Many young Brahmins [. . .]

spent time in Europe, studying art or music (e.g. Adams, 1928). And many more learned and played music in or around Boston (Whipple, n.d.), or attended public lectures on the arts.

Nor was there a lack of theories about the nature of good art. Although aesthetic philosophies blossomed after the high-culture institutions were established, even the mid-1850s nurtured aesthetic philosophers like Brook Farmer John S. Dwight, editor of *Dwight's Journal of Music*. Some Bostonians were aware of the latest developments in European music and acquainted with classical standards in the visual arts.

High culture (and by this I mean a strongly classified, consensually defined body of art distinct from 'popular' fare) failed to develop in Boston prior to the 1870s because the organizational models through which art was distributed were not equipped to define and sustain such a body and a view of art. Each of the three major models for organizing the distribution of aesthetic experience before 1870 – the for-profit firm, the co-operative enterprise and the communal association – was flawed in some important way.

The problems of the privately owned, for-profit firm are most obvious. As Weber (1968, vol. 2, sec. 9: 937) has argued, the market declassifies culture: presenters of cultural events mix genres and cross boundaries to teach out to larger audiences. The Boston Museum, founded in the 1840s, mixed fine art and side show oddities, Shakespeare and theatrical ephemerata. For-profit galleries exhibited art as spectacle: when James Jackson Jarves showed his fine collection of Italian primitives at Derby's Institute of Fine Arts in New York, 'the decor of this . . . dazzlingly ornate commercial emporium . . . caused much more favorable comment than Jarves' queer old pictures' (Burt, 1977: 57).

If anything, commerce was even less favorable to the insulation of high art in the performance media. Fine-art theatre in Boston never seems to have got off the ground. And the numerous commercial orchestras that either resided in or toured Boston during this period mixed fine-arts and light music indiscriminately. [. . .]

[. . .]

The lines dividing non-profit, co-operative, for-profit and public enterprise were not as strong in the nineteenth century as they would become in the twentieth. Civic-minded guarantors might hold stock in commercial ventures with no hope of gaining a profit (e.g. Symphony Hall at the end of the century). The goals of the charitable corporation were usually defined into its charter, but otherwise it legally resembled its for-profit counterpart. Even less clearly defined was what I call the voluntary association: closed associations of individuals (sometimes incorporated, sometimes not) to further the aims of the participating members, rather than of the community as a whole. For associations like the Handel and Haydn Society, which might give public concerts, or the Athenaeum, which took an active rôle in public affairs, privateness was relative. But, ultimately, each was a voluntary and exclusive instrument of its members.

Why were these communal associations ill-suited to serve as the organizational bases for high culture in Boston? Why could the Athenaeum, a private library, or the Boston Art Club, which sponsored contemporary art shows (Boston Art Club, 1878), not have developed continuous programs of public exhibitions? Could not the Handel and Haydn Society, the Harvard Musical Association (formed by Harvard

graduates who wished to pursue after graduation musical interests developed in the College's Pierian Sodality) or one of the numerous singing circles have developed into a permanent orchestra? They faced no commercial temptations to study, exhibit or perform any but the highest art. (Indeed, the Harvard Musical Association's performances were so austere as to give rise to the proverb 'dull as a symphony concert' (Howe, 1914: 8)).

None of them, however, could, by the late nineteenth century, claim to speak for the community as a whole, even if they chose to. Each represented only a fraction (although, in the case of Athenaeum, a very large and potent fraction) of the elite; and in the case of the musical associations and the Art Club, members of the middle class and artistic professionals were active as well. The culture of an elite status group must be monopolized, it must be legitimate and it must be sacralized. Boston's cultural capitalists would have to find a form able to achieve all these aims: a single organizational base for each art form; institutions that could claim to serve the community, even as they defined the community to include only the elite and the upper-middle classes; and enough social distance between artist and audience, between performer and public, to permit the mystification necessary to define a body of artistic work as sacred.

This they did in the period between 1870 and 1900. By the end of the century, in art and music (but not in theatre (see Twentieth Century Club, 1910: Poggi, 1968)), the differences between high and popular-culture artists and performers were becoming distinct, as were the physical settings in which high and popular art were presented.

The form that the distribution of high culture would take was the non-profit corporation, governed by a self-perpetuating board of trustees who, eventually, would delegate most artistic decisions to professional artists or art historians (Zolberg, 1974, 1981). The charitable corporation was not designed to define a high culture that elites could monopolize; nor are non-profit organizations by their nature exclusive. But the non-profit corporation had five virtues that enabled it to play a key rôle in this instance. First, the corporation was a familiar and successful tool by which nineteenth-century elites organized their affairs (see Fredrickson, 1965; Story, 1980; Hall, 1982). In the economic realm it enabled them to raise capital for such profitable ventures as the Calumet and Hecla Mines, the western railroads and the telephone company. In the non-profit arena, it had been a useful instrument for elite communal governance at Harvard, the Massachusetts General Hospital and a host of charitable institutions (Story, 1980). Second, by entrusting governance decisions to trustees who were committed either to providing financial support or to soliciting it from their peers, the non-profit form effectively (if not completely) insulated museums and orchestras from the pressures of the market. Third, by vesting control in a well integrated social and financial elite, the charitable corporation enabled its governors to rule without interference from the state or from other social classes. Fourth, those organizations whose trustees were able to enlist the support of the greater part of the elite could provide the stability needed for a necessarily lengthy process of defining art and developing ancillary institutions to insulate high-cultural from popular-cultural work, performance and careers. Finally, and less obviously, the goals of the charitable corporation, unlike those of the profit-seeking firm, are diffuse and ambiguous enough to accommodate a range of conflict-

ing purposes and changing ends. The broad charters of Boston's major cultural organizations permitted their missions to be redefined with time, and enabled their governors to claim (and to believe) that they pursued communitarian goals even as they institutionalized a view and vision of art that made elite culture less and less accessible to the vast majority of Boston's citizens.

The context of cultural capitalism

In almost every literate society, dominant status groups or classes eventually have developed their own styles of art and the institutional means of supporting them. It was predictable that this would happen in the United States, despite the absence of an hereditary aristocracy. It is more difficult, however, to explain the timing of this process. Dwight and others wished (but failed) to start a permanent professional symphony orchestra from at least the late 1840s. The Athenaeum's proprietors tried to raise a public subscription to purchase the Jarves collection in the late 1850s, but they failed. What had changed?

Consider, first, the simple increase in scale and wealth between 1800 and 1870. At the time of the revolution, Boston's population was under 10,000. By 1800 it had risen to 25,000; by 1846 it was 120,000. By 1870, over a quarter of a million people lived in Boston (Lane, 1975). The increase in the size of the local cultural market facilitated a boom in theatre building in the 1830s (Nye, 1960: 264), a rise in the number and stability of book and music stores (Fisher, 1918: 30) and the growth of markets for theatre, music, opera, dancing and equestrian shows (Nye, 1960: 143). The growth of population was accompanied by an increase in wealth. Boston's first fortunes were mercantile, the fruits of the China trade, large by local, but small by national standards. In 1840, Boston had but a handful of millionaires. By 1890, after post-Civil War booms in railroads, mining, banking and communications, there were 400 (Jaher, 1968, 1972; Story, 1980). Even the physical scale of the city changed during this period: beginning in 1856, developers began filling in the waters of the Back Bay, creating a huge track of publicly owned land, partially devoted to civic and cultural buildings. As wealthy outlanders from Lawrence, Lynn and Lexington migrated to Beacon Hill and Cambridge, streetcars reduced the cost and the difficulty of travel to Boston from its suburbs (Warner, 1970). In short, Boston was larger, wealthier and more compact in 1870 than it had been 50 years before.

With growth came challenges to the stability of the community and to the cultural authority (Starr, 1982) of elites. Irish immigrants flowed into Boston from the 1840s to work in the city's industrial enterprises (Handlin, 1972; Thernstrom, 1972): industrial employment rôles doubled between 1845 and 1855 (Handlin, 1972). With industry and immigration came disease, pauperism, alcoholism, rising infant mortality and vice. The Catholic Irish were, by provenance and religion, outside the consensus that the Brahmins had established. By 1900, 30% of Boston's residents were foreign-born and 70% were of foreign parentage (Green, 1966: 102). By the close of the Civil War, Boston's immigrants were organizing to challenge the native elite in the political arena (Solomon, 1956).

If immigration and industrialization wrought traumatic changes in the city's social fabric, the political assault on Brahmin institutions by native populists proved

even more frightening. The Know-Nothings who captured state government in the 1850s attacked the social exclusivity of Harvard College frontally, amending its charter and threatening state control over its governance, hiring and admissions policies (Story, 1980). Scalded by these attacks, Boston's leadership retreated from the public sector to found a system of non-profit organizations that permitted them to maintain some control over the community even as they lost their command of its political institutions.

Story (1980) argues persuasively that this political challenge, and the wave of institution-building that followed it, transformed the Brahmins from an elite into a social class. As a social class, the Brahmins built institutions (schools, almshouses and charitable societies) aimed at securing control over the city's social life (Huggins, 1971; Vogel, 1981). As a status group, they constructed organizations (clubs, prep schools and cultural institutions) to seal themselves off from their increasingly unruly environment. Thus Vernon Parrington's only partially accurate observation that 'The Brahmins conceived the great business of life to be the erection of barriers against the intrusion of the unpleasant' (quoted in Shiverick, 1970: 129). The creation of a network of private institutions that could define and monopolize high art was an essential part of this process of building cultural boundaries.

The Brahmin class, however, was neither large enough to constitute a public for large-scale arts organizations, nor was it content to keep its cultural achievements solely to itself. Alongside of, and complicating, the Brahmins' drive towards exclusivity was a conflicting desire, as they saw it, to educate the community. The growth of the middle class during this period – a class that was economically and socially closer to the working class and thus in greater need of differentiating itself from it culturally – provided a natural clientele for Boston's inchoate high culture. While we have all too little information about the nature of the visitors to Boston's Museum or of the audiences for the Symphony, it seems certain from contemporary accounts (and sheer arithmetic) that many of them were middle class. The same impulse that created the markets for etiquette and instruction books in the mid-nineteenth century helped populate the galleries and concert halls of the century's last quarter (Nye, 1960; Douglas, 1978).

Cultural entrepreneurship: the Museum of Fine Arts and the Boston Symphony Orchestra

The first step in the creation of a high culture was the centralization of artistic activities within institutions controlled by Boston's cultural capitalists. This was accomplished with the foundings of the Museum of Fine Arts and the Boston Symphony Orchestra. These institutions were to provide a framework, in the visual arts and music, respectively, for the definition of high art, for its segregation from popular forms and for the elaboration of an etiquette of appropriation.

Bostonians had sought to found a museum for some time before 1870. In 1858, the state legislature, dominated by factions unfriendly to Boston's elite, refused to provide Back Bay land for a similar venture (Harris, 1962: 548). The immediate impetus for the Museum, however, was a bequest by Colonel Timothy Bigelow Lawrence of an armor collection too large for the Athenaeum's small gallery to

accommodate. Three years earlier the Athenaeum's Fine Arts Committee had sug-
gested that the galleries be expanded, but nothing had been done. With the Law-
rence bequest, and his widow's offer to contribute a wing to a new gallery, the
trustees voted that

> the present is a proper time for making an appeal to the public and
> especially to the friends of the Fine Arts, to raise the sum required to
> make available Mrs. Lawrence's proposed donation, and if possible, to
> provide even larger means to carry out so noble a design in the confident
> hope that it may be attended with success . . .
>
> (Whitehill, 1970: 6–8)

A new museum promised to solve problems for several of Boston's elite institutions:
Harvard had a collection of prints for which it sought a fire-safe depository, and MIT
and the American Social Science Association possessed collections of architectural
casts too large for them to store conveniently. After a series of meetings between
the Athenaeum trustees and other public and private decision makers, it was
decided to raise money for a museum on a tract of land in the Back Bay. (The land,
owned by the Boston Water Power Company, was made available through the
intervention of Mathias Denman Ross, a local developer who was keenly aware of
the effects of public and cultural buildings on the value of nearby real estate.)
In 1870 the state legislature chartered the enterprise and with the help of the
Athenaeum, which sponsored exhibitions throughout this period, fund-raising
began.[3]

The initial aspirations of the Museum founders were somewhat modest. The key
figure in the founding was Charles Callahan Perkins, great-nephew of a China-trade
magnate, kinsman of the chairman of the Athenaeum's Fine Arts Committee and
himself President of the Boston Art Club. Perkins wrote two books on Italian
sculpture in the 1860s, championed arts education in Boston's public schools and
served as head of the American Social Science Association's arts-education panel in
1869. (He had studied painting and sculpture in Europe for almost 10 years, before
concluding that he lacked the creativity to be a good artist.) Perkins, in a report to
the ASSA had asserted 'the feasibility of establishing a regular Museum of Art at
moderate expense', with primarily educational aims. Since Boston's collections had
few originals, he recommended that the new collection consist of reproductions,
primarily plaster casts of sculpture and architecture.

The breadth of response to the first appeal for funds for the museum is striking.
Although the economy was not robust, $261,425 was collected for the building. Of
this amount, the largest gift was $25,000, only two were larger than $5000 and all
but $100,000 came from over 1000 gifts of less than $2000 from such sources as
local newspapers, public-school teachers and workers at a piano factory. (By con-
trast, when the Museum sought to raise $400,000 for new galleries and an endow-
ment 15 years later, $218,000 of the initial $240,000 in contributions came from a
mere 58 donors (Whitehill, 1970: 42).)

One reason for the breadth of early support was that the Museum, although in
private hands, was to be a professedly communitarian and educational venture. The
Board of Trustees contained a large segment of the Brahmin class: All but one of the

first 23 trustees were proprietors of the Athenaeum; 11 were members of the Saturday Club, while many others were members of the Somerset and St Botolph's clubs; most were graduates of Harvard and many were active in its affairs. The public nature of the Board was further emphasized by the inclusion on it of permanent and *ex-officio* appointments; from Harvard, MIT and the Athenaeum; the Mayor, the Chairman of the Boston Public Library's board, the trustee of the Lowell Institute, the Secretary of the State Board of Education and the Superintendent of Boston's schools. The trustees dedicated the institution to education: one hoped that the breadth of the board's membership would ensure that the Museum's managers would be 'prevented from squandering their funds upon the private fancies of would-be connoisseurs'. Indeed, the articles of incorporation required that the Museum be open free of charge at least four times a month. The public responded by flooding the Museum on free weekend days in the early years (Harris, 1962: 48–52).

The centralization of the visual arts around a museum required only the provision of a building and an institution controlled by a board of civic-minded members of the elite. The Museum functioned on a relatively small budget in its early years, under the direction of Charles Greely Loring, a Harvard graduate and Civil War general, who had studied Egyptology when his physician sent him to the banks of the Nile. The Museum's founders, facing the need to raise substantial funds, organized both private and public support carefully, mobilizing a consensus in favor of their project from the onset.

By contrast, the Boston Symphony Orchestra was, for its first years at least, a one-man operation, forced to wrest hegemony over Boston's musical life from several contenders, each with its own coterie of elite support. That Henry Lee Higginson, a partner in the brokerage firm of Lee-Higginson, was able to do so was a consequence of the soundness of his organizational vision, the firmness of his commitment, and equally important, his centrality to Boston's economic and social elite.

[. . .]

Higginson published his plans for the orchestra in a column, headed 'In the Interest of Good Music', that appeared in several of Boston's newspapers.

[. . .]

Despite a measure of public incredulity, and some resentment at Higginson's choice of European conductor, George Henschel, over local candidates, the BSO opened in December 1881 to the enthusiastic response of the musical public. (The demand for tickets was great; lines formed outside the box office the evening before they went on sale.) The social complexion of the first night's audience is indicated by a report in a Boston newspaper that 'the spirit of the music so affected the audience that when the English national air was recognized in Weber's Festival Overture, the people arose en masse and remained standing until the close'. By employing local musicians and permitting them to play with the Philharmonic Society and the Harvard Musical Association (both of which, like the BSO, offered about 20 concerts that season), Higginson earned the gratitude of the city's music lovers.

The trouble began in February 1882, when the players received Higginson's terms for the following season. To continue to work for the Symphony, they would

be required to make themselves available for rehearsals and performances from October through April, four days a week, and to play for no other conductor or musical association. (The Handel and Haydn Society, which had strong ties to the Athenaeum, was exempted from this prohibition.) The implications of the contract, which the players resisted unsuccessfully, were clear: Boston's other orchestras, lacking the salaries that Higginson's subsidies permitted, would be unable to compete for the services of Boston's musicians. (To make matters worse, a number of the city's journeymen musicians received no offers from Higginson at all.)

The response of the press, particularly of the Brahmin *Transcript*, suggests that loyalists of the other ensembles responded to Higginson's actions with outrage.

[. . .]

Higginson and his orchestra weathered the storm. Attendance stayed up and within a year, his was the only orchestral association in Boston, co-existing peacefully with the smaller Handel and Haydn Society. In order to achieve the kind of ensemble he desired, however, Higginson had to ensure that his musicians would commit their time and their attention to the BSO alone, and accept his (and his agent's, the conductor's) authority as inviolate. Since, in the past, all musicians, whatever their affiliations, were freelancers upon whom no single obligation weighed supreme, accomplishing these aspirations required a fundamental change in the relationship between musicians and their employers.

In part, effecting this internal monopolization of attention was simply a matter of gaining an external monopoly of classical-music performance. With the surrender of the Philharmonic Society and the Harvard Musical Association, two major competitors for the working time of Boston's musicians disappeared. Nonetheless, while his musicians were now more dependent upon the BSO for their livelihoods, and thus more amenable to his demands, his control over the work force was still challenged by the availability of light-music or dance engagements, teaching commitments and the tradition of lax discipline to which the players were accustomed.

[. . .]

Higginson was undeniably an autocrat. In later years he rejected the suggestions of friends to place the Orchestra under a board of trustees; and he used the threat of discontinuing his annual subventions as a bludgeon to forestall the unionization of the players. Yet Higginson accomplished what all orchestras would have to achieve if orchestral work was to be separated permanently from the playing of popular music and Dwight's dream of a permanent orchestra devoted to high-art music achieved: the creation of a permanent musical work force, under exclusive contract, willing to accept without question the authority of the conductor.

The Brahmins as an organization-forming class

The Museum of Fine Arts and the Boston Symphony Orchestra were both organizations embedded in a social class, formal organizations whose official structure was draped around the ongoing life of the group that governed, patronized, and staffed them. They were not separate products of different segments of an elite; or of artists

and critics who mobilized wealthy men to bankroll their causes. Rather they were the creations of a densely connected self-conscious social group intensely unified by multiple ties among its members based in kinship, commerce, club life and participation in a wide range of philanthropic associations. Indeed, if, as Stinchcombe (1965) has argued, there are 'organization-forming organizations' – organizations that spawn off other organizations in profusion – there are also organization-forming status groups, and the Brahmins were one of these. This they could be not just because of their cultural or religious convictions (to which Green (1966), Baltzell (1979) and Hall (1982) have called attention), but because they were integrated by their families' marriages, their Harvard educations, their joint business ventures, their memberships in a web of social clubs and their trusteeships of charitable and cultural organizations. This integration is exemplified in the associations of Higginson, and in the ties between the Museum and the Orchestra during the last 20 years of the nineteenth century.

It is likely that Higginson's keen instinct for brokerage – and the obligations he accrued as principal in one of Boston's two major houses – served him well in his efforts to establish the Orchestra. At first glance, Higginson's achievement in creating America's first elite-governed permanent symphony orchestra in Boston appears to be the work of a rugged individualist. On closer inspection, we see that it was precisely Higginson's centrality to the Brahmin social structure that enabled him to succeed. Only a lone, centrally located entrepreneur could have done what Higginson did, because to do so ruffled so many feathers: a committee would have compromised with the supporters of other musical associations and with the patrons of the more established local musicians. Nonetheless, if Higginson's youthful marginality permitted the attempt, it was his eventual centrality that enabled him to succeed. His career illustrates the importance of kinship, commerce, clubs and philanthropy in Boston elite life. Ties in each of these areas reinforced those in the others: each facilitated the success of the Orchestra, and each brought him into close connection with the cultural capitalists active in the MFA and led, eventually, to his selection as a Museum trustee.

Higginson was born a cousin to some of the leading families in Boston: the Cabots, the Lowells, the Perkins, the Morses, the Jacksons, the Channings and the Paines, among others (Perry, 1921: 14). (The first four of these families produced trustees of the Museum of Fine Arts during Higginson's lifetime. His kinsman Frances W. Higginson was also a Museum trustee.) In Cambridge, he was close to Charles Lowell and after his first European adventure, he studied with Samuel Eliot, a cousin of Harvard President Charles W. Eliot, and later a trustee of the Museum. During this period, he spent a great deal of time in the salon-like household of Louis Agassiz, befriending the scientist's son and marrying his daughter. So close did Henry remain to his Harvard classmates that, despite his withdrawal after freshman year, they permitted him to take part in their class's Commencement exercises.

When Henry went into business, he brought his family and college ties with him. A contemporary said of the Lee-Higginson firm, it 'owed in some measure to family alliances its well-advised connections with the best financial enterprises of the day' (Perry, 1921: 272). Indeed, Higginson's first successful speculation was his investment in the Calumet and Hecla mines, at the behest of his in-laws Agassiz and

Shaw (the latter an early donor of paintings to the Museum). The family firm was instrumental in the development of the western railroads, through the efforts of cousin Charles Jackson Paine. In this enterprise, Higginson associated with John M. Forbes and with Charles H. Perkins (kinsman of the MFA founder). Higginson was so intimate with the latter that he invested Perkins' money without consultation. Lee-Higginson made a fortune in the telephone company, and Higginson, in later years, was a director of General Electric. In some of these ventures, the firm co-operated with other Boston financiers. Higginson was on close terms with his competitors Kidder of Kidder, Peabody (the Museum's first treasurer) and Endicott, President of the New England Trust and Suffolk Savings (and the Museum's second Treasurer). Gardiner Martin Lane was a partner in Lee-Higginson when he resigned his position to assume the Museum's presidency in 1907.

Higginson was also an active clubman, a member of the Tavern Club, (and its President for 20 years), the Wednesday Evening Club, the Wintersnight, Friday Night and Officers Clubs, New York's Knickerbocker Club and from 1893, the Saturday Club. Among his Tavern Club colleagues were Harvard's Charles Eliot Norton (spiritual godfather of the Museum's aesthetes), William Dean Howells and Henry Lee. At the Friday Club he consorted with Howells, William James and Henry Adams. At the Saturday Club, his clubmates included the MFA's Thomas Gold Appleton and Martin Brimmer.

In the 1890s, Higginson's career in Boston philanthropy blossomed. (By now he was on the MFA's Board. Earlier, when the Museum's first President, Martin Brimmer, asked Charles Eliot Norton if Higginson should be invited, Norton wrote back that 'Higginson would be excellent, but he never attends meetings' (Harris, 1962: 551).) He lavished most of his attention (beyond that devoted to the Orchestra) on Harvard, which elected him a Fellow in 1893. He gave Harvard Soldiers Field and a new student union, was Treasurer of Radcliffe College, played a key rôle in the founding of the Graduate School of Business, patronized the medical school and gave anonymous gifts to deserving faculties. Higginson's position as Fellow of Harvard placed him at the summit of Boston's institutional life and undoubtedly reinforced his contacts with the Museum's trustees and friends. His personal art collection, which included Turners, Corots and Rodins, encouraged such interactions as well. (In 1893, he donated a valuable Dutch master to the MFA.)

Thus was the Orchestra's founder embedded in the Brahmin community. When Lee-Higginson furnished an emergency loan of $17,000 to the Museum of Fine Arts in 1889, with little prospect of repayment, was this because he was on the Board; was it a consequence of Higginson's kinship ties with the Cabots, Perkinses or Lowells; his business alliances with Kidder or Endicott; his club friendship with Norton; Harvard ties to the Eliots? The range of possibilities renders the question trivial and illustrates how closely knit was Higginson's world.

In 1893, when Higginson demanded that Boston build him a new and suitable Symphony Hall, lest he abandon the Orchestra to bankruptcy and dissolution, the initial appeal for funds was signed by a broad cross section of the city's elite: his friends and kinsmen Agassiz, Lodge, Lowell, Lee and John Lowell Gardner; Harvard's Eliot, Norton, Longfellow, Shattuck and Parkman; Peabody of Kidder Peabody, to name a few. Present on the list were at least four of Higginson's fellow MFA trustees: the President (Martin Brimmer), the Treasurer (by now,

John L. Gardner), Eliot and Norton. The group raised over $400,000, a substantial stake in that financially troubled year.

Conclusions

The Museum of Fine Arts and the Boston Symphony Orchestra were creations of the Brahmins, and the Brahmins alone. As such, their origins are easier to understand than were British or Continental efforts in which aristocrats and bourgeoisie played complex and interrelated rôles (Wolff, 1982). The Brahmins were a status group, and as such they strove towards exclusivity, towards the definition of a prestigious culture that they could monopolize as their own. Yet they were also a social class, and they were concerned, as is any dominant social class, with establishing hegemony over those they dominated. Some Marxist students of culture have misinterpreted the cultural institutions as efforts to dictate taste or to inculcate the masses with the ideas of elites. Certainly, the cultural capitalists, consummate organizers and intelligent men and women, were wise enough to understand the impossibility of socializing the masses in institutions from which they effectively were barred. Their concern with education, however, was not simply window-dressing or an effort at public relations. Higginson, for example, devoted much of his fortune to American universities and secondary schools. He once wrote a kinsman, from whom he sought a donation of $100,000 for Harvard, 'Educate, and save ourselves and our families and our money from the mobs!' (Perry, 1921: 329). Moreover, a secret or thoroughly esoteric culture could not have served to legitimate the status of American elites; it would be necessary to share it, at least partially. The tension between monopolization and hegemony, between exclusivity and legitimation, was a constant counterpoint to the efforts at classification of American urban elites.

This explains, in part, the initial emphasis on education at the Museum of Fine Arts. Yet, from the first, the Museum managers sought to educate through distinguishing true from vulgar art – at first, cautiously, later with more confidence. In the years that followed they would place increased emphasis on the original art that became available to them, until they abandoned reproductions altogether and with them their emphasis on education. In a less dramatic way, the Orchestra, which began with an artistic mandate, would further classify the contents of its programs and frame the aesthetic experience in the years to come.

In structure, however, the Museum and the Orchestra were similar innovations. Each was private, controlled by members of the Brahmin class, and established on the corporate model, dependent on private philanthropy and relatively long-range financial planning; each was sparely staffed and relied for much of its management on elite volunteers; and each counted among its founders wealthy men with considerable scholarly or artistic credentials who were centrally located in Boston's elite social structure. The Museum was established under broad auspices for the education of the community as a whole; the Orchestra was created by one man in the service of art and of those in the community with the sophistication or motivation to appreciate it. Within 40 years, the logic of cultural capitalism would moderate sharply, if not eliminate, these historically grounded differences. The Symphony would come to resemble the Museum in charter and governance, and the

Museum would abandon its broad social mission in favor of aestheticism and an elite clientele.

The creation of the MFA, the BSO and similar organizations throughout the United States created a base through which the ideal of high culture could be given institutional flesh. The alliance between class and culture that emerged was defined by, and thus inseparable from, its organizational mediation. As a consequence the classification 'high culture/popular culture' is comprehensible only in its dual sense as characterizing both a ritual classification and the organizational systems that give that classification meaning.

Notes

1 In a third sense, 'cultural capital' might refer to the entrepreneurs of popular culture – the Barnums, the Keiths, the Shuberts and others – who turned culture into profits. While we will not consider this group at any length, we must remember that it was in opposition to their activities that the former defined their own.
2 My debt to Bernstein (1975a, b) and to Mary Douglas (1966) is evident here. My use of the terms 'classification' and 'framing' is similar to Bernstein's.
3 This section relies heavily upon Walter Muir Whitehill's classic two-volume history of the Museum (1970) and to a lesser extent, on Neil Harris' fine paper (1962) for its facts, albeit not for their interpretation.

References

Adams, H. (1928). *The Education of Henry Adams: An Autobiography*. New York, Book League of America
Adorno, T. W. (1941). On popular music. *Studies in Philosophy and Social Science*, vol. 9, no. 1
Baltzell, E. D. (1979). *Puritan Boston and Quaker Philadelphia*. New York, Free Press
Barnum, P. T. (1879). *Struggles and Triumphs: or Forty Years Recollections*. Buffalo, New York, The Courier Company
Bernstein, B. (1975a). On the classification and framing of educational knowledge, in *Class, Codes and Control*, vol. 3. London, Routledge and Kegan Paul
Bernstein, B. (1975b). Ritual in education, in *Class, Codes and Control*, vol. 3. London Routledge and Kegan Paul
Boston Art Club (1878). *Constitution and By-Laws of the Boston Art Club, With a Sketch of its History*. Boston, E. H. Trulan
Bourdieu, P. and Passeron, J.-C. (1977). *Reproduction in Education, Society and Culture*. Beverly Hills, Sage
Bourdieu, P. and Passeron, J.-C. (1979). *The Inheritors: French Students and their Relation to Culture*. Chicago, University of Chicago Press
Burt, N. (1977). *Palaces for the People*. Boston, Little, Brown and Co.
Douglas, A. (1978). *The Feminization of American Culture*. New York, Avon
Douglas, M. (1966). *Purity and Danger: An Analysis of Pollution and Taboo*. London, Routledge and Kegan Paul
Fisher, W. A. (1918). *Notes on Music in Old Boston*. Boston, Oliver Ditson

Fredrickson, G. M. (1965). *The Inner Civil War: Northern Intellectuals and the Crisis of the Union*. New York, Harper and Row

Gans, H. J. (1974). *Popular Culture and High Culture*. New York, Basic Books

Green, M. (1966). *The Problem of Boston*. New York, Norton

Hall, P. D. (1982). *The Organization of American Culture 1700–1900: Private Institutions, Elites and the Origins of American Nationality*. New York, New York University Press

Handlin, O. (1972). *Boston's Immigrants, 1790–1880*. New York, Atheneum

Harris, N. (1962). The Gilded Age revisited: Boston and the museum movement. *American Quarterly*, vol. 14, Winter

Harris, N. (1966). *The Artist in American Society: The Formative Years. 1790–1860*. New York, George Braziller

Harris, N. (1973). *Humbug: The Art of P. T. Barnum*. Boston, Little, Brown and Co.

Hatch, C. (1962). Music for America: A cultural controversy of the 1850s. *American Quarterly*, vol. 14, Winter

Howe, M. A. D (1914). *The Boston Symphony Orchestra: An Historical Sketch*. Boston, Houghton Mifflin

Huggins, N. J. (1971). *Protestants against Poverty: Boston's Charities, 1870–1900*. Westport, Connecticut, Greenwood

Jaher, F. C. (1968). The Boston Brahmins in the age of industrial capitalism, in Jaher, F. C. (ed.), *The Age of Industrialism in America*. New York, Oxford University Press

Jaher, F. C. (1972). Nineteenth-century elites in Boston and New York. *Journal of Social History*, vol. 6, Spring

Lane, R. (1975). *Policing the City: Boston, 1822–85*. New York, Atheneum

Lowenthal, L. (1961). *Literature, Popular Culture, and Society*. Englewood Cliffs, Prentice-Hall

Lynnes, R. (1953). *The Tastemakers*. New York, Grosser and Dunlap

Nye, R. B. (1960). *The Cultural Life of the New Nation, 1776–1830*. New York, Harper and Row

Perry, B. (1921). *Life and Letters of Henry Lee Higginson*. Boston, Atlantic Monthly Press

Poggi, J. (1968). *Theater in America: The Impact of Economic Forces, 1870–1967*. Ithaca, Cornell University Press

Ryan, K. (1915). *Old Boston Museum Days*. Boston, Little, Brown and Co.

Shiverick, N. C. (1970). The social reorganization of Boston, in Williams, A. W., *A Social History of the Greater Boston Clubs*. New York, Barre

Solomon, B. M. (1956). *Ancestors and Immigrants*. New York, John Wiley

Starr, P. (1982) *The Social Transformation of American Medicine*. New York, Basic Books

Stinchcombe, A. L. (1965). Social structure and organizations, in March, J. G. (ed.), *Handbook of Organizations*. Chicago, Rand McNally

Story, R. (1980) *The Forging of an Aristocracy: Harvard and the Boston Upper Class, 1800–1870*. Middletown, Connecticut, Wesleyan University Press

Thernstrom, S. (1972). *Poverty and Progress: Social Mobility in a Nineteenth-Century City*. New York, Atheneum

Twentieth Century Club (1910). *The Amusement Situation in Boston*. Boston

Vogel, M. (1981) *The Invention of the Modern Hospital*. Chicago, University of Chicago Press

Warner, S. B. (1970) *Streetcar Suburbs: The Process of Growth in Boston, 1870–1900*. New York, Atheneum

Weber, M. (1968). *Economy and Society*, 3 volumes. New York, Bedminster Press

Whipple, G. M. (n.d.). *A Sketch of Musical Societies of Salem*. Salem, Massachusetts, Essex Institute

Whitehill, W. M. (1970). *Museum of Fine Arts. Boston: A Centennial History*. Cambridge, Harvard University Press

Wolff, J. (1982). The problem of ideology in the sociology of art: a case study of Manchester in the nineteenth century. *Media, Culture and Society*, vol. 4, no. 1

Zolberg, V. L. (1974). The art institute of Chicago: the sociology of a cultural institution. Ph.D. Dissertation. Department of Sociology, University of Chicago

Zolberg, V. L. (1981). Conflicting visions of American art museums. *Theory and Society*, vol. 10, January

VERA L. ZOLBERG

CONFLICTING VISIONS IN AMERICAN ART MUSEUMS

From *Theory and Society* 10 (1981), 103–25.

[. . .]

THE SELF-PROCLAIMED GOALS of art museums are aesthetic: to accumulate, preserve, and display art works as a value on behalf of society, and in order to educate the public in their appreciation. As in most organizations, these official goals were defined in general terms, with little specification of the structural mechanisms, content, and processes by which they were to be achieved. As Perrow has suggested with respect to other types of organizations, implementation of general goals is influenced by operational goals, official by codification in recent years, but mostly emerging through processes of negotiation and bargaining among various sets of actors, in or related to the organization. Operational goals are of two kinds: they may be official, directly oriented to the official goals of the organization, or unofficial, reflecting the personal goals of leading actors. Applying his formulation to museums is not simple, since it is nearly impossible to disaggregate official from unofficial operational goals. Furthermore, the operational goals themselves have changed over the century or so of the museum's existence in America.

[. . .] Art museums may be characterized as traversing three phases: first, a pre-professional one, during which relatively unspecialized amateurs, both laymen and museum employees, ran the institution, but with laymen dominant; second, a shift in dominance to the increasingly professionalized staffs and their chief executive, the Director; and third, managerial specialists, or 'technobureaucrats' claim administrative expertise as the legitimation of their growing influence. The struggle for dominance of which these phases are outcomes have centered on who should mold aesthetic policy, and according to what canons. But policy making is not reducible to mere dominance of one set of actors over another. The three-phase framework

which guides this analysis must take into account the pervasive collegiality, or performance of functions by a composite body of persons rather than according to a rigidly bureaucratic structure characterized by clearcut role allocation.

While the general task divisions in art museums are governance, performance, and patronage, and even though these functions can be conceptualized in an organizational table, neither at their founding nor today have they been performed by distinct, mutually exclusive sets of actors. Those who govern (trustees) are often also patrons (donors and clients); those who perform by organizing and preserving art (curators) are also involved in governance and patronize by their donations. Collegiality in this case is a type of 'multiple leadership' promoting such interpenetration of functions that it is difficult to distinguish clearly between administrative (managerial) and substantive (aesthetic) policy. [. . .]

The purpose of this essay is to shed light on how these organizations operate to produce certain outcomes by examining changing dominance patterns in leadership in relation to changing rationales underlying aesthetic policy, and the growth of non-aesthetic ancillary goals which, some fear, are becoming the tail wagging the dog of the museum's aesthetic mission. Throughout, however, it is suggested that the world external to the museum plays an important part in setting limits to, as well as creating opportunities for, working out internal processes.

The pre-professional era

Of the numerous museums and galleries launched in nineteenth century America by artists and collectors, a few became permanent institutions. Having rescued the professional artists who were often involved in these ventures from failure as amateur entrepreneurs, businessmen (often amateur artists themselves) established museums, but excluded professional artists from most official policy making roles. The laymen's purpose was to found cultural centers similar to those of Europe, except that in place of noble patronage, funding was based on substantial private support combined with lesser municipal government aid. Museums were to be outlets for exhibitions by collectors and artists, sometimes art schools, but mainly sources of refined entertainment for the 'better element' of the cities where they were located. At the same time, some undertook to elevate the taste of a larger segment of the population by permitting access to a broader, middle-class public, in part, at least, to justify what public support they were receiving, and in part to meet the newly perceived social obligation of spreading high culture to the 'masses'. In fact, few did so seriously or consistently.

Although founder-trustees varied in their degree of commitment to the enterprise, many were extraordinarily active: they bought or donated works, set up exhibits, cared for the collections and administered institutional finances. The Art Institute of Chicago provides a typical example of these practices. In its early days, trustees held the majority of seats on the important committees they had organized for the Board. Hired staff, of course, did much of this work as well, but trustees had final authority. In many ways, the museum was an intimate part of their lives. Whether an extension of their livingroom, where they could enjoy parties and theatricals; an educational institution of a quasi-tutorial or finishing-school type; a

gallery to exhibit their taste, not only as collectors, but also as decorators, hobbyists, and professional artists; an 'attic' to store personal collections in security while vacationing; or memorials for the dead and importantly, a locus for cementing contracts with similarly situated individuals, the Art Institute provided services in exchange for their time, energy and gifts. Moreover, *noblesse oblige*, transformed into a more efficient *bourgeoisie oblige*, would spread the Institute's services to the public, thereby enabling patrons to 'do good' as well. Although the founders were frequently lacking in formal higher education (in some cases, even secondary school education), many were avid amateur artists and collectors, self-taught or anxious to learn from 'experts', but with ideas of their own. It would be incorrect to infer from this that they lacked cultivation, since formal higher education was not yet widely diffused. Clearly, their influence was long-lasting, since tenure in office, especially for the President of the Board and Director was likely to be for life, a pattern common as well in other local and national cultural institutions. Their remarkable stability and active involvement are reflected in the organizational structure which remained roughly intact for nearly half of the Art Institute's history.

Founded in 1879, by 1900 it had become organized enough to have four curatorial departments, the core of which was the Department of Painting and Sculpture headed by the Director himself; Prints and Drawings were cared for by a trustee-connoisseur; Oriental Art was bought and maintained by a group of trustees; the Antiquarian Society, a ladies' club, gathered lace, fans, textiles, antiques, and occasional sculpture. This predominance of amateurs in acquiring and caring for the collection continued despite the fact that the Art Institute was soon to become involved with founding and staffing professional associations, such as the American Association of Museums and the Association of Art Museum Directors. But these were initially elite-sponsored bodies which rarely acted autonomously of the leading institutions which dominated them. Concerning aesthetic policy, the President was prime-mover in collaboration (more or less harmoniously) with the Director, an 'art man' with direct and indirect connections to artists and collectors. With amateurs in such influential positions, it is not surprising that despite their high aspirations to excellence, much of the art acquired is merely a reflection of the taste of the period. Except for a few Old Masters, some Impressionist works, Chinese art, and a few works forced upon the Director by enterprising trustees which subsequently came to be viewed as important (Odilon Redon, Toulouse-Lautrec), many of the pre-professional acquisitions were, according to a contemporary curator, 'mostly doggies and flowers' by forgotten mid-western artists and lady amateurs which are never displayed, and are disposed of whenever possible.

Even if curatorial posts had been held by full-time salaried employees, their aesthetic choices might not have been very different from those of the amateurs. This is not surprising if the training of museum workers is considered. Although university teaching of art history had increased dramatically between 1890 and 1910, a period during which museums expanded, as did private collecting, art history as a scholarly discipline did little more educationally than reproduce models of the gentlemanly amateur. Curators were hardly less likely than trustees to be talented amateurs, except that they worked for a living. According to the criteria for recruiting personnel in turn-of-the-century America, pleasant demeanor, social connections through family ties and graceful but unspecialized taste were of greater

importance than formally acquired competence. Social qualities would help the curator carry out his major function, which consisted of soliciting gifts from wealthy prospective donors, displaying just enough erudition to give confidence without threatening the connoisseurship of patrons, and sufficient grace to consort with them. The President of the American Association of Museums asserted even as late as 1910 that 'a curator is born and not made. I do not believe you can train a man to be a curator. He is the result of natural ability and circumstances. He must be a man . . . who must know something of everything and everything of something. Such a man is difficult to find.' This view of the curator emphasized largely ascriptive qualities, as befits the patrimonial relationship of staff to trustees in the pre-professional museum. For the emerging museum profession, it incorporated enough adherence to an ideology of merit, while retaining the aura of ineffable talent, to conform to a traditional, genteel image. While not excluding competence neces-sary, for example, to assure the authenticity of contemplated purchases, it suggests the need for 'diplomacy' once a work was purchased or accepted if it turned out to be a fake.

[. . .]

The professional era

Salaried occupations whose main locus is embedded within organizations may became professions if they link their service to a cognitive basis. When this cognitive basis involves a codification of knowledge grounded in science, with its appearance of neutrality and depersonalization, it may bind together a membership into an effective group capable of achieving collective mobility under favorable conditions. In the case of salaried museum workers this process took the form of a two-pronged attack on the domination of amateurs exploiting the growing respectability of university-connected disciplines such as art history, and invoking support from the associations which were taking on the role of creators and upholders of standards, ethics, and recruitment criteria for employees, and with respect to art works.

When an external academic discipline develops criteria that provide validation for an institution's functioning, the professional members of the institution increase their bargaining power *vis-à-vis* laymen within the organizational structure. Where intellectual consensus is high, and where laymen are successfully excluded from having 'opinions' through successful assertion of a monopoly over disciplinary canons as the sole legitimate criteria for deciding both goals and the means to attain them, laymen are cut off from decision making except with regard to matters specifically delegated to them by the professionals. These may include ceremonial functions, fund raising, and administrative overseeing of non-professional actors. These outcomes were the unofficial goals of museum workers, but they were achieved only in part. The power of laymen, while shaken by the onslaught of these forces, and by a loss of consensus as newer trustees with somewhat different orienta-tions joined their ranks, could not be completely broken. Consequently, even at the height of professional dominance, museum professionals were never to attain the level of authority medical staff have achieved in research hospitals. Yet the interplay of disciplinary development, growth of professional associations, and

criteria of recruitment based on competence, with corresponding growth in trustee sophistication, all in the context of new legal regulations pertaining to tax laws, were to have significant effects on museum professionals and art collections.

The professionalization of curators

[. . .]

In the face of the quasi-aristocratic, patrimonial ethos characteristic of the pre-professional phase, major museums with large collections were nevertheless obliged to seek trained staff to assure the care of art works and more rarely, promote high levels of scholarship. Paucity of training facilities in the United States and the relatively greater prestige of a European educational background meant that aspirants had to study abroad or that foreigners were engaged. 'Poaching' on one another's curators and directors became a fairly common practice, which certain professional associations condemned, perhaps to protect museums rather than to exercise professional autonomy. In order to regulate hiring practices the Association of American Museums set up a clearing-house for employment opportunities. These conflicts are vividly reflected in the Art Institute, which as early as 1913 supported research and promoted professional goals. Their local efforts were guided into new directions by the turn to serious scholarship during the 1920s by the College Art Association's publications, and the connection of the Institute of Fine Arts in New York to the Metropolitan Museum of Art. But as indicated by the spotty character of core departments even as late as the 1930s, professionalization came slowly at the Art Institute. While Oriental Art had a full-time curator from 1926, the Department of Prints and Drawings continued to be trustee-run. The Department of Painting and Sculpture obtained its own curator, distinct from the Director, but the Antiquarian Society (later called the Department of Western Art) continued to be headed by a non-professional woman, who remained until the late 1930s a favorite of trustees' wives but the bane of the professionally-oriented Director and his supporters. At an annual meeting of the Governing Members, for example, when the Director introduced each department head, he wryly singled out this 'lady curator of everything' as 'the person who could put a dishrag on display and make it look like a museum piece . . . and often does'.

Nevertheless, amateurishness was becoming outmoded. The trend already under way was accelerated by an extraneous event, the massive arrival of European refugees from Hitler, many of them renowned art historians and museum curators, along with art dealers and art book publishers. They were to have an important impact on the curatorial profession, at least indirectly, for on the whole only rarely did they themselves find work in museums. The reasons for this are diverse, ranging from the poor economic conditions of the Depression to prejudice in museum recruitment. Anti-semitism in many museums meant that Jews, who composed a large part of the émigrés, were excluded. More importantly, these Europeans were generally considered unsuitable, since 'the main function of the American museum official . . . of increasing the collection of art, money, or attendance' meant that 'his specialized interests, academic orientation, and ignorance of the Social Register . . . [made the émigré scholar] an undesirable *rara avis*.' In German museums a curator tended to be more autonomous in deciding acquisitions and merely pre-

sented choices to trustees. His time would be spent on research, not fund-raising. While they had relatively little employment opportunity in museums, however, the refugees are said to have broken 'the unspoken policy of not hiring Jews for tenure posts' in certain universities. Their entry into higher education, especially the Institute of Fine Arts at New York University, with its close relationship to the Metropolitan Museum of Art, transformed art history by 'removing a certain aura of preciosity and ever so upper-class dilettantism which had long been assiduously maintained or cultivated in the world of art scholarship in America, making it more than the scholarly fringe-benefit of gracious living'. The most striking aspect of the change was the transformation of American art history into a discipline with a standard methodology and a number of schools; a creative field stressing scholarly publications and a branch of intellectual thought. Art history has gained immense authority not only for museum curators, who more and more are trained in it, but to dealers and collectors, who must rely on its scholarly criteria for attributions rather than on 'feel'.

As these trends gained momentum, the Art Institute's Director and his allies (curators and some trustees) took steps to liberate the professionals from lay inter-ference in aesthetic matters by setting up structures of various kinds to enhance their solidarity in relation to the Board. An example is the disposition of a major bequest left to be shared by three departments. Rather than allow their curators to present requests for purchase funds to the lay committee in charge of disbursement separ-ately, thus competing with one another and effectively leaving the decision in lay hands, the three curators meet jointly ahead of time and decide on the allocation based on availability of works appropriate for each department. In effect, this may mean that one department could profit at the expense of the others as many as two or three times in a row. By debating the matter among themselves, however, the cur-ators present a united front to the Board. [. . .] While in the past the museum had been willing to accept almost any art gifts, regardless of restrictions concerning their display or disposition, refusing gifts with restrictions became the norm. As a conces-sion to donors, the museum offered instead 'name' memorial rooms or galleries in return for money donations, but underlined their refusal to be dominated by donors' tastes: 'No collection of art objects accompanied by conditions respecting definite location or period of exhibition will be accepted by the museum'. Since these organizational, personnel, and policy changes should have produced effects on the aesthetic character of the museum, the collection will next be examined.

Professional standards in the collection

Aesthetic changes in collections and exhibitions are revealed through two major policy shifts. The first was the gradual decline in number and variety of temporary exhibitions, and the second the more effective involvement of curators and Dir-ectors in acquisitions. The latter was achieved by using particular events, legislative policies, and extra-organizational trends. The Director and his supporters were able to change the museum from a combination of monuments in permanent collections and free-for-alls in temporary exhibits to a new format. As early as 1933, the Century of Progress Exposition served as a pretext for rearranging all holdings and loaned works from scattered memorial rooms into a chronological sequence by

medium and style groupings. This sequence, based on university art-historical principles, permitted curators subtly to expose gaps in the collection in order to gain support in collecting priorities. Another important event, the enactment in 1936 of a federal tax deduction for donations of art works, permitted the Director to bargain more effectively with prospective donors when he counseled them about which kinds of works to collect. Since donors came to depend upon museum acceptance of their works to validate their tax deduction, they were often obliged to accede to his or curators' advice in order to guarantee that gifts would come to rest in the museum. The result was that curators, acting as experts, gained a more important voice in setting policies, rather than, as before, graciously accepting anything that was offered. [. . .]

Examination of these materials strongly suggests that both the means of acquiring works of art and the very meaning of gifts have changed. In the early days of the museum, donors set their individual stamp upon their collections, and sometimes became curators because they brought a collection with them. Even now individual donors may use their own judgment, but in recent years the museum is more likely to purchase works outright, and attempt to control the private collecting of prospective donors by 'helping' them select. Even the term 'gift' is less clear, since it has come to refer to purchases by family foundations or endowments whose funds are administered by trustees and curators; individual art donations must be approved for accession by committees on which curators sit.

[. . .]

[. . .] In general, greater reliance came to be placed on academically trained curators who, instead of merely accepting gifts, evaluate works on their 'quality' and their usefulness in filling gaps in the 'survey' of art history, the rationale underlying arrangements. The Art Institute as well as most major art museums came to adopt the criteria described in an international publication:

> (E)xpansion of the museum and the appearance of art history are linked. Works are gathered and classified precisely according to the categories elaborated by art history, that is, according to major styles put in relation in each case more or less strictly, with the global fact of civilization.

In the meantime, from being involved in virtually every activity of the museum, trustees would find themselves gently led away from certain functions, though never completely cut off from them. An eminent Director of the Metropolitan Museum of Art, Francis Henry Taylor, was once moved to observe,

> Trustees are . . . gladly suffered as highly ornamental, and occasionally useful, sacred cows to be milked on sight. But God forbid that they should have ideas in art beyond their station, for if they ever really got the upper hand, then the public, whose cross-section they represent, might question the omniscience of the expert.

[. . .]

A post-professional era?

From the point of view of curators and art directors, recent trends in organizational structure, collection, and exhibition policies, and orientation to the public are sounding the knell for a professional museum. Notwithstanding their victory in evicting or isolating amateurish dilettantism, their success in professionalizing recruitment so that new curatorial personnel are properly certified (by the Master of Fine Arts, its equivalent, or the Ph.D.), and ensuring academic standards for acquisitions, new societal demands are having repercussions on all aspects of the museum's functioning. The demands for greater accessibility to the public and to new kinds of art, in order to receive both private and public support are intertwined, but their effects are particularly clear with regard to organizational changes and aesthetic outcomes. Although there is no problem about the consensus among curators concerning art validated by museum acceptance and by art historians, it stops short of more recent developments in art. In this area of uncertainty, non-academic factors enter prominently in decision-making processes. Pure aesthetic goals are, therefore, open to contamination and dilution. Conventional wisdom asserts that the fault for this must be laid at the door of expanding bureaucracies and the goal displacement which they entail, but, as will be shown, even the curatorial professionals are, for good reasons, accomplices in the processes which they deplore.

The technobureaucratic necessity

Curators play a potentially important role in committees dealing with collections, but have virtually no say in trustee-monopolized administrative committees. The administrative committees are the bodies that handle financial matters, building policies, launching new departments, and recruiting high-level personnel. Yet these functions have effects on aesthetic policies. Museums have grown phenomenally in recent years, as shown by their increasing expenditures. The operating budget of the Metropolitan, for example, increased from $9.2 million in 1967 to over $32 million by 1977; the Art Institute reported budgeted expenditures of close to $15 million in 1977, compared to only $8.5 million in 1970. Staff size at the Art Institute, which numbered about 470 in the late 1930s, reached 650 by 1976. While much of the increase in staff size is due to larger collections some of it comes from the growth of ancillary (not specifically aesthetic) activities such as shops, restaurants, public education and other community-related ventures to attract members. In this the Art Institute is extremely successful. By 1975 its membership had grown to nearly 58,000, having quadrupled in a little over three decades. This expansion has been one response to financial needs; another is to direct requests to federal and state government agencies.

One consequence of post-World War II expansion after a long period of stagnation was that new demands upon the Director ended his longevity in office. While until the early 1940s Directors (as well, incidentally, as Presidents) usually remained in office until death, since the 1950s both directorial and presidential terms have been shorter, often ended by resignation or retirement. On the whole, trustees have shown little confidence in recent years in the ability of scholars to manage museums, especially when they have grown to the complexity which has come to characterize

them. Trustees have preferred to take away what had been directorial functions having to do with budgetary and administrative matters and place these in the care of administrative specialists. Yet they appear to have no more confidence in these 'technobureaucrats' than in supposedly impractical aesthetes.

Wealth, success, and long experience in business, fund-raising, and related activities legitimate trustees' dominance over related matters in museums. Thus they maintain extraordinarily active control over recruitment and the behavior of administrators. This was attested to by an administrator with experience as fund-raiser for various charitable and public service associations. He was startled at how differently the Art Institute functioned. From the time of his recruitment when he was exhaustively interviewed by nine trustees, to the careful oversight of his actions by trustees or their lieutenant, the head of administrative staff, his autonomy was severely limited. Previously it had been he who formulated policy, made plans, and provided lucid statements for his Board members, who 'were only too glad to have the work done for them', and 'delighted' that he provided them with 'intelligent things to say'. Trustee domination over administrators is not likely to arouse an outcry, although it appears to be a cause of the high turnover of administrative personnel in cultural institutions. But trustee control over curators and Directors is regularly denounced by art historians, curators, and art critics. They wish a return to the days when the Director had been an 'art person', dominating both artistic and administrative policy making, with the support of friendly trustees. At the most he might grudgingly share some functions with a subservient Director of Administrative Services. Even this concession was viewed with distaste by the museum profession, which considered the split in functions an opening for trustee intervention. Yet trustees have restructured the museum's organization so as to increase the authority of the administrative head, while relegating the direction of curatorial functions to a subordinate status.

The Art Institute was one of the first major cultural institutions to adopt an organizational structure marking the formal demise of overall artistic and administrative control in one office, and replaced it with the division of these among separate vice-presidents. Above them is a President, who is a former university administrator. At the Metropolitan Museum of Art he is a former diplomat with government experience (as was the Metropolitan's first colorful and controversial Director). In both cases the new men claim not only to have no expertise in art, but consider this an asset. They insist that this ensures that aesthetic matters are kept in the hands of curators and Director. This may, however, be viewed as abdicating artistic concerns and a diversion of overall authority which a strong, art-oriented Director would not tolerate. [. . .]

[. . .]

The triumph of the new

Contemporary art has aroused much ambivalence in art museums, since it tends to follow fashion rather than be validated by the patina of age. Many museums have simply bypassed the problem by defining contemporary art as outside their purview, awaiting the day when it either vanishes into oblivion or attains general acceptance before considering it for inclusion. This is the case with the Louvre, and tended in

the past to be the policy of the National Gallery in Washington and to a certain extent the Museum of Fine Arts in Boston. The Art Institute chose the more difficult route of accepting contemporary works which their donors offered them.

[. . .] Fighting for the inclusion of modern art in 1954, the Director used the occasion of the death of a former President to enlist his posthumous support, both for professional control and for contemporary art, by citing a statement he had made in the 1940s: 'I will not interfere with the professional side of the museum. We have a staff of experts and we must respect their judgment.' To this the Director added in his eulogy that 'it was a position from which he never deviated . . . in spite of his wide experience in art and particularly in the face of his own and others' distaste for modern art, although he himself never collected Cubists and Surrealists he recognised . . . the artist's right to express himself with freedom and believed in the institute's liberal tradition.' Yet less than two decades later, the same (by now, former) Director would question the ease of entry of contemporary works, merely because a collector wanted them accepted. This view was expressed by another Director, significantly, perhaps, shortly after tendering his own resignation.

[. . .] From the donors' point of view dignified memorials are still an important goal and they also profit from having their works in museums, both because other, similar works in their private collections gain value, and they benefit from tax-deductible donations. Since contemporary art is less costly and more available than art historically 'certified' works, speculative buying is rampant. Regarded from this angle, the donor may seem self-interested and manipulative. But pecuniary motives do not entirely account for donations. The prospective donor may, after all, give to other institutions and receive tax advantages with fewer complications.

Art works donated to museums must be appraised by accredited authorities (including museum personnel), and appraised values may be questioned by the Internal Revenue Service, thus requiring review. Given possible complications, donors might consider it easier to make cash gifts to other types of institutions, and donate art to less demanding ones, such as smaller museums or to university galleries. Indeed they do this more than museums want them to. [. . .]

Beyond this, the 'triumph of the new' refers not only to contemporary art, but to the reassessment of older works, including the academically successful works of the late nineteenth century which had entered museum collections only to be expelled or relegated to backstairs and basements by the Impressionist-Cubist-Fauvist-Surrealist and more recent avant-grade movements. Redefinition of the old as well as discovery of the new can be made exciting and attractive to a variety of taste publics by 'packaging' the 'properties' and exploiting their appeal, whether to politically nascent groups (racial, ethnic, sexual) or to publics jaded or unconvinced by the modernist vision. Since museums are even more under pressure to cater to a broad public, they themselves are involved in this activity. Art historians are no less engaged in aesthetic revisionism. In the course of these activities, no matter how disinterested, new definitions of aesthetic value emerge and are incorporated into the race for 'box-office' appeal. The resemblance to the pre-professional days when trustees made the museum a fairground while directors demurred is striking. The post-professional era, then, is a return to concern with the public, but with one larger and more varied. The pursuit of scholarly-aesthetic purposes is made to depend upon public success.

Conclusion

By their nature, American art museums are pluralistic institutions. They cannot be simply characterized as the hobbies of affluent amateurs, or ivory towers for research or, despite appearances, playgrounds for 'the people'. To some extent they are all of these together, but with more or less emphasis on each, depending upon the support which each of the principal sets of actors is capable of mustering. Trustees, curators, and managers each possess a legitimacy which they have used to effect the pursuit of their unofficial goals, some of which converge with those of the institution itself. The level of success they attained is modified by trends external to the institution, including scholarly and professional developments, art market activity, pressure from aspiring elites, and the emergence of new funding sources.

Collecting involves the transformation of material into symbolic capital and is, therefore, a process in which museums play a pivotal role. Since trustees and prospective donors are continuing and even increasing their involvement in art collecting, whether from aesthetic interest or for speculative purposes, external processes of elite formation will continue to affect the art museum. Its aesthetic policies will result in gains and losses for particular individuals or groups, whether in the museum, or aspiring to enter. As repositories of art, museums are, therefore, willy-nilly linked to an external market whose speculations impinge upon their collections and exhibitions. Since principal actors are never totally insulated from it, and are even recruited in part because of their knowledge of it, a position in a museum itself may advance the interests of the parties involved. This lack of insulation from markets and the relative accessibility of non-professionals to its information helps to explain why the parallels between museums and other institutions, such as universities and hospitals, are not more striking. [. . .]

[. . .] With the growth of external public subsidies from federal and state governments and with the likelihood of their continuation into the future, although not necessarily at as rapid a rate of increase as in recent years, the balance of forces within the institution is likely to be shaken. Public support entails two requirements: organizational accountability and greater accessibility to large publics. Both of these demands emphasize the rising importance of bureaucratic managers. Like curators of the past, they have been the servants of the Board. But just as curators grasped at external developments in scholarship and professional organizations on which to base their legitimation, bureaucratic managers are following an analogous path. Eschewing aesthetic expertise, they try to run museums as rationally as they claim modern firms function: introducing methods of membership development (including advertisement), gaining control of local patronage markets, and lobbying for and trying to monopolize governmental funding sources. On the whole they have no power base within the museum, since they are resented by curatorial personnel, and are viewed as mere technicians by trustees. But the expertise that they bring to bear on organizational functioning is becoming a necessity for efficient operations and justification of the public funds received. Not surprisingly, schools of business administration and universities are offering specialized training in arts management. But the newly trained managers are likely to differ from the older. Since they are largely self-selected rather than drifting into cultural organizations, they may be more committed to the arts from the outset than their predecessors. [. . .]

[. . .] Furthermore, managers are less tied to an institution than are curators, since their skills are more easily convertible to other organizations or government agencies, while curators face an overcrowded market in museums and universities. The post-professional era is shaped by their growing importance, but is not wholly determined by it. Rather, their presence heightens the perpetual state of tension inherent in the multi-purpose institution the art museum.

Sociology, aesthetic form and the specificity of art

INTRODUCTION

During the 1970s and 1980s both dominant theoretical orientations and positivistic methodological scruples discouraged sociologists from paying serious attention to the aesthetic form and cultural patterning of works of art. Within the production of culture perspective, scholars such as Becker argued that discussion of the aesthetic properties of works of art by critics and art historians was not really about the intrinsic cultural properties of the art objects themselves, but a rationalisation of 'the allocation of valuable resources' (1982, 135) in the distribution of rewards to living artists or the determination of prices for the works of the dead. The success of particular artists and art movements was attributed not to the aesthetic properties and resonances of the works of art but to the economic and political power of prominent gatekeepers in the art world, able to confer or withhold the honorific label of art and impose hierarchies of values which were shaped by economic rather than aesthetic interests (Mulkay and Chaplin 1982). Even in cases where art was interpreted as an embodiment of some kind of cultural meaning, this involved analysis only of the themes or contents of works of art, not their styles which were taken as simple markers of membership of a particular artistic movement (Crane 1987).

There is, of course, quite a strong counter-tradition within Marxist sociology of art and literature centrally concerned with the question of the 'specificity of art', but in practice treating this as primarily a theoretical question rather than one of actual analysis (Wolff 1992). Fyfe and Law (1988) have drawn attention to the exclusion of the visual from sociology as a much broader problem and appealed for a study of techniques of visualisation in a wide variety of institutional domains – art, medicine, science, archaeology, criminology. In the same volume, Latour (1988) explores some of the differences between the visual transformations operated by art and science, and

the differing conceptions of 'faithfulness' in these two institutional settings, through an analysis of Holbein's *The Ambassadors*. We can perhaps only understand the specificity of visual representation in art by comparing the transformational mechanisms it deploys, and the uses to which it puts visualisation, with practices in other institutional contexts.

Recent surveys and position-papers in the sociology of art have also called for the integration of art-historical methods into the sociology of art (Zolberg 1990, 12; Bowler 1994). Recent work in sociological methodology has started to explore ways in which the 'soft' qualitative forms of style and visual analysis in art history can be formalised in order to be handled according to 'harder' sociological methods of measurement and data-manipulation (Mohr 1998). Part Five explores a range of attempts to integrate analysis of aesthetic form in art with sociological analysis, ranging from work originally written by Karl Mannheim in the 1920s to some of the most exciting contemporary developments in the sociological analysis of art. The first section looks at attempts to integrate art analysis into sociology on methodological and on more abstract theoretical levels. The second section addresses relationships between art styles, social structure and group processes. The final section looks at sociological treatments of art as a form of 'material culture'.

INTEGRATING ART ANALYSIS IN THE SOCIOLOGY OF ART

Conceptually and methodologically quite simple integrations of sociological and art-historical methodology can produce extremely fruitful results. This is best exemplified by a series of studies published by David Halle (1987, 1989, 1994) which combine very straightforward iconography with sociological techniques of survey and quantitative analysis. Starting from the assumption that modern art and visual culture could be adequately understood only in terms of its use in the material contexts for which it was originally created, namely homes, Halle conducted a systematic survey of samples of houses from upper-middle-class, middle-class and working-class residential areas in a number of districts in the New York metropolitan area. In addition to recording the themes of all works of visual art found in these houses, and their spatial location, he conducted interviews to find out about people's attitudes to art in general, and the meanings that they attributed to the particular images they chose to display in their own houses in particular. His primary findings indicate a very high level of uniformity in the themes and iconography of visual images found in people's homes across classes, and the interviews conducted in his surveys allow him to probe the meanings attributed to this iconography. He points to the parallel between the decline of the formal portrait, the informal style of most family photographs and the atrophy of the formal sections of houses, across classes, in the course of the twentieth century. The absence of non-kin photographs and the very short lineage of such displays of familial imagery (normally just the nuclear family with occasional grandparents) – in contrast with traditional ancestral galleries – point to the changing significance of kinship attachments. The proliferation of pictures of family togetherness suggest the centrality of the value placed on a happy family life as opposed to the power and professional success symbolised by earlier more formal portraiture. There are only

really two striking differences in group patterns of art display. The first is the presence of 'primitive art' in the houses of middle- and upper-class registered Democrats (absent in houses of lower classes and Republicans) which Halle interprets in terms of American racial politics. The second is in the pattern of display of religious art, which is increasingly restricted to Catholics of a working-class background. Landscapes are the most popular genre across all classes, and are normally peopleless, offering their owners a sense of peace and quiet retreat from the stress and noise of daily life. In addition to seriously undermining some of Bourdieu's theses about the class distinct-iveness of taste and the functions of such distinctions in reproducing class hierarchy, Halle's study offers a very different view of the place played by art in most people's lives from that afforded by, for example, analyses of practices of visiting and display in modern museums, which, after all, contain only a tiny fraction of the visual art which is consumed by the contemporary public, and are visited only occasionally by very limited numbers of people.

An alternative strategy to Halle's methodological integration of art history and sociology, is the theoretical integration attempted by Talcott Parsons (Chapter 18). Parsons is perhaps the most influential sociological theorist of the postwar period. His theoretical project sought to integrate the insights of utilitarianism (including Marx) and Durkheimian and Weberian sociology (and later, psychoanalysis) into a general theory of action. In the course of this project, Parsons from time to time had to consider the nature of art as a form of social action, although art was never one of his core foci of interest in the way in which, for example, power and solidarity were. I have included two selections from Parsons's most extensive discussions of art. The first (Chapter 18a), from his book *The Social System* (1951), seeks to define the nature of art as a particular type of symbolism – expressive symbolism, as opposed to evaluative or cognitive symbolism – which performs a particular function in any ongoing system of social interaction. Namely, it mediates the affective or feelingful component of actions, thereby creating relations of attachment between actors and lending greater stability to interaction systems than would be the case if their members interacted only on the basis of instrumental self-interest. He then goes on to define how the art object develops out of processes of 'differentiation', as systems of action become more complex, and both acts and the roles performed by actors become more specialised, leading, for example, to the emergence of a specialised role of 'artist'.

The second selection (Chapter 18b) looks more carefully at the specifically cul-tural properties of art in the context of a longer essay, 'Culture and the social system' (1961). This essay considers both the particular and the shared properties of such cultural systems as religion, art, science and law. Parsons argues that all cultural systems consist in sets of structural components that are related to each other as elements of a 'cybernetic hierarchy' – that is to say, there are elements low in energy and high in information which control or regulate other elements low in information but high in energy, in the same way as a thermostat regulates a boiler. It is here that Parsons seeks to integrate some of the categories of art-historical analysis, suggesting that the four components of art as a cultural system are (starting with the highest information): style patterns, compositional patterns, motifs, and content (although a case could be made for replacing content with 'techniques' – see Tanner 2000a). This

not only allows Parsons to analyse artistic action according to the same set of categories as other kinds of social action, whilst recognising the specific differentiating features of art, it also allows him to make some extremely interesting suggestions about such classic problems as that of evolution and change in art. In particular, he is able to develop a theory of artistic evolution which is analytically conceived, rather than grounded in the kind of Hegelian accounts of artistic progress rightly discredited in recent years. He sees artistic evolution as being characterised by what he calls the increasingly generalised or 'abstract' character of the higher order or orientational pattern components of art, especially compositional patterns and style rules. Such changes – as for example the change in musical style from Mozart to Beethoven, or in artistic style from the impressionists to the early cubism of Cézanne – Parsons argues, permit the creation of a wider range of more complexly ordered and hence more affectively powerful expressive meanings.

There have been a number of essays which have extended and sought to clarify Parsons's account of art. Some of these are primarily concerned with questions of art theory (Peacock 1976, Tanner 2000a), whilst others consider expressive symbolism in a wider context (Edelson 1976, Lidz and Lidz 1976, Staubmann 1997). Empirical studies using Parsons' framework to study art are relatively rare – partly a result of the very strong boundaries between art history and sociology during the period of Parsons' greatest influence, partly a function of the reaction against Parsons in the sociology of the 1970s and early 1980s (and amongst some even today), just when art history was becoming a little more open to perspectives from the social sciences. Peacock's (1975) monograph concentrates primarily on theatre, although it contains much of interest for art historians. My own work has used Parsons' sociology in the analysis of portraits and cult statues from classical Greece and Rome (Tanner 1992, 2000b, 2001). Kavolis's (1968) study, *Artistic Expression*, is broadly functionalist in orientation, relying on Parsons' concept of expressive symbolism as a mediator of affective meaning. In this work, Kavolis explores the relationship between social structure, political structure, value orientations, religious orientations and art styles, largely on the basis of two variable correlations between a sociological factor (for example feudal social structure) and a stylistic pattern (for example formalism or hierarchy) discoverable in a wide number of historical instances. Whilst fascinating in itself, and presenting an important starting point for rather deeper studies in comparative art, Kavolis's work in its nature is not able to exploit Parsons' important contributions to the understanding of art as a form of social action, or his broader evolutionary framework for studying artistic development, which presupposes long-term history of particular developmental processes rather than the correlational analysis performed by Kavolis.

ART STYLES, SOCIAL GROUPS AND SOCIAL STRUCTURES

There is a long tradition within the social history of art of interpreting art as an expression of class interests or ideals. The best-known examples are Hauser's *The Social History of Art* (1951) and Antal's *Florentine Painting and its Social Background* (1948). Perhaps the best-known sociological exponent of such a perspective is

Lucien Goldmann. Goldmann argued that classes were the bearers of 'ideologies', partial and often not fully coherent views of the world determined by class position in social structure. It was only in literature, and art, that such partial ideologies might be translated into coherent and systematic worldviews, realising the full potential of a class-based ideology. In this respect, art and literature maintained some autonomy from their social base, and a creative capacity, in so far as it was only through such expressive forms that groups might become fully aware of their own potential as a class (Hamilton 1974, 65–74). Although most of Goldmann's empirical work was on French literature, he also occasionally wrote about art. One particularly insightful little essay on Chagall explores the changing styles and contents of Chagall's paintings in terms of his relationships to and changing identifications with the social groups he was a member of through the course of his career (Goldmann 1960). This tradition of analysis is continued in Pierre Bourdieu and his collaborators' *Photography: A Middle Brow Art* (1965). This study explores the variable uses made of photography by different social groups: family men for whom photography is a vehicle for the collective memory of their small primary group; bachelors, disembedded from familial networks, predisposed to an aesthetic relationship to the photographic medium; petit-bourgeois members of camera clubs, fixated on the technical aspects of photography.

Perhaps the most theoretically interesting consideration of the relationship between art and social groups is Mannheim's discussion 'The dynamics of spiritual realities' (Chapter 16). Mannheim explores the relationship between different types of cultural objectification – individual attributions of subjective meaning, institutions, cultural objects – and various types of groups which might be the bearers of such cultural forms – 'life communities' (families, villages), 'existential communities' (such as classes or groups, sharing the same mode of existence, but not necessarily communicating with each other) and 'cultural communities' (sharing culture, but not the same social existence, for example English speakers in Europe as opposed to America). He extends Panofsky's concept of *Kunstwollen* or 'artistic volition' to other kinds of action – economic volition, social volition – and sees these volitions as partly internalised in the personality, partly embedded in cultural and social structures. Mannheim thus sets up a marvellously subtle analytic framework for understanding the social dynamics of culture. In particular, he is able to take account of the objective constraints of both cultural traditions and social structure in such processes, rather than privileging either one over the other. He suggests that multiple but not unlimited potential tendencies are embedded in any given cultural tradition, but which of these tendencies are realised, and exactly how, depends on the selective pressures of the social environment.

In addition to such relatively contextual studies of the relationship between art and group life, there is also a strand within the sociology of art which looks at macro-sociological relationships between art and society as a whole, often with a strongly evolutionary cast derived ultimately from Hegel. Sorokin developed an account of the transformation of art in a number of civilisations through phases of 'ideational' (symbolic, religiously oriented), 'idealistic' (elevated sensory experience, idealised naturalism) and 'sensate' (realistic art, aiming to give sensory pleasure) art (Sorokin 1937, 1966, Zolberg 1990, 165–8). Francastel has explored the transformation of systems

of spatial representation in art – in the medieval–Renaissance and academic–modern transitions – as transformations in the sensuous means whereby human beings relate to the natural and social universe in which they live. Changes in plastic space accompany not just changes in beliefs but changes in the fundamental institutionalised motives for action (Francastel 1948, 1951, 1963a, 1963b).

Robert Witkin's important study *Art and Social Structure* (1995) flies very much in the face of the historicist and contextual tendencies of recent art history. He explicitly advocates a return to the 'grand tradition' in art history of writers such as Riegl and Wölfflin as the heirs of the original art-historical grand narrative, Hegel's aesthetics. But Witkin makes this return on the basis of much more sophisticated theoretical frameworks. He integrates the aesthetic concepts of the critical idealist tradition in art history with the perceptual psychology of J.J. Gibson, cognitive psychology of Piaget and an evolutionary theory of the development of human–environment and human–human relations. He argues that there is a correspondence between the 'level of abstraction' of artistic style systems and the level of abstraction of the primary productive relations from society. Hunter-gatherers are embedded in nature and produce an *invocational haptic* (essentially fetishistic) art appropriate to 'co-actional relationship[s] . . . in which each member plays a role that is more or less fixed and predetermined' (1995, 37ff. on coaction, 46ff., 54ff. and 64ff. on invocational haptic and fetishistic art). The development of urban craft production in early modern Europe represented a relative disembedding of society from nature. With an increasingly advanced division of labour, 'interaction' replaces coaction and is 'mirrored' by a 'perceptual-realist' (naturalistic) art which *evokes* meanings, such as a sense of the religious, that are 'conceived as somehow being external to the imaging process . . . and the perceiving mind' (43ff. on early modern bourgeois society, 66ff. on perceptual realism). Modern social systems are concerned with 'reflexively producing the agency with which production gets done', through 'intra-actional' modes of relationship, within which 'individuals do not relate to each other as functional specialists' but as highly flexible 'organisational beings . . . reflexively co-operating with others in producing the organisation and themselves within it, and developing solutions to organisational problems' (41). The reflexive character of modernism in art – exemplified by the work of Picasso which explores 'seeing as such, the constitutive process through which sensuous and perceptual relations are made' (79) – provides what Witkin regards as the semiotically or culturally neccessary means for the functionally adequate sensuous thinking-through of the reflexive character of modern social relations. The selection reprinted (Chapter 17) here reads formal contradictions and inconsistencies in Van Eyck's *The Marriage of Arnolfini* (in the National Gallery, London) as the aesthetic articulation of a value tension between the rationalising feudal state of fifteenth-century Burgundy and the developing bourgeois order of the cities on which it depended.

ART AS MATERIAL CULTURE

Witkin's work is one example of a new emphasis in sociology on the *materiality* of art. Such an emphasis is not unprecedented. Parsons gave a material grounding to his sociology of art by rooting the development of individuals' expressive capacities in the sensuously mediated interaction between mother and child. Francastel, deeply influenced by the Durkheiman anthropology of Mauss and Leroi-Gourhan, placed a very strong emphasis on the importance of the technical foundations of art, in polemical opposition to, on the one side, the linguistic imperialism of structuralism and, on the other, text-oriented iconography which interpreted art as the reflection of philosophical systems. He insisted on the specific character and tools of visual art as a means of material representation (line, colour, light, volume, relief), their foundations in human visuality and their function in schematising sensations and thereby orienting sensuous experience and response (Francastel 1940/48; 1960). The 'fundamental character' of pictorial revolutions such as that of impressionism, he suggests, lies in the foundations of culture in the eye, independent of, experientially prior to and – in most cultures – more important than foundations in language and discourse (1961).

Recent work follows the lead of Francastel in integrating an emphasis on the materiality of art with long-standing sociological interests in processes of modernisation. We have already considered David Brain's account of the reconstruction of the material agency of architects in the creation of a modernist aesthetic for New Deal housing programmes in America (Brain 1994, Chapter 11). Gordon Fyfe has argued that modernisation is, at least in part, 'a visual process', in which the 'means of representation' are rationalised, and new 'powers of depiction' developed. He takes as his example the transformation of engraving and other techniques of pictorial reproduction in the development of the world of high art and art publishing in the nineteenth and early twentieth centuries (Fyfe 1985, Fyfe and Law 1988).

The most sustained body of work in the sociology of material culture is that of Chandra Mukerji. Mukerji's first major book (1983) looked at the role played by material-cultural innovation – new techniques of printing, methods of textile-production and dyeing, geographic information systems such as maps – in the development of the mass-consumer culture characteristic of modern capitalism. More recently she has interpreted the process of territorial state-formation in seventeenth-century France as 'simultaneously a form of material practice and of political representation' (1997, 8). Creating the modern state involved new ways of organising the landscape, emphasising territorial boundaries in place of the fortified centres characteristic of feudal society. It also involved the development of new social and cultural identities, French identities, transcending the local and regional loyalties characteristic of late medieval France. The royal gardens at Versailles, Mukerji argues, were a particularly strategic site for constructing this new political material culture. The formal landscaping of the gardens showcased the engineering skills used by French armies in fortifying and besieging towns. The designs of the formal flower beds materialised in nature the specifically French design culture being constructed within the state manufactories of Colbert. Courtiers clothed in the textiles created in these manufactories, and participating in the new theatrical events and modes of

dancing elaborated in the new academies, embodied a specifically French style of fashion and movement. Both to the French themelves and to foreign visitors to Versailles, this elaborate spectacle demonstrated both the cultural unity of the French state, and its capacity to mobilise people and territory in the construction of power. Such work places sociology of art right at the core of the major social processes of modernisation: economic rationalisation and state building. Art is not seen as a mere symptom, or as an ideological legitimation of more fundamental social and political changes, but as the very material medium through which such changes are realised.

Karl Mannheim

THE DYNAMICS OF SPIRITUAL
REALITIES

From D. Kettler, V. Meja and N. Stehr (eds), *Structures of Thinking*. London, Routledge, 1982, pp. 230–7. Originally written *c.*1922.

T HE SPIRITUAL REALITY OF the love relationship [. . .] must be marked off in two directions. It must be distinguished from the purely physically determined sexual relationship, which is, in the last analysis, more or less the same in all human communities, and from the reflective theoretical formulations arrived at by a 'theory of love' or by the participants in love when they reflect on it. Clearly there is a third alternative between these two poles, one which is not equivalent to the merely physical relatedness of the subjects and which also does not secure its primary form from a reflective act of concept formation, but which is rather to be sought in the spontaneous spiritualization of the physical relationship, which is actualized in existential acts (in feelings, transactions, and intentions). This third alternative is different in every cultural community and historically changing in each one. We know that 'love' means different things in different societies, that 'romantic love', for instance, is only one of the possible erotic relationships, and that this relationship, like all other spiritual love relationships, contains a measure of stereotyping for certain cultural circles, which are socially and historically determined. In their most spontaneous turns toward the other, the lovers unconsciously and involuntarily actualize one of the types of meaning that is possible in a particular lifespace, and even the wholly personal expression of the relationship having the most individual coloration still gains its distinctiveness in relation to this basis, and is thus determined by it in this event as well. When we undertake to address 'love' as a spiritual reality like *polis* and 'ceremony', we have in view this pre-theoretical, pre-reflective ascription of meaning, which always incorporates and works in the ever

identical physical relationship, but always gives it meaningful form in a different way. Like the institutions, love may be said to transform itself behind the backs of individuals, who merely actualize it.

If one attends to the fundamental theme brought out in this example, it becomes evident that a spiritual community in time takes all the facts of nature (trees, springs, mountains, rivers) as well as the phenomena of psychic life (feelings, love, longing, fear, etc.) and physical relationships and states (birth, death, sexual relationship, search for sustenance, etc.) and overlays them with specifically spiritual and cultural meanings (which are present prior to theoretical reflection), and that the theoretical reflection of every experiential community, when it attempts to grasp the nature of things in concepts, comes upon a nature which is already cloaked in meaning and shaped by spirit, and not upon pristine nature. The conjunctive community, its spirit, is to be found within these objectifications in its full development, and it spreads itself over all things, living not only in the souls of subjects but also in the space environing them. And when this spirit tries to grasp the spirit of its environment and inner world, what it finds is always itself.

We have already distinguished two types of such spiritual realities: first, those which with Durkheim we called 'institutions'; second, those ascriptions of meaning which reworked the natural environment and inner world into meaningful formations. Now we want to note a third kind of pre-theoretical collective meaning formation, which we shall simply call 'works' (*Werke*). It is clearly not the case that experiential space is wholly occupied by inner and outer nature become meaningful, alongside of social relationships and framework-forms regulated by prescription. There are also other spiritual realities which are formations of meaning in a distinctive way, although, like the meaning contents already cited, they help to build up the experiential and life-space of society. Probably no extensive analysis is needed to show what we mean by 'works' in this context: all the artifacts that the single individual creates, to all appearances simply out of himself, in isolation, which he introduces as new things into the world of nature in that he originates a meaning consciously, though that consciousness need not be theoretical. The significancies previously discussed were only superimposed upon 'inner' and 'outer' nature. They did not transform the natural thing that underlay them, but merely took it up into their meaning-contents. Sacred images, idols, utensils, clothing, dwellings, buildings, and so on are all characterized by the fact that the natural is used as means, as medium for realizing a contexture of meaning envisioned beforehand. While the 'inner' and 'outer' world becomes meaningful, is pre-given to the single individual because he grows into it and usually apprehends significancy as determination, attribute of nature itself (for it came into being 'behind his back'), the significancy 'work' comes into being before his eyes and at his hands; and the one who has not made or created it but merely views it, also associates with it the idea of its having been formed, the idea of its having the quality of a work. (This does not apply equally at all levels of culture. For a primitive, a work, a sacred image, has ontological character despite its character as work: it is the divinity itself.) Although this work has an individual creator, it is not the work and expression of him alone; in all that concerns technique, stylistic intention, etc., the collective ego of the community is at work. Everything stored up in earlier works asserts itself in any new

creations and moves the execution of the individual work in the direction of the collective process.

Spiritual realities (nature interwoven with meanings, institutions, works) are distinguished from one another only by incremental steps and degrees, and our presentation would not be complete if we neglected to interpolate between the works of individuals and the category of institutions those institutions without prescription, those collective works created by a plurality of persons, which are not correctly characterized as either works or institutions. We have in mind such formations as language, custom and other unregulated but self-regulating social relations, which are all totalities of meaning, all in a state of becoming, which arise spontaneously but can nevertheless not be identified with 'works' nor equated to a nature with significancies superimposed on it.

We cannot conduct in this place a thorough analysis of all the distinctions among the types of spiritual reality which have been noted. But we had to give some account of them in order to point out with some breadth how sociological space is completely occupied by the collective creations of life-community. There is no corner in which the spirit of the conjunctive life-community is not embodied. All of these things taken together comprise the world of meaning and of significancies. From this one can see that we are using the concept of a meaning in a very broad sense, very different from the theoretical concept (which refers, e.g., to the Pythagorean theorem). Neither artistic creations nor religious formations are theoretical formations of meaning. Nor are the meaningful relationships of feeling, such as the various forms of love, asceticism, or commitment, theoretical contextures of meaning (even though they may to some extent employ conceptual expression). They are nevertheless meanings, first because they possess that certain ontological abstractability from any individual subjective-psychic occurrence (even though they have their origins in such occurrences and must always be actualized by them, and are therefore most intimately bound up with them), and second, because they can therefore be attended to as realities in their own right. But they are not nature. They sometimes refer to natural things and incorporate things determined by nature into the stock of spiritual things. That these meanings are nevertheless not identical with the determinations of nature is proved by the circumstance that mankind, while always surrounded by the same three-dimensional reality governed by natural laws, and determined by the same naturally-determined psychological processes, has always created within the contexture of its life a different outer and inner world for itself out of these natural givens, and has thus always constructed an ever-different life-space for itself inside of the space determined by nature.

The argument that this spiritual reality, in any of the four types cited earlier, has a mode of being different from thing-like being as well as from the psychological course of things in individuals can be further strengthened by calling attention to a characteristic peculiar to this mode of being: its distinctive structure. We had already pointed out that the spiritual formations in being for a community in any period of time are not present piecemeal and independent of one another, but only as parts of a spiritual totality that is dynamic as a whole. All the spiritual entities, elements, occurring in the life-space of a given epoch undergo change in time, but each one in conjunction with the remaining elements of that life-space, not by itself. Change in one field is co-determined by change in the others. A common spirit, a

common tendency, is at work in the direction taken by change at any particular time. Sensitive and precise historical analyses in art history, but also in linguistic, literary, religious, economic and social history have shown us that the general process of development within the individual fields within a common life- and culture-space, though actualized by different individuals, moves in a common direction. In art history Riegl coined the useful term 'artistic volition' (*Kunstwollen*). Artistic volition refers to the tendency operating unconsciously in the creative artist which impels him to move in the direction of the dominant style even in his most spontaneous expressions and productions. Such a communally-conditioned will resides in each field of culture and determines its attributions of meaning, its productions, and its language. For this reason one could also speak of an 'economic volition', a 'social volition', and ultimately introduce the concept of a 'will to a world'. By this term we would understand not only the direction of the specific spirituality manifesting itself in works but also the deepest unity of style belonging to the consciousness of the community in all of its objectifications, conscious or unconscious.

That every individual production within a spiritual totality moves in a direction prescribed by its age, however individualistic the age may be, results not only from the fact that a similar kind of world volition has entered into every individual consciousness in a community, but also from the objective structure of the formations. In every style, in every artistic creative form there clearly lies (aside from the aspect of the creative design relating to the creator as subject) a principle (but not a theoretical one) that can be creatively carried through to its conclusion (as an idea is thought through to its conclusion). The fact that the Baroque developed out of the Renaissance is due partly to the fact that Baroque tendencies were already embedded in the artistic forms of the Renaissance, tendencies which had merely to be isolated and pursued further. An early Baroque painting or building already contains the tendencies whose logical conclusion can well be considered to constitute late Baroque. These objective tendencies embedded in individual formations also demonstrate that the latter have a distinctive existence of their own, even if it is not wholly independent of the existence of the community that stands behind them. Several different objective tendencies reside, in potential, within every formation, and each of them could in principle be carried to its logical conclusion if its distinctive direction were pursued. Which of these tendencies is taken up by the overall volition (*Gesamtwollen*) can only be explained by reference to the existence of the living community and not by reference to the structure of the formations alone. Nothing can better demonstrate that it is a matter of volition which of these tendencies residing within a formation is taken up and brought to fruition than the fact that the repertory of forms which originated in antiquity and blended itself with the artistic forms and volitions of the Christianized peoples of the great migration could still belatedly unfold, as classical element, several of its potential directions. On the basis of these classical elements contained in our repertory of forms, we have managed repeatedly to gain a new understanding of antiquity, and to take out and carry to creative conclusions distinct tendencies from among its objective possibilities, in the art of the Renaissance, as in classicism. Individual formations as well as the complex of such formations comprehensible as stylistic unity have an objective structure, which frees them, to some extent, from dependence on life, in its fluctuations.

Each individual carries on his life, of course, brings about some change in the general process, if only through the temporary creation of a new word, and thereby furthers the dynamics of the whole; but this ongoing existence does not take place in a vacuum devoid of tradition, but rather rests upon the given state of the life-community, which manifests itself in tendencies of will and structures of objects. Upbringing, teaching and daily life draws the individual into this life-space pervaded by volitional tendencies and stylistic orientations. Although the creative genius may soar up to a sphere above society, this sphere is supra-social only in a relative sense, for it arises out of the accumulation of accomplishments established by tradition. The genius merely advances the growth of seeds already embedded in the spiritual subsoil, and every innovation, however creative, is always drawn back into the general process.

When we now say that every life-community has a different world, we mean that the totality of spiritual realities of all four types is different in different communal life-spaces. The community is thus not only (as may have appeared in the first stage of our presentation) a totality bound together by common life-actions; it is also bound together by those spiritual formations that arise in it and contain the precipitate of its collective life. At the same time, however, this precipitate is something objective that can be considered in itself, something which, like an object, can be distinguished from its substratum, something which contains within itself in the form of tendencies and directions the independent germs of its potential for further development.

But every society survives by taking up new generations, in their designs; and the new generations become the bearers of what is fact and the shapers of what is to come, by virtue of their incorporation of new designs into the life-space of the community. This means that there is a steady, continuous process of revolutionizing the whole spiritual structure, so that two experiential spaces widely removed from one another in time already represent two different worlds throughout. And yet two depictions of the world emanating from the same community will be in very close contact with one another, provided that they have arisen within the same tradition (i.e., when there is also an existential continuity of generations behind them). The significance of this for interpretative understanding we shall be able to appreciate only later. The world-views are closely bound to one another, not only because this bond is guaranteed by the continuity of the existential designs of the community and its merely gradual transformation but also because what is later is connected with what is earlier by the objective side of the matter: that the later versions of spiritual formations have come out of seeds and tendencies present at the beginning. For this reason it is possible for cultural communities to encompass a wider range than life-communities. A life-community extends only as far as there is immediate existential contact. A cultural community also joins into a whole those individuals and groups who are only united in the designs and tendencies of objectifications. Wherever there is cultural community, there must also have been, some time and somewhere, immediate existential contact. It is accordingly not necessary that those who are members of one cultural community must also live simultaneously in existential community together, but there must have been mutual existential contact at some time. Where a unity can be uncovered in the later cultural heritage of scattered communities, there must have been an existential fusion in history. It may be that

the dispersed members of the community, having once more gone their separate ways after such existential contact, are variously living to a conclusion a different tendency among the possibilities and seeds they have taken up. They take these tendencies, individually, to distinctive conclusions, along the lines of their particular designs upon the world, but still continue to form a whole at this stage, because it is the same seeds that they have developed, if also differently. This circumstance implies a connection for a long time to come, even if partial or total isolation should ensue. The European-American cultural community is such a cultural community, but only to the extent that it is living off common objective and subjective (intentional) traditions. Within this entity, it constitutes nations, landscapes and spiritual dialects which are nothing but further developments of common seminal possibilities caught up in different specific existential life-communities.

It follows that we have several kinds of community, with cultural community as the most encompassing, and with family and friendship as the narrowest. The narrower communities subsist within the wider ones, and they are characterized by the fact that their distinctive 'wills' and 'objectifications' are sustained by those of the wider community, and even in so far as they are different, refer themselves to this common store. They render themselves distinct from the common basis by contrast with it.

Reviewing the ways in which the presence of these diverse spheres is reflected in a cross-section of contents of an individual's consciousness and in his designs, it becomes clear that he belongs to different communities with regard to different contents and subdivisions. In his total existence, then, the individual participates in various levels and spheres of communities; and only historical analysis, which must also be sociologically discriminating, can tell us where to refer an individual with regard to any given matter. In his consciousness the individual also accommodates contents belonging to some historically earlier system, as well as contents and existential orientations which may be present nowhere else, having originated in him as innovations, and which must be ascribed to one personality alone, being subject to socialization only later. Through self-exploration the individual may indeed discover 'experience' areas of psychic space never as yet experienced by others, but the direction (and even the opportunity for taking this new direction) is provided by the general state of consciousness, the general structure, the stage of the world in general which he shares with the other members of his community. His contributions to forward movement and continuing achievement arise out of the movement of the whole and return to it. While the ongoing creation is achievable only within the different individual consciousness and becomes dynamic only in these individual existences, these are in their turn altogether bound to the whole of the life and designs of the community, which ranges far above them.

Robert Witkin

VAN EYCK THROUGH THE LOOKING GLASS

From *Art and Social Structure*. Cambridge, Polity Press, 1995, pp. 138–54.

[. . .]

JAN VAN EYCK WAS a Netherlandish painter, the court painter of the Duke of Burgundy and Count of Flanders. In a famous painting of his dated 1434, and usually referred to as *The Marriage of Arnolfini*, he depicts, with great intimacy and refined detail, the interior of a bedchamber in which a marriage is taking place. The perceptual-realism with which surfaces are rendered is startling, and yet the painting is mysterious in that all this detail is somehow pervaded by a strange stasis (Fig. 1). My aim is to explore the inscription of social relations in the aesthetic structure of this particular painting. I shall 'read' a single painting in order to argue that there is an identity between the mode of structuring aesthetic means in this painting and the mode of structuring social relations in a society experiencing a particular transition. This identity can, and I would suggest does, hold, irrespective of the motives and purposes of the artist with respect to content and subject matter, what he or she wants to say, and it can hold even when the subject matter and content of works of art appear to have little manifest connection with the subject matter and content of material social relations. The attentional shift involves moving from a consideration of what a work is about, what it symbolizes, towards a consideration of how it symbolizes and seeing that the social order may be reflected in the ordering of aesthetic means whether or not social relations are reflected at the level of content.

The peculiar confluence of aristocratic and bourgeois interests, and their accompanying tensions, was the origin of the impressive court of the Valois monarchy. It was a confluence and tension realized fully in the work of its greatest painter. The Valois state was a creation of the late fourteenth and early fifteenth centuries. It united under the seigneury of the Burgundian Dukes a disparate collection

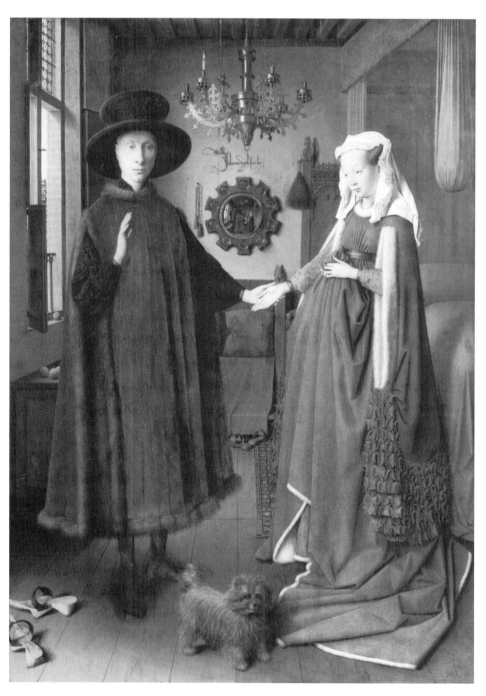

Figure 1 Jan van Eyck, *The Marriage of Giovanni (?) Arnolfini and Giovanna Cenami (?)*, 1434. National Gallery, London. Reproduced by kind permission.

of territories, mostly in the lowlands, which included a number of major urban centres. These were fiercely independent and were always seeking to assert that independence against the overlordship of the monarchy. The court was the very centre of power and social influence and the heart of business. New political relations were being forged with the rise of the haute bourgeoisie, with the developing political freedoms and primitively democratic relations in the cities. The feudal order was changing and a nascent bourgeois society was emerging from within it. The monarchy benefited enormously from the considerable revenues of the urban manufacturing and mercantile economy and the royal court was both illustrious and ostentatious in court ceremonial, perhaps to a greater extent than elsewhere in Europe. Philip the Good (Jan van Eyck's patron) established four provincial governments at Dijon, Brussels, Ghent and the Hague. He introduced a single common coinage for the Netherlands in 1433. He also organized the parliamentary life of the dominions in a centralized way.

Philip the Good was a ruler following a seigneurial policy at its most ambitious and yet his wealth and power depended chiefly on an 'advanced' (for its time) urban society, which was frequently rebellious. The revenues from Flanders were the greatest of all his revenues. The rich bourgeois friends and patrons of van Eyck, who included the merchant Arnolfini, were men of business and property and commerce and yet involved in the aristocratic and feudal court, which drew them to it. Even without knowing exactly how someone like van Eyck viewed these major social developments, we can be reasonably certain that he felt them quite deeply. He was employed by the duke not only as a painter but also as a political confidante, and entrusted with various secret missions abroad. As a great court painter, van Eyck was heir to the predominant feudal tradition in the art of the aristocratic society he served. At the same time his very position at the heart of this court society placed him at the concourse of all the modern bourgeois currents of his time. This very placement at the meeting of the old and the new, of the feudal past and the bourgeois future, provided, I believe, a profound tension at the heart of his work, one that we can read directly in the formal aesthetic structure of the work. I see this tension as the juxtaposition, within a single work, of two presentational codes. In order to 'capture' the juxtaposition of presentational codes, I shall attempt a formal analysis of this particular painting as a visual text, arguing that it seeks to retain and adapt the older code to aims that demand a new presentational code for their full realization.

Artists down to the sixteenth century were classed as craftsmen. Their training and work relegated them to the ranks of small shopkeepers and petty merchants. Van Eyck was clearly a particularly notable figure even in his own day. Giovanni Arnolfini was a silk merchant from Lucca who had business at the Valois court. His wife was Giovanna Cenami, the daughter of a rich merchant from Lucca. Van Eyck, although a court painter, undertook a number of commissions on behalf of rich bourgeois patrons. The constant flow of commerce and trade between the Italian cities and those of Flanders meant that the cultural influence of Italy was felt in Flanders and the cultural achievements of the great Renaissance artists were known to van Eyck. Alberti's treatise on painting was roughly contemporary and Brunelleschi's treatise on perspective had been published some twenty years earlier.

Van Eyck's compromise with perceptual-realism

I shall seek to use van Eyck's painting as a text and to argue that the formal treatment of the subject matter, as distinct from the content of the painting, reflects the value tension of a feudal order in transition. It is clear, for example, that Jan van Eyck was a master of realistic detail and spared no pains in simulating the appearances of things, and yet there are certain aspects of the painting that are puzzling in the light of that very fact.

1 Each object and figure, though rendered in vivid detail and clearly related to other objects in the context of an overall design, nevertheless appears somehow to be self-enclosed and independent, part of a visual arrangement of independent things, more or less unaffected by its relationship to other things. In a truly perceptual-realist work, how objects are rendered depends on how they are related within an overall space and supposing a particular viewpoint. If they are further away, for example, they are smaller and do not have the same clarity or detail as objects that are near. Panofsky has argued that van Eyck painted as though using a telescope and a microscope. The most distant objects are painted in minute detail and with great clarity. It is a 'God's eye-view' of the world.

2 The man and woman are not rendered in their correct sizes. They are a little too large, given the scale of their surroundings. The dog is too small. Throughout the painting, however, van Eyck gives evidence of the fact that he has no technical difficulty with rendering things in their correct size–distance ratios and demonstrates a consistent mastery of perspectival effects associated with Renaissance perceptual-realism. The subject of linear perspective is technically complex. Van Eyck's use of such effects, while consistent in the context of his own work, did not accord with any fully developed system. Rather, the very freedom with which he deploys perspectival effects discloses the ambivalence at the level of presentational codes.

3 The two halves of the painting (divided vertically into left/right, man's half/woman's half) are not treated formally in the same way. There is a distinct shift in 'visual language' as one moves from one to the other. The left-hand side of the picture develops a language of tonality, subtle variations in light and shade, while the right-hand side develops a language of colour.

4 Finally, the objects so lovingly and carefully rendered as material things are saturated with symbolic meanings and the entire scene is carefully composed as a pictorial arrangement of such symbols and not as a simple record of a real historical moment in the wedding of the two. For an account of these symbolic meanings see Panofsky.

Read as a text, the peculiarity of van Eyck's painting of the marriage lies in the way in which van Eyck seeks to reconcile two mutually exclusive modes of symbolling, two levels of abstraction, within a unified aesthetic work, thereby rendering important social values in ways characteristic of a transition between two different types of society.

The painting – a formal analysis

The puzzles are seemingly endless. Is it a marriage? Where is the priest? If those are witnesses in the little mirror, is one of them van Eyck? Why does the man hold the woman's hand in his left hand and not his right? Is it a morganatic marriage? Is the woman pregnant? To my mind the most plausible account of the picture is the one offered by Panofsky and it is the account upon which I have drawn most freely for my exposition here, more particularly in respect of the iconography of the work. The picture has been the subject of a great deal of speculation. Some have argued that it is a painting of van Eyck himself and his wife, others that it is a morganatic marriage. Panofsky's account of the painting, apart from being the most satisfying interpretation among those available, is also the most widely accepted and reproduced in the literature. Gombrich follows it closely in *The Story of Art*, as does Chatelet in his book *Van Eyck*. The picture is that of a marriage; no priest was necessary at that time in order to solemnize a marriage (this was a century before the Treaty of Trent, which made that necessary). The fact that the marriage took place in such a chamber with a large bed in it is also not unusual. Alberti's contemporaneous treatise on the family describes, in normative terms, just such a marriage solemnized between two people in just such a place without even witnesses present. It is unlikely that the woman is pregnant. Such a style of dress, which emphasized the fullness of the skirt, perhaps deliberately suggesting the fruitfulness of pregnancy, was quite fashionable at the time for an occasion such as this. The man is holding the woman's right hand in his left because the moment upon which the painter chose to focus is that in which the man raises his right hand in the swearing of the *Fides Levata*. Only his left hand is free (consistent with the logic of the painting) to hold the hand of his bride. There is no need to read into this some added significance, such as the possibility of a morganatic marriage.

There are a number of observations that we can make about the painting itself which demand only an everyday non-specialist knowledge. The principal figures in the painting are a man and woman standing side by side. The pose is a somewhat stiff and formal one, ceremonial in appearance. The man has his right hand raised and his left hand supporting the back of the right hand of the woman, which has its open palm facing forwards. The room is a bedchamber; there is a large canopied bed in the right half of the picture. Beside it is a seat. The wooden floorboards are covered in the region of the bed by a patterned carpet. On the left side of the room is a window and below it a chest. The external brickwork at the side of the window is clearly visible and on the sill is placed a single piece of fruit. More fruit is present on the chest below. In the left foreground there is a pair of shoes. Another pair is present in the background behind the couple. In the central axis of the picture there is a chandelier, a convex mirror set in carved wood and a small dog in the foreground between the couple.

There are yet more observations that we can make without calling on the specialist help of an art historian. The bedroom is clearly that of a wealthy person. The furniture and furnishings, carpets and curtains, etc., are of rich and well-crafted materials. So, too, are the materials with which the couple are clothed, the rich wine-coloured gown and fur trimmings of the man and the green dress with the blue

sleeves and underskirt worn by the woman. The chandelier is impressive, the mirror is beautifully decorated and is clearly a precious object.

Beyond these observations of the marks of opulence and wealth in the objects depicted there are a number of observations to be made about the technical accomplishment of the painting itself. The skill of the artist in rendering the details and qualities of surfaces is staggering. These include the floorboards, down to the grain and knots, the intricate patterning of the carpet, the hairs of the dog and the fur of the man's gown, the look and feel of materials such as wood and metal and masonry, the delicately carved figures which include ten scenes from the Passion of Christ set in the wooden surround of the small convex mirror, the rich red drapes of the bed, the marks of wear in the slippers and much else besides. The artist appears to have delighted in rendering every little detail with the utmost clarity, laying out in a small pictorial space a visual feast in which a variety of surfaces are intricately worked up to the point where all their sensuous materiality is fully realized. Such a motive is consistent with an evocational mode of symbolling in which important values are experienced at a higher level of abstraction as belonging to the overall system of relations in which they participate. In van Eyck's painting, however, these interactions are there but they are suppressed to a sufficient degree so as to preserve the independent integrity of the objects and figures depicted.

The self-contained, self-sufficient object

The dualism of aesthetic motive is apparent throughout the work in the loving care with which the artist renders, in the most realistic detail, the qualities of objects and materials while at the same time treating them as somehow complete and self-enclosed in themselves, each a jewel to be rendered with the same clarity whether it belongs to the foreground or the background. It is not that van Eyck ignores optical values. On the contrary, he cultivates them with great skill but he takes care to preserve the independence of each object in the manner of his depiction. This rendering of details that somehow preserve their independence is clearly what displeased Michelangelo when he remarked of the Flemish painters that while skilled in the painting of stuffs of all kinds, they lacked a sense of the larger whole.

Linear perspective

To move on from these observations to others, which bear more directly upon issues of style and form, presupposes a more specialist interest in pictures and some knowledge of pictorial conventions. It is here, however, that some of the paradoxes of van Eyck's system of representation become more apparent. In order to simulate the optical values obtained in natural perception, that is, to render objects on a two-dimensional surface so that they look more or less as they do in everyday life – possessed of body and mass and located in relation to other objects in a continuous space – the artist must use certain techniques. The two most important of these, both of which are employed in the van Eyck picture, are 'linear perspective', through which the appearance of depth and distance can be simulated on a surface, and the use of chiaroscuro (light and shade originating in a unified light source) through which the appearances of objects and surfaces can be successfully modelled.

Gradations of tone, as surfaces are turned away from the light, are a means of suggesting three-dimensional form and volume. The convergence of parallel lines, as they recede into the distance, to one of an infinite number of vanishing points on the horizon, opens up the deep space of the picture.

Through the use of linear perspective and chiaroscuro, artists can establish the relative perceptual values to be assigned to particular objects in a picture (size, mass, etc.) in accordance with a rational system of optical transformations. Colour, as it developed in the European Renaissance traditions, also represented a rational system of optical transformations. However, if linear perspective and chiaroscuro are so important in the pictorial descriptions of objects, colour can be used most effect- ively to symbolize states of being or subjective values or to convey feeling. Colour is an important (not exclusive) means whereby artists can establish the relative per- ceptual values to be assigned to states of being and feeling, to subject values, in the picture. There is enough evidence in this one picture alone to indicate that van Eyck, in the first half of the fifteenth century, was a master of effects in all three formal areas but he uses them freely, accommodating them to another more traditional mode of symbolling.

Van Eyck employs perspective in a brilliantly effective way, not only to open up the space around objects and the space of the little room but to indicate the spatial contrast between the inside of the room and the world beyond the window. However, the brilliance of the spatial effects is perhaps best noted in the case of the mirror. This small object in the central axis of the picture actually contains the space of the whole room viewed from behind; that is, it describes a larger space than exists in what is directly presented of the room. The effect is achieved with the use of linear perspective, which accommodates the appropriate image distor- tion produced by the convex surface of the mirror – a surface that increases still further the space that can be encompassed in the representation. In the mirror is reflected the entry through an open door of two figures at the far end of the room – one of them is believed to be van Eyck himself – in front of Arnolfini and his bride, whom we now view from behind. In the mirror, too, the light sources, both from the window at the left of the room and the open door, are more fully specified.

It is difficult to believe, on the evidence of this painting alone, that van Eyck was either technically lacking in competence in the use of perspective or that he was careless or casual in his use of it. Yet we must note that both in this painting and in others, van Eyck's use of perspective subverts the very aesthetic motive for which it was designed. The room is not constructed in accordance with a strict one-point linear perspective. Panofsky has argued that there are four vanishing points. In a recent and detailed formal analysis, James Elkins has supported Panofsky's general point (albeit substituting the notion of 'areas' for 'points') and has provided far more information about van Eyck's complex construction of perspectival effects. Moreover, van Eyck does not use perspective to create a completely rationally ordered system of perceptual values because he does not use it consistently to render all objects and figures in their correct relative size–distance ratios. If we do not attribute the fact to some deficiency in the skill of the painter then we must suggest a more positive reason for the distortion. We can hardly do better than to note the concluding remark in Elkins's paper: 'He

accomplished by eye, and with consistency between paintings, a compromise between medieval and Renaissance sensitivities.'

Strictly applied, linear perspective universalizes perceptual values. It fixes sizes and distance in terms of a purely rational system of optical transformations. It follows that the perceptual values assigned to objects will not be an intrinsic property of those objects, something that is enclosed within them, but will be objectively assigned on the basis of the precise relations and relative locations of objects in a coherent and continuous space. Traditionally, however, the perceptual values of the object, the overall size of a figure or the size of particular features, etc, were made to correspond directly to the values the painting sought to realize. The victorious king might be larger than his enemies, expressive features such as the eyes of the saints might be exaggerated, and so forth. The values to be depicted in such paintings were somehow interiorized in the forms depicted and for this reason, perceptual values such as size corresponded to the value intrinsic to the form.

This older mode of symbolling persists as a powerful aesthetic motive in van Eyck's painting. The central symbol, the couple itself, is somehow partially 'uncoupled' from the perceptual-realist logic which dominates the painting as a whole. The values that constitute the subject matter of the painting are perceived as intrinsic to the forms that make up this central symbol (that is, they are treated as interiorized in the couple). The perceptual values assigned to the couple, including size, are thus a function of the ideal qualities deemed to be intrinsic to them, that is, to originate in their being. We can find other examples in paintings of van Eyck that are even more marked in the use of this mode of symbolling. In van Eyck's painting of *The Madonna in a Church*, he shows his skill in rendering columns and architectural features in their correct sizes. The Virgin, however, is a truly gigantic figure in relation to her surroundings. Panofsky argues that van Eyck was painting, not the Virgin *in* the church but the Virgin *as* the church. Again, however, I would add that we need to see that in concentrating important values in the central symbol in this way, van Eyck was treating such values in the traditional way as interiorized in the forms in which they were realized, and this, as I shall argue below, subverts the mode of symbolling that is involved in perceptual realism.

The treatment of light – chiaroscuro and colour

It is in the handling of light, of tonality and colour, however, that van Eyck appears to be centuries ahead of his contemporaries. The subtle gradations of tones and tonal blends produced by the cool daylight from the window on the left, as it lights the surfaces variously oriented towards or away from it, is intensely and consistently observed, lending a realism and a lustre to the modelling of surfaces and generating the impressions of density, of mass, of recession and depth. The face and hands are brightly lit and the area around the mirror behind the couple is bathed in a faint glowing light. The fuller specification of the light source as reflected in the mirror, which includes the open door, accounts for this effect.

The two halves of the picture work in somewhat different ways and it is here that we find van Eyck again reconciling two contrasting aesthetic motives within a single composition. If we draw an imaginary line vertically down the centre of the

picture, it is clear that in the left half of the picture the exploration of tonality is strongest. The language used is one of tonal contrasts and tonal harmonies. The use of colour is carefully restrained. The dark wine-coloured gown of the man with the large-brimmed dark hat, the relatively neutral hues of the wooden floorboards, the window frame, the masonry, all exemplify the restraint in the use of colour. By contrast, the right of the picture is marked by a strong and expansive use of colour. There is the bright green dress of the woman with the blue sleeves and underskirt, and the vivid orange red of the bed canopy and of the seat at the back.

This juxtaposition of the tonal left and the coloured right of the picture adds to the vitality of the composition. More than this, however, there is a sense in which the language of tonality and the language of colour can oppose each other. Tones describe the presence or absence of light *upon* surfaces. Strong colour gives the impression of being light that comes from or *through* surfaces. The stronger the colour values the more they detract from the language of tone. I would argue that this juxtaposition of tone and colour forms part of a larger unification within the composition of two quite distinct pictorial motives. If tonal values, the values of light upon surfaces, are so effective in the modelling of objects, then colour values, the values of light through surfaces, are equally effective in rendering states of sensuous tension, mood or feeling, states of being. The colours of surfaces appear to belong to their objects in a more intimate way than tones, to correspond directly in some way to the sensuous values felt as interiorized within them.

The use of colour is particularly suggestive of values that describe the subject, that are concerned with states or modes of being, that is, with what I shall call 'subject values'. However, there are different ways of using colour. In a sophisticated perceptual-realist use of colour, there are fine gradations of hue and complex colour harmonies as well as colour interactions in which the colours of one object are altered by their proximity to the colours of other objects, thereby subordinating particular objects to the overall system of colour interactions constituting the sur-face of the picture as a whole. On the other hand, the use of areas of strong local colour to describe the surfaces of particular objects tends to heighten the sense of the colour values as corresponding directly to the 'subject values' felt somehow as located in and contained by the objects and figures depicted.

In van Eyck's painting of the marriage, the greater colourific complexity occurs in the development of the more subdued and repressed colours of the left (man's half) of the painting. The richer, more expressive use of areas of strong local colour in the right (woman's half) of the painting gives colour a more dominant role in the description of objects – the dress, the underskirt and sleeves, the bed canopy and so forth. With this shift in language and this heightened contrast with the tonal left of the painting we are confronted with a materiality that is somehow more 'saturated' with the 'sensuous subject'. On the right of the picture the very modelling of the woman is somewhat different from that of the man. The woman seems less realistic-ally, more 'symbolically' drawn, corresponding more to the 'type' of the sweet Madonna to be found in many Gothic churches. The 'fish-faced' man, however, gives an impression of being somewhat more of an individual personality than a type. We should not overdraw the contrast, however. The two figures are still stylized and formal as befits not only the occasion but van Eyck's use of them as a central symbol. Nevertheless, it seems to me that there is a difference between the two figures in

respect of the degree and kind of stylization, a difference consistent with van Eyck's determined treatment of the two halves of the painting in accordance with different symbolling modes.

We are therefore looking at a painting in which the two halves work, symbolically, in a fundamentally different way. The more 'objective' (modern) perceptual-realism of the left, tonal half is contrasted with the more 'subjective' (traditional) formalism of the right, colour half. Also, the more subtle and complex colour blending and colour harmonies of the left half are contrasted with the use of stronger (and flatter) local colour in the right half. It is as though van Eyck has used the two halves to symbol value in two different modes, one of which belongs to the traditional aristocratic feudal order and the other to the modern feudal order, an order increasingly permeated by bourgeois values. Overlaying this contrast is a gendered division – that between the harder and more objective male side and the softer and more sensuously expressive female side. Not only are the two languages (tonality and colour) and the two halves of the painting integrated within a formally unified perceptual-realist picture but the treatment of the couple in the marriage itself unites them symbolically.

The gendered division of the painting exemplifies the power of aesthetic means in the formulation of social relations. As I read this painting, van Eyck captures, as a division between the aristocratic world of spiritual values and the bourgeois world of practical values, a dichotomy which later served to describe an opposition within bourgeois society. The opposition was between the economic, rational and instrumental sphere of life, which is the province of the 'man of affairs', and the spiritual and socio-emotional sphere of life which is centred on the 'woman of virtue', quintessentially symbolized by the Virgin Mary. The development of bourgeois society deepened this division between the instrumental and expressive domains of life, between the sphere of production and consumption, work and leisure, between what Habermas calls 'man as *bourgeois* and as *homme*'. According to Habermas, there emerged, in the latter half of the eighteenth century, an important division between the public world of 'private' individuals – a world centred on the instrumental sphere of economic production – and the sphere of domestic and familial relations in which (the illusion of) personal autonomy and creative and humanistic value-making could be conserved. The sphere of private and familial relations served (ideally) to restore the human qualities and spiritual values which the instrumental life destroyed. Parsons's functional analysis of the family portrays the father as the 'instrumental leader' of the family and the mother as the 'socio-emotional' leader. Such a distinction reflects the gender ideology of bourgeois society and comes at the end of a very long line of development. We would have to place van Eyck's painting at the beginning of that development and yet, so it seems to me, the division between the instrumental and expressive is captured here, not as a gendered division within bourgeois society but as a division between tradition and modernity which is symbolized in the gender division within the painting. It is as though that which separates the bourgeois from the feudal order is recreated within the emerging bourgeois world in that which separates the domestic sphere, dominated by woman, from the instrumental sphere, dominated by man.

Surprisingly, Panofsky's account does not mention the vertical division of this painting into a tonal and a colour half. I have read one account that does so by a

former curator of the National Gallery, although he comments only on the 'liveliness' that this brings to the composition. However, this type of unification appears in other pictures by van Eyck and these are certainly analysed by Panofsky. For example, in the painting *The 'Friedsam' Annunciation*, the two halves of the church (left and right) are formally unified but one half is Gothic (modern) and the other half is Romanesque (traditional). In other paintings, the lines of division mark the boundaries between the sacred and the profane. In the painting of *The Madonna with Canon van der Paele*, for example, the formally unified composition is, nevertheless, a depiction of two different worlds. The Virgin is not really present with the canon, other than as a vision, which is why his gaze is not directed at her. She is present in his mind's eye and is a traditionally stylized figure depicted as of disproportionately great stature. He is drawn with a perceptual-realism that is marked. Equally realist in its treatment is the depiction of the *Madonna with Chancellor Rolin*, in another of van Eyck's paintings. Again, the stylized Madonna is present only to the mind's eye, although, formally, the composition is unified in a perceptual-realist mode. Here the complexity of this left/right divide is greater because, in the background of the picture, there is a river dividing the landscape beyond the balcony into two vertical halves. Again, although formally unified, the right half represents the Celestial City and the left, the earthly realm.

Symbolism in the painting

The single most important source for the symbolism of this painting is Panofsky's account of it in *Netherlandish Painting*. In the mirror, we can see that there are two witnesses to the marriage, one of whom is the painter himself – not depicted as painting but as present and witnessing the event. That the picture represents an act of witnessing is suggested by the painter's signature, which is placed not where we might expect it to be, on the frame, but in the centre of the picture above the mirror. Furthermore, the signature is worked in the florid style characteristic of legal documents at the time, and the claim it makes, that *Jan van Eyck was here 1434*, contrasts with the more usual claim that *Jan van Eyck made me*. Though the painting is a witnessing of a marriage (a fact of significant sociological interest in itself) it is not a fifteenth-century equivalent of a wedding photograph. If the painting truly captured a real event, a real moment in time and space, it would work like a fifteenth-century snapshot of that moment in the wedding of Giovanni Arnolfini, Florentine merchant, and Giovanna Cenami, daughter of a rich merchant of Lucca, where the former swears the *Fides Levata*. However, it is clear that the painter did not seek to capture any such real moment as it actually occurred in the wedding of the two. Indeed, it would be surprising if he did, for no such motive existed among painters until centuries later. Rather, the painter gathered together a number of potent symbols and carefully arranged them in an ideal construction of a moment, a ritualized pictorial moment, which symbolizes a marriage in all its religious meaning and which nevertheless purports to be 'realistic' and to conform to the logic of a perceptual-realist depiction. It is in this sense that the painter works a double illusion, that of making pigment simulate real appearances and that of making an idealization appear as a real substantive (historical) moment.

The fruitfulness promised in the swell of the woman's skirt, and emphasized in the resting of her hand upon the skirt just below the waist, is echoed in the fruit beneath the window and in the pendulous drape hanging from the bed canopy like a ripe fruit. The carved figure above the seat beside the bed is believed to be that of St Margaret, the patron saint of childbirth. The apple on the window-still recalls the events in the Garden of Eden. The single lit candle in the chandelier (it is daylight) symbolizes the Divine Presence. It is placed on the man's side. The shoes, casually cast off in the foreground, add a touch of informality to the visual display but, in the context of the formal symbolism of the painting, they recall God's command to Moses on Mount Sinai to remove this shoes before entering a holy place. The little dog in the foreground is a symbol of marital fidelity and is placed between the couple.

In addition to the use of conventional symbols, the painting employs aesthetic means to symbol states of being. The bright lighting of the faces and the hands of the two and the glow surrounding the mirror in the background add to the spiritual ambience of the painting, setting up a counterpoint between inner (spiritual) light and the outer (worldly) light, welling from the window. The effect is enhanced by the peaceful expressions and the 'sightless' eyes of the two, which convey an inwardness of gaze, a spiritual readying, which completes this effect. The abnegation of the outer senses, implicit in the demeanour of the two, emphasizes the richness of the spiritual life, a richness paradoxically echoed for those same senses in the richness of the room and all its contents.

The suppression of optical values is necessary in an art that has to realize ideas at a low level of abstraction. It is this mode of symbolling that I have called *invocational*, precisely because it invokes the value to be depicted directly in the presented form. In van Eyck's painting of the marriage, the preservation of this mode of symbolling is to be seen in all four aspects singled out for analysis, in the self-enclosed character of objects depicted, their completeness and perfection in themselves, in the size distortion and stylization of the central figures, in the use of strong local colour in the context of the left–right asymmetry of the painting and in the organization of significant symbols within the painting. This invocational mode of symbolling is appropriate to a society that is still seigneurial, one in which the interactonal mode of social relationship and the political forms associated with it are still at an early stage in their development.

When depicted objects are treated 'subjectively' in Panofsky's sense, the opposite situation prevails; optical values are emphasized and each appearance of a thing becomes an integral part of an overall system of interactions – linear perspective, chiaroscuro, colour interactions, etc. – from which it derives its particular values. Values to be thought are experienced as somehow beyond the material appearances which evoke or express them, as originating in the larger system of interactions of relations in which they are involved.

Talcott Parsons

ART AS EXPRESSIVE SYMBOLISM: ACTION THEORY AND THE SOCIOLOGY OF ART

(a) EXPRESSIVE SYMBOLISM AND SOCIAL INTERACTION

Extracts from 'Expressive symbols and the social system: the communication of affect', in *The Social System*. New York, The Free Press, 1951, pp. 384–9, 408–14.

[. . .]

EXPRESSIVE SYMBOLS CONSTITUTE THAT part of the cultural tradition relative to which expressive interests have primacy. In the 'purest' form they constitute the cultural patterning of action of the expressive type where the interest in immediate gratifications is primary and neither instrumental nor evaluative considerations have primacy. It should immediately be pointed out that this does not in the least imply that such expressive interests are in any sense crudely 'hedonistic'. They consist in the primacy of the interest in immediate gratification of *whatever* need-dispositions are relevant in the action context in question. These may be need-dispositions to care for others, or to 'create' highly abstract ideas or cultural forms. The essential point is the primacy of 'acting out' the need-disposition itself rather than subordinating gratification to a goal outside the immediate situation or to a restrictive norm. The 'quality' of the need-disposition is not at issue.

Expressive action, in our central paradigm, as a type of action, occupies a place parallel with that of the instrumental type. Like all action it is culturally patterned or formed. Expressive symbols then are the symbol-systems through which expressive action is oriented to the situation. Again like all of culture it has a normative aspect. As this has been stated above, there are appreciative standards in the cultural tradition by which expressive interests and actions are judged. These standards constitute the essential ordering principles of systems of expressive symbols.

In expressive action as such, systems of expressive symbols, including the relevant appreciative standards, have a place homologous to that of belief systems in instrumentally oriented action. They constitute the cultural element which has primacy in the patterning of the concrete action processes. Cognitive patterns, or beliefs, may themselves become the focus of a special type of instrumental activity which we have called investigation. Similarly, expressive symbol systems may themselves be developed as the goal of a type of instrumentally oriented activity, which may be called 'artistic creation'. This must be clearly distinguished from expressive action itself, which is 'acting out' *in terms of* a pattern of expressive symbolism, not the process of deliberately creating such a pattern.

Of course only a small part of the expressive symbolism of a culture is the product of deliberate artistic creation just as very much of its cognitive orientation patterning is not the result of scientific or philosophical investigation, but has grown up 'spontaneously' in the course of action processes where other interests have had primacy.

Finally, just as cognitive and evaluative interests may be fused in ideological and religious belief systems, so expressive and evaluative interests may be fused in relation to systems of expressive symbols. Where this evaluative interest involves symbolic references to a supernatural order we will speak of religious symbolism. Where it does not, we shall speak simply of evaluative symbolism, as in the case of symbolic acts of solidarity with the other members of a collectivity or the symbolization of an attachment to a social object.

As we have stated, expressive symbolism is the primary cultural component in any form of expressive action, and is involved in some way in all types of action. But in attempting to analyze the most important modes of relation of systems of expressive symbolism to the social system, it seems best to start, once more, with the paradigm of social interaction. In this connection we have pointed out repeatedly that specific actions and expectations tend to become organized and generalized around the reciprocal attitudes of ego and alter toward each other, and toward the common cultural patterns which define the situation for the interaction process.

Expressive symbolism is that part of the cultural tradition most directly integrated with the cathectic interests of the actor. In so far as it is the reciprocity of attitude which becomes the primary focus of these cathectic interests, it follows that expressive symbolism will tend to be organized relative to these attitudes as a point of reference.

From this point of view the concrete expressive symbols which are part of the process of interaction serve a threefold function, as do all elements of culture: (1) they aid in communication between the interacting parties, in this case the communication of cathectic 'meanings'; (2) they organize the interaction process through normative regulation, through imposing appreciative standards on it; and (3) they serve as direct objects for the gratification of the relevant need-dispositions. The special feature of this aspect of culture is the differentiation of a system of symbols with respect to all of these functions, from other elements of culture through the primacy of the expressive interest.

The most important starting point of our analysis is the recognition that the organization of orientations within the interactive relationship about reciprocity of attitudes *already and in itself*, constitutes the development of an expressive

symbol-system. This is because the particular discrete act acquires a *meaning* which in some way involves a reference beyond the 'intrinsic' significance of the particular act itself. It is fitted into a context of association in such a way that the whole complex of associated acts is invested with a cathectic significance. Once this has happened it is no longer possible to isolate the specific act from the complex in which it has become embedded; it has acquired a meaning which is added to its immediate intrinsic significance. It thus fulfills Durkheim's main criterion of a symbol, that its meaning is 'superadded' to its intrinsic properties. Thus the response of the mother to the crying of a child comes, apparently very early, to be felt as 'symbolic' of her attitude toward the child, not merely as an instrumental measure of relieving the particular distress which occasioned the crying. We may say, then, that the prototype of the expressive symbol, within the context of inter-action, is the *symbolic act*. It also follows that in a stabilized interaction system all acts have this symbolic quality to some degree, all serve as expressive symbols. They are the modes of gratification of ego's need-dispositions and at the same time signs to alter of what ego's attitudes toward him are.

[. . .]

If we regard symbolic acts occurring within the interaction process as the focus of the genesis of expressive symbolism, we can then proceed to analyze the generali-zation of this symbolic significance, that is of symbolization of the relevant attitudes, to objects other than acts. Such objects, it is evident, come to be drawn into the associational complex which is organized about the reciprocal attitudes of ego and alter. Our classification of the objects in the situation gives us the basis for such an analysis of generalization. In the first place ego and alter themselves, as objects to each other, come to be drawn in. In so far as they are treated as actors, it is their acts which are the symbols. But these acts may be 'interpreted' as manifestations of action-relevant qualities. The feeling, then, that alter is an 'honest man' or a 'very friendly person' may be generalized in this direction.

Secondly, the bodies of ego and alter as a special class of physical objects are obviously so closely associated with their action that their features inevitably acquire symbolic significance and come to be cathected. Physical traits such as stature, body shape, hair color, facial features and the like are involved. Fundamental aspects of the significance of the anatomical differences of the sexes also fit into this context. This is in all probability the case with the basic erotic symbolism which has played such a prominent part in psychoanalytic theory. The penis, for example, is a feature of the body around which a whole complex of sentiments may cluster, both in relation to ego's own attitudes toward himself, and to those of alter. Thus the insistence in Freudian theory that many other objects should be treated as symbols of the penis is correct but is only one side of the picture. There is every reason to believe that the penis is itself a symbolic object to a high degree and that a sub-stantial part of its psychological significance is to be interpreted in the light of this fact. In more general terms it may perhaps be said that 'one way' symbolic significance, as exemplified in the case of Freudian sexual symbolism, constitutes a limiting case. The more general case is the symbolic or associational *complex* in which in some sense and to some degree every item symbolizes every other. Thus elongated objects may symbolize the penis but in turn the penis symbolizes the

'masculinity' of its possessor and the whole complex of qualities and attitudes comprised under this term.

Third, there is the whole realm of physical objects besides the organisms of ego and of the relevant alters. These are the physical objects which constitute the immediate physical environment of the interaction process and which are involved in it, instrumentally or otherwise. One of the most obvious examples is clothing. Because of its direct relation to the body, and the fact that visual impressions of the body include clothing, clothing becomes one of the main foci of sentiments associated with the body. In addition clothing is considerably more subject to manipulative modification than are most of the features of the body itself, and hence presents a highly suitable medium for expressive purposes. Very similar considerations apply to the premises in which important activities take place, such as the home, and to its furnishings and utensils and the like.

Finally cultural objects themselves are of course also drawn into the association complex. The type of case of particular relevance here is that of the symbolic creations which have no 'use' beyond their expressive significance. The ideal type is that of 'works of art'. There is always a physical aspect of a concrete work of art, but the more essential one is the cultural. In the pure type of the work of art the physical object, or even the concrete action process, e.g., in the case of 'playing' a musical composition, would not be cathected but for its significance in the context of expressive symbolism.

[. . .]

The role of the artist

In the above treatment one type of differentiation of roles with respect to expressive symbolism was discussed, namely, that in which the role itself was an integral part of the general system of expressive symbolism of the culture. We must now turn to the second type noted above, that where the incumbent of a differentiated role becomes not so much himself a symbol, as a specialist in the creation and manipulation (application) of expressive symbols. We find here a direct parallel to the creation and application of beliefs by the scientist or philosopher and the applied scientist. The term artist is generally used to designate both types, but differentiated as the 'creative' artist and the 'performer'.

As we have noted above, expressive symbolism like cognitive beliefs is 'originally' and 'normally' embedded in the ordinary processes of action. The ordinary person who acts, and surrounds his action with objects in accord with a definite expressive 'style' is no more an artist in the present sense than is the peasant who possesses knowledge about his soil, seed, fertilizer and crop pests and uses this knowledge in a practical way, a scientist. In both cases the use of the cultural pattern may be very skillful and 'sound', but this is not the criterion. The criterion is rather specialization of role with respect to the relevant aspects of the cultural tradition itself. In a strict sense then the creative artist is the person who specializes in the production of *new patterns* of expressive symbolism, and the performing artist is the person who specializes in the skilled implementation of such symbolism in an action context. Both are 'experts' with respect to a particular phase of the cultural tradition.

As is the case with any other type of specialty, this artistic type arises through differentiation relative to the other components of the total action complex. Once differentiated, furthermore, there is the same order of problem of the relation between the technical function of the role and its relational context which exists with respect to other differentiated roles.

[. . .]

There is a particular combination of expressive and instrumental elements of orientation in the role of the artist which is important to understanding some of the peculiarities of the role. For himself and for his public the artist is engaged in creating expressive symbols. But it is precisely the difference in one respect between sophisticated art and purely 'spontaneous' expressive activity that there is a 'technical' aspect of the artist's work which is directly comparable with other techniques. This aspect of his activity is instrumental. It depends on knowledge and skill in exactly the same fundamental sense as does industrial technology, or the technology of scientific research. The artist must accept severe disciplines, must spend much time in study and practicing his skills. But his goal is to produce appropriate patterns for the expression of affect, to 'stir up' his audience or public. There seems to be an inherent tension between these two aspects of the role, which is not present for the scientist, because the content of the latter's goal is not of the same order of direct cathectic significance. How much certain aspects of the situation in the western world are culture bound it is difficult without careful comparative study to say. However, the well-known association of art with 'Bohemianism', with the repudiation of many of the main institutionalized patterns of ordinary life, is clearly very much less marked in the case of science. It may at least be suggested that in a society where affectively neutral patterns are institutionalized to such a high degree, the expressive interests of the artist come more drastically into conflict with the main institutional structure than do the interests of the scientist. In more expressively oriented societies the conflict is presumably not so acute, but conversely the opportunity for the scientist is less well developed.

The parallel between the role of the artist and of the scientist extends to the structure of the continuum between the 'pure' creative artist and the corresponding types of application. Corresponding to the professions in which science is applied, like medicine or engineering, we may distinguish the performer of sophisticated works of art, who is himself a trained 'professional'. Of course only some among the media of artistic expression admit of specialized performance. The principal examples in our culture are music, the theater and the dance whereas some forms of literature, painting, sculpture and architecture do not admit of a separate role of performance. In their essentials the specialized roles of performers in these fields are similar in structure to that of the creative artist himself. There are, of course, often transitional types between the two as well. Thus a great concert musician or conductor is certainly 'creative', but in a sense parallel to that in which a great surgeon is.

'Pure' art, whether as practiced by the creative artist or the performer, is parallel to specialization relative to non-evaluative cognitive orientation, to belief systems. As we have seen evaluative symbolism, religious or not, is not 'purely' expressive. We can, however, have specialization in the creation and performance of evaluative symbolism as well as of 'pure art'. The core of Greek art seems in these

terms to have been evaluative in its original setting, to have been both civic and religious in different contexts. Similarly religious art has played a very prominent part in Western culture. A distinction should, however, be made between artistic creation which is itself an act of religious devotion, as in the building of cathedrals, and the use of religious symbolic *content* in artistic creations, as is the case with so much of Renaissance art. A good deal of the latter should not be called religious art in a full sense. It shades over into 'pure' art.

In the above sense, the actual conduct of collective ceremonials may in certain cases be treated as artistic performance of a special type. Much of the 'embellishment' of religious ritual is clearly art in this sense. Thus the singing of a Bach mass as part of the religious service itself is an integral part of the religious expression. But the singing of the same mass in a secular concert hall may be an act of a quite different order. Similarly, Lincoln's Gettysburg address as originally delivered was not 'literature,' it was an act of expressive symbolization of the collective need-dispositions of the nation, or at least the North; it was part of a collectivity ceremonial. It has, however, to a certain degree become divorced from this context and come to be treated as 'art'.

Thus in addition to the creative artist and the artistic performer we may speak of the ceremonial performer, who manipulates artistic symbolism in an evaluative context, where its meaning in terms of explicit common values is directly symbolized.

The distinction is paralleled by that between modes of participation of the public or audience. The standards of pure art in this sense are institutionalized only in 'acceptance' terms. As we ordinarily put it, we are 'pleased' or 'moved' by a work of art or its performance. But this attitude does not have specifically binding implications for our action beyond this specific context. In general, attendance at performances, or paying attention to art as such, is treated as voluntary.

(b) THE CULTURAL ELABORATION OF EXPRESSIVE MEANINGS AND THE EVOLUTION OF ART

Extract from 'Culture and the social system', in T. Parsons *et al.* (eds), *Theories of Society*. New York, The Free Press, 1961, pp. 963–93.

Culture, meaning and the differentiation of action systems

[. . .]

HUMAN ACTION IS ORGANIZED through and in terms of the patterning of the meanings of objects and of orientations to objects in the world of human experience.[1]

'Meaning' in the present technical usage, should be understood as a *relational* category. In philosophical terms, it implies both a 'knowing' (or, to avoid a cognitive bias, an 'orienting') subject or actor, and an object – or, more generally, a *system* comprising a plurality both of actors and of objects. Orientations to objects are conceived as structured or, in the term commonly used in the cultural context, as 'patterned'. In other words, there are elements of 'consistency', 'order', or 'coherence' – between orientations *to* different discrete objects and classes of objects; and between the orientations *of* different actors and classes of actors. In this sense, the structure of cultural meanings constitutes the 'ground' of any system of action, as distinguished from the set of situational conditions to which its functioning is subject.

[. . .]

[. . .] A great deal of the treatment of culture has emphasized the element of *pattern* as such, considering culture as a system of 'eternal objects'.[2] Culture conceived exclusively in these terms, however important its part in the determination of action might be, would be deprived of the status of being a *system* of action in the same sense that behavioral organisms, personalities, and social systems are action systems. This pattern element is an authentically central aspect of culture, but is not exhaustive. Broadly, it comprises the *structural* component of cultural systems; the 'content' of their pattern-maintenance systems and subsystems. The analysis of this cultural structure as such is, in our opinion, the task area of formal disciplines such as logic, mathematics, structural linguistics, the systematics of stylistic form, the purely logical structure of a theological system, and the formal analysis of legal norms.

How a cultural system is also a system of action in the direct sense is best shown through a comparison with the social system. Like all other action systems, a social system involves the organization of *all* the components which in any sense enter into action. A social system is distinctive, not in its ultimate components, but in focusing the organization of these ultimate components around the exigencies of the functioning of systems of social interaction as such – analytically, independently of the exigencies of personality functioning or of cultural integrity as such, though interdependent with them. From the general premises of action theory it follows that, if the functions of culture are as essential as they seem to be, the important patterns of culture, i.e., complexes of meaning, could not be created and/or maintained as available resources for action in the other systems of action unless there were processes of action primarily oriented to their creation and/or maintenance. These processes may be part of a 'society' just as the life of an individual as personality may be; but analytically, the subsystem of action focused in this way should be distinguished from the social system as focused on interaction relationships. The maintenance of a religious orientation through the functioning of a church would be considered as a case of interpenetration of cultural and social system; but a church as such would be regarded as a collectivity with cultural primacy, i.e., as first, a cultural 'system of action', and second, a social system. Similarly, the organization of scientific research is, in the first instance, cultural in focus, and secondarily social, because it must meet exigencies of interaction.

Cultural patterns as such will be considered as forming the focus of organization for a set of subsystems in the action system. The primacy of this focus distinguishes a cultural system from a social system, a personality system, or a behavioral organism.

[. . .]

Cathectic meaning and expressive symbols

The other dimension defining relations of cultural systems to external objects also involves the relative primacy of different components in the meaning of objects. In this case, however, it involves their meaning as objects of *goal*-orientation of action systems. In other words, objects are regarded in terms of their significance for the immediate stabilization of a condition of disturbance or tension in the relation between a system of action and relevant parts of its situation or environment. In psychology this is often described as the 'cathexis' of objects. We shall use this term more generally, to refer to any category of the meaning of an object with respect to which its significance in terms of goal-attainment or of blocking such attainment is paramount.

An attempt at the present order of theoretical systematization in this field is somewhat unfamiliar. For this reason we will first propose a set of categories which formulate the relation between basic orientations and the modalities of the relevant objects at the *general* action system level. This formulation will use terminology related to the psychological, using in particular *cathexis* as a key term. We will then attempt to translate the results into terms appropriate to the level of the cultural system where the appropriate objects are *expressive symbols*.

At the level of the general action system, then, the lowest level of the 'cathectic meaning' of an object is its treatment as a 'means-object' or, in economic terminology, as an object of utility. The next level is its treatment as 'goal-object' for the personality – the acting system's attainment and/or maintenance of a specific *relation* to this object has 'consummatory' significance for the system. The actor may become 'attached' to such an object. These two categories of cathectic meaning are important at the most elementary level of unit relations or interaction.

As the first essay of the General Introduction indicated, however, cathectic system relations are not limited to these two levels – the more extensive and time-extended the system, the less its cathectic relations are so limited. The level above the 'consummatory' is the level of 'inclusion' or 'adherence'. This is best illustrated by the interaction of individual persons. Though Alter (as person in role) may be 'cathected' by Ego, as an object with minimal involvement of higher-level cultural components, if a 'serious', long-term, and stable relationship is established, it will necessarily generate a normative structure of *shared* meanings. One aspect of this is that Ego and Alter combine to constitute a *collectivity*, in the sociological sense. Then, in addition to Alter's meaning as a discrete person, there is, for Ego, the meaning of their common membership in or adherence to the collectivity comprised by Ego and Alter together. The principle involved in this interaction between people may be generalized to apply to any case of a system of action related to an object in its environment. We must consider both the meaning of the comple-

mentary object standing on the same level of cathectic meaning as the actor of reference; and the meaning of the object constituted by both of them, and possibly others, through their interaction. This latter is the meaning of inclusion, adherence, or membership, as distinguished from the meaning of attachment or consummation.

[. . .]

The cultural bases of expressive meaning

The above categories have been formulated at the level of the general structure of action, without taking into account the special features which develop when the concern is at the cultural level as such. In the cultural case the focus is on *meaning* as such rather than on the empirical features of the concrete object-relation; it concerns *symbols* rather than actual objects of cathexis, utility etc. A symbol must, as we shall see later, be meaningfully related to its 'real' referent, but if the relation of the orienting actor to both were identical the distinction between symbol and referent would become redundant. Thus if the conception of the 'fatherhood' of God is symbolic, there must of course be a sense in which the relation of a believer to his God is *analogous* to that of a child to his father, but it can be a true symbol *only* if it is *not* in fact a father–child relationship in the empirical sense.

The cultural categories which belong here, therefore, are categories of expressive *symbolism*, as distinguished from the intrinsic cathectic interest in 'real' objects. If we take expressive symbolization as in some sense parallel to empirical knowledge, then we can suggest a classification of components of systems of such symbolization. The focal category will be that of symbolic *content*, as such, the symbols which are expected to be the objects of cathexis in place of 'real' objects; an example would be the Madonna and Child of Renaissance painting as the portrayal of a realistic social relationship type of great importance in the society of the time, but as 'meaning' more than a pictorial representation of an actual mother and child. The facilities which are necessary to build up such a symbolic representation are the technical devices and procedures utilized by the artist which, like the facts of the scientist, are organized and codified, not merely ad hoc 'play' with canvas, pigments and brushes. But this technically produced symbol acquires its artistic meaning by virtue of its incorporation in still higher-order meaning or pattern systems. This seems to be the kind of thing that art historians and critics speak of when they refer to questions of 'form' and 'style'. In a sense not directly reducible to the levels of content and technique, these are the specifically 'aesthetic' components of the symbolization, by virtue of which it acquires expressive significance beyond the particular case or its realistic references.

The external-internal axis of differentiation is essentially that between concrete symbolizations on the one hand and the codes in which their meaning must be interpreted on the other. This is a distinction which will be seen presently to be of very general importance in connection with the problems of language. The instrumental-consummatory line of differentiation on the other hand is parallel to that between methods and results in the case of science. Here it may be spoken of as the distinction between the primary resources at the disposal of the artist, namely

techniques and normative patterns of style, and the results at which he aims which are respectively effective concrete symbol-formations and form-patterns which generalize the relations between whole complexes of more specific symbols.

[. . .]

[. . .] In sophisticated cultures, works of art are clearly differentiated from scientific knowledge. They purport to reflect or 'describe' empirical reality only on certain limiting fringes; and even there, not in patterns organized through the analytical generalization of scientific theory. Second, in relation to patterns of value, art does not primarily carry evaluative judgments or commitments; it may be appreciated or enjoyed for its own sake. Finally, though like all patterns of orientation, art is in some sense ultimately rooted in orientations of meaning; works of art per se are not attempts to articulate these grounds – this belongs to philosophy and theology as *cognitive* disciplines – but rather to create forms of expression which are adequate, and to manipulate objects in creating these forms of expression.

Art, like all other components of cultural systems, involves particularized signs and symbols, and generalized patterns that somehow organize and govern their use. The most common words for these generalized patterns are 'form' and 'style' which are, as we have suggested, analogous to the grammar, syntax, and phraseology of language.

[. . .]

The evolution of expressive culture

The question of cumulation in the field of expressive symbolization, i.e., of the arts, has been deliberately left until now because it has so generally been cited as the prototypal case of complete irrelevance of the idea of cumulative development. It is the most difficult to analyze in this way, because, in all systems of action, the cathectic relation to situational objects is the most highly particularized of all essential relations. In contrast, the instrumental relation to means, e.g., to objects of utility, has more generalized meaning – as does, in a quite different direction, the justification of cathexes in relation to the integrative problems of the system to which they relate, i.e., in the case of the social system to its institutionalized norms.

Cathectic-artistic generalization can therefore be expected to assume special forms clearly differentiated from those of empirical cognition, meaning-orientation, and even evaluation. A special mode of 'condensation' of meaning seems to be a keynote of aesthetic or appreciative patterns, in this sense. Since the reference is object-oriented, it may reasonably be assumed that this has tended particularly to emphasize symbols, and hence generalization through the patterning of symbols rather than the symbolization of patterns. For one particular case of special relevance to the personality system, the symbolism of dreams as treated by Freud is probably a prototype of artistic symbolism – it is the highly condensed expression of a profusely rich set of associations of the content of experience and of expectations.

One difficulty in seeing the element of generalization in the arts may derive from the common tendency to emphasize the importance of artistic symbolism as such. If, beyond the general particularity of reference of the cathectic field of meaning, one of

the lower levels of generality of any cultural subsystem is stressed, then it is easy to overlook the elements corresponding to the syntactical and phraseological levels in the case of language, or to general theory in the case of science.

For the arts, these are form and style. It is fairly commonplace in this area for even works that are called 'realistic' to be far from direct representations of their subject matter. Through selection, condensation, symbolization, and patterned arrangement of components, much more meaning can be condensed in a small compass than could be in real life – except in the most crucial experiences and events.

The development of art forms cannot be understood as an additive process of inventing new symbols one at a time. Symbols are critically important to the arts; and one major task of their analysis is the clarification of the characteristics of artistic symbols as distinguished from the characteristics which figure most prominently in science and philosophy.

One most important point about artistic symbolism is vividly indicated by Burke. This is the multiplicity of references involved in the same symbol and symbolic complex. Burke emphasizes the simultaneous involvement of the civic level in Greek tragedy, and the religious level which in some sense is, relative to the former, an 'archaic' substratum of meaning. This order of multiple reference of symbols seems to maintain for cathectic symbolization in the personality field, as found in the Freudian type of interpretation of dreams and used generally to interpret material produced during psychoanalysis. It is essentially to the patterns of order involved in the *organization* of these multiple symbolic references that one must look for the elements of generalized patterning involved in systems of expressive symbolism.

The central problems concern the senses in which such pattern systems can be arranged in series of levels of generality, and how they are linked with the other components of the cultural system as a whole. For the latter problem, the most immediately significant and tangible set of links are those to the religious belief and symbol system. The case analyzed by Burke may be considered prototypal; in artistic systems, there is always a more manifest level of the centrality of symbolization, and a substratum which, in terms of the development of the culture, is historically earlier – on the scale of 'sophistication', less general, and closer to religious traditions than the higher levels.

The ways in which art differentiates from a religious matrix are closely related to this. The patterns of form which were differentiated from a religious matrix are, in the present sense, more general than those embedded in religion. These considerations are advanced to help to place the arts more completely in the general process of structural differentiation of systems of action, since this underlies the higher-level patterns of integration associated with the concept of upgrading. Essentially, the phenomenon of the 'relativizing of relativity' (noted with reference to the other three subsystems of culture) is the key to the problem of cumulation in the field of expressive symbolization. The impression of planless pluralism derives largely from the treatment of style patterns in isolation both from the cultural system of which they are a part and from the society. When both contexts are carefully considered and theoretically analyzed, comparatively and in developmental perspective, the inevitable conclusion is that expressive symbolism is an integral part of the total socio-cultural complex.

Perhaps one example is in order. European music underwent a major transformation in the transition from Handel and Mozart, through Beethoven, to the patterns of the nineteenth century. Beethoven did much more than invent a few new musical tricks or gadgets unknown to his predecessors. He introduced a major reorganization of musical form, most conspicuous in the symphonic form and illustrated by the contrast of the *Eroica* with his first two, much more Mozartian, symphonies. This produced a range and power for expression, especially of intense emotion and conflict, that had been absent from the highly integrated but more restricted style of eighteenth-century music. As often remarked, this cultural change was connected with the French Revolution and the Napoleonic era – i.e., with the dissolution of the aristocratic society of the Old Regime in Europe. Beethoven, in one of the major arts, revealed possibilities of expressing emotion that were in certain respects comparable with those Freud, nearly a century later, opened on the level of science.

Notes

1 The German term *Sinnzusammenhänge*, though difficult to translate, is particularly expressive in this connection.
2 The phrase is Whitehead's. This was the view taken by the author, both in *The Structure of Social Action* and in collaboration with Shils, in *Toward a General Theory of Action*. It no longer seems adequate in the light of further theoretical developments, and has been modified along the lines sketched in the following paragraphs.

References

Abrams, M.H. 1989a. 'Art as such: the sociology of modern aesthetics', in M. Fischer
 (ed.), *Doing Things with Texts: Essays in Criticism and Critical Theory*. New
 York and London, W.W. Norton, pp. 135–58.
——. 1989b. 'From Addison to Kant: modern aesthetics and the exemplary in art', in
 M. Fischer (ed.), *Doing Things with Texts: Essays in Criticism and Critical
 Theory*. New York and London, W.W. Norton, pp. 159–87.
Adler, J. 1975. 'Innovative art and obsolescent artists', *Social Research* 42: 359–78.
Alexander, J. 1987. 'The centrality of the classics', in A. Giddens and J. Turner (eds),
 Social Theory Today. Cambridge, Polity Press, pp. 11–57.
Alexander, V.D. 1996a. *Museums and Money: The Impact of Funding on Exhibitions,
 Scholarship and Management*. Bloomington, Ind., Indiana University Press.
——. 1996b. 'From philanthropy to funding: the effects of corporate and public
 support on American art museums', *Poetics* 24: 87–130.
——. 1996c. 'Pictures at an exhibition: conflicting pressures in museums and the
 display of art', *American Journal of Sociology* 101: 797–839.
Alpers, S. 1991. 'The museum as a way of seeing', in I. Karp and S. Lavine (eds),
 Exhibiting Cultures: The Poetics and Politics of Museum Display. Washington,
 DC, Smithsonian Institution, pp. 25–32.
Antal, F. 1948. *Florentine Painting and its Social Background*. London, Routledge.
Antoni, C. 1940. *From History to Sociology*. London, Routledge.
Arato, A. and E. Gebhardt 1982. 'Aesthetic theory and cultural criticism' in A. Arato
 and E. Gebhardt (eds), *The Essential Frankfurt School Reader*. New York,
 Continuum, pp. 185–224.
Argan, G.C. 1975. 'Ideology and iconology', *Critical Inquiry* 2.2: 297–305.
Bal, M. and N. Bryson. 1991. 'Semiotics and art history', *Art Bulletin* 73.2:
 174–208.
Balfe, J.H. 1981. 'Social mobility and modern art: abstract expressionism and its

generative audience', in L. Kresberg (ed.), *Research in Social Movements, Conflict and Change*, no. 4, Greenwich, Conn., JAI Press, pp. 235–51.

——. ed. 1993. *Paying the Piper: Causes and Consequences of Artistic Patronage*. Chicago, University of Illinois Press.

Barasch, M. 1985. *Theories of Art: From Plato to Winckelmann*. New York, New York University Press.

Barker, E., N. Webb and K. Woods. 1999. *The Changing Status of the Artist*. New Haven, Conn. and London, Yale University Press.

Barthes, R. 1968 (tr. 1977). 'The death of the author', in *Image, Music, Text*, ed. S. Heath. London, Fontana, pp. 142–8.

Baxandall, M. 1980. *The Limewood Sculptors of Renaissance Germany*. New Haven, Conn., Yale University Press.

——. 1985. *Patterns of Intention: On the Historical Explanation of Pictures*. New Haven, Conn., Yale University Press.

Becker, H. 1976. 'Art worlds as social types', in R. Peterson (ed.), *The Production of Culture*. Beverly Hills, Calif., Sage, pp. 41–56.

——. 1978. 'Arts and crafts', *American Journal of Sociology* 83.4: 862–89.

——. 1982. *Art Worlds*. Berkeley, Calif., University of California Press.

Benjamin, W. 1973 (originally published 1936). 'The work of art in the age of mechanical reproduction', in *Illuminations: Essays and Reflections*. New York, Random House, pp. 217–52.

Berenson, B. 1954. *The Arch of Constantine: The Decline of Form*. London, Chapman & Hall.

Berezin, M. 1991. 'The organization of political ideology: culture, state and theatre in Fascist Italy', *American Sociological Review* 56: 639–51.

Blunt, A. 1940. *Artistic Theory in Italy: 1450–1660*. Oxford, Oxford University Press.

Bourdieu, P. 1967. 'Postface', in E. Panofsky, *Architecture gothique et pensée scholastique*, trans. P. Bourdieu. Paris, Éditions de Minuit, pp. 135–67.

——. 1968. 'Outline of a sociological theory of art perception', *International Social Science Journal* 20: 589–612.

——. 1971. 'Intellectual field and creative project', in M.K.D. Young (ed.), *Knowledge and Control*. London, Macmillan, pp. 161–88.

——. 1973. 'Cultural reproduction and social reproduction', in R. Brown (ed.), *Knowledge, Education and Cultural Change*. London, Tavistock, pp. 71–112.

——. 1977. *Reproduction in Culture, Education, Society*. Beverly Hills, Calif., Sage.

——. 1984. *Distinction: a Social Critique of the Judgement of Taste*. London, Routledge.

——. 1993a. *The Field of Cultural Production: Essays on Art and Literature*, ed. R. Johnson. Cambridge, Polity.

——. 1993b. *Sociology in Question*. London, Sage.

——. 1996. *The Rules of Art: Genesis and Structure of the Literary Field*. Cambridge, Polity.

Bourdieu, P. with L. Boltanski, R. Castel, J.-C. Chamboredon and D. Schnapper. 1965 (tr. 1990). *Photography: A Middle Brow Art*. Cambridge, Polity.

Bowler, A. 1994. 'Methodological dilemmas in the sociology of art', in D. Crane (ed.),

The Sociology of Culture: Emerging Theoretical Perspectives. Oxford, Blackwell, pp. 247–66.

Brain, D. 1989. 'Structure and strategy in the production of culture: implications of a post-structuralist perspective for the sociology of culture', *Comparative Social Research* 11: 31–74.

——. 1994. 'Cultural production as society in the making: architecture as an exemplar of the social construction of cultural artifacts', in D. Crane (ed.), *The Sociology of Culture: Emerging Theoretical Perspectives*. Oxford, Blackwell, pp. 191–220.

Brown, M. 1982. 'The classic is the Baroque: on the principle of Wölfflin's art history', *Critical Inquiry* 9: 379–404.

Bryson, N. 1992. 'Art in context', in R. Cohen (ed.), *Studies in Historical Change*. Charlottesville, Virg., University of Virginia Press, pp. 18–42.

Burckhardt, J. 1958 (originally published 1860). *The Civilization of the Renaissance in Italy*. New York, Harper & Row.

Bürger, P. 1983. 'Literary institution and modernisation', *Poetics* 12: 419–33.

——. 1984. *Theory of the Avant-garde*. Minneapolis, Minn., University of Minnesota Press.

Burke, P. 1971. 'Pierre Francastel and the sociology of art', *European Journal of Sociology* 12: 141–54.

——. 1987. *The Italian Renaissance: Culture and Society in Italy*. Cambridge, Polity Press.

——. 1990. *The French Historical Revolution: The Annales School 1929–89*. Cambridge, Polity Press.

——. 1994. 'The Italian artist and his roles', in P. Burke (ed.), *History of Italian Art, Volume 1*. Cambridge, Polity Press, pp. 1–28.

Bystryn, M. 1978. 'Art galleries as gatekeepers: the case of the abstract expressionists', *Social Research* 45: 390–408.

Cerulo, K. 1995. *Identity Designs: The Sights and Sounds of a Nation*. New Brunswick, NJ, Rutgers University Press.

Clarke, T.J. 1973a. *Image of the People: Gustave Courbet and the 1848 French Revolution*. London, Thames & Hudson.

——. 1973b. *The Absolute Bourgeois: Artists and Politics in France, 1848–1851*. London, Thames & Hudson.

——. 1985. *The Painting of Modern Life: Paris in the Art of Manet and his Followers*. New York, Alfred Knopf.

Coser, L.A. 1978. Issue Editor. 'The production of culture'. *Social Research* 45.2.

Crane, D. 1976. 'Reward systems in art, science and religion', in R. Peterson (ed.), *The Production of Culture*. Beverly Hills, Calif., Sage, pp. 57–72.

——. 1987. *The Transformation of the Avant-garde: The New York Art World, 1940–1985*. Chicago, University of Chicago Press.

——. 1992. *The Production of Culture: Media and the Urban Arts*. Beverly Hills, Calif., Sage.

Dauber, K. 1992. 'Object, genre and Buddhist sculpture', *Theory and Society* 21: 561–92.

Davis, M.S. 1973. 'Georg Simmel and the aesthetics of social reality', *Social Forces* 51.1: 320–9.

DeNora, T. 1991. 'Musical patronage and social change in Beethoven's Vienna', *American Journal of Sociology* 97.2: 310–46.

DiMaggio, P. 1977. 'Market structure, the creative process and popular culture: toward an organizational reinterpretation of mass culture theory', *Journal of Popular Culture* 11: 436–52.

——. 1982a. 'Cultural entrepreneurship in nineteenth-century Boston, I: the creation of an organizational base for high culture in America', *Media, Culture and Society* 4: 33–50.

——. 1982b. 'Cultural entrepreneurship in nineteenth-century Boston, II: the classification and framing of American art', *Media, Culture and Society* 4: 303–22.

——. 1987. 'Classification in art', *American Sociological Review* 52: 440–55.

——. 1991. 'Social structure, institutions and cultural goods: the case of the United States', in P. Bourdieu and J. Coleman (eds), *Social Theory for a Changing Society*. Boulder, Col., Westview Press and Russell Sage Foundation, pp. 133–55.

DiMaggio, P. and P.M. Hirsch. 1976. 'Production organizations in the arts', in R. Peterson (ed.), *The Production of Culture*. Beverly Hills, Calif., Sage, pp. 73–90.

DiMaggio, P. and K. Sternberg. 1985. 'Conformity and diversity in American resident theatres', in J. Balfe and M.J. Wyszomirski (eds), *Art, Ideology and Politics*. New York: Praeger, pp. 116–39.

DiMaggio, P. and M. Useem, 1978a. 'Cultural property and public policy: emerging tensions in government support for the arts', *Social Research* 45: 356–89.

——. 1978b. 'Cultural democracy in a period of cultural expansion: the social composition of arts audiences in the United States', *Social Problems* 26: 179–97.

——. 1978c. 'Social class and arts consumption: the origins and consequences of class differences in exposure to the arts in America', *Theory and Society* 5.2: 141–62.

Dubin, S.C. 1987. *Bureaucratizing the Muse: Public Funds and the Cultural Worker*. Chicago, University of Chicago Press.

Duncan, C. 1991. 'Art museums and the rituals of citizenship', in I. Karp and S.D. Lavine (eds), *Exhibiting Cultures: The Politics and Poetics of Museum Display*. Washington, DC, Smithsonian Institution Press, pp. 88–103.

Duncan, C. and A. Wallach, 1980. 'The universal survey museum', *Art History* 3.4: 448–69.

Durkheim, E. 1893 (tr. 1984). *The Division of Labour in Society*. New York, The Free Press.

——. 1895 (tr. 1950). *The Rules of Sociological Method*. New York, The Free Press.

——. 1897 (tr. 1951). *Suicide: a Study in Sociology*. New York, The Free Press.

——. 1912 (tr. 1915). *The Elementary Forms of the Religious Life*. New York, The Free Press.

Duvignaud, J. 1972. *The Sociology of Art*. London, Paladin.

Eagleton, T. 1976. *Marxism and Literary Criticism*. London, Methuen.

——. 1990. *The Ideology of the Aesthetic*. Oxford, Blackwell.

Edelson, M. 1976. 'Toward a study of interpretation in psychoanalysis', in J. J. Loubser, R. C. Baum, A. Effrat and V. Lidz (eds), *Explorations in General Theory in Social Science*. New York, The Free Press, pp. 151–81.

Eisler, C. 1969. 'Kunstgeschichte American style: a study in migration', in D. Fleming and B. Bailyn (eds), *The Intellectual Migration: Europe and America 1930–1960*. Cambridge, Mass., Harvard University Press, pp. 544–629.

Elias, N. 1978. *The Civilizing Process*, 2 vols. New York, Pantheon.

——. 1983. *The Court Society*. New York, Pantheon.

——. 1993. *Mozart: Portrait of a Genius*. Cambridge, Polity Press.

Elsner, J. 1995. *Art and the Roman Viewer: The Transformation of Art from the Pagan World to Christianity*. Cambridge, Cambridge University Press.

Etzkorn, K.P. 1968. *Georg Simmel: The Conflict in Modern Culture and Other Essays*. New York: Teachers College Press.

Fine, G.A. 1992. 'The culture of production: aesthetic choice and constraints in culinary work', *American Journal of Sociology* 95: 1269–94.

Foucault, M. 1973. *The Birth of the Clinic: An Archaeology of Medical Perception*. London, Tavistock.

Francastel, P. 1940/48. 'Art et sociologie', *Année Sociologique*, in P. Francastel, *La Réalité figurative: élements structurels de sociologie de l'art*. Paris, Denoel/Gonthier, 1965, pp. 27–55.

——. 1948. 'Espace génétique et espace plastique', *Revue d'Esthetique*, in P. Francastel, *La Réalité figurative: élements structurels de sociologie de l'art*. Paris, Denoel/Gonthier, 1965, pp. 127–48.

——. 1951. *Peinture et société: Naissance et destruction d'un espace plastique de la renaissance au cubisme*. Paris, Denoel/Gonthier.

——. 1960. 'Problèmes de la sociologie de l'art', in G. Gurvitch (ed.), *Traité de sociologie*. Paris, Presses Universitaires de France, pp. 279–96.

——. 1961. 'Art et histoire: dimension et measure des civilisations', *Annales ESC* 16, in P. Francastel, *La Réalité figurative: élements structurels de sociologie de l'art*. Paris, Denoel/Gonthier, pp. 71–95.

——. 1963a. 'The destruction of plastic space', in W. Sypher (ed.), *Art History*. Gloucester, Mass., Peter Smith, pp. 378–98.

——. 1963b. 'Main trends in European art', in G.S. Metraux and F. Crouzet (eds), *The Ninteenth Century World*. New York, Mentor, pp. 370–400.

——. 1965. 'Sociologie de l'art et problematique de l'imaginaire', in P. Francastel, *La Réalité figurative: élements structurels de sociologie de l'art*. Paris, Denoel/Gonthier, pp. 9–26.

Frank, M. 1989. *What is Neostructuralism?* Minneapolis, Minn., University of Minnesota Press.

Freedberg, D. 1989. *The Power of Images: Studies in the History and Theory of Response*. Chicago, University of Chicago Press.

Freidson, E. 1986a. *Professional Powers: A Study of the Institutionalisation of Formal Knowledge*. Chicago, University of Chicago Press.

——. 1986b. 'Les professions artistiques comme defi à l'analyse sociologique', *Revue Française de Sociologie* 27: 431–43.

Frisby, D. 1981. *Sociological Impressionism: A Reassessment of Georg Simmel's Social Theory*. London, Heinemann.

——. 1986. *Fragments of Modernity: Theories of Modernity in the Work of Simmel, Kracauer and Benjamin*. Cambridge, Mass., MIT Press.

Fyfe, G. 1985. 'Art and reproduction: some aspects of the relations between painters and engravers in London, 1760–1850', *Media, Culture and Society* 7: 399–425.

——. 1986. 'Art exhibitions and power during the nineteenth century', in J. Law (ed.), *Power, Action and Belief: A New Sociology of Knowledge*? Sociological Review Monograph 32. London, Routledge & Kegan Paul, pp. 20–45.

——. 1996. ' "A Trojan horse at the Tate": theorizing the museum as agency and structure', in S. MacDonald and G. Fyfe (eds), *Theorizing Museums: Representing Identity and Diversity in a Changing World*. Oxford, Blackwell, pp. 203–28.

——. 1998. 'On the relevance of Basil Bernstein's theory of codes to the sociology of art museums', *Journal of Material Culture* 3.3: 325–54.

Fyfe, G. and J. Law. 1988. 'Editors' introduction', in G. Fyfe and J. Law (eds), *Picturing Power: Visual Depiction and Social Relations*. Sociological Review Monograph 35, pp. 1–14.

Gans, H.J. 1974. *Popular Culture and High Culture: An Analysis and Evaluation of Taste*. New York, Basic Books.

Gimpel, J. 1970. 'Freemasons and sculptors', in M.C. Albrecht, J.H. Barnett and M. Griff (eds), *The Sociology of Art and Literature: A Reader*. London, Duckworth, pp. 279–87.

Goldmann, L. 1960. 'Sur la peinture de Chagall: reflexions d'un sociologue', *Annales ESC* 15: 267–83.

Goldstein, C. 1996. *Teaching Art: Academies and Schools from Vasari to Albers*. Cambridge, Cambridge University Press.

Gombrich, E.H. 1953/63. 'The social history of art', in *Meditations on a Hobby Horse and Other Essays in the Theory of Art*. London, Phaidon, pp. 86–94.

——. 1957/63. 'Art and scholarship', in *Meditations on a Hobby Horse and Other Essays in the Theory of Art*. London, Phaidon, pp. 106–19.

——. 1960. *Art and Illusion: A Study in the Psychology of Pictorial Representation*. London, Phaidon.

——. 1963/66. 'Norm and form: the stylistic categories of art history and their origins in Renaissance ideals', in *Gombrich on the Renaissance, volume 1: Norm and Form*. London, Phaidon, pp. 81–98.

——. 1967/79. 'In search of cultural history', in E.H. Gombrich, *Ideals and Idols: Essays on Values in History and in Art*. London, Phaidon, pp. 24–59.

——. 1973/79. 'Art history and the social sciences', in E.H. Gombrich, *Ideals and Idols: Essays on Values in History and in Art*. London, Phaidon, pp. 131–66.

——. 1974/79. 'The logic of Vanity Fair: alternatives to historicism in the study of fashions, style and taste', in E.H. Gombrich, *Ideals and Idols: Essays on Values in History and in Art*. London, Phaidon, pp. 60–92.

——. 1984a. 'The father of art history: a reading of the *Lectures on Aesthetics* of

G.W.F. Hegel', in E.H. Gombrich, *Tributes: Interpreters of our Cultural Tradition*. London, Phaidon, pp. 51–69.

——. 1984b. 'The high seriousness of play: reflections on *Homo Ludens* by J. Huizinga, (1972–1945)', in E.H. Gombrich, *Tributes: Interpreters of our Cultural Tradition*. London, Phaidon, pp. 139–63.

Green, N. 1987. 'Dealing in temperaments: economic transformations of the artistic field in France during the second half of the 19th century', *Art History* 10: 59–75.

——. 1989. 'Circuits of production, circuits of consumption: the case of mid-nineteenth century French art dealing', *Art Journal* 48.1: 29–33.

Greenblatt, S. 1991. 'Resonance and wonder', in I. Karp and S. Lavine (eds), *Exhibiting Cultures: The Poetics and Politics of Display*. Washington, DC, Smithsonian Institution, pp. 42–56.

Greenfeld, L. 1984. 'The role of the public in the success of artistic styles', *Archives Européennes de Sociologie* 25: 83–98.

——. 1989. *Different Worlds: A Sociological Study of Taste, Choice and Success in Art*. Cambridge, Cambridge University Press.

Griff, M. 1968. 'The recruitment and socialisation of artists', in D.L. Sills (ed.), *International Encyclopaedia of the Social Sciences* vol. 5, pp. 447–54.

Griswold, W. 1987. 'A methodological framework for the sociology of culture', *Sociological Methodology* 14: 1–35.

Habermas, J. 1962 (tr. 1989). *The Structural Transformation of the Public Sphere: An Inquiry into a Category of Bourgeois Society*. Cambridge, Mass., MIT Press.

Hadjinikolaou, N. 1978. *Art History and Class Struggle*. London, Pluto Press.

Halle, D. 1987. 'The family photograph', *Art Journal* 46.3: 217–25.

——. 1989. 'Class and culture in modern America: the vision of the landscape in the residences of contemporary Americans', in J. Salzman (ed.), *Prospects: An Annual of American Cultural Studies*. New York: Cambridge University Press, pp. 373–406.

——. 1991a. 'Bringing materialism back in: art in the houses of the working and middle classes', in S. MacNall, R.F. Levine and R. Fantasia (eds), *Bringing Class Back In: Contemporary and Historical Perspectives*. Boulder, Col., Westview, pp. 241–59.

——. 1991b. 'Displaying the dream: the visual presentation of family and self in the modern American household', *Journal of Comparative Family Studies* 22: 217–29.

——. 1992. 'The audience for abstract art: class, culture and power', in M. Lamont and M. Fournier (eds), *Cultivating Differences: Symbolic Boundaries and the Making of Inequality*. Chicago, University of Chicago Press, pp. 131–51.

——. 1994. *Inside Culture: Class, Culture and Everyday Life in Modern America*. Chicago, University of Chicago Press.

Hamilton, P. 1974. *Knowledge and Social Structure: An Introduction to the Classical Argument in the Sociology of Knowledge*. London, Routledge.

Harris, N. 1970. 'The pattern of artistic community', in M.C. Albrecht, J.H. Barnett and M. Griff (eds), *The Sociology of Art and Literature: A Reader*. London, Duckworth, pp. 298–310.

Hart, J. 1993. 'Erwin Panofsky and Karl Mannheim: a dialogue on interpretation', *Critical Inquiry* 19: 534–60.

Hasenmueller, C. 1978. 'Panofsky, iconography and semiotics', *Journal of Aesthetics and Art Criticism* 36: 289–301.

Haskell, F. 1968. 'Art and Society', in D. L. Sills (ed.), *International Encyclopaedia of the Social Sciences,* vol. 5, pp. 439–47.

——. 1980 (originally published 1965). *Patrons and Painters: A Study in the Relations Between Italian Art and Society in the Age of the Baroque.* New Haven, Conn., Yale University Press.

——. 1993. *History and its Images: Art and the Interpretation of the Past.* New Haven, Conn., Yale University Press.

Hauser, A. 1951. *The Social History of Art.* London, Routledge & Kegan Paul.

——. 1958. *The Philosophy of Art History.* Evanston, Ill., Northwestern University Press.

Hawthorn, G. 1987. *Enlightenment and Despair: A History of Social Theory.* Cambridge, Cambridge University Press.

——. 1991. *Plausible Worlds: Possibility and Understanding in History and the Social Sciences.* Cambridge, Cambridge University Press.

Heilbron, J. 1995. *The Rise of Social Theory.* Cambridge, Polity.

Heinich, N. 1996. *The Glory of Van Gogh: An Anthropology of Admiration.* Princeton, NJ, Princeton University Press.

Heirich, M. 1976. 'Cultural breakthroughs', in R. Peterson (ed.), *The Production of Culture.* Beverly Hills, Calif., Sage, pp. 23–40.

Hirsch, P.M. 1972. 'Processing fads and fashions: an organization set analysis of cultural industry systems', *American Journal of Sociology* 77, 4: 639–59.

Holly, M.A. 1984. *Panofsky and the Foundations of Art History.* Ithaca, NY, Cornell University Press.

Honour, H. 1979. *Romanticism.* New York, Harper & Row.

Horkheimer, M. and T.W. Adorno. 1947 (tr. 1972). *Dialectic of Enlightenment.* New York, Continuum.

Hunter, I. 1992. 'Aesthetics and cultural studies', in L. Grossberg, C. Nelson and C.C. Treichler (eds), *Cultural Studies.* New York, Routledge, pp. 347–72.

Iversen, M. 1979. 'Style as structure: Alois Riegl's historiography', *Art History* 2: 62–72.

——. 1993. *Alois Riegl: Art History and Theory.* Cambridge, Mass., MIT Press.

Jay, M. 1973. *The Dialectical Imagination: A History of the Frankfurt School and the Institute for Social Research, 1923–1950.* Boston, Little, Brown.

Kavolis, V. 1968. *Artistic Expression: A Sociological Analysis.* Ithaca, NY, Cornell University Press.

Kempers, B. 1992. *Painting, Power and Patronage: The Rise of the Professional Artist in Renaissance Italy.* London, Allen Lane.

Kris, E. and O. Kurz. 1934 (tr. 1979). *Legend, Myth and Magic in the Image of the Artist. A Historical Experiment.* New Haven, Conn., Yale University Press.

Kristeller, P.O. 1990 (originally published 1951/2). 'The modern system of the arts', in

P.O. Kristeller, *Renaissance Thought and the Arts*. Princeton, NY, Princeton University Press, pp. 163–227.

Lachmann, R. 1988. 'Graffiti as career and ideology', *American Journal of Sociology* 94: 229–50.

Lamont, M. 1992. *Money, Morals and Manners: The Culture of the French and the American Upper Middle Class*. Chicago, University of Chicago Press.

Latour, B. 1988. 'Opening one eye while closing the other: a note on some religious paintings', in G. Fyfe and J. Law (eds), *Picturing Power: Visual Depiction and Social Relations*. Sociological Review Monograph 35. pp. 15–38.

Layton, R. 1991. *The Anthropology of Art*. Cambridge, Cambridge University Press.

Levine, E.M. 1972. 'Chicago's art world', *Urban Life and Culture* 1: 292–322.

Levine, L.W. 1988. *Highbrow, Lowbrow: The Emergence of Cultural Hierarchy in America*. Cambridge, Mass., Harvard University Press.

Lévi-Strauss, C. 1958a. (tr. 1963). 'Split representation in the art of Asia and America', in C. Lévi-Strauss, *Structural Anthropology*. New York, Basic Books, pp. 245–68.

——. 1958b. (tr. 1963). 'The serpent with fish inside his body', in C. Lévi-Strauss, *Structural Anthropology*. New York, Basic Books, pp. 269–76.

——. 1962. (tr. 1966). *The Savage Mind*. Chicago, University of Chicago Press.

——. 1975. (tr. 1983). *The Way of the Masks*. London, Cape.

Lidz, C.W. and V. Lidz. 1976. 'Piaget's psychology of the intelligence and the theory of action', in J.J. Loubser, R.C. Baum, A. Effrat and V. Lidz (eds), *Explorations in General Theory in Social Science*. New York, The Free Press, pp. 195–239.

Lowenthal, L. 1961. *Literature, Popular Culture and Society*. Palo Alto, Calif., Pacific Books.

Lukács, G. 1923 (tr. 1971). *History and Class Consciousness: Studies in Marxist Dialectics*. London, Merlin Press.

McCall, M.M. 1977. 'Art without a market: creating artistic value in a provincial art world', *Symbolic Interaction* 1: 32–43.

McClennan, A. 1994. *Inventing the Louvre: Art, Politics and the Origins of the Modern Museum in Eighteenth-century Paris*. Cambridge, Cambridge University Press.

Mainardi, P. 1989. 'Editor's statement: nineteenth century art institutions', *Art Journal* 48.1: 7–8.

Mannheim, K. 1922 (tr. 1993). 'On the interpretation of Weltanschauung', in K. Wolff (ed.), *From Karl Mannheim*, 2nd edn. London, Transaction, pp. 136–86.

——. 1982. *Structures of Thinking*, edited and introduced by D. Kettler, V. Meja and N. Stehr. London, Routledge & Kegan Paul.

Marcuse, H. 1968. 'The affirmative character of culture', in H. Marcuse, *Negations: Essays in Critical Theory*. London, Allen Lane, pp. 88–133.

Martin, F.D. 1963a. 'The imperatives of stylistic development: psychological and formal', *Bucknell Review* 11.2: 53–70.

——. 1963b. 'The sociological imperative of stylistic development', *Bucknell Review* 11.4: 54–80.

Martindale, A. 1972. *The Rise of the Artist in the Middle Ages and the Early Renais-sance*. London, Thames & Hudson.

Martorella, R. 1990. *Corporate Art*. New Brunswick, NJ, Rutgers University Press.

Menger, P.M. and R. Moulin, 1983. 'Les professions artistiques', *Sociologie du Travail* 25: 383–5.

Miller, D. (ed.) 1995. *Acknowledging Consumption*. London: Routledge.

Mohr, J.W. 1998. 'Measuring meaning structures', *Annual Review of Sociology* 24: 345–70.

Montias, J.M. 1982. *Artists and Artisans in Delft: A Socio-economic Study*. Princeton, NJ, Princeton University Press.

Morgan, D. 'Cultural work and friendship work: the case of Bloomsbury', *Media, Culture and Society* 4: 19–32.

Moulin, R. 1967 (tr. 1987). *The French Art Market: A Sociological View*. London, Rutgers University Press.

——. 1983. 'De l'artisan au professionel: l'artiste', *Sociologie du Travail* 25: 388–403.

Mukerji, C. 1983. *From Graven Images: Patterns of Modern Materialism*. New York, Columbia University Press.

——. 1990. 'Reading and writing with nature: social claims and the French formal garden', *Theory and Society* 19: 651–79.

——. 1994. 'The political mobilisation of nature in seventeenth century French formal gardens', *Theory and Society* 23: 651–77.

——. 1997. *Territorial Ambitions and the Gardens of Versailles*. Cambridge, Cambridge University Press.

Mulkay, M. and E. Chaplin. 1982. 'Aesthetics and the artistic career: a study of anomie in fine art painting', *Sociological Quarterly* 23: 117–38.

Munn, N.D. 1964. 'Totemic designs and group continuity in Walbiri cosmology', in M. Reay (ed.), *Aborigines Now: New Perspectives in the Study of Aboriginal Communities*. Sydney, Angus and Roberston, pp. 83–100.

Nochlin, L. 1988. 'Successes and failures at the Orsay musuem, or whatever happened to the social history of art?', *Art in America* 76.1: 88.

Panofsky, E. 1920 (tr. 1981). 'The concept of artistic volition', *Critical Inquiry* 8: 17–33.

——. 1924 (tr. 1968). *Idea: A Concept in Art Theory*. New York, Harper & Row.

——. 1939. *Studies in Iconology: Humanistic Themes in the Art of the Renaissance*. Oxford, Oxford University Press.

——. 1951. *Gothic Architecture and Scholasticism: An Inquiry into the Analogy of the Arts, Philosophy and Religion in the Middle Ages*. New York, Meridian.

——. 1955. (originally published 1940). 'The history of art as a humanistic discipline', in E. Panofsky, *Meaning in the Visual Arts*. Chicago, University of Chicago Press, pp. 1–25.

Parsons, T. 1951. *The Social System*. New York, The Free Press.

——. 1961. 'Culture and the social system', in T. Parsons, E.A. Shills, K.D. Naegele and J.R. Pitts (eds), *Theories of Society*. New York, The Free Press, pp. 971–93.

——. 1964. *Social Structure and Personality*. New York, The Free Press.

——. 1974/78. 'Religion in post-industrial America: the problem of secularization', *Social Research* 41: 193–225 in T. Parsons, *Action Theory and the Human Condition*. New York, The Free Press, pp. 300–22.

Parsons, T. and G. Platt, 1973. *The American University*. Cambridge, Mass., Harvard University Press.

Parsons, T. and W. White, 1961. 'The link between character and society', in S.M. Lipset and L. Lowenthal (eds), *Culture and Social Character*, in T. Parsons 1964, *Social Structure and Personality*. New York, The Free Press, 1964, pp. 183–235.

Peacock, J.L. 1975. *Consciousness and Change: Symbolic Anthropology in Evolutionary Perspective*. Oxford, Basil Blackwell.

——. 1976. 'Expressive symbolism', in J.J. Loubser, R.C. Bram, A. Effrat and V. Lidz (eds), *Explorations in General Theory in Social Science*. New York, The Free Press, pp. 264–76.

Pears, I. 1988. *The Discovery of Painting: The Growth of Interest in the Arts in England 1680–1768*. New Haven, Conn., Yale University Press.

Perry, G. and C. Cunningham. 1999. *Academies, Museums and Canons of Art*. London: Yale University Press and the Open University.

Peterson, R.A. 1976. 'The production of culture: a prolegomenon', in R.A. Peterson (ed.), *The Production of Culture*. Beverly Hills, Calif., Sage, pp. 7–22.

——. 1978. 'The production of cultural change: the case of contemporary country music', *Social Research* 45.2: 292–314.

——. 1985. 'Six constraints on the production of literary works', *Poetics* 14: 45–67.

——. 1986. 'From impresario to arts administrator: formal accountability in non-profit cultural organisations', in P. DiMaggio (ed.), *Non-profit Enterprise in the Arts: Studies in Mission and Constraint*. New York, Oxford University Press, pp. 161–83.

——. 1994. 'Culture studies through the production perspective', in D. Crane (ed.), *The Sociology of Culture: Emerging Theoretical Perspectives*. Oxford, Blackwell, pp. 163–89.

Peterson, R.A. and D.G. Berger. 1975. 'Cycles in symbol production: the case of popular music', *American Sociological Review* 40: 158–73.

Pevsner, N. 1940. *Academies of Art: Past and Present*. Cambridge, Cambridge University Press.

Podro, M. 1982. *The Critical Historians of Art*. New Haven, Conn., Yale University Press.

Pollock, G. 1983. 'Artists, mythologies and media – genius, madness and art history', *Screen* 21.3: 57–96.

Potts, A. 1994. *Flesh and the Ideal: Winckelmann and the Origins of Art History*. New Haven, Conn., Yale University Press.

Press, A. 1994. 'The sociology of cultural reception: notes towards an emerging paradigm', in D. Crane (ed.), *The Sociology of Culture: Emerging Theoretical Perspectives*. Oxford, Blackwell, pp. 221–46.

Preziosi, D. 1989. *Rethinking Art History: Meditations on a Coy Science*. New Haven, Conn., Yale University Press.

Radway, J. 1984. *Reading the Romance: Women, Patriarchy and Popular Literature*. Chapel Hill, NC, University of North Carolina Press.

Rees, A.L. and F. Borzello. 1986. 'Introduction', in A.L. Rees and F. Borzello (eds), *The New Art History*. London, The Camden Press, pp. 2–10.

Riegl, A. 1902/30. *Das Holländische Gruppenporträt*, ed. K.M. Swoboda, 2 vols, Vienna, Österreichische Staatsdruckererei.

Rosenblum, B. 1978a. 'Style as social process', *American Sociological Review* 43: 422–38.

Rosenblum, B. 1978b. *Photographers at Work*. New York: Holmes and Maier.

Ryan, J. and R. Peterson. 1982. 'The product image: the fate of creativity in country music songwriting', *Annual Review of Communication Research* 10: 11–32.

Saussure, F. de. 1917 (tr. 1959). *Course in General Linguistics*. London, Owen.

Schapiro, M. 1939. 'The sculpture of Souillac', in W.R.W. Koehler (ed.), *Medieval Studies in Memory of A. Kingley Porter*. Cambridge, Mass., Harvard University Press, pp. 359–87.

——. 1994 (1964). 'On the relation of patron and artist: comments on a proposed model for the scientist', in M. Schapiro, collected papers, vol. 4, *Theory and Philosophy of Art*. New York: George Braziller, pp. 227–38.

Schiller, F. 1965 (originally published 1795). *On the Aesthetic Education of Man*, tr. and ed. E.M. Wilkinson and L.A. Willoughby. Oxford, Clarendon Press.

Schwartz, B. 1981. *Vertical Classification: A Study in Structuralism and the Sociology of Knowledge*. Chicago, University of Chicago Press.

Seed, J. and J. Wolff. 1984. 'Class and culture in nineteenth-century Manchester', *Theory, Culture and Society* 2: 38–53.

Shrum, W.M. Jr. 1996. *Fringe and Fortune: The Role of Critics in High and Popular Art*. Princeton, NJ, Princeton University Press.

Simmel, G. 1896 (tr. 1968). 'Sociological aesthetics', in K.P. Etzkorn (ed.), *Georg Simmel: The Conflict in Modern Culture and Other Essays*. New York, Teachers College Press, pp. 68–80.

——. 1903a (tr. 1959). 'The aesthetic significance of the face', in K. Wolff (ed.), *Georg Simmel, 1858–1918*. Columbus, Ohio, Ohio State University Press, pp. 276–81.

——. 1903b (tr. 1968). 'On aesthetic quantities', in K.P. Etzkorn (ed.), *Georg Simmel: The Conflict in Modern Culture and Other Essays*. New York, Teachers College Press, pp. 81–5.

——. 1904/1971. 'Fashion', in D.N. Levine (ed.), *Georg Simmel on Individuality and Social Forms*. Chicago, University of Chicago Press.

——. 1907 (tr. 1990). *The Philosophy of Money*. London, Routledge.

——. 1908 (tr. 1924). 'Sociology of the senses: visual interaction', in R.E. Park and E.W. Burgess (eds), *Introduction to the Science of Sociology*. Chicago, University of Chicago Press, pp. 356–61.

Sorokin, P.A. 1937. *Social and Cultural Dynamics*, vol. 1: *Fluctuations of Forms of Art*. New York, American Book Company.

——. 1966. 'Sociology of aesthetic systems', in P.A. Sorokin, *Sociological Theories of Today*. New York, Harper & Row, pp. 365–78.

Staubmann, H.M. 1997. 'Action theory and aesthetics: the place of the affective-cathectic action dimension in Talcott Parsons' general theory of action', *European Journal for Semiotic Studies* 9: 735–68.

Strauss, A. 1970. 'The art school and its students', in M.C. Albrecht, J.H. Barnett and M. Griff (eds), *The Sociology of Art and Literature: A Reader*. London, Duckworth, pp. 159–77.

Swingewood, A. 1987. *Sociological Poetics and Aesthetic Theory*. London, St Martin's Press.

Taine, H. 1867. *The Philosophy of Art*. London, Williams and Norgate.

Tanner, J.J. 1992. 'Art as expressive symbolism: civic portraits in classical Athens', *Cambridge Archaeological Journal* 2.2: 167–90.

——. 2000a. 'The body, expressive culture and social interaction: integrating art history and action theory', in H. Staubmann and H. Wenzel (eds), *Talcott Parsons: zur Aktualität eines Theorienprogramms*. Österreichische Zeitschrift für Soziologie Sonderband 6. Wiesbaden, Westdeutscher Verlag, pp. 285–24.

——. 2000b. 'Portraits, patrons and power in the late Roman republic', *Journal of Roman Studies* 90: 18–50.

——. 2001. 'Nature, culture and the body in classical Greek religious art', *World Archaeology* 33: 257–76.

Thompson, J.B. 1990. *Ideology and Modern Culture: Critical Social Theory in the Era of Mass Communication*. Stanford, Calif., Stanford University Press.

Tuchmann, G. 1982. 'Culture as resource: actions defining the Victorian novel', *Media, Culture and Society* 4: 3–18.

——. 1983. 'Consciousness industries and the production of culture', *Journal of Communication* 33.3: 330–41.

Turner, A.R. 1997. *The Renaissance in Florence*. London: Weidenfeld & Nicolson.

Veblen, T. 1979 (original published 1899). *The Theory of the Leisure Class*. Harmondsworth, Penguin Books.

Wackernagel, M. 1938 (tr. 1981). *The World of the Florentine Renaissance Artist: Projects and Patrons, Workshop and Art Market*. Princeton, NJ, Princeton University Press.

Warnke, M. 1985 (tr. 1991). *The Court Artist: On the Ancestry of the Modern Artist*. Cambridge: Cambridge University Press.

Weber, M. 1904/5 (tr. 1930). *The Protestant Ethic and the Spirit of Capitalism*. London, Allen & Unwin.

——. 1905 (tr. 1949). 'The logic of the cultural sciences', in M. Weber, *The Methodology of the Social Sciences*. New York, The Free Press, pp. 113–88.

——. 1912 (tr. 1958). *The Rational and Social Foundations of Music*. London, Feffer and Simons.

——. 1916 (tr. 1964). *The Religion of China: Confucianism and Taoism*. New York, The Free Press.

——. 1916/17 (tr. 1958). *The Religion of India: the Sociology of Hinduism and Buddhism*. New York, The Free Press.

——. 1917 (tr. 1949). 'The meaning of ethical neutrality in sociology and economics',

in M. Weber, *The Methodology of the Social Sciences*. New York, The Free Press, pp. 1–49.

——. 1917/19 (tr. 1952). *Ancient Judaism*. New York, The Free Press.

——. 1922 (tr. 1968). *Economy and Society*. Berkeley, Calif., University of California Press.

Weinstein, D. and M.A. Weinstein. 1993. *Postmodern(ised) Simmel*. London: Routledge.

White, H.C. and C.A. White. 1965. *Canvasses and Careers: Institutional Change in the French Painting World*. Chicago, University of Chicago Press.

Wickhoff, F. 1900. *Roman Art: Some of its Principles and their Application to Early Christian Painting*. London, Heinemann.

Wiggershaus, R. 1994. *The Frankfurt School: Its History, Theories and Significance*. Cambridge, Polity Press.

Williams, R. 1977. *Marxism and Literature*. Oxford, Oxford University Press.

——. 1981. *Culture*. London, Fontana.

Witkin, R. 1995. *Art and Social Structure*. Cambridge, Polity.

——. 1997. 'Constructing a sociology for an icon of aesthetic modernity: *Olympia* revisited', *Social Theory* 15: 101–25.

Wittkower, R. and M. Wittkower. 1963. *Born under Saturn – the Character and Conduct of Artists – A Documented History from Antiquity to the French Revolution*. New York, Norton.

Wölfflin, H. 1888 (tr. 1964). *Renaissance and Baroque*. Ithaca, NY, Cornell University Press.

——. 1898 (tr. 1952). *Classic Art: An Introduction to the Italiam Renaissance*. London, Phaidon.

——. 1915 (tr. 1950). *Principles of Art History: The Problem of the Development of Style in Later Art*. New York, Dover.

Wolff, J. 1981. *The Social Production of Art*. London: Macmillan.

——. 1982. 'The problem of ideology in the sociology of art: a case study of Manchester in the nineteenth century', *Media, Culture and Society* 4: 63–75.

——. 1987. 'The ideology of autonomous art', in R. Leppert and S. McClary (eds), *Music and Society: The Politics of Composition, Performance and Reception*. Cambridge, Cambridge University Press, pp. 1–12.

——. 1992. 'Excess and inhibition: interdisciplinarity in the study of art', in L. Grossberg, C. Nelson and C.C. Treichler (eds), *Cultural Studies*. London: Routledge, pp. 706–16.

Wuthnow, R. 1989. *Communities of Discourse: Ideology and Social Structure in the Reformation, the Enlightenment and European Socialism*. Cambridge, Mass., Harvard University Press.

Zolberg, V.L. 1980. 'Displayed art and performed music: selective innovation and the structure of artistic media', *Sociological Quarterly* 21: 219–231.

——. 1981. 'Conflicting visions in American art museums', *Theory and Society* 10: 103–25.

——. 1986. 'Tensions of mission in American art museums', in P. DiMaggio (ed.), *Nonprofit Enterprise in the Arts*. New York, Oxford University Press, pp. 184–98.

——. 1990. *Constructing a Sociology of the Arts*. Cambridge: Cambridge University Press.

——. 1992. 'Barrier or leveler? The case of the art museum', in M. Lamont and M. Fournier (eds), *Cultivating Differences: Symbolic Boundaries and the Making of Inequality*. Chicago, University of Chicago Press, pp. 187–204.

——. 1996. 'Paying for art: the temptations of privatisation à l'américaine', *International Sociology* 11: 395–408.

Index